THE WORLD OF THE
IMPRESSIONISTS

Steven Adams

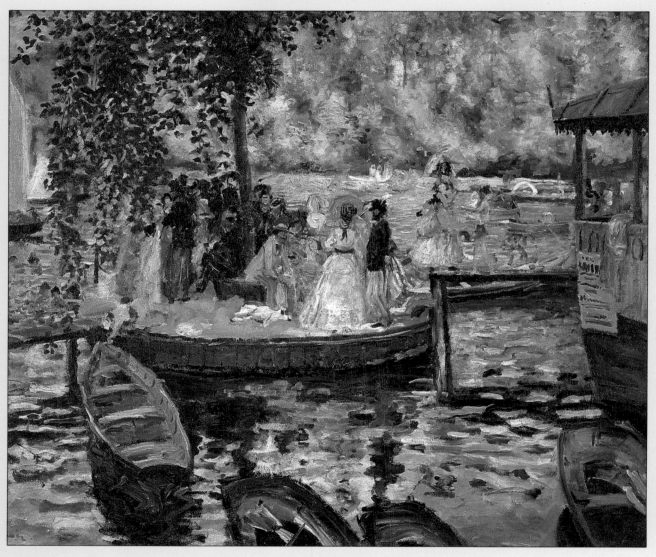

With over 300 illustrations

THAMES AND HUDSON

A QUARTO BOOK

First published in Great Britain in 1989 by Thames and
Hudson Limited, London

This book was produced and designed by
Quarto Publishing plc
The Old Brewery
6 Blundell Street
London N7 9BH

Contibuting editors Anne Crane, Suzanne Wyndham
Editorial Paula Borthwick, Nicholas Law, Mary Senéchal,
 Anthony Whitehorn
Art Editor William Mason
Photography Ian Howes, Paul Forrester
Maps Sally Launder
Picture Manager Joanna Wiese
Picture Research Nick Rowling
Indexer Ann Hall

Editorial Director Jeremy Harwood
Art Director Nick Buzzard
Production Director Richard Neo
Typeset in Great Britain by Ampersand Ltd,
 Bournemouth
Manufactured in Hong Kong by Regent Publishing
 Services Ltd
Printed by Leefung-Asco Printers Ltd., Hong Kong

TITLE PAGE: *This is one of several studies that Renoir made at La
Grenouillère, a restaurant and bathing place on the Seine at
Croissy. He spent two months there with Monet in 1869 and it is
from then that the real working companionship between the two
men dates.*

CONTENTS

INTRODUCTION

Impressionism evolved in the spectacular milieu that was Paris during the Second Empire. Earlier generations of artists, following the precepts of the state-sponsored Académie des Beaux Arts, made highly refined paintings with subjects taken from the Bible or classical history. The traditional authoritarian style dating originally from the age of Louis XIV, was often revived in an attempt to lend the ailing régimes of the 19th-century something of the dignity and political kudos of the ancien régime. The Impressionists, however, rejected conservative academic traditions and, following the advice of critics such as Baudelaire and Champfleury, painted subjects taken not from the classical past but from the present. Manet, Monet, Pissarro, Sisley , Renoir, Degas and others held up a mirror to French society and documented the subjects of modern life – the newly designed vistas along boulevards; the railway, scenes of cafe life, prostitution, the theatre, the coast and the countryside made accessible by the expanding railway network – with painstaking fidelity.

This society was going through a series of dramatic changes, just as the character and outlook of French painting was to do largely as a result of the impact of Impressionism. The Bourbon monarchy, restored after the final defeat of Napoleon in 1815 had been forced to recognize and balance the conflicting interests of a variety of social groups and classes from monarchist factions on the right to republicans on the extreme left. Each of these social groups enjoyed its moment of glory – the reign of Charles X saw an attempt to restore the values of the ancien régime, while the republican parties, an active force in French politics since the revolution of 1789, enjoyed fleeting power in the wake of the uprisings of 1830 and 1848. On the whole, however, political life for the most part was dominated by conservative governments acting in the interests of the middle classes. The financiers and landowners that had campaigned against the near-absolutist regime of Charles X were loth in 1830 to embrace the revolutionary ideals of 1789. They turned instead to a new style of monarchy under the direction of Louis-Philippe, whose aim was to steer a middle path between the excesses of absolutist kingship and revolutionary terror and to maintain a political 'juste milieu' in the interests of the bourgeoisie. Although Louis Philippe's conservative administration foundered in 1848 and was replaced by a provisional republican government, middle-class conservatism recurred with a vengeance following the election of Louis Napoleon as President in 1848.

The economic recession that had been one of the causes of the 1848 revolution ended in 1851, and Louis Napoleon took full advantage of the boom that followed by taking part in a triumphal tour of France and parading as the nation's saviour. The value of shares rose dramatically and interest rates began to fall; credit increased and new banks were established, including the Crédit Agricole, the Crédit Lyonnais and the Crédit Mobilier. The size of the French railway network increased by over 300 per cent between 1852 and 1860; France became increasingly active in foreign trade, while heavy industry increased its output.

Public works were among the most adventurous programmes of the Second Empire and the Third Republic; 70 per cent of the capital was razed during the second half of the century. The factories and the urban poor that worked in them were moved out of the capital to the faubourgs – shanty towns on the outskirts of Paris. The remainder of the capital, in particular the quarters to the north and west, was carefully replanned to present a spectacular ideological expression of the affluence and grandeur of the times. Residential appartments, elegant shops, theatres, restaurants and street cafés laid out on wide pavements offered a spectacular playground for the nouveaux-riche bourgeoisie, many of whom had made considerable sums of money in the booming economy. The new design was not just an external display of the Second Empire's wealth; it also helped the government to maintain social order. The uprisings of 1830 and especially 1848, still fresh in the minds of Napoleon and his ministers, were fought in narrow streets. Long, wide boulevards straddling the city not only looked elegant and impressive, they were also virtually impossible – so it was thought – to barricade, provided excellent firing lines and enabled troops to move about the capital with ease.

The efforts of the developing network of critics and dealers active in Paris at the end of the 19th century eventually proved successful. Impressionist painting was no longer vilified; it shed many of the radical connotations that had been falsely associated with it as French society itself became ever more stable. Impressionism no longer shocked the middle classes; instead, they collected it, paying in some cases thousands of francs for pictures, which, two decades before, could have been bought for less than a couple of hundred francs. The Ecole des Beaux Arts continued to recruit students and the Salon continued to exhibit academic paintings, but such institutions were now largely discredited and associated with the values of long-defunct régimes. Impressionist painters now were associated with the establishment and enjoyed the status of masters. Monet, in the last years of his life, was lionized by critics and took great delight in giving *ex cathedra* lectures on Impressionism, many of which still colour our perceptions of the movement.

The younger generation of European avant-garde painters that followed the Impressionists rejected realism and retreated into an introspective interest in abstract form and colour. The Impressionists were thus one of the last movements in modern art to take an active interest in the social life of the milieu of which they formed part. For this reason Impressionism is best understood not by recourse to art historical terminology, but rather through the cultural and social changes that France underwent in the second half of the 19th century. This book attempts to document the social backdrop against which Impressionism unfolded.

It was this world that the Impressionists were to capture so faithfully. However the conservative Parisian middle classes that so often appeared in Impressionist painting disliked Impressionism. They had first recoiled in horror at the work of Edouard Manet when his *Le Déjeuner sur l'herbe*, depicting two bourgeois dandies in the company of a naked whore, was shown at the Salon des Refusés in 1863; thereafter, with a few exceptions, his work became an object of derision whenever it was put on public show. The Impressionists, of whom Manet was considered by many critics to be the founder, were tarred with the same brush. They found it difficult to show their works at the official Salon, an annual exhibition dominated by academicians, and the works on show at the first Impressionist exhibition, held in 1874, were pilloried by the press and public. So close was the bond between the arts and the state that any attempt to challenge the accepted academic style was seen to carry dangerous political overtones. The Impressionists were either considered to be dangerous 'democrats' or hacks; the cursory unfinished style of painting evolved to capture the fleeting effects of movement and light was considered to be a mark of incompetence.

Many members of the Impressionist circle were, in fact, far from revolutionary, Degas was a conservative in matters of politics, and his painting is in many respects quite traditional. He followed the conventional practice of making paintings in the studio rather than in the open air and greatly admired the paintings of Ingres, the darling of the academic establishment, Pissarro had strong sympathies with the Anarchist movement; other members of the circle, however, shared few political interests. So diverse were the aims and ideas of the various members of the Impressionist circle that many critics wrote about them at length in an attempt to impose some theoretical rigour on the movement. The poet Stéphane Mallarmé and the critic Edmond Duranty saw within Impressionist painting an attempt to present a radical new democratic vision in keeping with the aspirations of the urban middle classes. Théodore Duret, in contrast, described the movement in an essay entitled *Les Peintres 'Impressionnistes'* as a school primarily concerned with landscape painting. The very term 'Impressionniste' was invented by a critic and the movement was to a large extent defined and sustained by successive generations of art dealers and critics. The Impressionists are, perhaps, best understood not as a movement with a coherent aesthetic programme but rather as a group of painters united in their opposition to the conservative tastes of the Ecole and Salon. Gradually, the tide turned in their favour, aided by a slow change in middle-class taste – and the slow, but sure, recognition of their natural talents and abilities.

THE PRECURSORS OF IMPRESSIONISM

The major artists to whom the label 'Impressionists' came to be attached were all born within 11 years of each other between 1830 and 1841. All of them studied in Paris, many at the same art school. Thus they shared the same preoccupations and the same immediate past. Most of them, too, were from the bourgeoisie, whether great or small, and therefore born into the class which was to dominate French artistic taste for the better part of the 19th century.

The use of art as propaganda had been widespread during the revolutionary years; and, as General Bonaparte transformed himself first into First Consul and then into the Emperor Napoleon, he too resorted to hagiographical iconography. Under the *ancien régime*, patronage of artists had been largely in the hands of the monarchy and the aristocracy, but it now fell into those of the state and the nouveaux riche bourgeoisie.

The crushing defeat at the battle of Waterloo in 1815 had been a severe blow to French nationalistic pride and consequently the restored Bourbon monarchy felt the need to encourage art that would help to restore France's belief in herself. This was partially achieved by encouraging the re-awakening of interest in history and therefore of history painting, a subject of long-standing academic importance, and partially by upholding the Napoleonic land settlements and adopting relatively conservative financial policies. The relative financial stability this brought about was to last from 1822 to 1914, though, naturally, there were some economic crises along the way. Both allowed the bourgeoisie to cling to its inherent conservatism and at the same time indulge its materialism.

GROWING PROSPERITY FOR THE MIDDLE CLASS

The revival under the Restoration of political discussion and intellectual life, a more open-minded attitude that led increasingly to scientific and industrial developments and the emergence of a popular press, all combined to encourage greater fragmentation of society, and inevitably, a multiplicity of political parties. The forced abdication of Charles X in July 1830 was caused as much by the antagonism of the re-established aristocracy, combined with that of the swelling ranks of the new clergy and the men who had made the new fortunes and thought they had a right to share in the government, as by any dislike in general of the monarchy as an institution. This was evident from the fact of Charles X's replacement by the Orléanist Louis-Philippe as 'King of the French' a month later. Louis introduced France to constitutional monarchy. He sought, amongst other policies, to enhance his legitimacy by the creation of a History Museum at Versailles, which gave even further impetus to the school of history painters, whose works were to remain fashionable in academic circles and with the public at large for the better part of the century. The 18 years of his reign were also marked by a flourishing of industry, which enriched the growing middle class and gave a boost to investment of all kinds, including that in works of art. The press regained much of the freedom it had been denied under the Restoration and gave voice to idealistic and socialist theories. When the uprisings of February 1848 forced Louis-Philippe to abdicate, the provisional government that replaced him removed all restrictions. This led to an even greater proliferation of newspapers and journals, but their freedom, like the term of the Second Republic, was short-lived.

In November the same year the Assembly voted for a constitution which called for a Legislative Assembly and a President to be elected by universal male suffrage. The

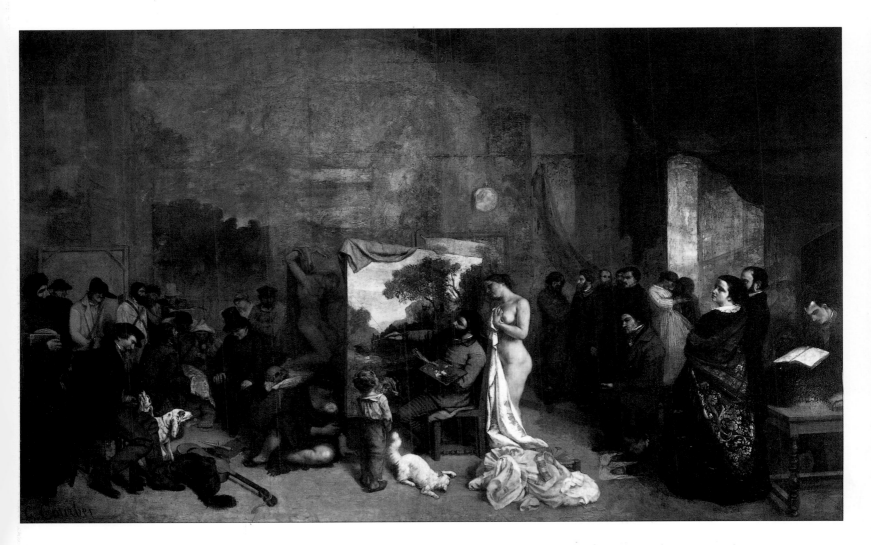

The Painter's Studio *by Gustave Courbet. Painted in 1885, the*
picture was shown at Courbet's Pavilion du Réalisme and was
originally entitled Interior of my studio; a true allegory
determining a phase of seven years of my artistic life.
Courbet appears at the centre of the picture seated at an easel.
Beside him stands a child, a symbol of the untutored innocence upon
which, Courbet believed, realist painting was based. To the artist's
left stand representatives of the working classes including a curé, a
Jew, an Irish peasant and her child; to his right are writers, critics
and intellectuals including Charles Baudelaire, Champfleury, the
radical philosopher Prudhon and the collector Alfred Bruyas.

leading candidate, whose support came mainly from the provinces and who, ironically in
view of his later actions, owed some of his success to manipulation of the press, was
Louis-Napoleon, who had tried to overthrow Louis-Philippe's regime in both 1836 and 1846
He was duly elected, and one of his first decrees as Prince-President was to reintroduce laws
to curb press freedom. After the *coup d'état* of 1851, when he dissolved the Legislative
Assembly and his proclamation, a year later, of himself as emperor, Napoleon III established
what amounted to a total and draconian censorship. However, there was by now a large
public for papers of all kinds, so to cater for it, in the absence of political news and views,
articles on literature, music and art became the rage instead. Cultural matters thus became a
polemical battlefield, giving rise to a new breed of professional critics who found exaggerated
praise or derision made good copy, and who, in polarizing differences of opinion, created
divergencies between 'isms' that were largely factitious. Journalists have always found that
disputes, whether in the field of politics, literature or art, make news and that public interest is
stimulated by catchphrases and labels, however little their actual meaning. Just as the bogey
of the extreme Left was created to frighten the electorate, so, in time, would the revolutionary
character of the 'new' painters be stressed to makes issues for discussion. In point of fact, the
division between what came to be seen as opposing sides hardly existed in reality.

continued on page 12

ARTISTS, PAINTS AND COLOURS

Technological advances as a result of the Industrial Revolution played a central role in the Impressionist achievement by giving the movement's artists the ability to develop their own painting techniques and take advantage of the new colours. The three significant developments were the introduction of mechanical grinding, oil binders, and additives to keep paint fluid and workable in the new tube containers. All these combined to influence the texture of mid-19th century paints, which were more suited to impasto work.

As always, the result was a battle between old and new, tradition and experiment. Though many sound, bright transparent colours had come on to the market by the 1860s, the traditionalists considered them brash and vulgar and therefore unsuited to the demands of academic painting. However, it was precisely these colours, with the addition of opaque stable lead white, that were to feature in the palettes of Manet, Degas and the other Impressionists. They were also deeply influenced by the theories of Eugène Chevreul, a French chemist who researched into colour harmonies. In his *The Principles of Har-*

mony and Contrast of Colours and their Application to the Arts of 1839, he held that colours in proximity influence and modify each other. This, plus his theories of negative after-image – the idea that any colour on its own appears to be surrounded by a faint aureole of its complementary colour – and optical mixture became central tenets of Impressionism. The last, for instance, led them to tinge shadows with colours complementary to those of the object casting the shadow and to juxtapose colours on the canvas that visually seem to fuse at a distance.

Monet and Pissarro had first-hand knowledge of Chevreul's work, which obviously influenced the composition of their basic palettes. The latter's, for instance, was composed solely of the six rainbow colours – white lead, light chrome yellow, Veronese green, ultramarine or cobalt blue, dark madder lake and vermilion. Monet's became somewhat heavier over the years, but, as the painter himself explained, this was due to deteriorating sight. He wrote: 'While I could no longer continue playing about with shades or landscape in delicate colours, I could see as well as ever when it came to vivid colours.'

Berthe Morisot photographed at work in her studio (right). Morisot was the pupil of Corot and Fantin-Latour; she successfully exhibited at the Salon in 1864; in 1868, while she was copying a painting by Rubens in the Louvre, Fantin-Latour introduced her to Manet, with whom she was to become closely associated, eventually marrying his brother, Eugène, in 1874. A leading member of what critics termed the Impressionist 'gang', she was largely responsible for organizing the last group exhibition in 1866. Her brushwork is noted for its restlessness.

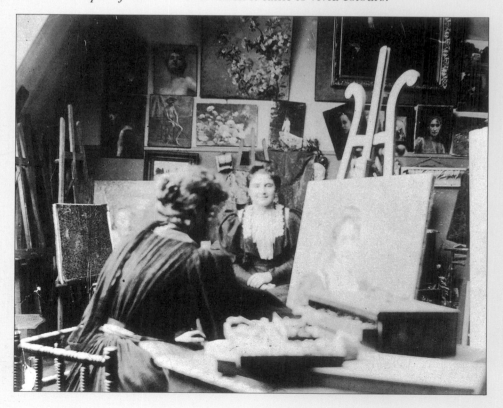

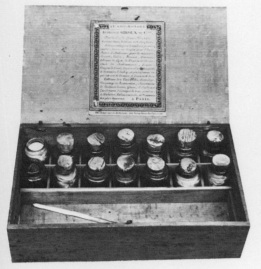

This box of powder pigments in bottles (left) was packaged and sold by the French colour merchant Alphonse Giroux around 1800. The label on the lid lists other artists' materials supplied by this dealer. Such merchants became a dominant force in artistic life; at times, Monet had to stop painting when he could not afford to pay for paint.

Pigs' bladders, stoppered with ivory tacks (right and below), were the traditional oil colour containers of the early 19th century.

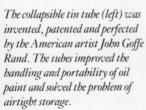

The collapsible tin tube (left) was invented, patented and perfected by the American artist John Goffe Rand. The tubes improved the handling and portability of oil paint and solved the problem of airtight storage.

Painters at work touching up their canvases before the official opening of the Salon (right). For all artists, this was a dominant influence on their lives – even for those, such as Pissarro, who resolutely stood out against exhibiting. Bazille, too, hated the system: in 1867, he wrote: '…I will no longer send anything to the jury. It's much too ridiculous, when one knows one isn't a fool, to be exposed to these administrative whims, above all when one doesn't care about medals and prize-givings'.

SUPPORTS AND CANVASES

The Impressionists favoured white and pale tinted primings; from around 1870, the ground was increasingly exploited. Here are samples of 19th-century canvas, the first being the reverse side of primed étude weight canvas.

Face side of étude weight canvas, primed with one coat of ton clair, a pale yellowish tinted ground.

Demi-fine or half-fine weight canvas primed with one coat grey ground to give a grainy or a grain face.

Half-fine canvas with two coats grey priming to give smooth or lisse faces.

Unprimed face of twill weave canvas, showing diagonal texture. All the samples shown here date from around 1900.

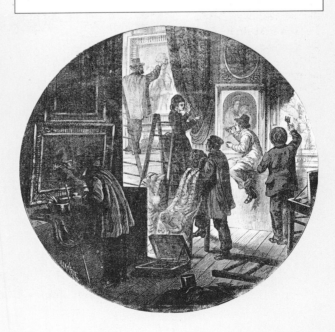

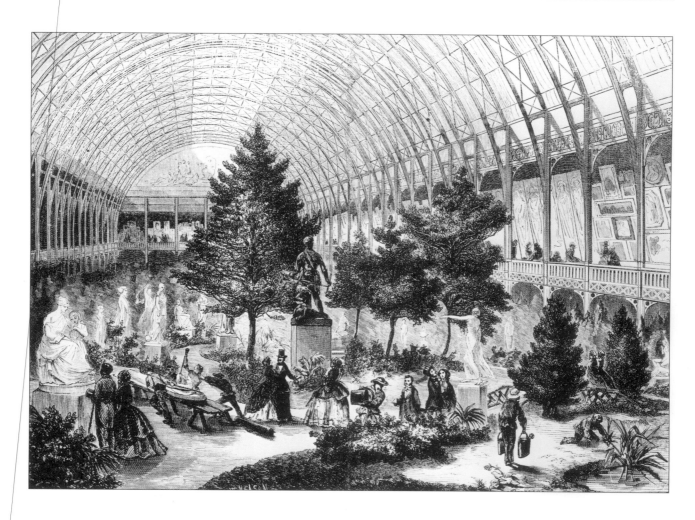

A view of the interior of part of the Palais de l'Industrie. The Palais, constructed in 1885 to house the first Exposition Universelle, was later used as the venue for the Salon, a biennial and later annual exhibition of painting and sculpture. Sculptures were displayed in the centre of the exhibition on the ground floor; paintings stacked one upon the other can be seen on the balcony.

THE ACADEMY AND FRENCH ART

The generation of artists born in the 1830s grew up therefore in a France where fortunes were being made at the same time as an urban proletariat was coming into being, with political instability and extreme conservatism in matters of taste going hand in hand. Early 19th-century French academic art, which thrived on state commissions, especially for the large number of newly erected municipal buildings and the provincial museums created by Napoleon I, was inevitably conditioned by this political background, and, in so far as it was a product of the state, reflected the demands of the regime in power.

As a system, it had its origins in the foundation of the Académie Royale de Peinture et de Sculpture in 1648 by Cardinal Mazarin and the young Louis XIV. Created to give artists a greater freedom than they had possessed in their former Guild of St Luke with its restrictive practices, it was also intended to put painting and sculpture on an intellectual par with their sister art, literature, for which the Académie Française had been founded 13 years before.

The Académie Royale gave itself rules which it claimed were underwritten by antiquity, the Old Masters and Cartesian common sense. These were further defined in 1664, when Colbert gave it a new constitution, which turned it primarily into a teaching establishment to carry out the artistic commissions that would bear witness to the achievements and glory of the Sun King. It continued to be a learned body, lending its members prestige and giving them the privilege of public exhibitions, originally held in the Salon d'Apollon at the Louvre, while insisting on a strict hierarchy of subjects that were permissible. The Académie Royale in its turn became doctrinaire and authoritarian and laid increasing stress on the belief that nature

should only be shown in an ideal form. The more frivolous Regency which followed the last gloomy years of Louis XIV's long reign and the sophisticated court of Louis XV ushered in a style of decorative elegance, which in its turn led to a new questioning of artistic values. In reaction to the licentiousness of boudoir gallantries, the moral content of a work of art once more became fashionable, even if it led to sentimentality, as in works by Jean-Baptiste Greuze (1725-1805). A new attitude to nature was born, in both the writings of the philosopher Jean-Jacques Rousseau (1712-78) and the art criticism, the first of its kind, by the Encyclopédiste, Denis Diderot (1713-84), who reviewed the Salons.

During the Revolution, the Salons had become annual events and the jury, made up of academicians who selected the works for exhibition, was abolished. However, with the right to exhibit open to all, the number of artists wishing to show became so large that the jury system had to be reinstated. Not until 1848 was the jury abolished again. The Académie Royale itself, however, was dissolved in 1793 by Jacques-Louis David (1748-1825) who, in his paintings, turned back to classical themes, making them fashionable again, while at the same time subjecting his own pupils to a rigid system of instruction. Though various bodies were substituted for the Académie, none was satisfactory, and it was re-constituted a year after the Restoration in 1816, with the new title of Académie des Beaux-Arts and with a school, the Ecole des Beaux-Arts, attached to it.

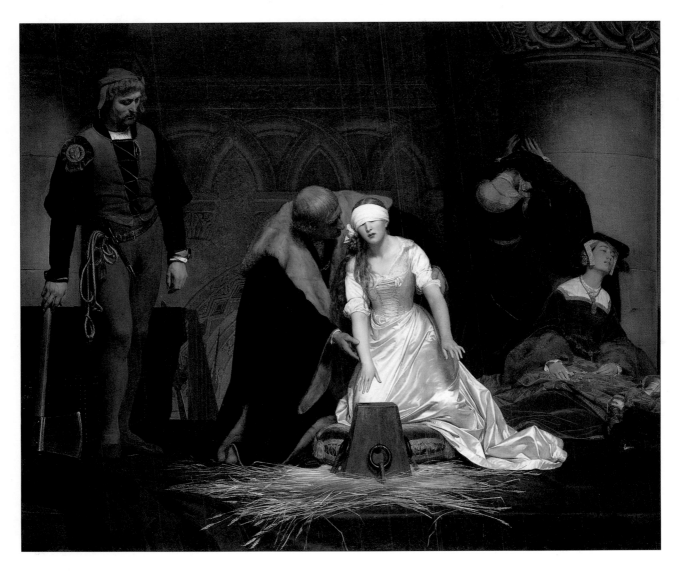

The Execution of Lady Jane Grey by Paul Delaroche, painted in 1883 and shown at the Salon in the following year. Sentimental subjects, often taken from modern rather than classical history, were enormously popular with middle-class visitors to the Salon.

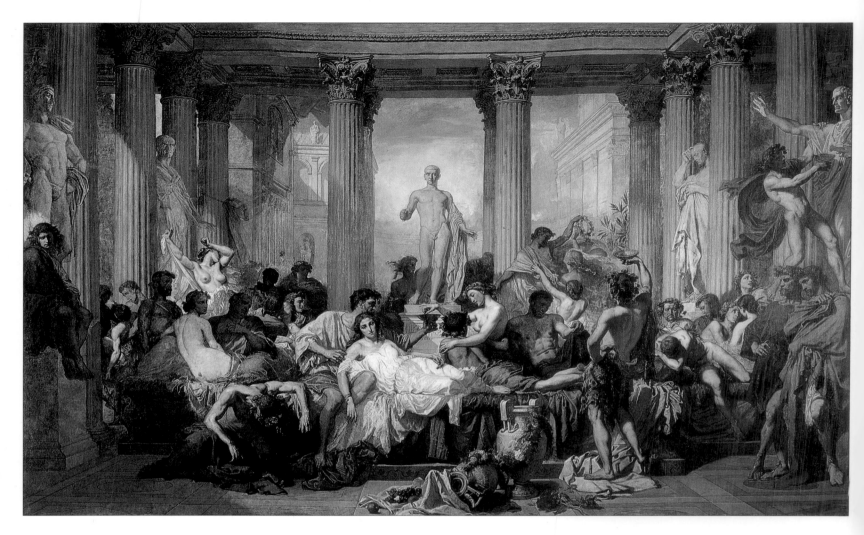

The Romans of the Decadence *by Thomas Couture was painted in 1847. The painting caused a sensation when it was shown at the Salon of that year. The drunken orgy, watched by* statues of Roman dignitaries from the past, illustrates the state of decay into which the empire had fallen under the Emperor Nero's administration.

The newly reconstituted Académie was therefore one of the institutions at the Restoration which, like the aristocracy and the clergy, clung to its elitist and restrictive rules and regulations, both of entry and subject-matter, and it quickly established a stranglehold on public art. It also remained the pinnacle for aspiring artists, who rightly believed that the way to fame and fortune lay through its doors.

Consequently the aim of most students was to win a place at the Ecole des Beaux-Arts, to be awarded the Prix de Rome (a three-year scholarship to the French Academy in Rome) and to exhibit at the Salon, which was the only opportunity the public had of seeing works of art. After crossing those hurdles, they could expect prestigious and remunerative public commissions, and an additional income from pupils paying them substantial fees in the hope of achieving similar success. Thus the choice of a suitable atelier was important in attaining these goals, since many of the leading teachers were also members of the committees that selected paintings for the Salon and awarded the official prizes, thereby ensuring the continuity of entrenched academic principles.

ROMANTICISM AND THE ROMANTIC CHALLENGE

However, the established academic view did not go unchallenged. The most successful opposition came from the Romantic painters, whose concerns were with liberty and freedom for self-expression. The most eloquent exponent of Romanticism, which stressed not only the

primacy of emotion over intellect but also that of colour over line, was Eugène Delacroix (1798-1863). His works were seen by contemporary critics as the antithesis of the Neo-classicism of Jean-Auguste-Dominique Ingres (1780-1867). Delacroix was as influential as he was eloquent, and his use of bright colours applied with rapid brush-strokes was to have a great impact on the art of the time. Theodore Gericault (1791–1824), too, had explored the extremes of feeling and experience, against which a Realist such as Gustave Courbet (1819-77) would later react.

Such men had to fight not only against the conservatism of the Academy, but also against that of the public. The latter found the work of the Romantics both brutal and incomprehensible. Thus it was that those artists with a modicum of talent, a strong constitution, good connections and, above all, the ability to give the public what it wanted, could forge a glittering career for themselves.

The successful academic painters of the years from 1830 to 1850 were exemplified in the

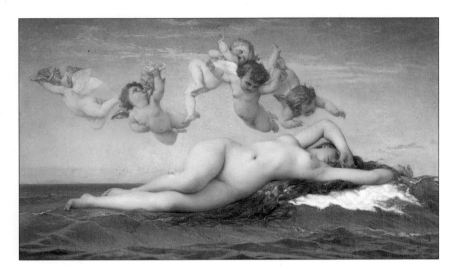

Birth of Venus by Alexandre Cabanel, painted in 1863. Cabanel's classical, but erotic, figure is in marked contrast to Manet's more realistic treatment of the nude in his Déjeuner sur l'herbe. *Napoleon III bought the former picture but condemned the latter as 'immodest'. The two works were shown at the Salon of 1863 and the Salon des Refusés respectively.*

field of history painting, by Paul Delaroche (1797-1856). He exhibited *The Execution of Lady Jane Grey* in the Salon of 1834 to huge critical acclaim. Adapting the classical style of David, Delaroche centred his figures on the canvas in a meticulously planned composition, and obeyed academic precepts religiously, down to the high finish of the paint. The Parisian bourgeoisie saw something of Joan of Arc, a national heroine undergoing one of her periodic rehabilitations, in the portrayal of the beautiful and innocent young queen about to be beheaded, and it touched their hearts. As a *tour de force* of sentiment, with a simple narrative that even the most philistine could understand, it was one of the most popular pictures in the exhibition and actually reduced some viewers to tears.

During the 1830s and 1840s painters like Delaroche, Horace Vernet (1786-1863) and Thomas Couture (1815-79) formed what one contemporary critic, mindful of Chateau-briand's *bon mot* about 'the heroes of July, cheated of their republic by the *juste milieu*', termed the middle path. This avoided the excesses of Romanticism on the one hand and arid Classicism on the other. Other successful artists included Jules-Joseph Lefebvre (1836-1911), Ernest Meissonier (1815-91), Isidore Alexandre Augustin Pils (1813-75), Tony Robert-Fleury (1837-1912), Marc Gabriel Charles Gleyre (1808-74), and notably Jean-Louis Gérôme (1824-1904) and Alexander Cabanel (1824-89), who all won recognition from public, state and press. Gérôme, whose style, according to Charles Baudelaire (1821-67), could be placed somewhere between that of Ingres and Delaroche, was praised for his anecdotal paintings of classical subjects such as his *Death of Julius Caesar* and his erotic *Phyrre*, the toast of the 1861 Salon. Cabanel, who specialized in genteel classical allegories, was perennially popular. Typical of his work is *The Birth of Venus*, which was shown at the Salon of 1863, bought by Napoleon III and earned the painter membership of both the Légion d'honneur

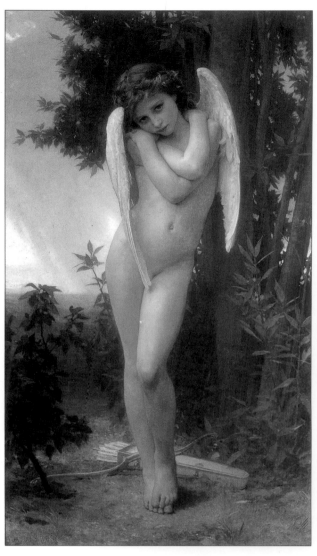

La Danse *by Adolphe-William Bouguereau,
painted in 1857 (above).* Cupidon, *also by
Bouguereau (right), painted in 1891.
Technically well-finished pictures, loosely
based upon classical themes set the standard for
academic painting of the period.*

and the Académie des Beaux-Arts. To be accorded the accolade of membership of the Légion
d'Honneur was a sure sign of public esteem, and one eagerly sought after by ambitious men to
whom such things mattered. Few contemporary observers would have agreed with the view
of the critic Jules-Antoine Castagnary (1830-88) – and modern opinion – that 'when the time
comes to write about evolutions and deviations of nineteenth-century French painting one can
forget Cabanel and one must reckon with Manet'. It is ironic, in the circumstances, that one of
Manet's most ardent desires in later life was to be so honoured.

This artistic establishment continued for some decades to provide its middle-class public
with inoffensive and technically proficient paintings – not only undemanding narratives,
society portraits and the like, but also pleasant landscapes. While in general landscapes were
painted, as they had been for the past 200 years, in the studio, and the theme was not
recognized as a major genre, some of these academic painters did undertake preliminary work
in the open air direct from the subject. Adolphe William Bouguereau (1825-1905), Meissonier
and Léon Cogniet (1794-1880) for example, made small quickly executed sketches from nature
that could well pass as precocious experiments in Impressionism. Bouguereau's *Eglise en
campagne* is an unaffected rendering of a country church, evidently painted at speed, in broad
sweeps of paint without any attempt to produce a high degree of technical finish.

Although critical opinion of the works of these artists has changed (and may be about to
change back again), their output remains significant, for it was on the whole responsible for
creating the cultural setting in which the precursors of what was to become known as
Impressionism appeared in the 1840s and 1850s.

THE EMERGENCE OF THE BARBIZON SCHOOL

One of the first groups of painters to accord rapidly made *plein-air* sketches the status of finished pictures with importance in their own right, as appropriate forms in which to represent the natural world, was that which came to be known as the Barbizon School. Barbizon, a village near Fontainebleau, had been discovered in 1824 by two minor artists, Claude Aligny and Philippe le Dieu, on a visit to the porcelain factory nearby:

> Word was brought back to Paris of the discovery of this bit of unspoilt primitive
> Nature only a day's walk distant from that most modern of European capitals,
> and the next year the artists invaded the place, occupying every nook and
> corner. Those who could not find lodgings in Barbizon stopped at the White
> Horse in Chailly, among others Corot, Rousseau, Barye, Diaz.

Théodore Rousseau (1812-67) started to visit the district in 1836, but did not settle there until ten years later. His decision to do so was partially prompted by his lack of success at the Salon, to which he had not been admitted since 1831.

The group that soon collected around Barbizon consisted of Narcisse Virgile Diaz de la Peña (1807/8-76), Charles-François Daubigny (1817-78), Constant Tryon (1810-65) and Charles-Emile Jacque (1813-94). These artists were not at first united by an overt artistic programme, though the painters found their rural retreat a welcome relief from the competitive atmosphere in Paris. Jean-François Millet (1814-75) arrived in 1849 and was the only artist to make Barbizon his permanent home. As C. S. Smith later commented:

continued on page 20

The Haywain *by John Constable, painted in 1821. Although the picture was not singled out for high praise at the Royal Academy in London in 1821, it was awarded a gold medal at the Paris Salon three years later in 1824. The French public were* impressed by the naturalism in English landscape paintings of the period. Such pictures stood in marked contrast to the stilted works turned out by contemporary French artists.

THE IMPRESSIONISTS AND INDUSTRY

At the time the Impressionist movement was taking shape, France itself was going through substantial changes. Napoleon III was determined to give the French internal prosperity and, at least during the early years of the regime, he was strikingly successful. Industrial production doubled and, within a decade, foreign trade did the same. Mighty new banking concerns, such as the Crédit Lyonnais and the Crédit Foncier, were founded, while, in the cities, huge stores, such as the Bon Marché and the Louvre, were established. The railway network increased in size from 3,685 kilometres to 17,924. France was booming and well on the way to becoming one of the world's leading industrial powers.

Nevertheless, there was a dark side. Despite the claims of the regime, the benefits of the new prosperity were largely confined to the middle classes. This was a fact that novelists such as Zola were swift to recognize; Zola's *Germinal*, for instance, is a vivid portrayal of the misery caused by the demands of capital and its effects on the lives of the miners of a grim coal town, who eventually resort to strike action. Their strike is broken. The Impressionists, however, tended to concentrate on the individual rather than the group phenomenon, so much of this passed them by. Monet's celebrated paintings of the Gare St-Lazare, for instance, are devoid of any sense of social consciousness; though he probed the pictorial aspects of the machinery he painted, the results say nothing about its usefulness or its impact on the life of the times. The Impressionist with the greatest interest in social matters was undoubtedly Pissarro; Degas, on the other hand, was an extreme conservative who argued that it was wrong to make 'art available to the lower classes'.

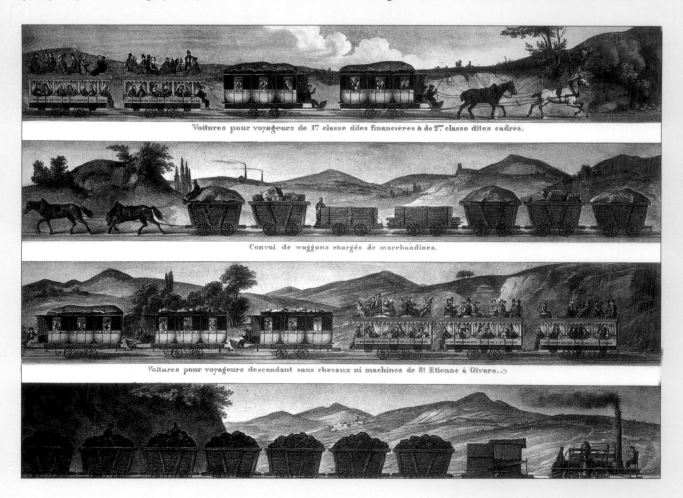

Voitures pour voyageurs de 1^{re} classe dites financières & de 2^{me} classe dites cadres.

Convoi de waggons chargés de marchandises.

Voitures pour voyageurs descendant sans chevaux ni machines de S^t Etienne à Givors.

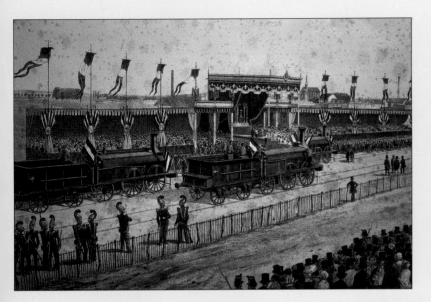

France's new railways were a source of great national pride; this gravure print (left) shows the opening of the line between Paris and Strasbourg. To a regime like Napoleon III's, such public works – even though the railways were privately owned – were a clear demonstration of the benefits of enlightened despotism. Industrial unrest increased from year to year, however, especially among the coal miners of the north-east (below left).

Fernand Cormon's view of the interior of an iron foundry (below). Under Napoleon, France built the world's first ironclad warships, but, impressive though industrial progress was, it was still surpassed by that of the Prussian-led North German Confederation, as the Franco-Prussian War was to show. As a result of her defeat, France lost Alsace-Lorraine, an important industrial base for the iron and steel industries.

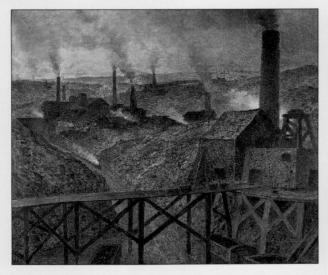

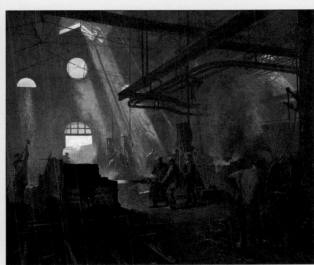

The Lyon–St Etienne railway line produced this print (left) to advertise the benefits of railways in terms of trade and passenger travel. What was not shown was the difference railways would make to war; in 1859 they made it possible for Napoleon III to concentrate his army in Italy within a few weeks of declaring war on Austria.

Delahaye painted this view of the gas factory at Courcelles (right) in 1884. Social progress under the Third Republic was to prove as slow as it had been under the Second Empire and the working classes turned more and more to socialist ideas as a consequence. It was the innate conservatism of France's land-owning peasantry that preserved the country's political stability.

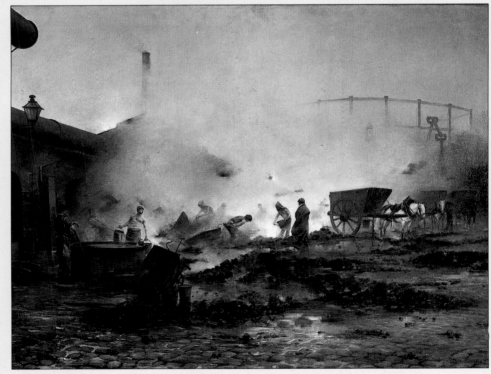

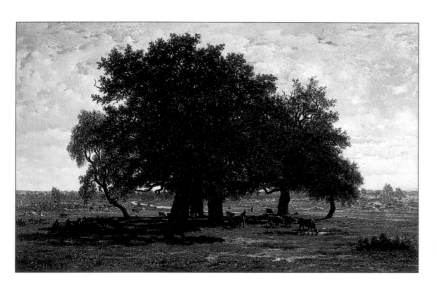

Holm Oaks, Apremont *by Théodore Rousseau (left). Painted in a district south of Fontainebleau known for its fine quality timber, the artist has avoided classical subject matter and presents a more naturalistic study of a cluster of oaks and cattle set against the*

backdrop of the rising sun. La Vanne *by Charles Daubigny painted in 1851 (right). With the exception of Boudin, Daubigny was probably the only landscapist of the period to work totally from nature. His work had a major influence on Monet.*

> The distinctive feature of Barbizon, to the men of 1830, was that its isolation served as a screen to shut away all suggestions of manifold activities and interests, and concentrate attention upon man in his few primeval relations to Nature – man as husbandman, man as husband, and father.

The landscapes the Barbizon group produced were painted rapidly, either wholly or in part in the open air, incorporated no other subject matter and were intended, irrespective of their degree of finish, as self-sufficient works of art. Many display great lyricism; the forests and plains of Fontainebleau and Chailly are portrayed with a marked reverence for natural beauty; imposing trees, for example, are often shown in a dramatic light, animated against stormy skies. One of the most important influences on the Barbizon painters was the work of John Constable (1776-1837), whose fine landscapes of the English countryside were produced during the first quarter of the century. With their emphasis on rural scenes and the fleeting effects of light and shade, conveyed with passages of vivid colour, Constable's techniques had previously been absorbed by Delacroix, who altered his *Massacre at Chios* after having seen *The Haywain* at the 1824 Salon. Théophile Thoré (Willy Bürger, 1807-69), a long-standing supporter of the Barbizon School, credited Constable with nothing less than the regeneration of French landscape painting. Richard Parkes Bonington (1802-28), another Englishman, had established a reputation for his *plein-air* watercolours, which also influenced both Delacroix and the Impressionists.

In its concern with everyday, rather than Biblical or classical subjects, the Barbizon School had much in common with 17th-century Dutch painting. In this connection, it is significant that Dutch art, previously considered by the Académie to be a parochial backwater of European painting, was collected by both Rousseau and Daubigny, and began to win attention from critics who were also Barbizon supporters. Thoré, who, in his capacity as Director of the Académie des Beaux-Arts, had given valuable state commissions to Rousseau, had made a detailed study of Dutch art and written a guide to the museums of Holland, as well as a series of articles on Vermeer.

However, many of the more conservative critics confidently wrote off both the Barbizon School and Dutch painting. It is also worthy of note that, even if the Barbizon painters did not win instant critical acclaim, the Duc d'Orléans and the prime minister, Casimir-Perier, bought

their pictures. Count Nieuwerkerke, Director-General of the French National Museums from 1849 and Superintendant for the Fine Arts from 1863, found the Barbizon painters' work dangerously democratic, a term that in post-1848 Paris implied dangerously revolutionary: 'This is the painting of democrats, of those who do not change their linen…this art displeases and disgusts me.' Other critics simply found both schools undignified. One, Paul de Saint-Victor, art critic for *La Presse* and Inspector-General for the Fine Arts, argued the traditionalist case for landscapes animated by a pantheon of classical gods and heroes:

> We prefer the sacred grove where fauns make their way, to the forest in which woodcutters are working; the Greek spring in which nymphs are bathing, to the Flemish pond in which ducks are paddling; and the half-naked shepherd who, with his Virgilian crook, drives his rams and she-goats along the Georgic paths of Poussin, to the peasant, pipe in mouth, who climbs Ruisdael's back road.

COROT AND BARBIZON

By the middle of the century, the area round Barbizon had become well known; it was used as a literary setting by George Sand, the Goncourt brothers and Gustave Flaubert, and the public had come to associate it with *plein-air* painting. In addition, the railway line from Paris was extended to the village of Melun and the consequent reduction of the journey time to an hour and a half and the cost to a few francs made Barbizon popular with day trippers, who enjoyed the rural atmosphere and country air.

Jean-Baptiste Camille Corot (1796-1875) was one of the first painters to insist that studies made in the open were worthy of the same status as traditionally well finished studio tableaux, even though he also believed that *plein-air* studies had to be completed in the studio. Many of his paintings are simple, tonal studies with little of the romantic fervour found in Rousseau's work. They present instead a gentle, almost Franciscan view of nature, a faithful record of

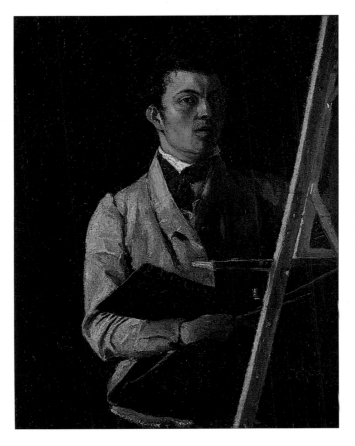

Self Portrait by Jean-Baptiste Camille Corot, painted in 1825. The picture shows Corot at the age of 29. The artist deliberately constructed the subject with patches of paint, each one being an attempt to see objectively the colours and tones before him. Corot employed a similar method in his landscapes, many of which were made in and around the forest of Fontainebleau. Corot was an important source of inspiration for many young landscape painters. Monet, Renoir, Pissarro and Bazille each paid tribute to his influence upon their own development as landscape painters.

everyday scenes. Some critics raised on a rich diet of anecdotal *machines de salon* undoubtedly found his pictures undemanding and bland. In his Salon review of 1859, Baudelaire makes this point, but he perceptively goes on to praise the virtues of the work of both Rousseau and Corot.

> If M. Rousseau – who, for all his occasional incompleteness, is perpetually restless and throbbing with life – if M. Rousseau seems like a man who is tormented by several devils and does not know which to heed, M. Corot, who is his absolute antithesis, has the devil too seldom within him. However inadequate and even injust this expression may be, I chose it as approximately giving the reason which prevents this serious artist from dazzling and astonishing us. He does astonish I freely admit – but slowly; he does enchant – little by little but you have to know how to penetrate into the science of his art, for with him there is no glaring brilliance, but everywhere an infallible strictness of harmony.

As far as academicians and the public at large were concerned, however, Corot, like the Barbizon School, was received with indifference. He was represented at the 1855 Exposition Universelle by only six pictures in marked contrast to Ingres and Delacroix, who exhibited 40 and 36 canvases respectively; but nine years later even he was selected to the Salon jury by his artistic peers.

The absence of spectacle in much of the work of Corot and Daubigny provided an important precedent for the Impressionists. In such works as Corot's *The Leaning Tree Trunk* and Daubigny's *Barge on the River*, the scenes not only fail to incorporate any Biblical, historical or literary references but also lack any intrinsic beauty; their claim to attention seems to rest on their mere existence in the natural world. In their faithful representation of the scene before the painters' eyes, the landscapes of Corot and Daubigny possess at times an almost photographic realism in what they depict, that is, rather than in any textural finish. Corot, for one, was well aware of photographic techniques – photography was at the start of its heyday – and actually imitated in his paintings the blurring that occurred when light was diffused on the sensitized glass photographic plates.

THE MOVE TO THE NORMANDY COAST

The Norman seashore was another popular location for naturalistic landscape painters. Courbet, visiting Le Havre in 1859, came across the seascapes of Eugène Boudin (1824-98) and was impressed with them. Boudin had owned a stationery and picture-framing shop and Couture, Troyon and Millet were amongst his clients. Courbet and Boudin subsequently toured the Normandy coast together, visiting the Seine estuary, a favourite subject for many of the Barbizon painters. A Dutch painter, Johan Barthold Jongkind (1819-97), who worked with them, also favoured marine subjects and views of ports, and his study of the effects of air and atmosphere was to be influential. Many of the painters worked at the farm of Saint-Siméon, near Le Havre, which became known as the 'Barbizon of Normandy'. Both it and Barbizon itself, so beloved by the *plein-air* painters, had much in common, and both, to which access by train was now possible, became fashionable tourist centres. In the picturesque fishing villages round Honfleur (of which Boudin was a native), Trouville and Deauville, made famous by the artists, the new passion of the middle classes for sea-bathing soon resulted in the indigenous community being outnumbered by five to one.

MILLET, COURBET AND REALISM

The works of Corot and the Barbizon School were deliberately devoid of any literary, moral or political content; not so those of Millet and Courbet. At the beginning of Millet's career, in the promise he showed at Delaroche's Paris studio, he seemed destined for success along

Corot's Saules et Chaumières. *In common with the Barbizon group, Corot's aim was to rediscover realism. His paintings, however, though usually started in the open air, were often finished in his atelier. He told Renoir: 'One can never be sure of what one has done; one must always go over it again in the studio'.*

well-trodden paths. This changed however when his master failed to support his nomination for the Prix de Rome. Like many of his contemporaries who had fallen out with officialdom, Millet then suffered considerable hardship in the capital before he left for Barbizon in 1849, fleeing both the political disturbances and an outbreak of cholera. He expected to remain at Barbizon for only a short period, but in the event spent the next 27 years there.

Paintings of peasants were commonplace in French painting at the time but Millet, himself the son of a peasant, elevated the genre by giving those he portrayed a gravity and

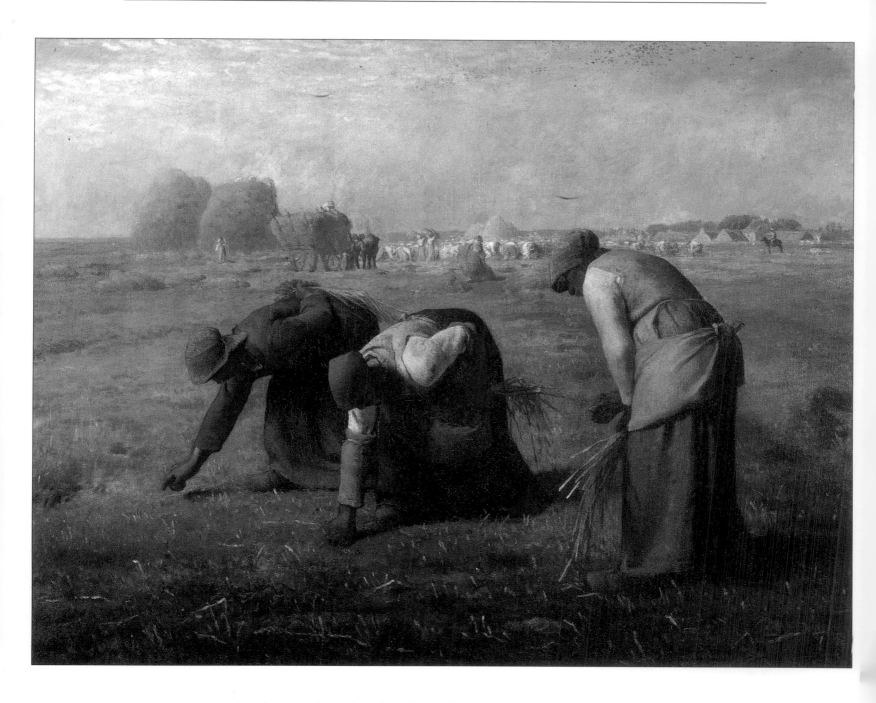

pathos (even to the point of sentimentality) absent from other paintings of this kind. In one respect, Millet's rural scenes are consistent with the ethos of Rousseau, in that they invest the countryside with a spiritual significance. However, in according a peasant the same degree of dignity and romance with which the Barbizon School had invested an oak tree, Millet's work had political overtones.

It is hardly surprising that his *Man with a Hoe*, exhibited in a political climate dominated by the popularist conservatism that came to prevail in the wake of the 1848 revolution, was considered to be a 'socialist' picture, especially since the figure in the painting was named Dumoulard, after a peasant who had recently murdered his landlord. Millet replied:

> Socialist! But really, I might well reply in the words of the countryman
> answering a charge made against him in his native district 'Folk in the village be
> saying I be Saint-Simonist; it bean't true, I doan't know what that be!'

Millet was also perhaps being nostalgic in painting scenes of peasant life – nostalgic for a life he

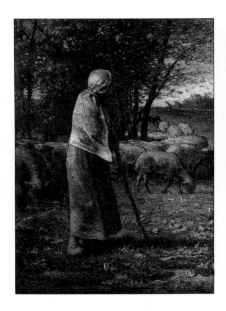 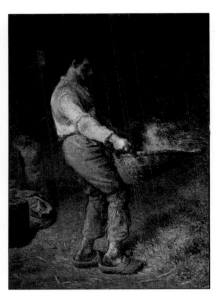

The Gleaners *1857 (opposite)*, The
Little Shepherdess *1854 (far left), and*
Le Vanneur *1856 (left) by Jean François
Millet, each show peasants at work.
Millet's peasants are not the romanticized
rustics commonly found in 18th- and
19th-century painting, but real
agricultural labourers, whose bodies show
visible signs of constant hard toil. Millet
believed that labour conferred an almost
religious sanctity upon workers and many
of his subjects are painted with obvious
sympathy for their plight. Contemporary
critics often disliked Millet's paintings and
thought the subjects were too undignified
for serious painting.*

had abandoned, as many of his peers had done at much the same time. This may well have
contributed to the fact that he was to become a highly successful painter, held in considerable
popular esteem later.

In contrast to Millet, Courbet took a more radical stance in his approach to both art and
politics. His example had a formative influence on the development of Impressionism,
although he, and Pissarro, were the only two painters who held strong political views and
expressed them. He had indicated that he was proposing to show works on his own in rivalry
with the official Salon which was to be combined with the Exposition Universelle in 1855 and
indeed had a special pavilion constructed in the avenue Montaigne to house them. Even
though 11 of his pictures, including *The Stonebreakers*, were eventually exhibited at the
Exposition, he still went ahead with his private show, advertising it by a sign which read:
REALISM: G. Courbet: exhibition of forty of his pictures and the preface to the catalogue, signed
by him but thought to have been written by Champfleury, the *nom-de-plume* of Jules Husson
or Fleury, (1821-89) flung down a defiant challenge to orthodoxy:

> The title 'realist' has been imposed on me in the same way as the title 'romantic'
> was imposed on the men of 1830. Titles have never given the right idea of
> things; if they did, works would be unnecessary
>
> Without going into the question as to the rightness or wrongness of a label
> which, let us hope, no one is expected to understand fully, I would only offer a
> few words of explanation which may avert misconception.
>
> I have studied the art of the ancients and moderns without any dogmatic or
> preconceived ideas. I have not tried to imitate the former or to copy the latter,
> nor have I addressed myself to the pointless objective of 'art for art's sake'. No –
> all I have tried to do is to derive, from a complete knowledge of tradition, a
> reasoned sense of my own indpendence and individuality.
>
> To achieve skill through knowledge – that has been my purpose. To record the
> manners, ideas and aspect of the age as I myself saw them – to be a man as well
> as a painter, in short to create living art – that is my aim.

Courbet was thus contributing to an expanding body of opinion that held that the true subject
of art was everyday life and that, as Honoré Daumier argued, art should 'be of its time'.

Landscape in the Snow *1857 (above)*, Landscape in the Snow at Ornans, *1858 (above right) and* The Meeting *1854 (right) by Gustave Courbet. The last, more commonly known as* Bonjour Monsieur Courbet, *shows the artist meeting his friend, the collector Alfred Bruyas on the road to the village of Sète outside Montpellier. Courbet based his own portrait on the image of the Wandering Jew, taken from a popular print.*

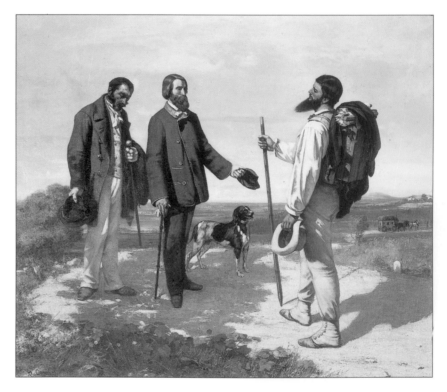

Courbet embodied his views in unsentimental paintings of both urban and rural life, in some cases realized on a monumental scale, as *The Stonebreakers* and *The Burial at Ornans* both painted in 1849. The sentimentality that marred other pictures of the working classes, such as those of Millet and Jules Breton in France and Henry Wallis and Walter Deverell in England, was absent from his work. Indeed, given Courbet's fiercely radical political standpoint, his hatred of the regime and his almost Jacobin-like belief that the lower orders had been cheated of the benefits of revolution, it would have been inappropriate. The figures in both pictures are not invested with any social or spiritual virtue; they seem to have no hope of redemption from their obviously miserable lot. *The Burial at Ornans*, which shows a group of provincial bourgeois and peasants gathered round the grave at a funeral, is an attempt simply to portray, rather than comment on, both classes. Its immediacy is heightened by the deliberately clumsy

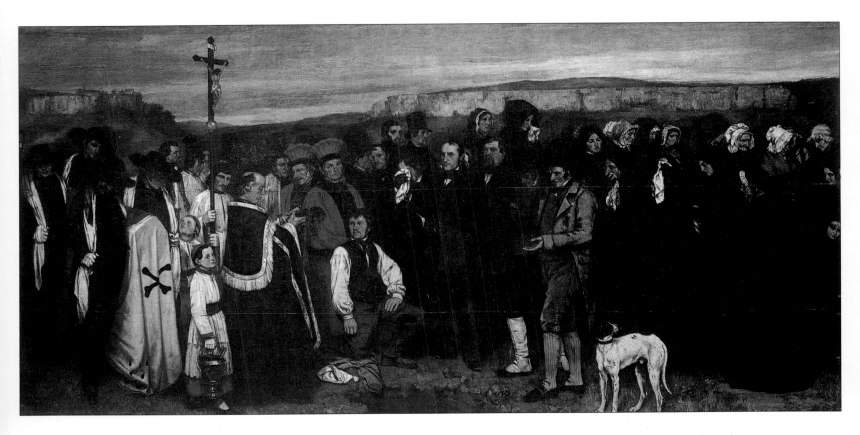

The Burial at Ornans *by Gustave Courbet, painted in 1849 and shown at the Salon of 1850-1. It depicts a bourgeois burial. Courbet emphasized the secular dimension of a commonplace death by removing any spiritual references. He concentrates instead on the visible facts of the event and has realized the subject on a vast scale measuring three by almost seven metres.*

composition and aggressive application of the paint, laid on in many places with a palette knife. It was not only the subject matter and technique of *The Burial at Ornans* that scandalised some members of the public, however, but also the apparent absence of any kind of message. The critic Louis de Godfroy, writing of the 1850 Salon in the *Revue des Deux Mondes* accepted that a common funeral could serve as a fitting theme for a picture, but not without some comment on death in general rather than on one inconsequential death in particular.

Courbet's ability to render the everyday world with a documentary zeal that neither shies away from or sanctifies unpleasant scenes can be seen across the entire range of his paintings from monumental landscapes to small still lifes. His *Demoiselles au bord de la Seine*, for example, shows what are obviously two prostitutes reclining on the banks of a river in urban parkland; one is partly undressed and a boat used for assignations with clients stands ready nearby. Courbet's picture neither solicits sympathy for the women nor invites condemnation; it simply depicts, without comment, prostitution as part of the urban landscape of the period, a fact of contemporary life, which was a recurrent theme of the exponents of Realism.

The Realistic School consisted of a group of painters, writers and political theorists who met often in the *Brasserie des Martyrs* in Paris to thrash out their views. Amongst the artists were not only Courbet, but François Bonvin (1817-87) and the young Claude Monet (1840-1926); the critic Jules-Antoine Castagnary, a staunch defender of Millet, Corot and Daubigny as well as of Courbet and Champfleury, novelist and art historian and a fellow-traveller of the anarchist philosopher Pierre-Joseph Proudhon (1809-65); the poet, novelist and journalist, Théophile Gautier (1811-72); the poet Fernand Desnoyers; and Edmond Duranty (1833-80), novelist and author of the pamphlet 'Réalisme', written in defence of Courbet's painting. By the middle of the 1860s, the Brasserie des Martyrs, together with the Andler Keller, constituted two of the most radical artistic milieux in a city which was fast becoming the gayest and most exciting in the world.

THE CHANGING FACE OF PARIS

One of the most remarkable features of the imperial period was the rapid growth of France's cities – and of Paris, in particular. How much this was a result of general economic factors and how much the deliberate result of the regime's policies cannot be determined precisely, but one thing is clear. Just as the Impressionists were to change the face of painting, so the face of Paris itself was being transformed. This was perhaps the greatest achievement of the Second Empire; it was the result of the rebuilding programme launched by Baron Haussmann during his term as Prefect.

Before Haussmann's radical replanning, much of Paris still looked as it had in the Sun King's time. The process started in 1859, with the demolition of the old Farmers-General wall around the city and the creation of seven new arrondissements. This gave Paris a population of two million and expanded the city to as far as the circle of protective forts that had been constructed around the capital by the Thiers administration during the reign of Louis-Philippe. Within Paris itself, similar far-reaching changes were taking place. In the centre, 20,000 houses were demolished and 40,000 new ones built, while a network of wide boulevards cut cleanly through the narrow, evil-smelling alleys of the old city.

Surprisingly, Haussmann's grand scheme met with mixed reactions. Edwin Child, an English apprentice working for a fashionable jeweller in the city, thought that the result was 'about the most magnificent town, I should think, in the world; all houses being six, seven and eight storeys high and everything so different and so far superior in elegance, utility, sociability, etc., to London'. The conservative Goncourt brothers, on the other hand, gloomily recorded that Haussmann's Paris made them think 'of some American Babylon of the future'. Above all, there was the cost, which Haussmann could only meet by juggling with state borrowing.

Beneath the glittering facade Haussmann had created, there was also another blacker side. The high rents in his new city – these had roughly doubled by 1870 – gradually forced workers out into new slums that were just as insalubrious as those that had been demolished.

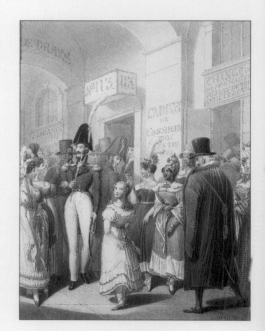

A lively street scene in one of the arcades of the Palais Royal, one of the most attractive buildings of old Paris (right). A large part of it was set on fire during the Paris Commune of 1871 by Communard arsonists.

The Vendôme column (below) was erected by Napoleon I; under Napoleon III, it became a hated symbol of the regime. Courbet was instrumental in urging its destruction; the Communards obliged on 16 May 1871. Colonel Stanley, a British observer, commented: 'It is a blackguard Vandalism'.

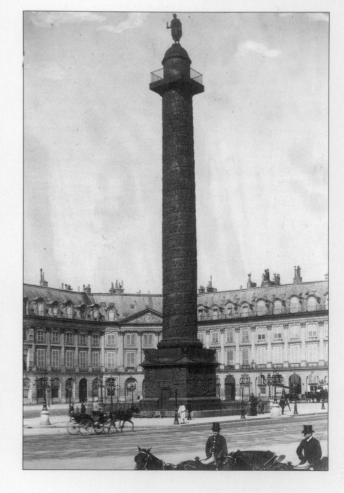

The Mardi Gras festivities in the boulevard des Italiens (right). This scene was painted before Haussmann had started his rebuilding programme, but, even after it, parts of the city still looked surprisingly rural. The countryside was just a step beyond the Arc de Triomphe.

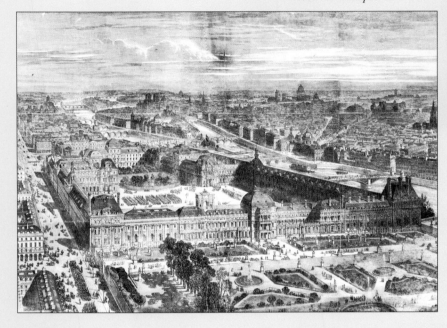

This panorama of Paris dates from 1855. The Louvre and the completed rue de Rivoli can be clearly seen (left). The street led to the Hôtel de Ville, the heart of radical Paris. It was there that the Third Republic was proclaimed in 1870.

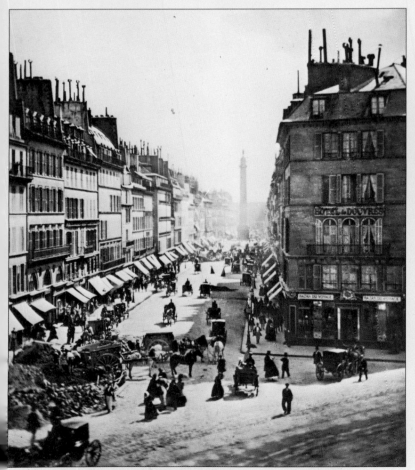

Haussmann's new, wide boulevards (left) had several purposes, not the least of which was their deliberate positioning to aid the regime in keeping public order. Even the use of macadam as street paving had a dual motive, as the acute eye of Queen Victoria noted when she visited Paris in 1855.

The macadam, she thought, would 'prevent the people from taking up the pavement as hitherto'. Montmartre, however, remained largely unaffected by Haussmann's plans (above); it even kept its famous windmills until later in the century.

2 THE EMERGENCE OF IMPRESSIONISM

By 1850 Paris had a population of one million people, many of them crowded into dirty, insalubrious and narrow streets, which had undergone little change since the days of the Middle Ages. They were breeding grounds for disease and crime, and above all, for insurrectionary mobs who could defend themselves with ease by throwing up barricades, as they had done in 1830 and 1848, bringing the government down on each occasion. Napoleon III realized the dangers and therefore instructed Baron Haussmann, Prefect of the Seine from 1852-70, to re-design the city to rid himself of the threat of popular revolution and at the same time create a fitting capital for his imperial pretensions. Haussmann went to work with a will, and an enormous budget; his wholesale demolition of old houses, to replace them with his new streets, was ruthless. The network of long straight roads he created was less to ease traffic congestion than, in his own words, to provide 'strategic communication', which, in effect, meant swift access for the police and clear firing lines for the troops. It earned him much criticism at the time, but even more controversial, in social terms, was the fact that he drove a wedge between rich and poor, who until then, had lived on relatively amicable terms together in the same *quartiers*. The poor were forced out of the capital to seek work in the factories that were springing up in the suburbs, or were huddled into the eastern parts of the city, while the rich moved to the west. The result was a widening of the social divide.

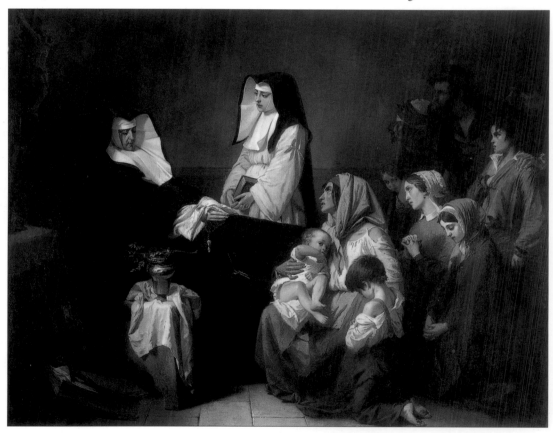

The Death of a Nun, *by Isadore Pils, is typical of the conventional, conservative depictional approach taken by the academics of the Salon in the mid-19th century. The paintings they produced were a faithful reflection of the tastes of the French public of the time.*

Lost Illusions *or* The Evening *painted by Charles Gleyre in 1851. Gleyre had the reputation of being a sympathetic teacher as well as a well-known master, which was one of the reasons Monet,* Renoir and Bazille all entered his studio. Renoir later recalled that, *though Gleyre had been 'no help to his pupils', he had left them 'pretty much to their own devices'.*

As bankers and industrialists became richer and richer, a whole new range of attractions sprang up to serve them. Large department stores, such as the Bon Marché and the Samaritaine, offered their wives a wide choice of clothes and furnishings, while any number of cafés, restaurants and theatres opened on the main boulevards that Haussmann had lovingly created, standing out at night through the glitter shed by their sparkling new gas lights. The Emperor was soon to install his court in the Tuileries and embark on a policy of buying works of art to enhance his prestige. Paris had replaced Rome as the mecca for aspiring artists and by one of those strange chances of history, an exceptionally talented group of young men were to be found studying there in the 1860s.

GLEYRE AND THE YOUNG IMPRESSIONISTS

The teaching in the Ecole des Beaux-Arts and many of the studios was formal to the point of being repressive, however. It consisted, for the most part, of a treadmill of exercises. The level at which tuition began depended on the experience and ability of the student. Novices started by making drawings from printed engravings of parts of the human body; before an attempt could be made at the entire head, numerous studies of eyes, noses and ears had to be undertaken. Teachers set great store by this method, the theory being that diligent application was a passable substitute for real talent.

The first exercises consisted of copying only the outline of an engraving. Once this had been mastered, the student gradually learned how to give form to the shape by suggesting light and shade with cross-hatching. The process continued with students making drawings,

continued on page 38

THE PARIS OF THE IMPRESSIONISTS

For the Impressionists, Haussmann's new Paris was the centre of their universe during their years of struggle; it was the battlefield that had to be conquered, while, as painters of 'la vie moderne' extolled by Baudelaire, it provided them with an unparalleled social backdrop for their cityscapes and city scenes. Their aims were summed up by Castagnary in an article in 1863. 'The naturalist school', he wrote, 'declares that art is the expression of life under all phases and on all levels and that its sole aim is to reproduce nature by carrying it to its maximum power and intensity. It is truth balanced with science. It re-establishes the broken relationship between man and nature. By its two-fold attempt, in the life of the fields, which it is interpreting with such uncouth force, and in town life, which reserves for it the most beautiful triumphs, the naturalist school tends to embrace all the forms of the visible world'. Manet had already paved the way in his *Concert in the Tuileries Gardens*, painted in 1862; by 1867, Monet and Renoir were both painting their first cityscapes and scenes of Paris life.

What sort of city had Haussmann created for the Parisians – and the Impressionists – through his bold alterations of the city's layout? The overriding impression is one of light and space; he was the creator of the place de l'Opéra, the Etoile, the place de la Nation and the Bois de Boulogne. He had eliminated the old slums, the infamous centres of disease and the haunts of robbers and murderers. such as the Buttes-Chaumont. His boulevards, he believed, had at last succeeded 'in cutting through the habitual storm centres', though, as the events of 1871 were to show, he had largely defeated his own objective. The Parisians – at least, the working classes – remained determinedly radical.

One problem Haussmann's Paris faced was not of its making. Though wages rose, they simply did not keep pace with the cost of living; in Paris, in particular, the average daily wage rose only 30 per cent up to 1870, while the cost of living increased by a minimum of 45 per cent, one of the contributory factors being the high rents that had followed in the wake of Haussmann's rebuilding. An 11-hour working day was the norm; Edwin Child began his own work as an apprentice at 5am.

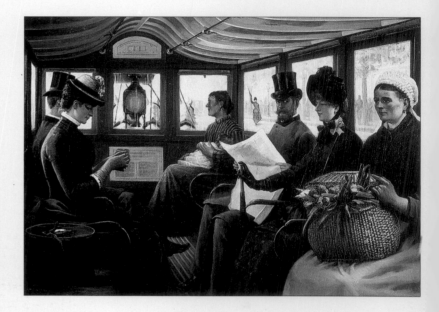

Parisians quickly took to the new omnibuses (above) when they were introduced on to the wide streets and spacious squares that were the essential core of Haussmann's rebuilding. However, despite appearances, the results were deepening social division, especially as rising rents forced the workers from the centre of the city into new ghettoes that were radical hotbeds.

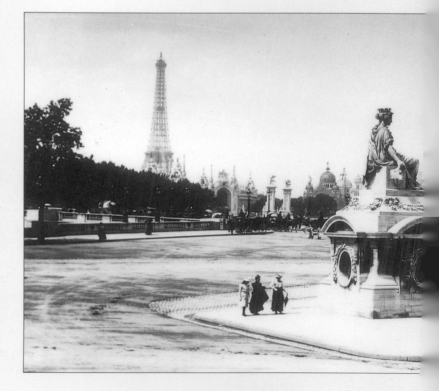

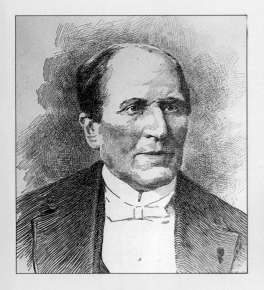

PARIS — La Basilique du Sacré-Cœur et l'Escalier Monumental
Sacré-Cœur Basilica and monumental Staircase

Haussmann himself (above) was determined to leave his mark on Paris and his rebuilding programme enabled him to achieve this aim. He is largely responsible for the city's present appearance. One of his far-sighted moves was to site the city's main railway stations in a circle outside the old city so that broad approach roads could be created for them; he also created open spaces, such as the Bois de Boulogne. His ambitious plans, however, involved juggling with state funds, for which he was eventually discredited.

In July 1873, 'in witness of **repentance and as a symbol of hope***, the National Assembly voted for the construction of the Sacré-Coeur (above), an immense basilica to be erected in Montmartre on the spot where the Commune had broken out in March 1871. It was finally completed in 1919. The buildings destroyed during the Commune included the Tuileries, the Palais de Justice and the Hôtel de Ville (right). This had been the Communard headquarters; outside it, the revolutionary government had been proclaimed.*

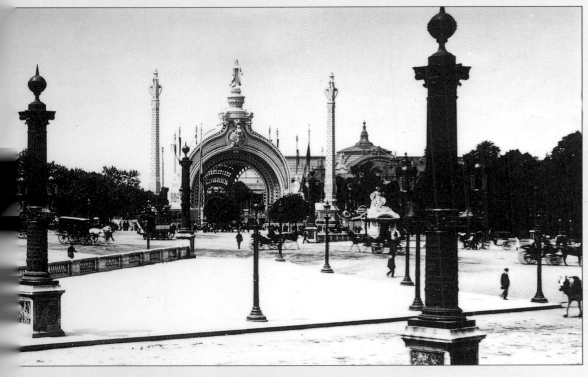

Much of Haussmann's work survived the Commune, however; a few days after fighting had ceased, the US Minister Washburne, noted 'a marvellous change…the smouldering fires have been extinguished and the tottering walls pulled down'. The work of rebuilding speedily began; the view here (left) would have been immediately familiar to Haussmann, though he would have failed to recognize the immense tower in the background. This was the work of the engineer architect Georges Eiffel and was erected in 1889 to commemorate the 1789 revolution and for the World's Fair.

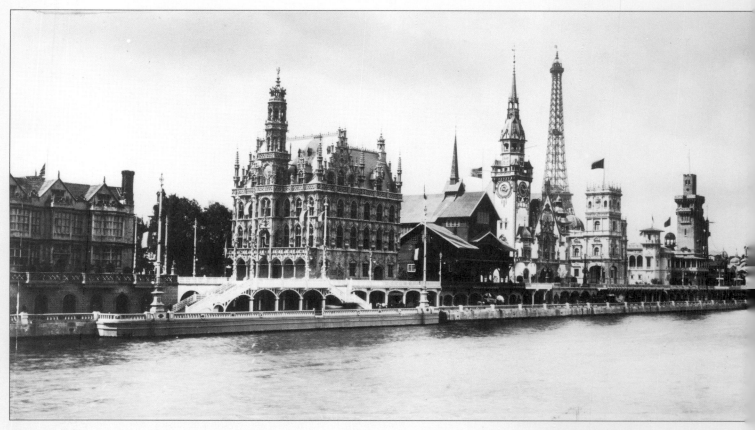

These facts, however, largely escaped the Impressionists, who despite their social involvement, were far from being politically active. Indeed, industrialization as a subject was largely ignored by them; even Monet's paintings of steam engines cannot be seen as anything more than vivid and powerful depictions and certainly not as social comment on the industrial age. This is equally true of his *Unloading Coal*, painted at Argenteuil in 1872. Though, at first sight, the dour depiction of men unloading coal seems as though Monet were making a positive social statement, in reality the likelihood is that he was more interested in the atmospheric effect he could achieve.

What the Impressionists could do was to bring a city scene to full, vivid life, whether it was a view of a boulevard or of a bridge on the Seine. The river and what happened on it was a source of constant fascination and inspiration to them – this is demonstrated in the study of the Pont des Arts, which Renoir painted as early as 1867, and of the Pont Neuf, which he and Monet both painted from the same angle, but with totally different results. Renoir's picture is a perfect vision of a sun-drenched day in high summer; Monet, on the other hand, chose to show the bridge on a rainy day, with subdued bluish tones predominating throughout the rendering.

Another favourite river-linked subject that fitted

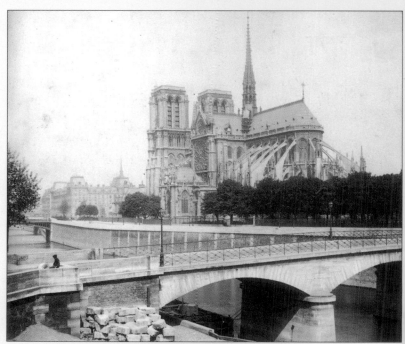

Notre-Dame (above) stands by the Seine on the Ile de la Cité. It was the landmark of medieval Paris – its building started in 1163 – and was the setting for the coronation of Napoleon I in 1804. Its restoration predated Haussmann, however; it started in 1841 under the Orléanist regime of Louis-Philippe and lasted 23 years.

Looking south along the Seine in around 1880 (right). There are obvious landmarks visible, such as Notre-Dame; what is missing from the Parisian skyline is the Eiffel Tower, which was not erected until the end of the decade. For the Impressionists, Paris and the Parisians were a constant source of inspiration.

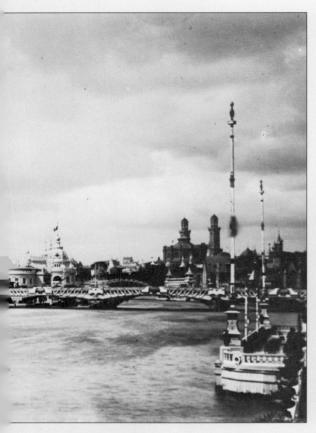

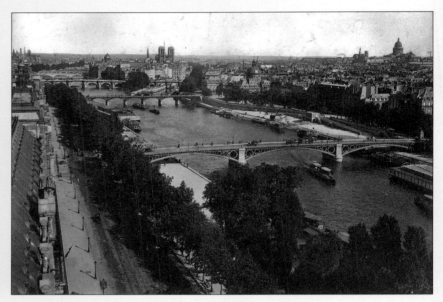

A panoramic view of Paris, taken looking along the Seine with some of the city's chief landmarks, including the Eiffel Tower, clearly visible (left). As well as being an important commercial artery, the river was a source of recreation for Parisians. Bathing and boating were readily available just outside the city proper.

The Seine and the city, taken from the Louvre (below). This photograph clearly shows the network of bridges that were built to span the river, some of which, notably the Pont Neuf, were favourite subjects for the Impressionists. Renoir, Monet and Berthe Morisot all painted the Pont Neuf, while working along the river.

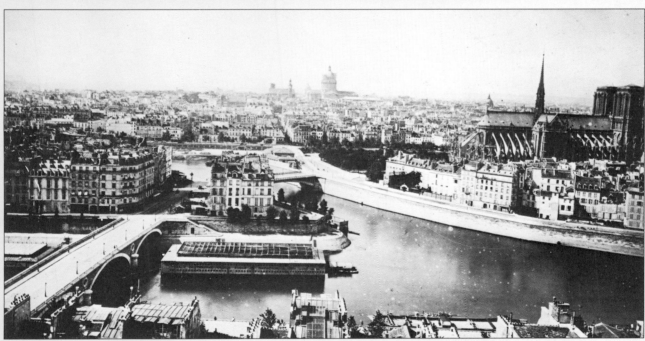

in with the general theme of social observation was Parisians at play at Argenteuil and around Chatou at Bougival. Such resorts could now be easily reached by the new cheap excursion trains; many bourgeois Parisians could be found on summer afternoons rowing on the river or making up bathing parties. The Impressionists warmed to the former pursuit; in 1865, Bazille wrote to his father: 'Two friends and I won a first prize at the regattas in Bougival yester-day…The name of the boat is La Cagnotte, but, unfortunately, they do not print the names of the oarsmen'. Just along the river was La Grenouillère, a small restaurant and bathing place, where Monet and Renoir were to make some of their happiest studies, even though their progress was hampered by their poverty. Monet wrote to Bazille: 'Here I'm at a halt through lack of paints…I'm jealous, mean; I'm going mad'.

Within the city itself, the boulevards Haussmann had created as part of his master plan were instrumental in creating a new townscape, which the Impressionists were to make a central feature of their art. Here, they were quick to take advantage of the new viewpoints suggested to them by photography. Take, for instance, the paintings created by Monet in June 1878, when Paris and France celebrated the first Fête Nationale to be held since the Franco-Prussian War and the Commune. The flag-bedecked streets are a riot of colour, capturing to the full what must have been the excitement of the occasion. Equally striking was Monet's view of the boulevard des Capucines, painted in 1873 from the photographer Nader's studio and exhibited in the first Impressionist exhibition the following year. Even a totally hostile critic like Louis Leroy took the point, though he immediately mocked at it. His review took the form of a dialogue between critic and academic painter. The latter speaks first.

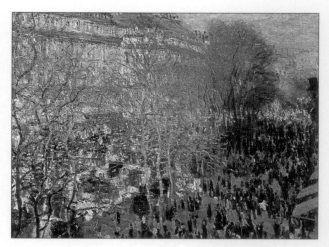

Early morning in Paris (below). Along this street in the city centre, horse-drawn carriages, known as fiacres, and an omnibus await the last of the evening's revellers. The streets themselves have been newly swept, ready for the bustle of the day.

The boulevard des Capucines was painted by Monet in 1873 (above). It was included in the first Impressionist exhibition of the following year. This itself was held in the same studio in which this picture was painted.

THE EMERGENCE OF IMPRESSIONISM

'"Ah-ha", he sneered... "That's Impressionism or I don't know what it means. Only can you be so good as to tell me what those innumerable black tongue-lickings in the lower part of the picture represent?"

"Why those are people walking along", I replied.

"Then do I look like that when I'm walking along the boulevard des Capucines? Blood and thunder! So you're making fun of me at last?"'.

What the Impressionists faced was the ultimate challenge of depicting a new Paris – a city that the genius of Haussmann had transformed from a motley collection of medieval alleys, Bourbon palaces and 18th-century faubourgs into a monu-ment of modern planning, symbolizing the wealth of the industrial age. Even though many of them were to leave the city in the 1880s, they did not desert it completely.

With the Parisians, however, the Impressionists had a love-hate relationship. However much they were rejected, the city retained its attraction and appeal. Manet went as far as proposing to the government that he should create public works of art for the city, though, not surprisingly, the idea was rejected. Perhaps Pissarro best summed up Impress-ionist feelings, when, in 1871, he expressed his 'ardent hope' that 'Paris will recover her supremacy'.

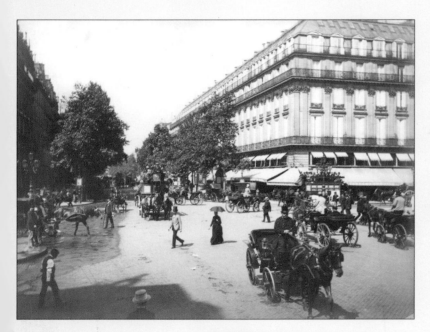

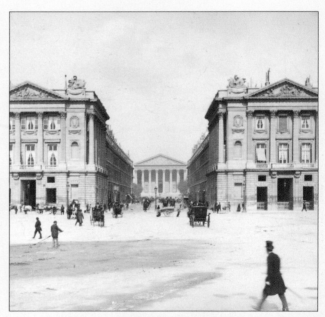

This contemporary photograph (above left), though taken from a different angle, shows how realistically Monet captured the colour and vivacity of street life in Paris, as well as demonstrating the perfection of Haussmann's grand plan. Despite the savage contemporary criticism of Monet's work, it is clear that the painting is far superior to the photograph. The place de la Concorde (above right) was the scene of the execution of Louis XVI; it was then known as the place de la Révolution, being renamed by the Directory in 1795. The bustle of night-time Paris and the excitement of an evening out were captured by Béraud (right).

37

Artist's Studio, rue de la Condamine by Frédéric Bazille painted in 1869 (left). Included in the picture are Zola (leaning over the stairs speaking to Renoir), Maître (playing the piano), and (left to right) Monet, Manet and Bazille around the easel. An early cartoon drawing by Claude Monet (below left). Boudin first recognized Monet's talent when he saw similar sketches being sold by a framemaker in Le Havre. The Engaged Couple or The Sisley Family by Pierre-Auguste Renoir painted in 1868 (below). The picture shows the painter Alfred Sisley and Eugénie Lescouezec, and was inspired both by the full length figure studies by Manet and by Monet's Women in the Garden. Renoir's painting, however, is more conventionally finished than those by Manet and Monet in order to meet the conventional demands of the Salon jury.

first of plaster casts, and then from the living human form. Painting was introduced at a relatively advanced stage of the course and was taught in the same rigid step-by-step way as drawing. A series of oil sketches was made to determine the composition and the laying-in of lights, darks, mid-tones and colours. Only after every detail had been planned would the final painting be started.

One of the leading teachers was Charles Gleyre. He himself had studied in the studio of Delaroche, but, though he trained his students in the traditional manner, he encouraged a degree of originality in his pupils, unlike some of the other teachers. Moreover, he had a reputation as a landscape painter who could offer tuition to aspirants for the Prix de Paysage Historique, the official prize for landscape painting. According to Albert Boime, Renoir, Sisley and Bazille may well have decided to study with Gleyre just because he offered this; none of them seemed to have started with any radical artistic preconceptions.

Pierre-Auguste Renoir (1841-1919) joined Gleyre's studio after serving a four-year apprenticeship with a firm of porcelain manufacturers in Paris, during which time he attended drawing lessons with the sculptor Callouette. Alfred Sisley (1839-99) arrived a year later, at the same time as Frédéric Bazille (1841-70), and in 1863 petitioned against Count Nieuwerkerke's decision to abolish the Prix de Paysage Historique, which would have disenfranchised landscape painters from official competitions. Letters to his parents record that his tuition proceeded in the traditional manner, and indeed his first pictures follow the academic formulae advocated by Gleyre.

Claude Monet had studied at the Académie Suisse for a short time before embarking on his military service and joined Gleyre's studio at the same time as Bazille in 1862. He was rather more experienced than the other three in that he had been present at the meetings at the Brasserie des Martyrs, where he would have heard all kinds of artistic theories discussed. He

The Garden at Saint Adresse by Claude Monet, painted in 1867 and shown at the fourth Impressionist exhibition in May 1879. It depicts a garden on the Norman coast near the port of Le Havre. The steep point of view and the informal composition of figures betray the influence both of Japanese prints and photography. Monet was among the many to be influenced.

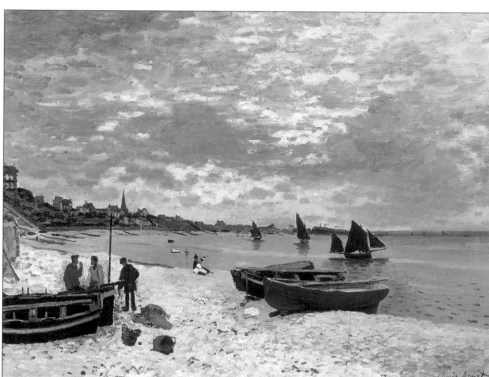

Women in the Garden *by Claude Monet (left). Monet began this large composition, measuring over two by two-and-a-half metres, in the open air while working at Ville d'Avray in the* summer of 1866. *The canvas was so large that a special pit was dug into which the bottom could be lowered.* The Beach at Saint-Adresse *by Monet, 1867 (right).*

had already met Troyon and Amand Gautier (1852-94), and had worked with Boudin in 1856. These four young men, who quickly became friends, found they had much in common, not least their admiration for the work of the Barbizon School, Boudin and Jongkind. Monet and Bazille went to Barbizon in 1863 and the following year saw them, together with Renoir and Sisley, painting there with the older artists, who introduced them to working in the open and to a direct response to landscape stripped of any literary content. The influence of Corot, Diaz and Millet is evident in their paintings at this time, as can be seen in Monet's *Road to the forest with Woodgatherers* and Sisley's *Country Lane Near Marlotte* (1865).

The Académie Suisse, on the quai des Orfèvres, was a different kind of nursery. It was run not by a painter but by an ex-model, who charged only modest fees and permitted the pupils to draw from life without tuition. The school therefore attracted a number of artists who wished for a less formal training than that offered by the Ecole des Beaux-Arts and the studios of established artists, or those who were disenchanted with their progress at them. Millet, for example, had joined the Académie Suisse after his failure to be nominated by Delaroche for the Prix de Rome in 1839. The freedom the Académie Suisse offered encouraged experimentation and technical incompetence was not derided.

Claude Monet had been a pupil there in 1860, as had, for a short time, Paul Cézanne (1839-1906). Camille Pissarro (1830-1903), and Jean-Baptiste Armand Guillaumin (1841-1927) were to meet there. Corot, as an independent artist working outside the academic tradition, declined to accept regular pupils, but he was pleased to give advice to the young. He offered informal tuition to both Pissarro and Berthe Morisot (1841-95) and, in a catalogue entry for the Salon of 1864, Pissarro cited him as his 'master'.

So by the early 1860s there was a group of students who had been trained at the schools of Gleyre or Suisse, and who shared an admiration for the painters advocating working in the open. While the Academicians may have complained that the quick open air sketch was not, in itself, a self-sufficient work of art, those young painters, who adopted it and developed it

literally into a fine art, also paved the way for a host of amateur painters. For the first time, such amateurs could enjoy what was to become a popular hobby. This, in its turn, led to a wider acceptance of the work of the *plein-air* painters in later life.

Edouard Manet (1832-83) stood a little apart. He spent six years in Couture's studio, where, in spite of his master's unusual habit of taking his pupils out for field trips, he was not altogether happy, as he himself recorded:

> I don't know why I am here. Everything we see is ridiculous. The light is wrong; the shadows are wrong. When I arrive at the studio, it seems to me I'm entering a tomb. I realize you can't have a model disrobing in the street. But there are fields, and, at least in summer, studies from the nude could be done in the country, since the nude is, it appears, the first and last word in art.

Manet first came to public attention with *The Spanish Singer*, exhibited at the Salon of 1861, where it won an honourable mention, and both praise and criticism from the press, largely on the same grounds. These were that it was broadly painted, some thought in the manner of Courbet, and more realistic than the sentimental representations of fashionable hispanic scenes in contemporary popular prints. Fernand Desnoyers asked:

> Where could Manet have come from? The Spanish musician was painted in a certain new, *strange* way that the astonished young painters had come to believe was their own secret; a kind of painting lying in between that called realist and that called romantic.

The Philosopher *by Edouard Manet, painted in 1865 (left). The broad handling of the paint and the dramatic use of light were taken from Spanish art of the 17th century.* Lola de Valence *by Edouard Manet, 1861-2 (below). The model was a member of a Spanish ballet troupe performing at the Paris Hippodrome.*

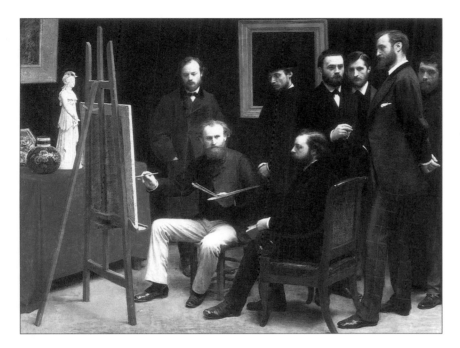

A Studio in the Batignolles Quarter *by Henri Fantin-Latour. Painted in 1870 on the eve of the outbreak of the Franco-Prussian war, the picture shows from left to right Scholderer, Renoir, Astruc, Zola, Maître, Bazille and Monet gathered around the seated Manet. The picture was shown at the Salon of 1870 and demonstrates the increasing sense of common cause shared by artists and writers associated with the Groupe de Batignolles.*

Indeed, two of the 'astonished young painters', Henri Fantin-Latour (1836-1904) and Alphonse Legros (1837-91), as well as Baudelaire, Champfleury and Duranty, immediately arranged to visit Manet in his studio to express their admiration for this painting, and it was from this date that Manet began to be seen as a figurehead of the avant-garde, albeit rather unwillingly. He himself resisted this label, claiming that he was a traditionalist.

Manet's popular success with *The Spanish Singer* was short-lived, however. All three paintings he submitted to the Salon of 1863 were rejected, but then so were 2,783 works of a total of 5,000 entries. Although in 1861 there were already 104 independent art dealers and galleries in Paris, the Salon still provided the only certain way for a professional painter to make himself known, for it regularly attracted press coverage, large crowds, and even more important, the official attention that would lead to commissions.

NAPOLEON III AND THE SALON DES REFUSES

The situation came to a head in 1863. That year, the rules governing Salon entry were changed. Artists who had won some previous honour were allowed to exhibit works without submitting them to scrutiny by the jury; others, however, were only allowed to submit three works each. Napoleon III, made aware of the storm of protest over the unprecedented number of rejections, went to inspect them for himself before the Salon opened, and was surprised by what he saw. He therefore gave orders that a separate and simultaneous exhibition of the rejects be held in order for the public to form its own judgment. The result was the Salon des Refusés, as the exhibition was termed.

Where the Emperor led, Paris followed. There were over 7,000 visitors to the Salon des Refusés on the day it opened to the public. Jean-Charles Cazin (1841-1901), one of the Refusés, described it thus:

> There was no more than a turnstile to separate the show from the other one. As at Madame Tussaud's in London, one passed into the Chamber of Horrors. People expected to have a good laugh, and laugh they did, as soon as they got through the door. Manet, in the farthest hall, went right through the wall with his *Déjeuner sur l'herbe*.

The critics varied in their response to the works shown. Thoré thought that some of them attempted to record nature 'without preconceived ideals', and Castagnary, a supporter of the

Barbizon School, also gave the artists qualified praise. Most reviewers, though, were savagely hostile – it was Manet's *Le Déjeuner sur l'herbe* that bore the brunt of their vituperation.

When we look at Manet's painting today, it is difficult to understand the depths of hostility it aroused on its public debut. The picture shows four figures in a landscape; in the foreground, the two men are clothed, but the woman by their side is naked. It was this juxtaposition, allied to the fact that the men were dressed in contemporary, rather than historical, garb – the cap worn by one of them is the students' *faluche* – that was found distasteful, evoking, as it did, the dread word prostitution. The outrage generally felt was summed up in Napoleon III's own pithy phrase – 'it offends against modesty'. Emile Zola, on the other hand, defended it:

> The public was scandalised by this nude, which was all it saw in the painting. "Good Heavens! How indecent! A woman without a stitch on alongside two clothed men". Such a thing had never been seen before! But that was a gross mistake, for in the Louvre there are more than fifty canvases in which both clothed and nude figures occur.

Zola also records the mirth provoked by *White Girl* by James Abbott McNeill Whistler (1834-1903), a study of a young woman with red hair dressed in white standing beside a wolf-skin rug. Visitors looked at it 'in hysterics'. So great was the uproar that some of the artists, such as Pissarro, Fantin-Latour and Jongkind, who were accorded favourable reviews, thought that reproval at the Salon des Refusés was preferable to approval at the Salon proper.

In 1864 Manet submitted *Episode from a Bullfight* and *The Dead Christ and Angels* to the Salon jury. Both were accepted, though Edmond About in his review considered that they were two damp squibs which had failed to go off and were beneath discussion. The following year, however, an impenitent Manet gave, unwittingly, a further hostage to fortune in submitting *Olympia*. A reclining nude, with echoes of both Titian's *Venus of Urbino* and Goya's *Naked Maja*, its overt sexual provocation was upsetting in a way that Cabanel's *Birth of Venus* – the star picture of the 1863 Salon – was not. Champfleury wrote to Baudelaire saying that 'like a man falling into a snow drift, Manet has made a hole in public opinion', while Manet himself told Baudelaire that 'Abuses rain on me like hail. I have never before been in such a fix'.

continued on page 48

LE DEJEUNER SUR L'HERBE
EDOUARD MANET (1832-1883)

A preparatory sketch for the *Déjeuner sur l'herbe* by Edouard Manet (right) painted in 1863. The finished picture (overleaf) outraged the public when it was shown at the Salon des Refusés and some critics saw the work as no more than a *blague* (a practical joke). Zola, however, observed that a number of similar pictures showing naked women and clothed men could be found in the Louvre. In fact, the painting derives from some thoroughly traditional sources, not least an engraving after Raphael's *Judgement of Paris* by Marcantonio Raimondi and Giorgione's *Fête champêtre*. Although the painting has an important place in the evolution of the realist school, Manet's debt to academic tradition is evident, not only in his use of the work of the Old Masters, but also in his dependence on academic technique in the use of preparatory painted sketches.

The picture, moreover, was made not in the open, but in the studio. Manet was not converted to painting in the open air until he visited Monet at Argenteuil a decade later.

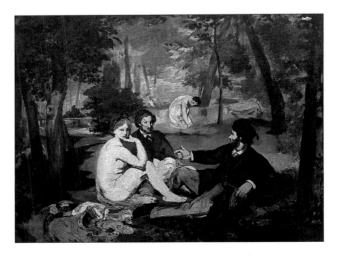

This is confirmed by the somewhat self-conscious anti-naturalism both in the lack of modelling, which is particularly evident in the girl's flesh, and the strange rendition of space. There is little traditional perspective, while the background is reminiscent of a stage backdrop.

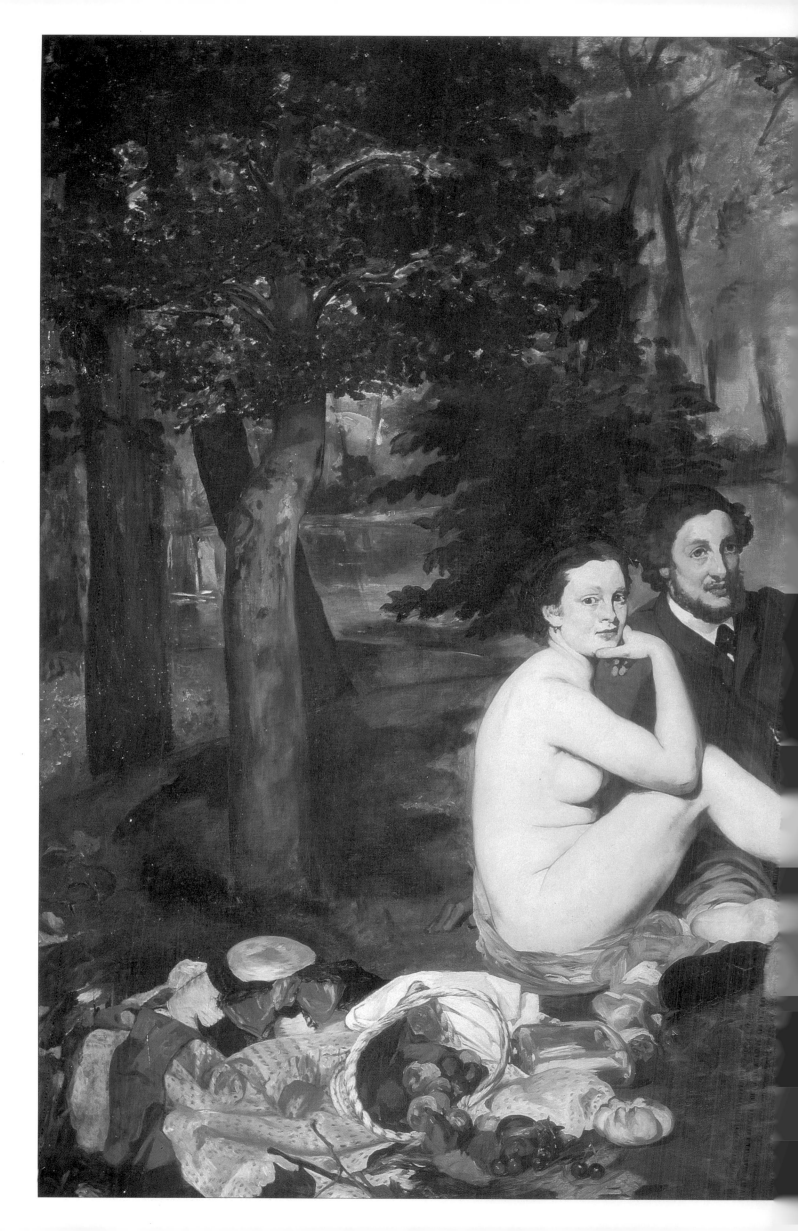

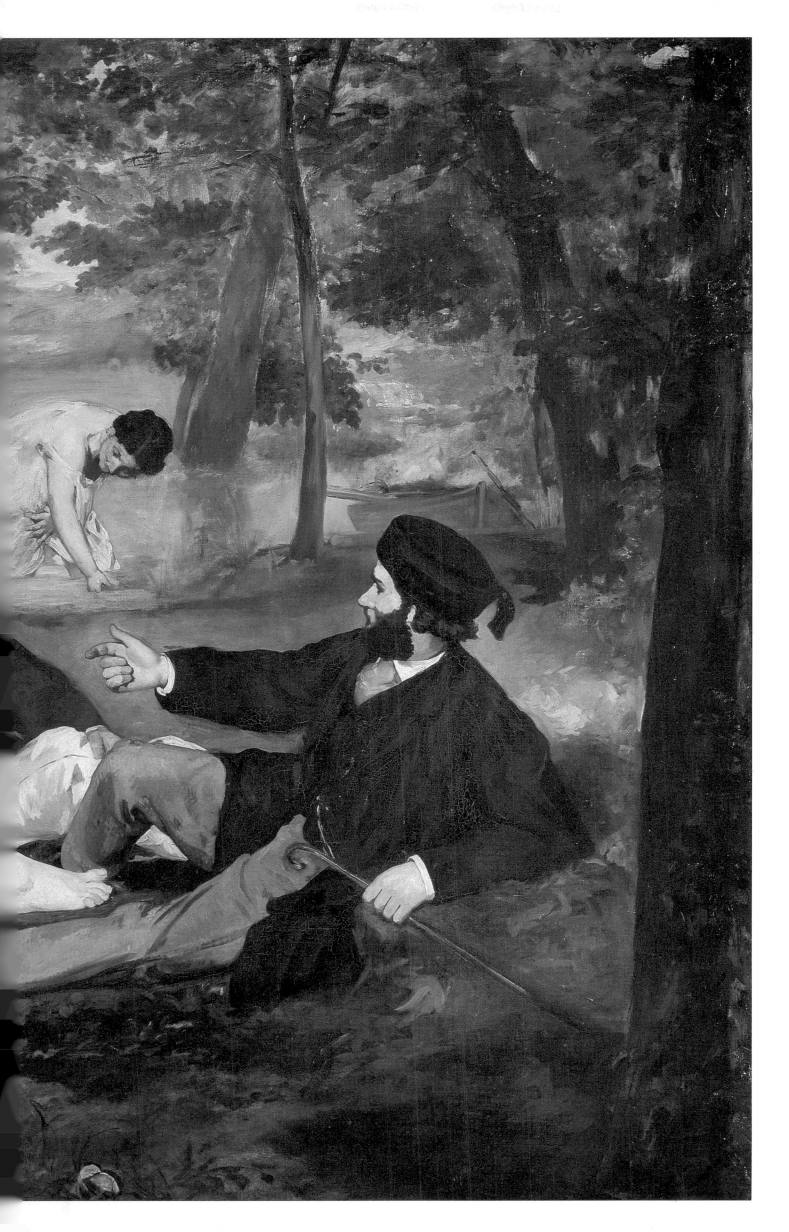

OLYMPIA
EDOUARD MANET (1832-1883)

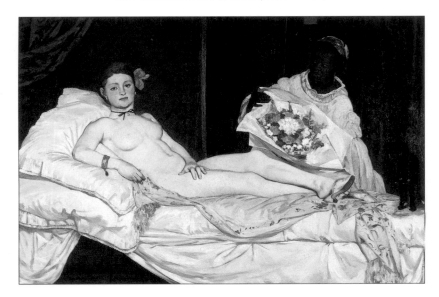

Baudelaire insisted that Manet submit his *Olympia*, painted in 1863, for exhibition at the Salon of 1865. The work created a sensation when the Salon opened, being roundly condemned as an outrage against public morality. The subject is treated totally uncompromisingly, in complete contrast with academic convention.

Painted largely in monochrome planes of even colour, light in the foreground and dark in the background, the picture is enlivened by touches of polychrome detail. What immediately catches the eye is the contrast between the relatively smooth way in which Manet handles the figure, with its acutely observed tonal values, with the more painterly approach to the sheets and pillow. Here, Manet makes full use of blue in the shadow areas – a feature that was to be enthusiastically taken up by the younger Impressionists. The positioning of figure and bed parallel to the picture plane is somewhat daring in compositional terms, especially with the bed in the foreground so close to the viewer. This is also the case with *Le Balcon* (1868-9).

Throughout, Manet is concerned with impression, rather than artifice. The head, with its cool gaze trained at the spectator, is scarcely modelled at all, although a light semi-transparent brown has been used to trace the model's pointed chin. Like the oriental shawl, which discloses rather than conceals, the slippers *(detail)* accentuate the artificiality of the figure. The colours in the floral bouquet are echoed in the blue trim of the slippers and the red and green of the embroidered flowers.

The bouquet itself, which provides the counterbalance to Olympia's head, is composed of a central white flower, surrounded by alternating dashes of light blue and dark green. These are encircled by touches of white, offset by four evenly spaced red accents. Sprays of fern, painted wet-in-wet, encompass the bouquet. In contrast to the thin application of coloured pigment on some of the flowers, the wrapping paper has been created with a bold sweep of thick white paint, which, in places, overlaps the foliage.

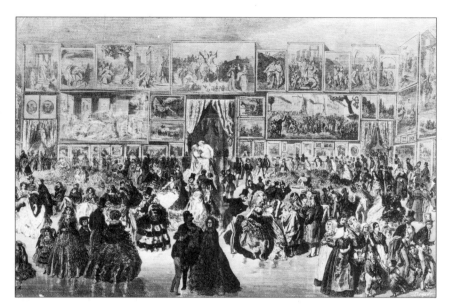

The Salon of 1868. Thousands of paintings were crammed into the Salon each year and exhibitors regularly complained about the location of their work. Before 1863 paintings were exhibited with little regard to their scale and a good location was often best achieved by bribing the warders responsible for hanging the pictures. After the reform of the Salon, prompted in part by the protests that led to the Salon des Refusés, paintings were hung more logically. The engraving shows how larger paintings were placed above smaller canvases. Complaints, however, persisted throughout the 1860s and 1870s; Zola recorded that Manet's contributions to the Salon of 1868 were poorly placed, either beside the door or in the corner.

The hysterical reaction to *Olympia* was typical of the double standards of Parisian society at the height of the imperial period. Prostitution, like the poor, was always with the Parisians and, during the 1860s, the number of street-walkers had increased hugely; in 1869, 106,479 of them were examined in their 'Maisons de Tolérance' and most found to be suffering from the advanced stages of syphilis. What was new in the society of the Second Empire was the phenomenon of the rich courtesan. Their portrayal in *opéra comique*, literature and art was permissible, provided that they were disguised as classical goddesses, but to show kept women or common tarts without moral condemnation of their profession was unacceptable in a society that prided itself on its moralism – at least, on the surface.

The subject in *Olympia* is no conventional nude of the kind created by the academicians. She boldly meets the spectator's gaze in the very centre of the composition, and draws attention to her left hand covering her pudendum; the black ribbon, with its pearl pendant, is tied in a bow that asks to be undone; and the black servant is delivering a bunch of flowers from a client expecting, or grateful for, favours. But the critics did not draw attention either to the painting's antecedents or discuss its content directly, though by concentrating on its form they did so by implication. They described the woman as dirty and deformed – manifestly untrue – and generally made, in T.J. Clarke's words, 'embarrassed noises off'.

THE STRUGGLES OF THE REFUSES

The achievements of the Refusés, not surprisingly, were modest. Some minor changes were made in the organization of the official Salon. Exhibitions were to be held annually rather than biennially, and there was a diminution of official participation in the selection of works to be shown. However the public tended to side with the jurors.

Notwithstanding this, Cézanne wrote to Count Nieuwerkerke in 1866 asking for another Salon des Refusés, on the grounds that he had to submit his work to jurors who had no more regard for his painting than he had for their critical judgement. Emile Zola (1840-1902), a childhood friend of the artist, wrote an article entitled 'Mon Salon' in *L'Evénement*, which he had just joined, in Cézanne's support. Zola claimed that the jury was so corrupt, both in taste and in the way it administered the annual exhibition, that it offered the public not art but its 'mutilated corpse'. Cézanne painted a portrait of his father that year, reading *L'Evénement*. The following March Bazille sent Count Nieuwerkerke yet another petition, to which was attached a list of signatories, who included Monet, Renoir, Pissarro, Sisley, Jongkind, Manet and Daubigny, but it had no effect.

It is clear from the letter Bazille wrote to his parents a little later that other plans were being discussed:

 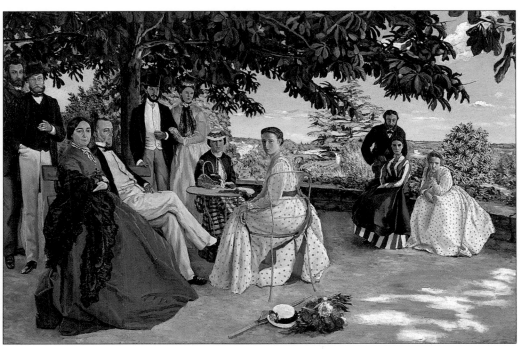

Achille Emperaire *by Paul Cézanne, painted in 1868 (left).*
Like many of Cézanne's early pictures, the portrait of the painter
Emperaire is painted with aggressive gestures of paint and in

ponderous, sombre tones. The Family Reunion *by Frédéric*
Bazille (right). Painted in 1867 while Bazille was on holiday at
Meric, the picture is influenced by Manet and Monet.

> A dozen talented people have resolved to rent a big studio each year where we
> will show as many paintings as we want. We will invite the painters whom we
> like to send paintings. Courbet, Corot, Diaz and Daubigny and many others
> with whom you are not familiar have promised to send paintings, and highly
> approve of the idea. With the latter, and Manet, who is better than all of us, we
> are likely to succeed.

Unfortunately, the scheme came to nothing, foundering for lack of funds. Manet, however, was wealthy. After the damning reviews his work had received, he chose not to enter the Salon for 1867, and the fact that he was not invited, as he had expected to be, to submit work for the Exposition Universelle, led him to show 50 paintings at his own expense.

MANET AT THE CAFÉ GUERBOIS

The problems of where and how to show work must have been high on the list of subjects discussed by Manet and the group of friends who met regularly from about 1866 at the Café Guerbois, 11 grande rue des Batignolles (today 9 avenue de Clichy). The group included both older artists and the younger members of the avant-garde, and, although they held much in common, they did not necessarily agree on everything. Indeed, Manet fought a duel with Duranty, in which the latter was slightly wounded, over an article in *Paris-Journal* to which he objected. But their rejection by the art establishment, their contempt for official art, their shared devotion to painting in the open, and their belief that what they produced outside the studio was a finished work of art in its own right, were links in a chain that held them together.

There seems, as far as one can judge, to have been little specific political discussion or argument. Literary, artistic, even scientific topics generated passionate interest, but the Impressionists, who barely held together an artistic manifesto for 12 years, seem to have voiced no strong political views. They were 'revolutionary' more in their attitude to the artist's position in society and his right to complete independence than in adhering to any political doctrine that advocated social or political measures.

continued on page 52

THE IMPRESSIONISTS AND THE CAFES

Bars, cafés and cabarets became a dominant feature of social life in Paris during the days of the Second Empire; for the emerging Impressionists, the Café Guerbois, in what was then the grand rue des Batignolles (now the avenue de Clichy) became a second home. There, between 1869 and 1873, Manet and his friends and followers held court; later, from around 1877, the Impressionist côterie was to move to the quieter Café de la Nouvelle-Athènes, on the place Pigalle.

By 1869, all the Impressionists knew each other well; throughout the week, such figures as Astruc, Duranty, Silvestre, Duret, Guillemet, Bracquemond and Bazille were almost daily attenders, while the café was also visited frequently by Fantin-Latour, Degas and Renoir. Zola, Maître and Guys made occasional appearances, while Cézanne, Sisley, Monet and Pissarro could be found there whenever they were in Paris.

According to Monet, Thursday evening had been set aside for regular artistic gatherings, but, on any evening a visitor was almost certain to find a group of artists engaged in a heated exchange of opinions.

Manet was unquestionably the dominant personality, as Silvestre recalled in his *Au Pays du Souvenir*: 'This revolutionary – the word is not too strong – had the manners of a perfect gentleman…Blond, with a sparse narrow beard which was forked at the end, he had in the extraordinary vivacity of his gaze, in the mocking expression on his lips…a very strong dose of the Parisian street urchin. Although very generous and very good-hearted, he was deliberately ironic in conversation and often cruel. He had a marvellous command of the annihilating and devastating phrase'.

Indeed, Manet's quickness to pick an argument led to a duel with Duranty, in which Zola acted as a second for the painter. Paul Alexis, a mutual friend, reported that 'being completely ignorant of the art of fencing', the two duellists 'threw themselves on each other with such savage bravery' that 'their two swords appeared to have been turned into a pair of corkscrews…By that very evening they had become the best of friends again and the habitués of the Café Guerbois, happy and relieved, composed a triolet of nine lines in their honour'.

Cafés such as the Taverne Pousset (left) at La Sortie des Théâtres became an integral part of the Parisian social scene in the 19th century. They catered for all classes and all tastes – some were intellectual centres, some the haunts of artists and writers and some the second homes of politicians and financiers. At the bottom end of the scale were the cabarets in areas such as Belleville, where, for a few sous, the working classes could drink themselves into oblivion on cheap and plentiful alcohol.

The Impressionists were great painters of café life; this is Renoir's The Café *(below). Unlike Manet or Degas, Renoir concentrated on the lighter, rather than the darker, side of café society.*

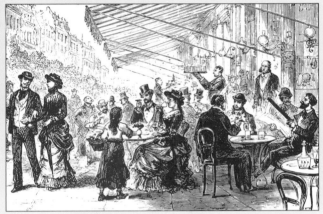

Open-air entertainment was a Parisian speciality, as this scene at the Café des Ambassadeurs in the Champs Elysées demonstrates (above). Other establishments sprang up along the city's new boulevards (left). Here could be found the demi-mondaines and the cocottes – prostitution was one of the capital's flourishing industries.

The interior of the Restaurant Le Train Bleu in all its 19th-century splendour (right). The 'cabinet particulier' was a prominent restaurant feature of the imperial period; for prostitutes, Paris seemed a paradise. On the Champs Elysées, one of the Goncourts heard a cocotte boasting of 'making 900 francs; one lives on three and puts 600 in a savings bank'. Even within the Goncourts' circle, few evenings passed without some form of sexual discussion, while, according to police records, there were some 5,000 registered prostitutes, plus 30,000 'freelancers'.

Obviously, though, the Café Guerbois provided a forum for lively discussions on the topics that did interest and concern Manet and his friends. Monet recalled these evenings in a conversation in 1900:

> There I met Fantin-Latour, Cézanne, Degas,…the art critic Duranty, Emile Zola, who was then making his first foray into literature, and several others. For my part I used to take Sisley, Bazille and Renoir there. Nothing could have been more interesting than the discussions we had with our perpetual clash of opinions. They kept our wits sharpened, encouraged a mood of frank and impartial enquiry and provided us with enough enthusiasm to keep at it for weeks on end until our ideas became clear and coherent. From them we emerged more finely tempered, our wills firmer, our thoughts clearer and less confused.

Manet's emergence as the key figure in the embryonic movement was not altogether to his liking, but that position, acquired after the Salon of 1861, was given concrete form in Fantin-Latour's *A Studio in the Batignolles Quarter*, an imaginary group portrait painted in 1870. It shows Manet flanked by Renoir, Zola, Bazille and Zacharie Astruc (1835-1907) and it was quickly seen by many critics as a manifesto of a 'new' school of painting, with Manet as its catalyst and leader. Bertall's cartoon, a pastiche of Fantin-Latour's portrait, mockingly depicted him as Christ among the apostles.

Whereas his enthusiasm for Courbet in 1855 had been qualified, Baudelaire had come to feel that Manet more closely accorded, in his imaginative and urbane approach to realism, to his own interpretation of it, which he had outlined both in his Salon review of 1854 and reverted to in his essay 'L'Héroisme de la Vie Moderne', published in 1863. In the former he had argued not for an unchanging ideal of beauty, but for one that was consistent with contemporary values. He wrote:

> The pageant of fashionable life and the thousands of floating existences – criminals and kept women – which drift about in the underworlds of a great city; the *Gazette des Tribunaux* and the *Moniteur* newspapers all prove to us that we have only to open our eyes to recognise our heroism.

Manet had painted a scene from fashionable life in 1862 with his *Concert in the Tuileries Gardens*, in which he portrayed an informal gathering of people enjoying themselves in urban surroundings. All the figures have been identified; they include Albert de Balleroy, with whom Manet shared a studio, Manet's brother Eugène, Fantin-Latour, Baudelaire himself, Astruc, Champfleury and Jacques Offenbach, the 'Mozart of the Champs-Elysées' whose operettas both satirized contemporary society and enchanted it. It is possible, however, as Clarke has suggested, that Manet, himself a member of the upper social stratum, was pointing to 'society in the face of the Empire' as opposed to the customs of the *nouveaux riches* that colonised other quarters of Baron Haussmann's re-designed city.

THE URBAN LANDSCAPE

Both urban and rural landscapes were also painted by Monet, Renoir, Degas and Morisot and, to a lesser extent, by Pissarro and Sisley, but few of them were shown at the Salons between 1864 and 1870. When Corot and Daubigny served on the jury, they had some chance of inclusion, although Daubigny failed to get a sketch by Renoir accepted in 1866. Both Corot and Daubigny were absent in 1867 and Monet, Bazille, Sisley, Renoir and Pissarro all failed to gain entry. Daubigny's encouragement in 1868 to the younger painters to submit landscapes, was, moreover, criticised by Count Nieuwerkerke. In any case, the Salon was not an appropriate environment for displaying small landscapes and many of the artists whose works

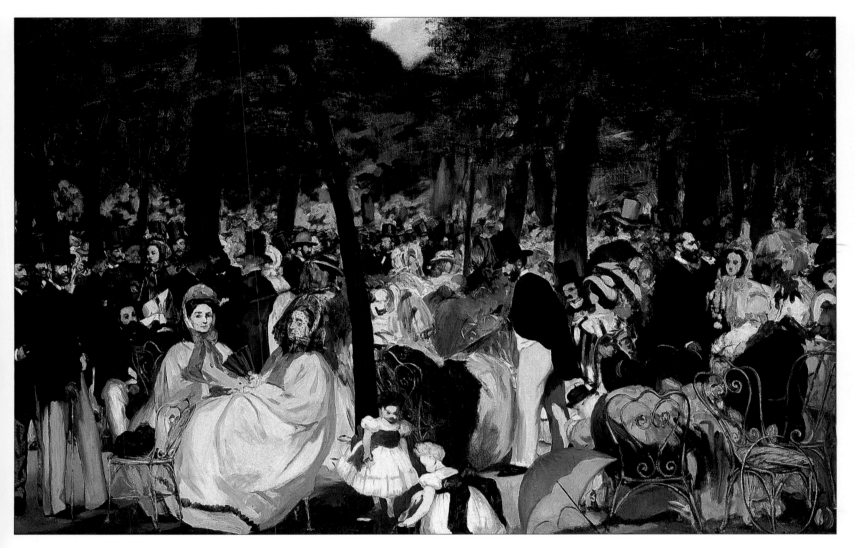

Concert in the Tuileries Gardens *by Edouard Manet, painted in 1862. Critics such as Baudelaire and Champfleury advised artists to paint subjects taken from 'modern life'; this was Manet's* *first study of the modern urban environment. The picture was among those included in an independent exhibition of the artist's work held at the Galerie Martinet Martinique in 1863.*

were accepted complained that they were poorly hung.

Despite these problems, the urban landscape as a subject was becoming another hallmark of the new group of painters. Monet was the first of Gleyre's students to produce one, but in 1867 Renoir painted *Le Pont des Arts* and a year later, *Skaters in the Bois de Boulogne*. In the latter, he takes a viewpoint slightly above the subject, a device Manet had used in his *The Exposition Universelle of 1867* and one of which Monet was fond.

At this period, however, it was perhaps Edgar Degas (1834-1917) who took the city as his theme most consistently. His highly formalized compositions are more reminiscent of Ingres' classicism than the unmediated experience propounded by Corot and the Barbizon School; indeed, he himself claimed that his work was rooted in tradition:

> No art was ever less spontaneous than mine. What I do is the result of reflection and study of the great masters. Of inspiration, spontaneity and temperament I know nothing.

Degas' work has a breathtaking capacity to evoke common experience. He often achieved this by writing notes of seemingly inconsequential events, and then using them to produce highly stage-managed paintings possessing an almost photographic veracity.

continued on page 56

THE ORCHESTRA OF THE PARIS OPERA
EDGAR DEGAS (1834-1917)

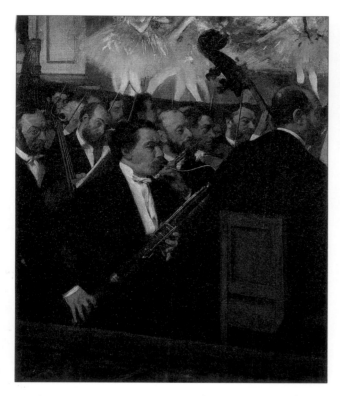

Degas painted his view of the orchestra of the Opéra in
1868. Like Manet, Degas concentrated his attention on
urban, rather than rural, subjects, especially the
distractions of the race-track, the circus, cafés-concert
and the ballet. Here Degas depicts the orchestra pit at the
Opéra, the opulent state-sponsored Académie Nationale
de Musique housed in the largest theatre in the world. The
Opéra stood on a site measuring three acres; it seated 2,156
people and its internationally renowned singing stars
commanded salaries of tens and in some cases hundreds of
thousands of francs. Degas shows the orchestra seen from
a part of the auditorium reserved exclusively for men. The
painting uses a variety of naturalistic devices. For
instance, the figure playing the double-bass has his back
to the audience and looks out of the composition. The
performers on stage are cut at shoulder height by the
upper edge of the frame. Close examination of the detail of
the painting (right) shows that the figures are taken to a
high degree of finish. Passages across some of the faces and
the detail on the instruments are painted with meticulous
care and must, of necessity, have been made in the studio
rather than before the subject.

By the mid-19th century, photography had reached a high degree of technical skill; it was possible, for instance, to take photographs at shutter speeds of around one-fiftieth of a second. The convention whereby an image of a fleeting moment could be caught on a glass plate without the intervention of an intermediary was to have its effect upon many of the 'naturalist' painters, who saw it as a means of capturing both this fleeting moment and doing so in an objective manner. They also employed the curious perspectives and distortions arrived at by the camera, as can be seen in Monet's *Le Boulevard des Capucines*. Photography also made it possible for Manet to produce a faithful record of an occasion which he could not possibly have witnessed for himself in *The Execution of the Emperor Maximilian*, which he started in the autumn following the actual event.

This painting was a rare excursion into the political field by Manet, or, indeed, any of the Impressionist painters. The European Maximilian, who had been placed on a Mexican throne supported by French bayonets, had been executed in July 1867 by the victorious rebels and the slump in the regime's prestige that followed was immeasurable. The French felt that Napoleon III, who had withdrawn the troops who might have averted the tragedy, was responsible. Manet, whose private exhibition had opened that May and failed to give him satisfaction, saw in the subject a way to strike at the artistic establishment and paint a 'history picture'. He spent the better part of a year working on variations, but when it was rumoured he intended to submit it to the 1868 Salon, he was given to understand that it would not be accepted – on politically sensitive grounds.

Not all the painters, however, were willing to admit to using photographs because they thought that to do so would compromise their reputation for being adept with paint. On the other hand, they were less reluctant to admit their debt to Japanese prints, which, with the opening of the Treaty ports and Japan's participation in trade fairs, could now be bought in Paris at La Porte Chinoise, Descell's à l'Empire Chinois and Madame Desoye's shop in the rue de Rivoli, as well as at similar shops that proliferated in the wake of the Exposition Universelle. Many of the painters, their friends and their patrons acquired them. Degas bought prints by Utamaro and Kiyonga, and Fantin-Latour and Astruc were members of the Société de Jing Jai, a secret sect devoted to *japonisme*, which became all the rage. James Tissot (1836-1902), the Goncourts and Philippe Burty (1830-90) were keen collectors, as was Théodore Duret (1838-1927). Duret, who worked in the cognac trade, went on a tour of the Orient in 1871-2 with Henri Cernuschi to help him put together the celebrated collection of oriental art which is now in the Musée Cernuschi, Paris. Manet's *Portrait of Duret*, which he gave him and for which he was rewarded by a case of old brandy, gives no hint of this but in his *Portrait of Emile Zola*, he shows both a Japanese screen and a print by Kuniaki II on the wall behind the novelist.

Although Whistler, Tissot and, to some extent, Monet wrote overtly oriental themes into their pictures, it was the dramatic foreshortening and cropping of the edges of their compositions by Japanese artists that affected the Impressionists most. These compositional and perspectival formulae, which coincided with naturalistic and photographic conventions, constantly recur in their works.

COLOUR AND ITS NEW USES

Allied to these novel techniques influenced by photography and *japonisme*, and the wish to capture the fugitive moment of perceived experience by its rapid notation in paint, was a new use of colour. *Plein-air* painting in part had been made possible by the availability of easily portable paints in pure colours – a result of improved chemical technology – which also enabled the artists to lighten their palette. All of this is epitomized in the paintings Monet and Renoir made at La Grenouillère, an open air café and bathing resort on the Seine near Bougival, in 1869. Here, the artists captured the fleeting effects of light on the water with a network of brush-strokes, where each mark corresponded to the momentary effect of colour reflected from the surface of the water on the surrounding landscape.

Renoir painted La Grenouillère *in 1869. Both he and Monet painted several studies of the fashionable bathing-place on the Ile de Croisy, on the Seine just outside Paris. One contemporary observer described La Grenouillère – the riverside restaurant on the island – as 'Trouville on the banks of the Seine'. The paintings Renoir and Monet created here mark an important moment in the evolution of Impressionist technique. The pictures are made on location with the subject in actual view; the speed at which the artists worked is evident from the way in which the entire surface of the canvas is freely painted.*

Thus as the decade came to a close, all the elements for a new avant-garde school were in place: the emergence of artists who had achieved independence; freedom from a restricted and conventional style; the legitimacy of both urban and rural landscapes in their own right; subjects which conveyed no message and had no moral content; an obsession with transience, light and how it was perceived and conveyed; and brilliant, pure colour applied with rapid brush-strokes.

However, the society in which the Impressionists lived – a society that, so far, had failed to recognize their talents – was about to undergo a cataclysmic change. The regime of Napoleon III had embarked on various military adventures. The Crimean War and the intervention in Italy had been relatively successful – the expedition to Mexico, however, had been a fiasco. Now, as the events of 1870 were to show, Baron de Rothschild had been right when he warned Napoleon III 'Ecoutez-vous, pas de paix, pas d'empire'.

The Beach at Trouville *was painted by Claude Monet in 1870, shortly before the outbreak of the Franco-Prussian war. The figure on the left of the painting is Camille, Monet's long-time mistress and now his wife; the one on the left, it has been suggested, is Madame Boudin. The paint has been applied in a very radical manner. The highlight on Camille's skirt is made with a slab of white paint applied directly to the canvas with a coarse hog's hair brush, while the faces of the two figures are treated with cursory dashes of paint.*

THE IMPRESSIONISTS AND THE EMPIRE

For the young painters who were to band together to form the Impressionist movement, the struggle they were waging against the straightjacket of the Salon system was mirrored by the way in which France was governed under Napoleon III's regime. As the years passed, it became clearer and clearer that the survival of the regime depended on the strength of will and purpose of the emperor himself; equally clearly, as opposition to the regime increased, it became obvious that he was failing.

Napoleon III's position was always an uncertain one. He knew that he had only come to power because of a split between the two royalist parties; he knew that many Frenchmen regarded him as a usurper; he realized, too, that it was France's boredom with the dull, safe regime of Louis-Philippe that had paved his way to power. Consequently, he was determined to excite and what better way was there of doing this than through the pursuit of a showy foreign policy in pursuit of 'la gloire'. This was a reason, though not the sole one, for his interventions in the Crimea and in Italy; it lay behind the fiasco of the Mexican expedition and eventually forced him into the Franco-Prussian War.

Of course, Napoleon III was well-meaning; indeed, he endeavoured to introduce a whole range of

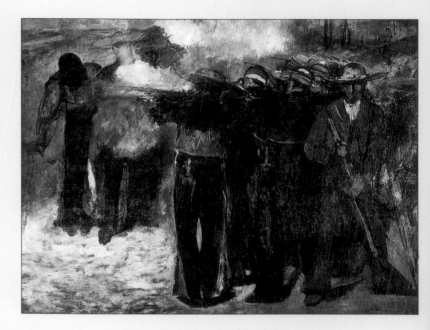

Proudhon (below left) was France's most influential socialist thinker. By the 1860s, however, the working class was turning to Karl Marx. Adolphe Thiers (bottom right) led the parliamentary opposition and eventually became leader of the Third Republic.

Manet's depiction of the execution of the Emperor Maximilian (above) was banned from exhibition because it was thought to attack France's intervention in Mexico and its subsequent withdrawal of support.

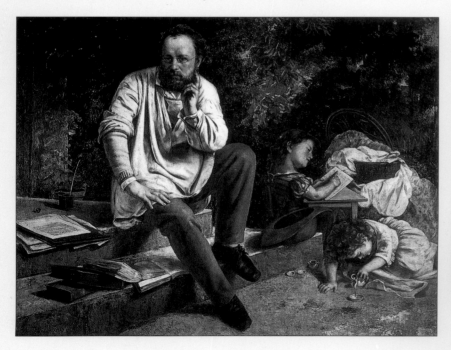

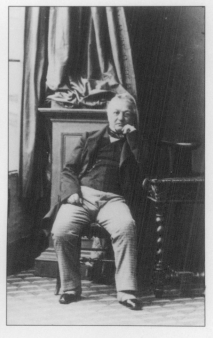

The Mexican expedition (below) was Napoleon's last foreign adventure, in which he attempted to create an empire for a puppet emperor. The French went ahead without the support of other powers; eventually American pressure forced the withdrawal of the imperial forces.

social reforms. Unfortunately, many of his progressive ideas were frustrated by the greed of the middle classes and the innate conservatism of the French provinces – a fact that did not escape the working classes, who became Napoleon's bitterest foes. The intellectuals, too, became equally disaffected. The writers of the period hated the regime passionately for its interference in their work. Flaubert was prosecuted in 1857 for offending public morals in *Madame Bovary*, while Gautier grumbled to the Goncourt brothers: 'What can you do when they won't have any sex in a novel? Now I'm reduced to writing a conscientious description of a wall and, even so, I'm forbidden to describe what may be drawn on it'.

The artists were equally embittered. Like Zola and Duret, Manet was an ardent republican and a profound admirer of Gambetta; Pissarro was a socialist with a leaning towards anarchy; Monet, too, had deep republican sympathies. Above all, there was the example of Courbet, with his contemptuous rejection of the offer of the Legion of Honour.

Though, by 1869, Napoleon had conceded the trappings of a parliamentary regime, it was too little too late. As the emperor told Cobden: 'it is very difficult in France to make reforms; we make revolutions in France, not reforms'.

Léon Gambetta (top), a close friend of Manet, came to national prominence when he undertook the defence of Delescluze whom the government accused of sedition in 1868. His brilliant defence turned the trial into a devastating indictment of imperial policies and made a laughing stock of the empire. He became a deputy and later Minister of the Interior in the government of National Defence, set up in 1870 after the fall of the Napoleonic regime.

Napoleon III and Bismarck confer after the emperor's surrender at Sedan in 1870 (above). It was Napoleon's misfortune to be confronted by Bismarck at the height of his powers; he was outmanoeuvred diplomatically, just as he had been on the battlefield. The Prussian Chancellor refused to moderate his terms, describing France as 'a nation full of envy and jealousy'. Following the meeting, Napoleon was held as a prisoner-of-war in Germany.

3 THE FIRST IMPRESSIONIST EXHIBITION

The next decade was to be a momentous one for the group of artists who had been meeting in the Café Guerbois. It started disastrously with the traumatic events of 1870. Napoleon III and the Prussians had been on bad terms for some years and the war that had been threatening now broke out. Its immediate *causus* occurred on 2 July 1870, when Leopold, Prince of Hohenzollern, offered himself as a candidate for the vacant Spanish throne. The French, fearing a Prussian presence on their south-western frontier, objected, and Leopold's offer was withdrawn ten days later. However, Napoleon III still demanded assurances from Wilhelm I of Prussia that there would be no further claim in the future.

The Prussian reply, deliberately amended by Bismarck so that it read as a provocation rather than conciliation, was given to the press in the notorious 'Ems telegram' and led to uproar in France. Popular opinion forced Napoleon to declare war on 19 July. The French were convinced that they would be victorious and, in any case, Napoleon III personally needed the political prestige that success would bring. Both people and emperor were to be speedily disillusioned. The imperial forces quickly proved no match for the Prussian war machine. After the first battle of the war on 4 August, ignominious defeat followed ignominious defeat until Napoleon was forced to capitulate at Sedan on 1 September.

The immediate response was a rising in Paris, the fall of the empire and the proclaiming of the Third Republic on 4 September. However, the new government of National Defence fared no better, as the Prussian onslaught continued, reaching the outskirts of Paris by 19 September. The city determined to resist and a siege was the logical consequence, though no one on either side anticipated how long it would last, or what its consequences would be.

Bazille painted The Ramparts at Aigues-Mortes, Montpellier *in 1867. The broad and direct handling of the paint is influenced by the example of Monet.*

The Thames and the Houses of Parliament *was painted by Monet in 1871, while the painter was a refugee in England. Monet came to London in September 1870, shortly after the* outbreak *of war, and made several similar studies. He was to return to the subject of the atmospheric effects of London fog on subsequent visits to the capital.*

THE IMPRESSIONISTS AND THE WAR

The Impressionist response to the war was mixed. Manet enlisted in the National Guard, Degas in the artillery and Renoir served in the 10th Cavalry Regiment, looking after the horses. Bazille, who had joined the Zouaves, a regiment renowned for undertaking dangerous missions, was killed on 28 November 1870, just eight days short of his 29th birthday. Pissarro remained at his home in Louveciennes until the Prussian advance forced him to flee, while Cézanne had left for Aix-en-Provence and then L'Estaque in the south of France to avoid the risk of conscription.

Monet and Pissarro, after Napoleon's defeat, had fled to England. Paul Durand-Ruel (1831-1922), a notable art dealer of the time, had also left Paris for London, with a substantial collection of paintings by Corot, Troyon, Daubigny, Millet and Diaz to exhibit in the gallery he had just opened in New Bond Street. It was there that Monet was introduced to him by Daubigny, who had also fled and was moved by the financial distress in which the younger man found himself.

Durand-Ruel, anxious to enlarge his repertoire and keen to promote younger painters, showed one painting by Monet and two by Pissarro, but they failed to sell. Moreover, although both Monet and Pissarro thought that the English public would accept their work, since it revered that of Constable and Turner, the Royal Academy did not accept their submissions either, probably because, as Alan Bowness has suggested, it was out of step with English taste at the time. Avant-garde patrons were more interested in the abstract formal concerns of the Aesthetic Movement, while the public still favoured anecdotal history paintings by Sir John Everett Millais (1829-96), Tissot, Frederic, Lord Leighton (1830-86) and W.P. Frith (1815-1909). The most respected French artists in London were, according to Duret, Gérôme and Rosa Bonheur (1822-99).

continued on page 66

WAR AND THE IMPRESSIONISTS

In 1900, Monet recalled the events of 1870 in a few brief lines in an interview he gave to *Le Temps*. 'War was declared on Germany. I had just got married. We went over to London, where I met Pissarro and Bonvin. I endured much poverty, for my works were not popular there. Life was difficult'. These laconic words do little justice to one of the watersheds in 19th-century history, but perhaps capture the differing ways in which the Impressionists reacted to the outbreak of the Franco-Prussian War, the swift defeat of the imperial armies, the fall of Napoleon III and the proclamation of the Third Republic.

The French collapse had an overwhelming impact – all the more so for being totally unexpected. When war broke out, war fever gripped Paris. Mobs in the street sang the banned Marseillaise and chanted endlessly 'Vive la guerre'. The Zouaves, whom

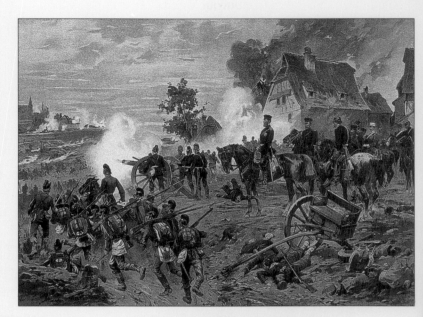

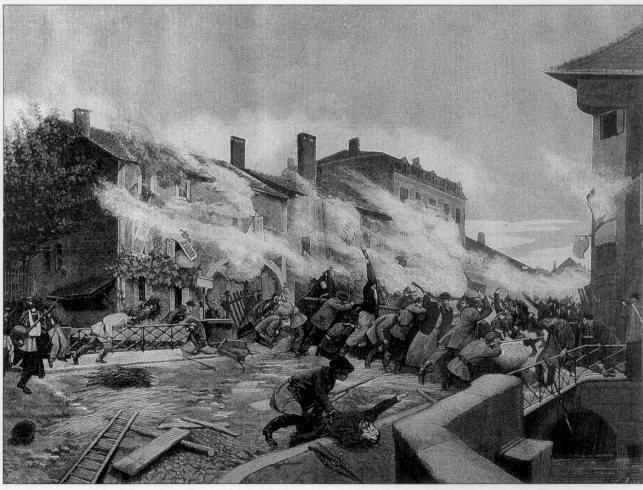

Bazille was soon to join as a volunteer, paraded a parrot that had been taught to screech 'A Berlin!'. Even a supposedly acute observer, Delane of the London *Times*, declared 'I would lay my last shilling on Casquette against Pumpernickel'. With Napoleon's capitulation at Sedan, this world was turned upside down. The day the news reached Paris, Edmond de Goncourt commented in his celebrated journal: 'Who can describe the consternation written on every face…the crowds collecting at street corners and outside town halls, the siege of the newspaper kiosks, the triple line of readers gathering around every gas-lamp?…Then, there is the menacing roar of the crowd, in which stupefaction has begun to give

Napoleon III surrenders to Kaiser Wilhelm I of Prussia at Sedan (below). During the last hours of the battle, Napoleon, his faced rouged to disguise his illness – he was suffering agony from a huge stone in his kidneys – had ridden among his wavering troops, hoping to be killed, but eventually ordered the white flag to be hoisted. 'Since I could not die at the head of my troops, I can only put my sword in Your Majesty's hand', he wrote to the Prussian king.

The scene in the Corps Législatif on 4 September 1870 (below) was chaotic, as the mob outside demanded Napoleon III's abdication. People were allowed to enter the chamber on the slightest pretext, the imperial police explaining 'there's a session going on to overthrow the government'. When the mob finally invaded the chamber, Jules Favre led them away to the Hôtel de Ville, telling them it was there that 'we must proclaim the republic'.

French troops advance into action during the battle of Weissenburg on 4 August 1870 (left), while the people of Rambervillers prepare to defend their town against the Prussian invaders (bottom left). Despite much individual heroism, the failure of the Napoleonic armies was practically total, especially when it came to the higher levels of command. Marshal Bazaine allowed himself to be trapped in Metz and eventually was forced to surrender; Marshal MacMahon led his troops to total defeat at Sedan. One of the answers, according to Léon Gambetta, leading resistance outside Paris, was to launch guerrilla war, but the Prussian firing squads were quick to deal with such irregulars.

place to anger. Next there are great crowds moving along the boulevards and shouting "Down with the Empire!"' The next day, the regime fell.

The painters who remained in Paris for the duration of the siege were Manet, Degas and Berthe Morisot. Manet became a staff officer in the artillery of the National Guard; Degas volunteered for the infantry, but, because of his eyesight, was placed in the artillery. Berthe Morisot commented that the latter was 'always the same, a little mad but charmingly witty', though she later somewhat maliciously claimed that Manet spent most of the siege 'changing his uniforms'. Both Manet and his brother tried to persuade the Morisots to leave their home in Passy, but the family indignantly refused. Berthe's mother described a typical visit in a letter to her two other daughters. 'M. Degas was so impressed by the death of one of his friends, the sculptor Cuvelier, that he was quite impossible. Manet and he almost came to blows over questions of defence and the use of the

The Prussian decision to bombard besieged Paris into surrender was made in December 1870 and on 5 January 1871 the bombardment of Paris proper began (above). From then on, the shells fell at a rate of between 300 and 400 a day, though the Prussians usually waited until 10pm before opening fire on the city. Dr. Alan Herbert, a British resident, thought this 'very good-natured'.

National Guard, although both of them were ready to fight to the bitter end to save the country. M. Degas has enlisted in the artillery, but, according to what he says, has not yet heard a single gun fired'.

The Morisots and Manet used the balloon post, organized by Manet's friend Nadar, to send letters to the outside world. These give a vivid picture of life during the siege. Manet, for instance, told his wife that people were reduced to eating cats, dogs and rats, while, in a letter to his pupil Eva Gonzalès, he complained that donkey meat was too expensive for his purse. Despite these privations, he survived to see Paris surrender on 28 January 1871; the only Impressionist to be killed was Bazille.

The surrender did not mean the end of the struggle, however, for in March the workers rose to proclaim the Commune. Here, Renoir, who had returned to Paris, had a stroke of luck. Prevented from leaving the city to paint, he caught a glimpse of a photograph of Raoul Rigault, the Public Prosecutor and a leading figure in the Commune. In 1869, Renoir had unwittingly helped Rigault escape arrest by Napoleon's police; now, he was rewarded with a pass allowing 'Citizen Renoir' to work as he pleased. However, the ageing Courbet was not as fortunate. His radical sympathies led him to accept the post of Curator of Fine Arts and to organize the destruction of the Vendôme column. With the bloody suppression of the Commune by the troops of the provisional government at Versailles, he was arrested and imprisoned. In addition, he was fined 250,000 francs and, rather than find this astronomic sum, he fled to exile in Switzerland.

A balloon prepares to leave besieged Paris (below). Among the first passengers was Léon Gambetta, the newly appointed Minister of the Interior, on his way to Tours to organize provincial resistance.

According to onlookers, Gambetta appeared nervous, but, the anchor ropes were cast off, he unfurled a tricolour and displayed it to the crowd, whose response was a cry of 'Vive La France!'.

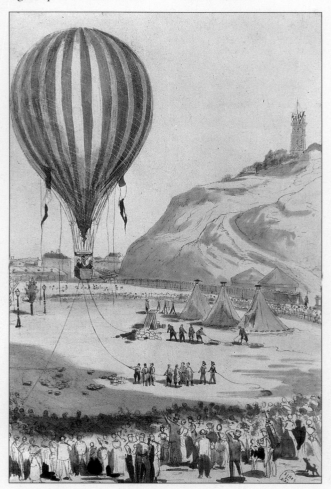

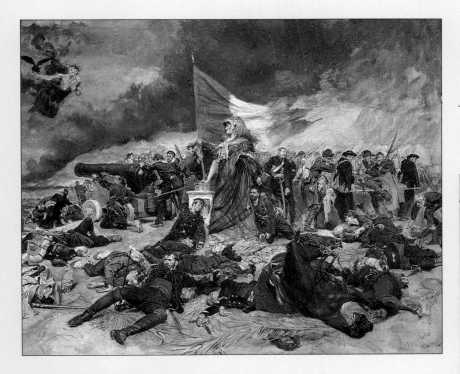

Manet's experiences during the siege inspired him to create two lithographs, Civil War *and* The Barricade. *The latter is shown here (below). Both were taken from drawings the painter made on the spot; Manet actually saw these corpses on the corner of the boulevard Malesherbes.*

An embattled Marianne, the symbol of France, stands at the heart of this idealized painting of the troops who defended Paris during the great siege (above). The artist is Ernest Meissonier.

The Commune falls and Paris burns (below). Edwin Child, a young apprentice, wrote in his diary for 24 May 'it seemed literally as if the whole town was on fire'.

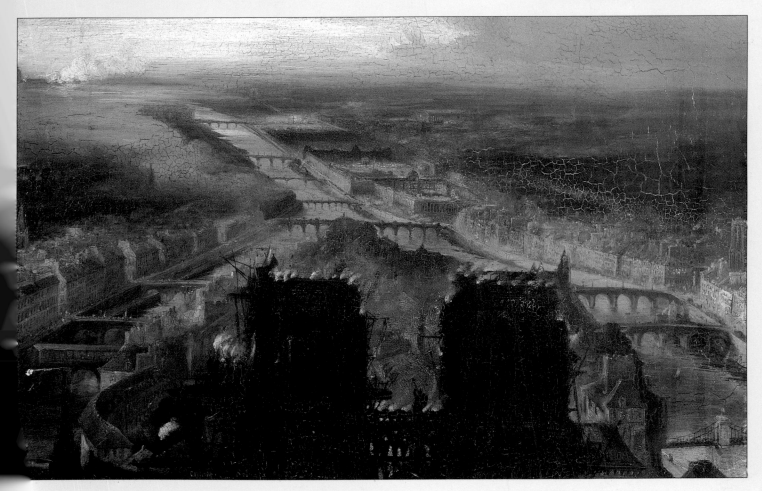

*The Road to Louveciennes was
painted by Pissarro in the winter of 1872
after his return to France in July of the
same year. Pissarro had suffered greatly as
a result of the Prussian occupation of his
home, many of the canvases he had created
up to that time being destroyed or lost.*

During this, his first visit to London, Monet painted a modest number of pictures, including one of Hyde Park, one of Green Park, two of the Pool of London, and one of the Thames and the Houses of Parliament. Pissarro made about a dozen paintings, mostly of the area around Norwood, of which he wrote later to the English art critic, Wynford Dewhurst:

> …Monet and I were very enthusiastic over the London landscapes. Monet
> worked in the parks whilst I, living at Lower Norwood, at that time a charming
> suburb, studied the effects of fog, snow and springtime. We worked from
> nature and later on Monet painted in London some superb studies of mist.

The Avenue, Sydenham, painted in the spring of 1871, retains much of the structural intensity of Pissarro's earlier paintings. The colours are often bright, yet they are applied to the canvas in flat opaque patches giving the scene a sense of permanence. Cézanne, whose own paintings had changed under Pissarro's influence around the time of their respective exiles, was later to bemoan the passing of this structural intensity: 'If Pissarro had continued to paint as he did in 1870,' he said, 'he would have been the strongest of us all'.

Monet's paintings, in contrast, employ a technique in which strokes of paint are used to capture fugitive effects, a method to be increasingly used by both men and the Impressionist circle in general. It was a technique that Monet and Renoir had already explored in their paintings of La Grenouillère in 1869. A similar method was used in the construction of parts of Monet's *Thames and Westminster*, painted in 1871. On the right of the picture the reflection of the jetty in the water is shown with a series of rapidly applied strokes of colour. The painting contains a variety of technical conventions. Some are traditional, such as the explanation of space partly through the use of aerial perspective and where the local colour of an object is modulated by the atmosphere in proportion to its distance from the viewer. Others are more daring. The angle between the two boats, for example, is marked only by the trace of the brush-mark on the surface of the paint. The recession of the water into the distance is shown in turn by the size of the brush-stroke, whereby large patches of paint look nearer than small ones, and a device reminiscent of the composition of some Japanese prints, where part of the picture recedes sharply into a vanishing point behind the silhouette of the jetty. Monet was to continue these formal experiments in a series of paintings executed in Holland shortly before his return to France.

DEFEAT AND THE PARIS COMMUNE

The country to which Monet returned, and Paris in particular, was demoralized, suffering from the humiliation not only of having lost the war, but by the final indignity of Wilhelm I being proclaimed Emperor of Germany in the Hall of Mirrors at Versailles on 18 January 1871 and the government's agreement to the enemy troops staging a victory parade through the heart of Paris. At the end of the siege, the Parisians were hungry, discontented, angry at the German presence and, as far as the members of the National Guard were concerned, still with cannon in their possession.

Thus armed, the radical faction in the city assumed power and declared a *Conseil communal* – the Commune. The government at Versailles, led by Adolphe Thiers, had to send in a French army to subdue the new insurgents, and a second siege began. Two months of bitter civil war ensued. The 'Bloody Week' *(semaine sanglante)* of 21-28 March 1871 saw massacres and reprisals of a horrifying scale, in which 20,000 Parisians perished.

Amongst the Communards who were to pay so dearly for their involvement was Courbet. In September 1870, he had been elected chairman of the Arts Commission formed to protect works of art in and around Paris, and had done so with assiduity. But during the Commune he became involved with the destruction of the column in the place Vendôme and for this he was tried and imprisoned after the collapse of the revolt. Shortly after his release, in July 1873, he fled to Switzerland.

Most of the Guerbois group were by now re-established in Paris. Cézanne returned from Aix-en-Provence in the autumn, while Monet was back by November 1871 and soon settled at Argenteuil, a small resort on the Seine a few miles north of the capital. Pissarro went back to his home at Louveciennes, which had been occupied by Prussian soldiers who had destroyed much of his work. He later settled at Pontoise, where he worked alongside Cézanne, Guillaumin, Gustave Achille Guillaumet (1840-87) and Edouard Béliard. However, it was not until 1873 that all the original members were reunited, when Degas, who had been to New Orleans to visit some relatives, returned to Paris.

Landscape at Louveciennes *(right) was painted by Camille Pissarro in 1870. This was one of many broadly painted landscapes showing views of the countryside around Louveciennes that Pissarro painted; they show the influence of Corot and Daubigny.* The Crystal Palace, London, *was painted by Pissarro in 1872 during his self-imposed exile in London. At the time, he was living in a nearby suburb.*

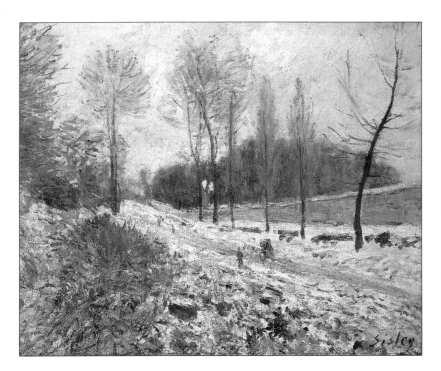

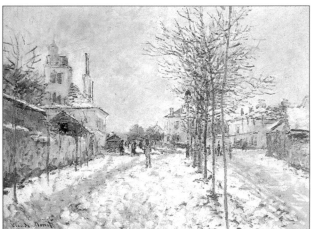

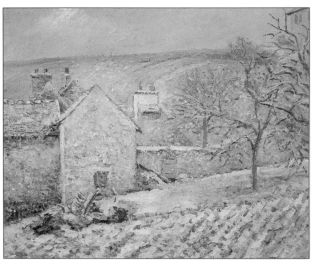

The Road to Louveciennes under Snow *(above) was painted by Alfred Sisley in 1885.* Snow Effect *by Claude Monet was painted in 1875. The painting shows the old boulevard de Pontoise.* Snow Effect at l'Hermitage *by Camille Pissarro was painted in 1874. Snow was one of the subjects that fascinated the Impressionists, and Sisley, Monet, Pissarro and Renoir each painted studies showing its effects. The paintings demonstrate their increasing interest in the interaction of colour – in particular the way in which colours are influenced by their surroundings.*

THE RELATIONSHIP WITH DURAND-RUEL

The period immediately after the war saw a momentary upturn in the fortunes of some of these painters. Durand-Ruel, on his return from London, bought works from Sisley, Degas and Renoir, and 24 paintings from Manet, for which he paid 35,000 francs. The dealer also bought 30 of Monet's paintings in 1872 and 34 in 1873, when Monet's income for the year was recorded as 25,000 francs. Pissarro's works, too, were selling well; he received 700 and 950 francs for two paintings in January 1873 at the auction of Hoschedé's collection. While it is always difficult to give exact comparisons, the most expensive seat at the Opéra cost 15 francs and the cheapest two francs 50 from the time the new building opened until 1914. A meal at the Restaurant Barratte, in the rue Berger in Les Halles, cost seven francs and this, according to Gérard de Nerval, is what you could get for this sum:

> The customary thing is to ask for Ostend oysters with chopped shallots
> peppered and soaked in vinegar, the mixture being sprinkled over the oysters.
> This is followed by onion soup, made to perfection, with Parmesan cheese. To
> this add a partridge or some fish fresh from the nearby market, claret, a dessert
> of choice fresh fruit, and you will agree you have supped well.

At the Restaurant Champeaux, on the corner of the rue Vivienne and the rue des Filles St-Thomas, a river trout cost one franc 75; a big partridge six francs 50; a fillet of beef for two people three francs 50; and a fruit salad one franc.

At the cheaper end of the market, you would have *hors d'oeuvre* or soup, a plate of meat

and vegetables, cheese, dessert, half a bottle of wine and as much bread as you wanted for 23 sous at the Dix-Huit Marmites, while chicken terrine with truffles, sole, a half a roast fowl with mushrooms, tomatoes and aubergines and a pear cost ten francs at the Cabaret Lyonnais in the rue du Port-Mahon. Students in the Latin Quarter could get soup, an entrée, vegetables, a meat course, salad, dessert, again as much bread as they wanted, and half a bottle of wine for one franc 80. On the other hand, these figures can be put in perspective if we recall that a mason's daily wage, in the Paris region in the 1860s, was only five francs 25 – by the 1880s, this had risen to seven francs 50 – while that of a baker was four francs 55 and seven francs respectively. A teacher earned between 1,000 and 1,500 francs a year.

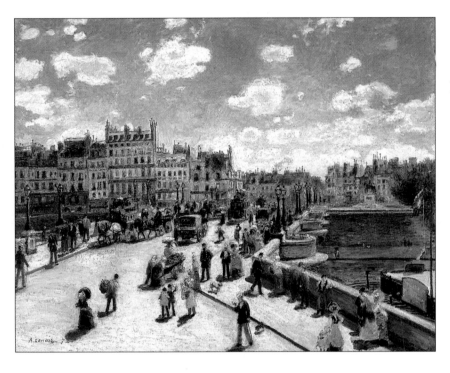

Le Pont Neuf by Pierre-Auguste Renoir was painted in 1872. Renoir worked from the terrace of a café on the corner of the quai du Louvre, looking across the western point of the Île de la Cité. Edmond, the artist's brother, recalled how he was 'employed to stop passers-by to ask the time in order that the artist would have a moment to paint the figures'. The speed at which the picture was created is evident in the rapid notation of paint on the figures in the foreground. The painting was bought at auction by Durand-Ruel in 1875 for 3,000 francs.

Although the future for the Impressionist painters looked secure, the recession that followed the financial crash of 1873 meant that the circle of the Café Guerbois, who had by now transferred their custom to the Café de la Nouvelle-Athènes in the place Pigalle, was forced to seek a new public outlet for their work.

Durand-Ruel was preparing a catalogue of paintings in his possession, and its introduction by Armand Sylvestre gives an insight into how a critic sympathetic to the Impressionist cause viewed the works of Monet, Sisley and Pissarro at the time. Sylvestre considered Monet to be the most skilful and daring of the circle:

> He loves to juxtapose on the lightly ruffled surface of water the multicoloured reflections of the setting sun, of brightly coloured boats, of changing clouds. Metallic tones, given off by the smoothness of the waves which splash over small, even surfaces, are recorded in his works, and the image of the shore is mutable – the houses are broken up as they are in a jigsaw puzzle. This effect, which is absolutely true to experience, and may have been borrowed from the Japanese school, strongly attracts young painters…

> …Their (Monet, Sisley and Pissarro) canvases, uncluttered, medium in size, are open in the surface they decorate, they are windows opening on to the joyous countryside, on rivers full of pleasure boats stretching into the distance, on a sky which shines with light mists, on the outdoor life panoramic and charming.

continued on page 72

JAPAN AND
THE IMPRESSIONISTS

One of the major topics to interest the artists who met regularly at the Café Guerbois was oriental art, which they had been able to study at the 1867 World's Fair and, in particular, Japanese prints and other Japanese artefacts. In this, they were reflecting what was to become a public trend; Japonaiserie became a major cultural craze.

In fact, the beginnings of this interest can be traced back a further decade. As early as 1856 Bracquemond had discovered a volume of Hokusai, which had been used for packing china, which he was quick to show to his fellow artists. Then, in 1862 came the opening of La Porte Chinoise, a shop in the rue de Rivoli. The shop's owners, M. and Mme. Desoye, had lived in Japan and it soon attracted a great number of artists. Whistler, for instance, bought blue and white china and Japanese costumes there (he was to pose in a kimono for Fantin-Latour's *Toast* in 1865), while Rossetti and Tissot, a friend of Degas, were also purchasers of Japanese costumes. Soon, Japanese objects, fans and prints were finding their way into almost every studio; Monet and Renoir both owned some, while Manet was among the most frequent visitors to La Porte Chinoise, together with Fantin-Latour, Baudelaire and the Goncourt brothers. Castagnary even claimed that, at this time, the members of the Batignolles group were referred to as 'the Japanese of painting'.

Nearly all the members of the emergent Impressionist group were enthusiastic about Japanese art, Cézanne and Renoir being the exceptions. Manet saw that the Japanese had anticipated him in the free use of patches of colour, while Monet was to follow the precedent the Japanese had set in eliminating unnecessary detail. He commented: 'Their refinement of taste has always pleased me and I approve of the suggestions of their aesthetic code, which evokes presence by means of a shadow, the whole by means of a fragment'. Pissarro admired the technical accomplishments of the printmakers, as much as the prints themselves. Of all the Impressionists, however, it was Degas who apparently showed the greatest interest in Japanese prints, particularly the unconventional viewpoints the Japanese artists exploited and their practice of allowing figures to be cut by the picture frame – a device he had already anticipated.

Monet, photographed in old age, is pictured standing on the bridge he built to span his waterlily pond at Giverny (left). The Japanese influence is clear; contrast the bridge in the photograph with the one in the Edo print (right). Monet's stepson Jean-Pierre Hoschedé described the effect Monet achieved as follows: '...beside this bridge there is a semicircular stone seat and planted around it, to protect it from the wind, a veritable forest of bamboo. The whole area...creates the feeling that one is not in Normandy, but has been transported to some Oriental country'.

This woodblock print of a **Courtesan Applying Lip-rouge,** *(right) is by Kitagawa Utamaro. The fan print (left) is by Kuniyoshi and dates from 1848; it is taken from the artist's* Seven Kokachi. *This style of print clearly influenced Monet when he came to paint his wife in Japanese costume in 1875-76 (below); he showed the painting at the second Impressionist exhibition, when* La Presse *commented, 'M. Monet…has produced a life-size portrait of the most startling kind…art lovers who are on the lookout for solid colouring and emphatic impasto will find this rather strange figure a real feast,'*

71

Monet painted The Basin at Argenteuil *in 1872. The picture shows the promenade at Argenteuil on the west bank of the Seine looking towards the Ile Marante in the background. The promenade was the main vantage point for watching the regattas that were held each summer on this especially wide section of the river north of the capital. Monet painted* Regatta at Argenteuil *the same year. Impressionist painting techniques were especially well suited to capturing the transitory effects of a subject such as this. In this instance, each ripple on the water's surface is translated into a gesture of paint.*

It is possible, therefore, that the members of the group may all have thought that their work was becoming acceptable and that they would see a change, in terms of public acceptance, in their fortunes. This, however, was not to be. The post-war government had become even more conservative in its taste in the fine arts than its predecessor. Anxious to restore a sense of national pride battered not only by defeat and civil war, but also by the Prussian demand for punitive reparations, the French state supported a style of painting which reflected the glories of a past more distant than that of the Second Empire.

IN SEARCH OF PAST GLORY

One manifestation of this was the large number of public statues and monuments that were erected in Paris during the period of rebuilding made necessary by the ravages of the war and the destruction inflicted during the Commune. One of the most typical, in the centre of the city, was the erection of an equestrian statue of Joan of Arc in the place des Pyramides, by Emmanuel Frémiet (erected 19 February 1874). It exemplified what A. Delzant had written in the *Courrier de France* at the time of the Salon of 1872:

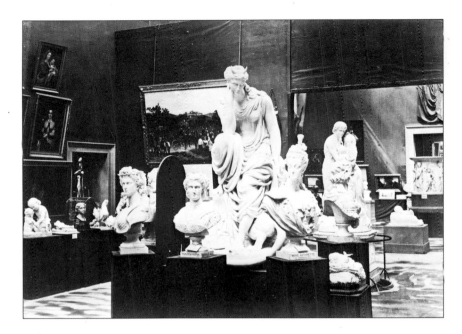

Heroic sculpture, inspired by the classical past, was a major feature of the post-war Salons, as the photograph here demonstrates.

Art is a soldier. It too has battles to wage like the army. It should vie to
regenerate its spirits and to make France vigorous and strong once more.

The Maid of Orleans, who had routed the English invaders some 450 years earlier, was seen as having immediate contemporary relevance. So, too, was Sainte Geneviève, the patron saint of Paris, who had protected the city against Hunnish invaders in the 5th century. The Pantheon, a church founded by Louis XV and to be dedicated to her, had been deconsecrated during the Revolution, when it served as a Temple of Fame, a necropolis for famous men. Now, the new Director of the Beaux-Arts, Philippe de Chennevières, sponsored a project to decorate its interior and in 1874 Pierre Puvis de Chavannes (1824-98) was contracted to paint a cycle of decorations recording her life and miracles.

In the belief that the paintings in the first post-war Salon should also provide a measure of pride and confidence in the future, great care was to be taken in their selection. The jury was no longer to be elected by painters who had exhibited previously, but was to be composed of those who had won some honour in previous years. Such, indeed, was the political sensitivity that prevailed that several works which it was thought might endanger negotiations with the Prussians were withdrawn. Not surprisingly, therefore, the Salon of 1872 contained an insipid collection of work. The paintings, unlike the sculptures, were thought to be so poor, that one critic, Paul Alexis, looked wistfully back to the comparatively liberal period of the Nieuwerkerke administration before the war.

Since the works, though reflecting the taste of the patrons of the Salon, failed to display an idealized vision of nationhood that might help to restore French pride, the government felt something further had to be done. The remedy it proposed was indicative of both its lack of confidence and its innate conservatism. In the belief that standards in painting could thereby be restored, the number of scholarships to study in Rome was increased and young artists were required to send copies of Old Masters home to France for other painters to study. To this end a new gallery, the Musée des Copies, showing 121 works, was opened in the Palais de l'Industrie in April 1873.

Despite its rampant conservatism, the Salon of that year saw an unprecedented number of submissions and, by extension, rejections. In fact 2,142 paintings were exhibited. Monet, Pissarro and Sisley did not send in works, probably because they were better served by Durand-Ruel's patronage, but amongst those rejected were Renoir, Eva Gonzalès (1849-83), Fantin-Latour, Cézanne and Jongkind. They, together with Manet and Pissarro, were among the 26 artists who petitioned for another Salon des Refusés. The government at first declined,

continued on page 76

PHOTOGRAPHY AND THE IMPRESSIONISTS

The mid-19th century saw photography come of age. As far as the painters of the time were concerned, the influence of the camera dates back to the 1840s, when a number of photographers working in the forests of Fontainebleau became known to Corot and other members of the Barbizon school; indeed, it has been suggested that the sudden, quite radical change in Corot's painting style in the late 1840s was due in part to the influence of landscape photography.

For the Impressionists, the camera was an invaluable tool, particularly when it came to recording instant impressions and analyzing movement. In particular, it influenced their vision of the new townscapes of Paris, in which the viewpoints they chose were suggested by photographic treatments of their chosen subjects. In Monet's *Boulevard des Capucines*, for instance, the way in which he depicted the pedestrians in the street below his viewpoint exactly parallels the effects found in contemporary photography. Cézanne, too, based his self-portrait of 1861 and his *Melting Snow in Fontainebleau* of around 1880 on photographs.

Of all the members of the Impressionist movement, however, it was Degas who used the camera most. Paul Valéry later recorded: 'He was among the first to study the real positions of the horse movement in the "instantaneous" photographs taken by Major Muybridge. For he had a liking and appreciation for photography at a time when artists despised it, or dared not admit that they made use of it. He took some very fine photographs himself and I still treasure one particular enlargement that he gave me…This masterpiece of its kind (a portrait of Renoir and Mallarmé, taken around 1880) involved the use of nine oil lamps and a fearful quarter of an hour of immobility for the subjects'.

The photographer best known to the Impressionists was probably Nadar, who met Bazille and Monet in the winter of 1865 and was a friend of Manet's. Renoir held one of his first exhibitions in Nadar's home, while his studio on the boulevard des Capucines was the scene of the first Impressionist exhibition. According to Monet, Nadar, who had just vacated the premises, lent them to the group rent-free.

The corpulent Nadar (right) was a man of many talents. He was the leading society photographer of the day (below, his portrait of the Comtesse de Ségur). However, he was also a member of the intellectual opposition to the Napoleonic regime, frequently to be found at the Café de la Nouvelle-Athènes, together with Courbet, Castagnary, Gambetta and Daudet. His popular reputation stemmed from his spectacular balloon ascents, staged in the heart of Paris.

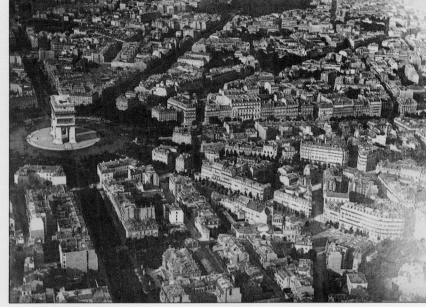

A cartoon of the period (above) is captioned 'Nadar raising photography to the height of art'. In fact, artists of the time were often loath to admit their debt to photography, which had been attacked by critics, notably Baudelaire, as nothing more than an imitation of true art.

This aerial view of the heart of Paris (above) was taken by Nadar from a captive balloon moored in the place de l'Etoile; the intrepid balloonist and his wife (left) pose before making an ascent. Nadar appears in Jules Verne's De La Terre à la Lune as 'Ardan'. A successful businessman, he was accused by his enemies of dropping advertisements for his own company over the Prussian lines instead of propaganda leaflets during an aerial reconnaissance.

Balzac (left) was captured in glowing hand-tinted colour by Nadar in a characteristically romantic pose. His novels and short stories – particularly the epic sequence produced over 20 years and entitled La Comédie Humaine, – had a great influence on French literature; they were a precise reproduction of French society of the time, picturing in full detail members of every class and profession. Daguerre (right) was a pioneer photographer, who invented the daguerreotype.

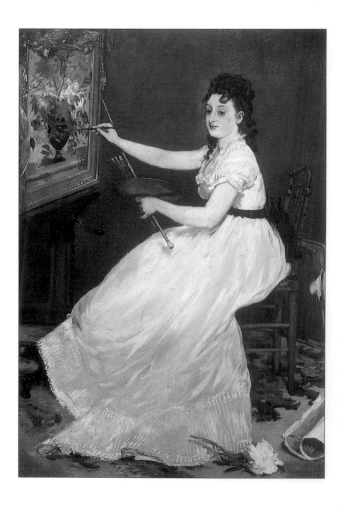

Eva Gonzales *by Edouard Manet, painted in 1870. The painting is of Manet's only pupil and was exhibited at the Salon of 1870 together with works by Gonzales herself. The painting was savagely attacked by the press; critics took exception to the rapid handling of the paint. Albert Wolff, writing in* Le Figaro, *condemned the portrait as 'coarse' and accused the artist of making the picture 'for the sole purpose of attracting attention'.*

but under pressure relented and a show of 477 paintings was mounted. Many of the works shown met with critical acclaim, in particular Renoir's monumental double equestrian portrait *A Morning Ride in the Bois de Boulogne*. Ironically, the Salon proper of 1873 also saw Manet's first public success. He showed two paintings – *Repose*, a full-length portrait of Berthe Morisot, and *Le Bon Bock*, a portrait of the engraver Bellot at the Café Guerbois. Both were at first attacked by the press, following the now established routine whereby Manet's work was pilloried, irrespective of its quality or content. On further reflection, however, both press and public changed their opinion and decided that they liked *Le Bon Bock*. One critic compared it favourably with the work of Cabanel, and saw its broad technique as appropriate to a working-class sitter in the same way that Cabanel's well finished style was appropriate to his more refined subjects. Manet's peers however looked upon this likable picture in the style of Hals as something of a concession on the part of its painter and intransigence on the part of the jury that it would only show work conforming to its own middlebrow standards.

TOWARDS THE FIRST EXHIBITION

It was in this context that some members of the Batignolles group, as it had by now become known, began to reconsider the prospects of an alternative exhibition that was not just another Salon des Refusés. Attempts to organize such an exhibition earlier had failed because of lack of funds and the intervention of war. Paul Alexis, in an article in *L'Avenir National* in May 1873, had suggested the formation of an artistic corporation, an idea culled no doubt from these discussions. Monet's enthusiastic reply was published in the same paper a week later, together with a note by Alexis naming a circle of naturalist painters whose aim was to paint 'nature and life in their larger realities'.

Some painters and critics who were otherwise well disposed to the aim of painting 'nature and life in their larger realities' argued against an independent exhibition, however.

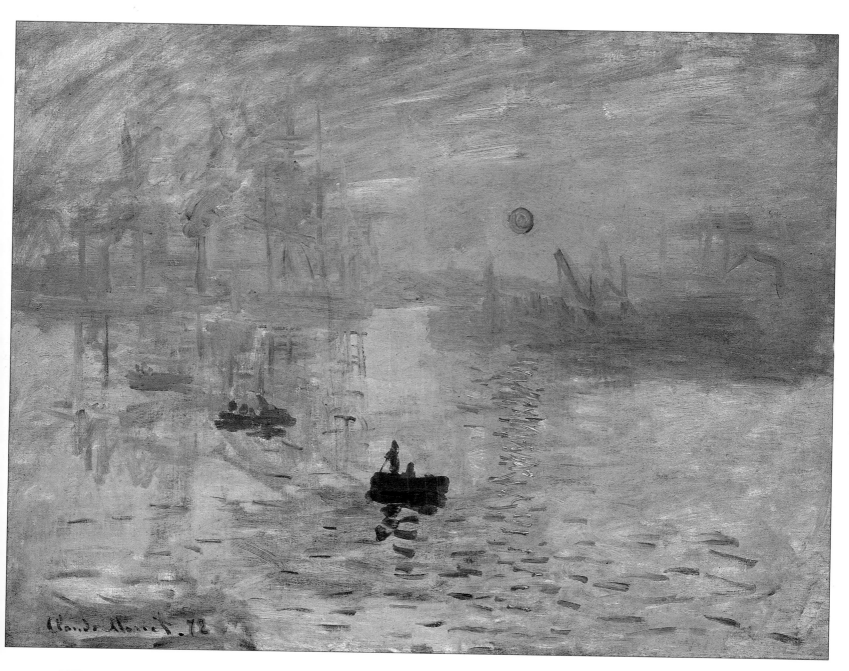

Impression: Sunrise *by Claude Monet, painted in 1872. The study of the port at Le Havre was condemned by critics and the public when it was shown at the first Impressionist exhibition two years later. 'Impressionism' took its name from the title of this very picture. Contemporary cartoonists were quick to take up the satirical theme. A cartoon by Honoré Daumier of 1873 (left) shows a visitor complaining about 'monstrous' realist paintings and the absence of 'la belle nature', while members of the Chamber of Deputies are terrified by paintings of the Impressionist school in a cartoon by Cham (right).*

MAISON DU PENDU, AUVERS
PAUL CEZANNE (1839-1906)

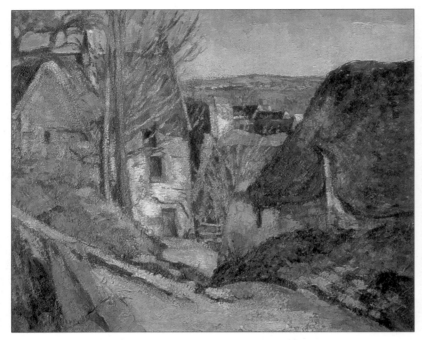

Cézanne painted his *Maison du pendu* (The House of the Hanged Man) in 1872-3. The painting, shown at the first Impressionist exhibition, stands in contrast to his version of Olympia. The choice of subject and its rendition show the extent to which the artist was moving away from the tortured and lurid imagery of his early pictures, the painting being more restrained both in technique and in colouring. Cézanne has established subtle harmonies of blue and brown, offset by small patches of bright red pigment in the background. Although Pissarro had a profound influence on Cézanne's work during this period, he never fully embraced an Impressionist technique. Patches of pigment are used not simply to record the subject, but to impose a structural order upon it. The detail (right) shows how Cézanne has charted the recession in the landscape from the trees in the foreground to the graded tones of the sky in the distance.

THE NATURE OF IMPRESSIONISM

Monet's use of the term 'Impression' gives some indication of the manner in which the painting was conceived. As an expression, 'Impression' was already current in discussions on mid-19th century French painting; it denoted the initial effect imposed on an artist's mind by a given subject. John House, however, has observed that Monet meant it to signify not the initial idea set off by a painter's reaction to a scene, but rather that idea in physical form made in paint on canvas.

Leroy, though, uses it as a term of derision, and as an analogue for the incomprehensible. Monsieur Vincent, in the meantime, has undergone a mystic conversion to Impressionism, which is the cue for his final onset of madness. Faced with Monet's *Le Déjeuner*, a large panel painted in a comparatively well finished manner, Vincent accuses the artist of sacrificing 'to the false gods of Meissonier!' Cézanne's *A Modern Olympia* drives Vincent to the final point of distraction, whereby he mistakes a guard for a talking exhibit. Leroy continues:

> ...And in order to give the appropriate seriousness to his theory of aesthetics old Vincent began to dance the scalp dance in front of the bewildered guard crying in a strangled voice:

> Hi-ho! I am an Impressionist on the march, the avenging palette knife, the *Boulevard des Capucines* of Monet, the *Maison du pendu* and the *Modern Olympia* of Cézanne...

Ian Dunlop has observed that many Parisians believed that artists were affected by insanity as a result of the tertiary stages of syphilis, brought about by the licentiousness they associated with a bohemian lifestyle. The theme of madness recurs again in a letter sent to Madame Morisot by her daughter's former teacher, Joseph Guichard after he had seen the first Impressionist exhibition. He refers to *Le Berceau* by 'Mlle Berthe' actually touching Cézanne's *A Modern Olympia* and concluded that the exhibition could only be the result of some madness. Marc de Montifaud (Marie Amélie Chartroule de Montifaud) thought *A Modern Olympia* to have been induced perhaps by oriental vapours or by hashish.

More seriously, some argued that, by putting on an independent exhibition, the Société Anonyme had challenged not only the authority of the state-sponsored Salon, but also that of the state itself. In flouting the artistic conventions, whereby history painting, portraits, landscape and still life each had their respective positions in a traditional hierarchy of subject matter, the exhibitors were seen to be expressing politically radical sympathies, whereas, in fact, they were doing no such thing, being mostly a-political. Predictably, such charges were largely brought by the right-wing press. Between 1874 and 1877, when the label 'Impressionist' became commonplace, many critics preferred to use the stronger term 'Intransigent', taking the name from the radical political party that had recently attempted to overthrow the constitutional monarchy in Spain. The word entered the vocabulary of the Third Republic and was used to denote anything or any movement that appeared to question the established order.

It has become part of the litany surrounding Impressionism to stress the derogatory reviews the first exhibition received, but, in fact, they were outnumbered by those in favour of the new painting. Many of the reviews saw quite clearly that the artists were not affiliated to the political left and took pains to make this clear. Castagnary, a supporter of the Third Republic, saw it not as challenge to the established order, but as evidence of innovation, which he thought essential to the restoration of French pride. Others congratulated the Société for its initiative in breaking the stranglehold of the Salon and the Académie. Armand Sylvestre thought that the new style would set a standard for future generations and Ernest Chesneau, writing in *Le Soir*, opined that it would soon become commonplace in the Salon itself. However, the critics, whether hostile or friendly, were at best over-sensitive and at worst

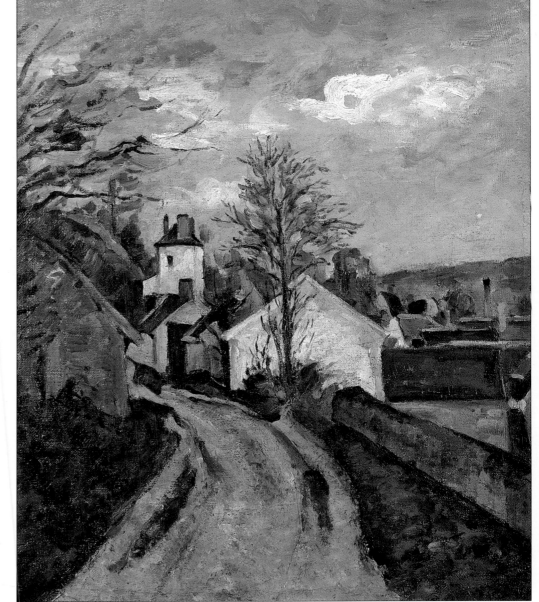

Farmyard at Auvers *by Paul Cézanne, painted in 1879-82.*
The painting (above left) was part of the collection of Gustave
Caillebotte and was bequeathed to the Musée du Luxembourg.
Cézanne painted Doctor Gachet's House at Auvers *(above*

right) in 1873. The painting belonged to Paul Gachet, a doctor of
medicine, a collector of Impressionist pictures and amateur
painter. Among the paintings he owned was A Modern
Olympia, *which he lent to the first Impressionist show.*

confused about the intentions of the movement; it would have been impossible, in the
aftermath of national defeat, to paint anything other than the most innocent and anodyne of
Salon paintings and not elicit some political response.

What is clear is that the first Impressionist exhibition failed to win general support. It had
sought to bypass the Salon and to appeal to the public at large, but the public, of whom some
3,500 had visited it, had responded with laughter and contempt. Few of the paintings that
were sold fetched high prices, and some artists, Degas and Morisot among them, failed to sell
any at all. Many of the unsold paintings were dispersed at auction at the Hôtel Drouot in
March 1875, when Monet's went for between 150 and 300 francs, while some of Renoir's did
not even reach 100 francs. The net loss at the exhibition and the poor results of the sale forced
the Société to abandon plans for a second exhibition until 1876.

'LA NOUVELLE PEINTURE'

The second Impressionist exhibition opened in April 1876 at Durand-Ruel's gallery at 11 rue Le Peletier. On the eve of the first exhibition two years earlier, members of the Société Anonyme had been optimistic about the chances of success and had hoped that the first exhibition would be a stepping stone to financial security and critical acclaim. The mood now, however, was quite different; the pictures had sold for derisory prices, partly because of the economic recession and partly because of the mixed press the exhibition had received. The Société Anonyme had been disbanded and its former members were apprehensive about holding a further show.

Some artists, notably Astrue, de Nittis, Boudin and Cézanne, declined to participate. The reason for Cézanne's refusal was perhaps because he had had to ask his father to pay off his share of the losses incurred in the first show and could not risk it happening again. However, Monet, Renoir, Pissarro, Degas, Sisley and Morisot took part. The conventional oil paintings, watercolours and prints by artists such as Lepic, Levert, Léon-Auguste Ottin *(fils)* and Béliard, whose style was on the whole unrelated to Impressionism, may actually have been hung at the beginning of the show in order to lessen the impact of the more contentious works, which were hung in the second and third galleries. Pissarro and Degas, whose paintings appear to have severely tested the patience of the press, were confined to the last room. Many of the right-wing reviews repeated their previous charges of political radicalism, madness and incompetence. Albert Wolff, writing for *Le Figaro*, a newspaper with one of the widest circulations in the capital, said:

> These self-styled artists who call themselves 'The Intransigents' or 'The Impressionists' take a canvas, some paint and brushes, throw some tones haphazardly on the canvas, and then sign it. This is the way in which the lost souls of the Ville-Evrard [a psychiatric hospital] pick up pebbles from the roadway, and believe that they have found diamonds.

Pissarro, who exhibited 12 landscapes, was criticized for his poor grasp of colour; Degas, who showed 24 works, including *The Cotton Exchange at New Orleans*, was censured not only for his use of colour, but also for his inability to draw. Renoir's *Torso of a Woman in Sunlight*, in which a three-quarter length nude is shown in the dappled shade of a tree, was said to be in a state 'of complete putrefaction'.

The spectacle the exhibition presented as a whole was a sad one, Wolff argued. It was:

> as afflicting as the sight of that poor lunatic whom I saw at Bicestre; he held in his left hand a coal shovel tucked under his chin like a violin, and with a stick, which he took for a bow, he kept playing … The Carnival of Venice, which he claimed to have played before all the crowned heads of Europe. If you placed this virtuoso at the entrance to the charade in the rue Le Peletier, the scenario would be complete…

He continued:

> …There is a woman in this group, as there nearly always is in any gang; she is

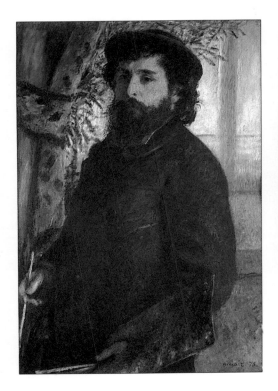

The Portrait of Claude Monet *by Pierre-Auguste Renoir was painted in 1875. The painting (above left) was shown at the second Impressionist exhibition, where it was well received by the* critics. Floor Scrapers *by Gustave Caillebotte (above right) was painted in 1876. The steep perspective and choice of a specifically urban subject is attributable to Degas' influence.*

called Berthe Morizot [sic], and she makes an interesting spectacle. With
her, feminine grace is retained amidst the outpourings of a mind in delirium.

Wolff's comments so angered Eugène Manet, the painter's brother, who had married Berthe Morisot, that he had to be restrained from challenging the critic to a duel.

Nevertheless the second Impressionist show was conspicuous for the number of informed and thoughtful reviews it generated. Henry James, writing for the *New York Tribune* in an article entitled 'Parisian Festivity', thought that the exhibition was: continued on page 90

BALL AT THE MOULIN DE LA GALLETTE
PIERRE-AUGUSTE RENOIR (1841-1919)

Renoir painted his *Ball at the Moulin de la Gallette* in 1876. The painting shows an open-air dance hall, one of the most prominent of its type in Paris, beside the Butte Montmartre. Renoir took a studio nearby and, according to George Rivière, made the picture on location, transporting the canvas to the dance hall each morning. Rivière identified many of the figures in the painting, most of whom were painters and associates of Renoir. The picture must, therefore, have been completed in the studio. The artist has retained an air of transience common in *plein-air* painting, both by the rapid application of paint and the cropping of the composition. The painting was the first by Renoir to contain a large number of figures; the artist has employed the effect of dappled sunlight used in earlier single figure studies and has applied it to the entire composition. The picture was included in the third Impressionist exhibition (a detail is shown overleaf).

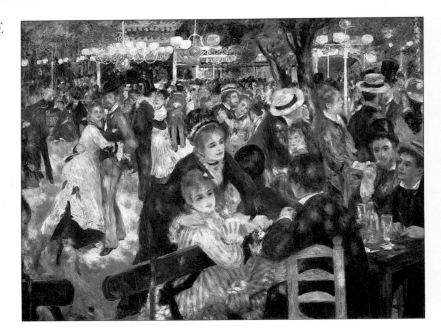

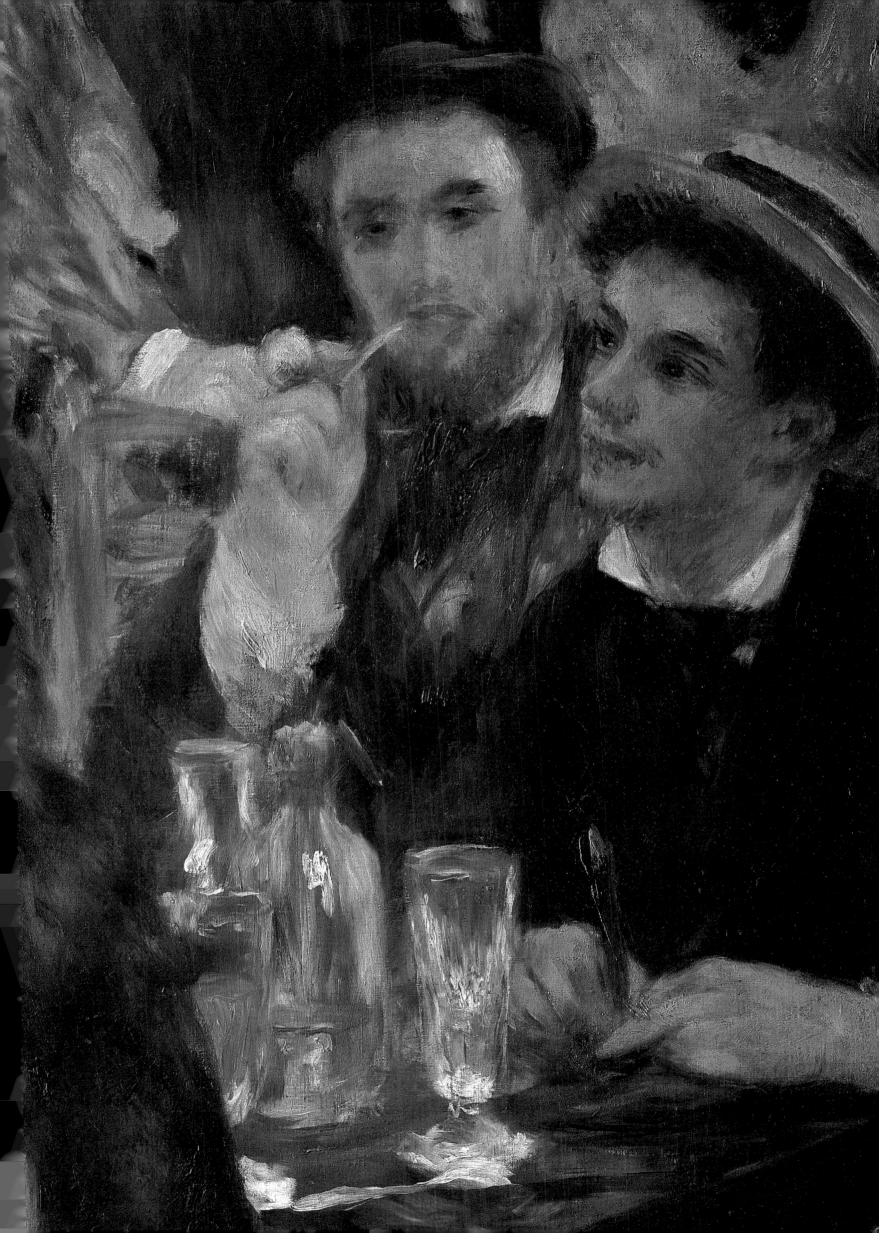

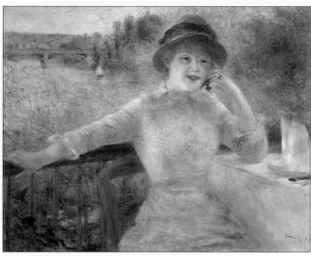

Eugène Manet and his Daughter *painted at Bougival by Berthe Morisot in 1881 (above left). Morisot specialized in domestic scenes. The sharp recession of space in the picture is influenced by Degas, with whom she was closely connected in the*

Impressionist circle. La Grenouillère *by Pierre-Auguste Renoir, painted in 1878 (above right). Renoir had first painted there in 1869, in company with Monet; the riverside scene was to inspire some of his most memorable canvases.*

decidedly interesting. But the effect of it was to make me think better than ever of all the good old rules which decree that beauty is beauty and ugliness is ugliness, and warn us off from the sophistications of satiety. The young contributors…are partisans of unadorned reality and absolute foes to arrangement, embellishment, selection, to the artist's allowing himself, as he has hitherto, since art began, found his best account in doing, to be preoccupied with the idea of the beautiful. The beautiful to them, is what the supernatural is to the Positivists – a metaphysical notion, which can only get one into a muddle and is to be severely let alone. Let it alone, they say, and it will come at its own pleasure; the painter's proper field is simply the actual, and to give a vivid impression of how a thing happens to look, at a particular moment, is the essence of his mission. This attitude has something in common with that of the English Pre-Raphaelites.

None of its members show signs of possessing first-rate talent, and indeed the 'Impressionist' doctrines strike me as incompatible, in an artist's mind, with the existence of first-rate talent. To embrace them you must be provided with a plentiful absence of imagination.

When the English realists 'went in', as the phrase is, for hard truth and stern fact, an irresistible instinct of righteousness caused them to try and purchase forgiveness for their infidelity to the old more or less moral proprieties and conventionalities, by an exquisite, patient, virtuous manipulation – by being above all things laborious. But the Impressionists, who, I think, are more consistent, abjure virtue altogether, and declare that a subject which has been crudely chosen shall be loosely treated.

Wynford Dewhurst, whose collected writings appeared in 1904, also thought that the Impressionists had things in common with the English painters, but made a point about their use of colour:

In colour they ultimately departed from the practice of the English, and Barbizon Schools. The Impressionists purified the palette, discarding blacks, browns, orchres, and muddy colours generally, together with all bitumens and

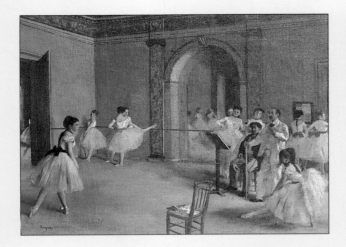

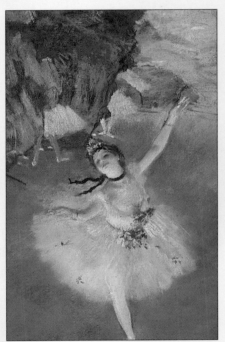

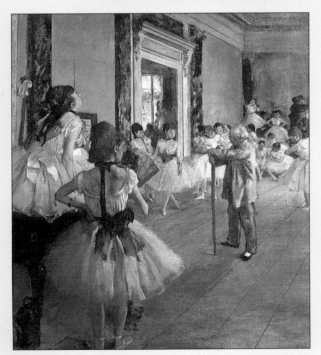

DEGAS AND THE DANCE

The Dance Studio in the rue Le Peletier by Edgar Degas, painted in 1872 (top left). *Miss La La at the Cirque Fernando* by Degas, 1879 (top right). Degas shows La La, a black acrobat noted for her feats of strength, spinning from a rope held in her mouth at the circus on the boulevard Rochechouart. The picture is painted from the point of view of the audience looking upwards from the auditorium. A detail from *A Dancer Curtseying* by Degas, 1878 (left). In this instance the audience looks down at the action on stage, the viewpoint being taken from that of a box at the theatre. *The Dance Class in the rue Le Peletier* by Degas, 1874 (bottom left). Degas made numerous studies of ballet dancers at the Opéra in both formal on-stage poses and informal backstage moments. Sketches, often in pastel, were made from life; paintings, despite their veracity, were the subject of sustained and concentrated effort in the studio. Paul Valéry observed that Degas combined 'instantaneous impressions with endless toil in the studio, capturing the fleeting moment by studying it in depth', while Edmond de Goncourt observed, after a visit to Degas' studio in 1874: 'The painter shows you his canvases, from time to time adding to his explanations by mimicking a choreographic development, by imitating, in the language of dancers, one of their arabesques…his arms curved, mixing with the dancing master's aesthetics, the aesthetics of the artist'.

siccatives. These they replaced by new and brilliant combinations, the result of modern chemical research. Cadmium Pales, Violet de Cobalt, Garance rose doré, enabled them to attain a higher degree of luminosity than was before possible. Special care was given to the study and rendering of colour, and also to the reflections to be found in shadows.

Like James, Charles Bigot, writing for *La Revue Politique et Litteraire*, grasped the fundamental characteristics of Impressionism. He saw that the style was founded on a rejection of academic traditions, but perceptively observed that Impressionism had actually emerged from the very principles of academic teaching itself. Bigot referred to the works in the second exhibition as *ébauches* – that is, paintings at a preliminary stage in their development where only the basic components of tone and colour are sketched in. Painting, he argued, is essentially a contemplative medium and summary notes of mere perceptions are inadequate as pictures worthy of sustained contemplation.

DISSENT AMONG THE IMPRESSIONISTS

The fact that there was a considerable body of favourable press opinion at this stage is an important point to bear in mind. This is because it helps to give an historical identity to what was on the whole an ill-defined movement riddled with contradictions and, increasingly, dissent among its members themselves. The dissent to some extent reflected the political situation in Paris at the time. By 1873 the main work of reconstruction after the war and the ravages of the Commune was complete. Marshal MacMahon had replaced Thiers, and in 1875 a tacit coalition of disillusioned royalists and practically minded republicans had finally managed to promulgate a constitution. The political ruling classes, almost without exception agnostic, Protestant or Jewish, represented the new plutocracy, and the next years were see an increasing splintering of the parties of the left. The burning issue of the day was a fierce antagonism between church and state, centring mainly on the question as to who should be responsible for education. In this field, as in others, the state's monopoly was challenged. The arts were no exception, as subsequent events were to show. Many of the writers who had

At the Stock Exchange *by Edgar Degas, painted in 1878-79. The figure on the far right of the picture is Ernst May, a collector of Impressionist paintings. The Stock Exchange, the Opéra and fashionable cafés, restaurants, galleries and art dealers each formed different facets of the affluent milieu of the northwest quarter of the capital. Guides of the period record how business began at the Stock Exchange shortly after midday after which 'the money-seeking throng hurries into the building'. Transactions continued until three in the afternoon and, though the bourse remained open until five, local cafés quickly began to fill with businessmen well before then. The painting was among 24 other works by the artist included in the fourth Impressionist exhibition.*

supported the Impressionists, such as Emile Zola, who had interceded on behalf of radical causes in the fine arts on several occasions in the recent past, felt the tide was on the turn. In 1876 he told the readers of *Le Messenger de l'Europe*, a French journal distributed in St Petersburg, that French art was in a state of turmoil:

> One cannot doubt that we are witnessing the birth of a new school. In this group a revolutionary ferment is revealed which will little by little win over the Academy of Beaux-Arts itself, and in twenty years will transform the Salon from which today the innovators are excluded. We can say that Manet, the first, set the example.

Edmond Duranty, another longstanding apologist for realist art, made a similar claim in a 38-page pamphlet written immediately after the second exhibition entitled *La nouvelle peinture*. Unlike other commentators, he devoted his attention not to the exhibition as such, but rather to the history and ideas that underpinned the new style of painting. He argued that the new naturalism could trace its origin back through the works of Courbet, Corot and Manet to the writings of the eighteenth-century *philosophe*, Diderot. In his 'Essay on Painting', written on the Salon of 1765, Diderot had dispensed with the same set of artistic rules that still held sway in French art schools 100 years later and advocated that artists should record nature not as a refined ideal but rather as it appears. Duranty goes on to quote Diderot at some length:

> But what I do know is that rules cannot compete against the omnipotence of nature, and that the age and condition of the subjects predicate compromise in a hundred different ways.

Diderot contended that age and 'condition' – that is, the social status – of a subject determine its appearance and will afford it its particular characteristics. A labourer, for example, will appear different from a banker because of the nature of the work each undertakes. Duranty immediately finds common cause with Diderot's theories in his own understanding of radical new trends in 19th-century painting. The various characteristics of modern life are, Duranty insisted, the very stuff of the new painting:

> Farewell to the human body treated like a vase, with an eye for the decorative curve. Farewell to the uniform monotony of bone structure, to the anatomical model beneath the nude. What we need are the special characteristics of the modern individual – in his clothing, in social situations, at home, or on the street. The fundamental idea gains sharpness of focus. This is the joining of torch to pencil, the study of states of mind reflected by physiognomy and clothing. It is the study of the relationship of a man to his home, or the particular influence of his profession on him, as reflected in the gestures he makes: the observation of all aspects of the environment in which he evolves and develops.

Duranty even suggests some potential and familiar subjects for the new painters:

> The individual will be at a piano, examining a sample of cotton in an office, or waiting in the wings for the moment to go on stage, or ironing on a makeshift table. He will be having lunch with his family or sitting in his armchair near his worktable, absorbed in thought. He might be avoiding carriages as he crosses the street or glancing at his watch as he hurries across the square. When at rest, he will not be merely pausing or striking a meaningless pose before the photographer's lens. This moment will be a part of his life as are his actions.

THE IMPRESSIONISTS AT ARGENTEUIL

The Railway Bridge at Argenteuil (right) by Claude Monet, painted in 1874. *The Artist's House at Argenteuil* (below) by Monet, 1872-73. The picture shows the painter's home on the corner of the rue P-Guienne and the boulevard Saint Denis. It was among the canvases shown by Durand-Ruel in London in 1882. *The Bridge at Argenteuil* (below left) by Monet dates from 1874. The painting shows the road bridge downstream from the railway bridge in the picture above. *Claude Monet in his Studio* by Edouard Manet, painted in the summer of 1874. The painting shows Monet and his wife in the floating studio the artist constructed to enable him to paint on the Seine at Argenteuil, where he lived in the 1870s.

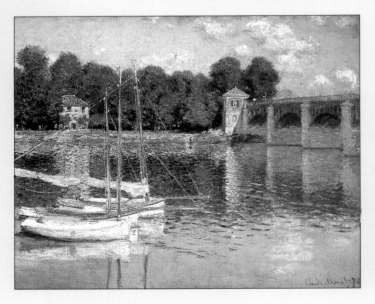

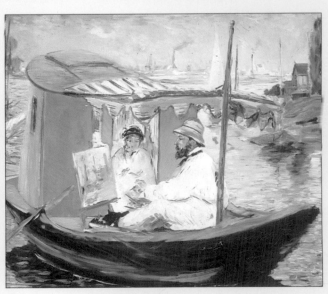

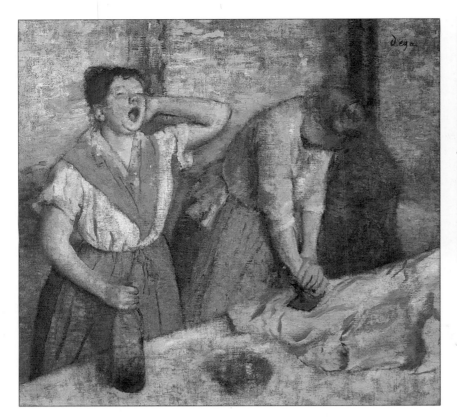

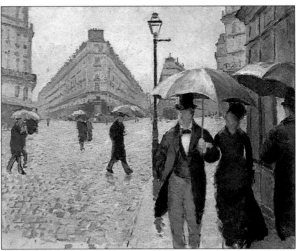

Sketch for The Place de l'Europe *by Gustave Caillebotte (above). The completed final study was one of six large paintings made by the artist for the third Impressionist exhibition. Degas painted* The Laundresses *(left) in 1884. Though the picture is an oil painting, Degas has religiously imitated the effect of pastels.*

> The language of an empty apartment must be clear enough to enable us to
> deduce the character and habits of its occupant. The passersby in a street
> should reveal the time of day and the moment of everyday life that is shown.

Throughout his essay, Duranty established links not only between Impressionism and the writings of the *philosophes*, but also with Veronese and the painters of the early Renaissance. Both Florentine and Venetian artists portrayed their subjects in contemporary settings and clothing; thus the Impressionists were in good company since they were carrying on a venerable artistic tradition. However, he is less happy about those of the Impressionist painters who produced exclusively *plein-air* landscapes, because he felt that they should concern themselves with men and women in their modern environment rather than concentrate on the relatively minor theme of inanimate nature. He also had doubts about their ability to see their intentions through to the end. He advised them

> to be careful, determined and patient. The voyage is dangerous, and they
> should have set out in bigger, more solid vessels. Some of their boats are quite
> small and narrow, only good for coastal painting. Let us hope, however, that
> this painting is fit for a long voyage.

Duranty did not refer directly to the work of individual members of the Impressionist group, although it is clear that the paintings of Gustave Caillebotte (1848-94) and Degas came closest to his ideal of realism. Indeed, his essay can be seen, in its respect for tradition, as a theoretical justification for the latter's work. However, Duranty's attempts to emphasize one aspect of Impressionism to the exclusion of others angered many of the Impressionists – in particular Monet and Renoir. In fact, the views of the members of the group were not as cohesive as labelling them all as Impressionists might indicate; indeed, Duranty's article had exacerbated the rifts that were developing between the original members into a strong factionalism that was to grow over the years until the movement, as a single cohesive force, fragmented.

continued on page 98

THE IMPRESSIONISTS AND THE REPUBLIC

By the 1880s, despite the traditional associations between the 'new' art and the Left, many of the Impressionists were becoming more conservative in their political opinions; in this, they reflected the innate conservatism of the Third Republic and their gradual progression towards acceptance by the establishment. The electoral system devised for the Third Republic was deliberately purpose-planned to strengthen the hand of the conservative provinces against the radicalism of the large cities, in particular Paris. Memories of the Commune and the bloodshed of civil war were slow to die.

For Manet, the process had started as early as 1868. After a two-day excursion to London, he wrote to Zola that the British artists he met 'don't have the kind of ridiculous jealousy that we have; they are almost all gentlemen', while, to Fantin-Latour he revealingly commented, 'What I want now is to earn money'. At the bottom of his heart, Manet was no longer the ardent republican of his youth; as the years passed by, what he really wanted was to achieve a social position as a painter, medals from the Salon jury and possibly the accolade of the Legion of Honour from the government. Renoir shared Man-

et's view. In 1882, he wrote to Durand-Ruel, refusing to join the group exhibition. His initial draft read: 'The public doesn't like anything smelling of politics and, at my age, I certainly don't want to become a revolutionary…Moreover, these characters know I took a great step forward by getting accepted by the Salon…It's not about politics any more; it's about pure art.'

Though Manet was a liberal and Monet sympathized with the socialist opposition, Degas had always been right-wing. The young William Rothenstein wrote of his 'temperamental respect for the aristocratic tradition…which included anti-Republican and anti-semitic tendencies, which later made him a strong partisan of the Militarists and anti-Dreyfusards.' Equally, Pissarro remained true to his socialist and anarchic roots; in 1885, he wrote of electoral politics: 'Universal suffrage, the instrument of domination of the capitalist bourgeoisie, let me tell you, has been condemned once and for all by the forces of progress. It is only the big shots it serves effectively…Universal suffrage has served as a weapon whereby the bourgeoisie controls the economic situation. Therefore it must disappear.'

The case of Alfred Dreyfus, a Jewish general staff officer accused of selling military secrets to the Germans, split the France of the 1890s into pro- and anti-Dreyfus camps. Dreyfus was tried in secret by a military court in 1894 and sentenced to life imprisonment on Devil's Island; two years later, however, Colonel Picquart, the head of the intelligence section, discovered new evidence indicating that another general staff officer, Major Esterhazy, was guilty of the crime. The army authorities rallied to the support of Esterhazy, suppressing the evidence that would have cleared Dreyfus' name; the case became a cause célèbre when Zola wrote an open letter to the French president, accusing the war ministry of complicity in the crime. Later, it was revealed that much of the evidence against Dreyfus had been forged, but the war ministry still refused to pardon him. Eventually, the French President was forced to intervene personally. Here (right), one of Dreyfus' trials is shown.

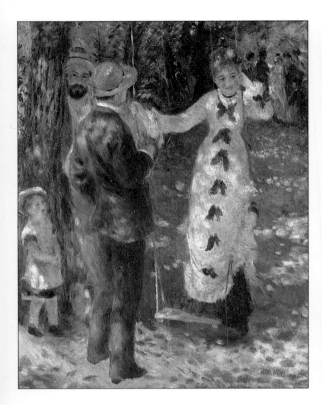

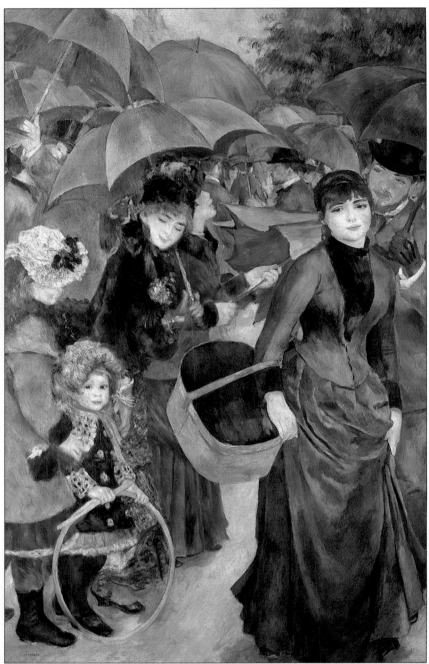

The Swing *(above) by Pierre-Auguste Renoir, painted in 1876. When the painting was shown at the third Impressionist exhibition, even some critics well disposed to Impressionism thought the dappled surface of the painting 'audacious'. Other critics disliked it; the reviewer for* L'Evénement, *thought the dress looked as if it was covered in grease stains. The* Umbrellas, *also by Renoir, was painted in 1881-82 and subsequently reworked three years later (right). Evidence of Renoir's changing technique can be seen by contrasting the face of the child on the right with the more finished appearance of the woman on the left of the painting.*

homes, while he himself stayed at his own house at Gennevilliers. Argenteuil, a popular leisure resort on the Seine, was, like Barbizon, easily accessible by train from Paris and attracted the Parisians, who had discovered the delights of boating and weekends in the country. The Goncourt brothers captured the atmosphere in *Manette Salomon*:

> One enjoyed the day, the fatigue, the speed, the free and vibrant out-of-doors,
> the glittering of the water, the sun flashing over the earth, the shimmering flame
> of all that dazes and dazzles in these sauntering outings, that almost animal
> intoxication with life conveyed by a great steaming river, blinded by light and
> fine weather.

Manet's painting of *Argenteuil*, accepted at the Salon of 1875, showed a change in the use of rapidly applied brush-strokes in place of his previously broad areas of flat painting and brighter colours, rather than his former abrupt transitions from light tones to dark ones.

continued on page 104

MUSIC AND
THE IMPRESSIONISTS

The enjoyment and love of music was a common bond between all the Impressionists, though their tastes were in advance of those of the Parisian public of the time. As early as 1865, discussions in the home of Bazille's relative, the Commandant Lejosne, often centred around musical topics – particularly around the controversial and much debated art of Richard Wagner, for whom Bazille had conceived a fanatical passion. This was shared by Renoir, Baudelaire and Fantin-Latour among others; the previous year Fantin-Latour had shown a painting entitled *Scène du Tannhäuser* at the Salon. Berlioz was another admired composer, though he won more recognition in Russia than from the majority of his countrymen, as in the case of his greatest work – his epic opera *Les Troyens*.

The reason for this obsession with Wagner was simple. His 'music of the future' was as deeply derided by the public at large as were the paintings produced by the Impressionists themselves. Though Napoleon III had commissioned the composer to produce a revised version of *Tannhäuser* for the Paris Opéra – the Paris version, as opposed to the original Dresden version – the première was a complete fiasco. The embittered composer put the opera's failure down to an intrigue by Meyerbeer, the most fashionable composer of the day, and his fellow Jews; in fact, the young bloods of the Jockey Club, who regarded the Opéra as an indispensable part of their social round, orchestrated the booing and whistling that broke out soon after the overture and continued throughout the performance. Feuillet's 'Monsieur de

Classical statues (left) decorate the exterior of Charles Garnier's opera house, which became the talk of Paris when it was finally completed in 1875. The building is a major example of Renaissance revival architecture; Garnier himself was an academician who had won the Prix de Rome.

Jacques Offenbach (left) was popularly nicknamed the 'Mozart of the Champs Elysées' and operas like Orphée aux Enfers, La Belle Hélène *and* La Vie Parisienne *were the smash hits of the day. Giuseppe Verdi (below) was the rising star of grand opera, though* Don Carlos, *which the Paris Opéra commissioned, had to be cut to reduce its length for the fashionable late-dining audience.*

A French caricature (right) sums up the popular view of Wagner's music – brassy, untuneful and full of German bombast. Wagner only gradually won acceptance; by the late 1880s, the young Shaw, on a flying visit to Paris while working as a music critic, was able to write of a concert: 'The anti-Wagner party was present in full force. It consists of ten or twelve old gentlemen, all more or less like the Duke of Cambridge in personal appearance…the audience was cordially opposed to these veterans, so they did not make much headway'.

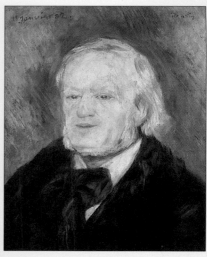

Renoir's portrait (above) of Wagner (1882) pleased both the sitter and the artist, though Renoir, at the time he made his initial sketch, 'felt very nervous and regretted I wasn't Ingres'. The sitting lasted only 35 minutes, after which Wagner exclaimed '"Ach! I look like a Protestant minister". Anyway, I was glad not to have made a botch-up of it and now have a souvenir of that splendid head.'

Fashionable gentlemen behind the scenes at the opera (below); the dancers were the appeal.

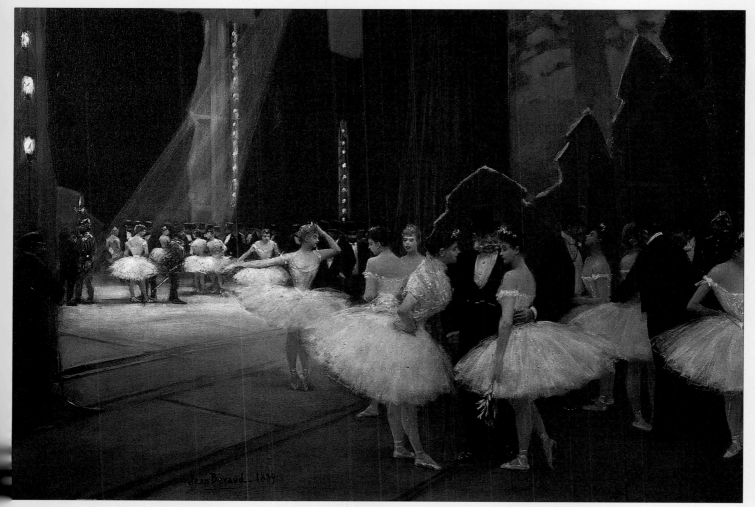

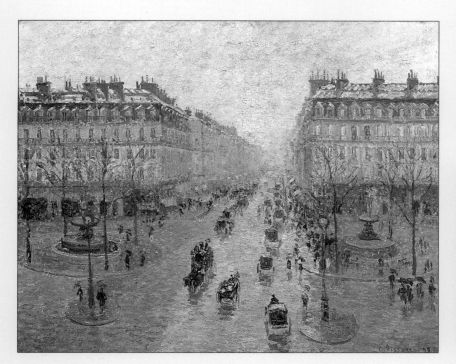

The tragic end of Bizet's Carmen; Don José weeps over the dying Carmen (below). The opera's reception on its première at the Opéra-Comique was typical of the Parisian public's fear of the new. The work was condemned for its realism and the disgusting sight of the female chorus actually smoking on stage. The opera only became successful after it was staged in Vienna.

Camors' was a typical example of the type involved: 'I generally rise in the morning…I go to the Bois, then to the club, and then to the Bois, and afterwards I return to the club…In the evening if there's a first night anywhere I fly to it'. Such dandies even had their own newspaper, the Naïade; it was made of rubber so that it could be read while wallowing in the bath!

Bazille, however, was not to be deterred. Together with Renoir and the judge Lascaux, he was a frequent attender at the concerts Wagner gave at the Concerts Pasdeloup and frequently made loud public demonstrations to show his enthusiasm. Cézanne, too, valued 'the noble tones of Richard Wagner' and seriously considered painting a picture to be titled *Ouverture de Tannhäuser*, though in fact the project never came to fruition.

It was Renoir, however, who actually had the honour of meeting and painting Wagner. On 15 January 1882, the day after the composer had finished the composition of his last opera, *Parsifal*, Renoir visited the villa in Palermo in which Wagner was staying and made a sketch, which he later worked up into a portrait. He wrote to a friend the following day: 'I hear the sound of footsteps muffled by thick carpet. It's the Master, in his velvet dressing gown, the wide sleeves lined with satin. He is very handsome, very courteous. He shakes my hand and begs me to sit down and then the most extraordinary conversation takes place, half in German and half in French, with guttural endings….We talk a great deal, though when I say we, all I did was to keep repeating "Yes, dear Master", "Of course, dear Master".'

Pissarro's view of the avenue de l'Opéra (above). The Opéra itself is just visible in the distance. The effect as a whole is visual confirmation of Pissarro's belief that the artist's task was to 'paint the essential character of things, try to convey it by any means whatsoever, without bothering about technique'.

A contemporary photograph of the place de l'Opéra with the Opéra itself in the background (below). Just as the Impressionists opposed the Salon, so many French composers derided the Opéra's musical standards and its hackneyed repertoire. Hector Berlioz, France's greatest composer of the time, described the Opéra as 'a mausoleum'.

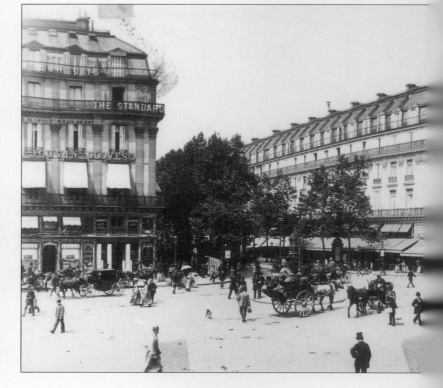

The grand staircase of the Opéra (left) is the building's single most striking feature. It was deliberately designed by Garnier for effect and to enable the fashionable audience to show off their clothes and jewels.

Claude Debussy (below) was just emerging as a composer as the Impressionists were finally becoming established. His music is often thought to mirror Impressionist philosophy, particularly in his symphonic study La Mer.

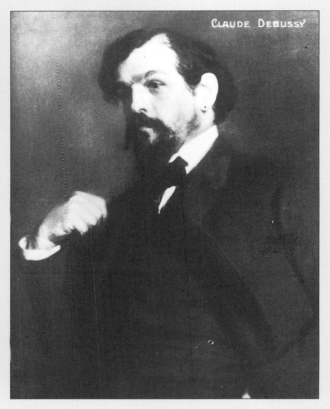

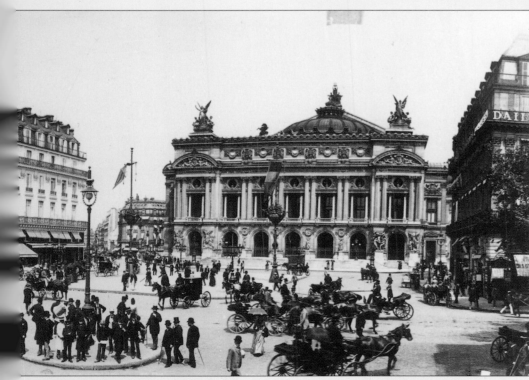

103

It shows two figures relaxing on a boat with the Seine and the river bank behind. The woman wears a fashionable day dress and her partner is got up as an amateur sailor. The press and the public hated it, considering Manet's already grave shortcomings to have been compounded by those of the Impressionists. It was almost certainly a contributory factor to the rejection of the two works he submitted to the Salon in 1876. *The Laundress* and *The Artist* gave the critic of *Le Bien Public* some fun:

> Here is what we learned this morning. When the jury came to examine Manet's paintings one of the members exclaimed, 'Enough of this. We have allowed Manet ten years to turn over a new leaf. He hasn't done so; on the contrary, he grows worse. Reject him.'

Manet, following Mallarmé's suggestion, exhibited the paintings at his own studio two weeks before the opening of the Salon. Such huge crowds flocked to see them that the studio had to be guarded by two policemen. Ironically, the sensationalist nature of the derogatory press reviews served to stimulate public interest, although, unlike similar reviews of books, it did not engender sales. The Parisians loved a spectacle, whether on the boulevards, in the Salon or in a studio. On the days that admission to the Salon was free, 50,000 people flocked to see the works on exhibition, while, in the 1880s and 1890s, half a million of them went to the theatre once a week and more than twice that number once a month. In 1880, Zola set out to examine the reactions and nature of this public in *Mes Haines* (My Hates):

> When the crowd laughs, it is nearly always over a trifle...Put ten people of average intelligence in front of a new and original painting, and all ten will behave in the most childish way. They will nudge each other, and comment on the work in the most facetious manner. Curious idlers in their turn will arrive on the scene to swell the group, and soon it will turn into a real hubbub, a paroxysm of mad folly. I'm not just imagining this. The artistic history of our times gives ample proof of how such purblind fools and scoffers gathered in front of works by Descamps, Delacroix and Courbet...Jesting is infectious, and every now and again Paris wakens to find that it has found a new subject for jest.

L'UNION AND THE THIRD EXHIBITION

Despite public interest, the future for the group as a whole did not look rosy, not least in financial terms. Renoir was selling works to Victor Chocquet and Georges Charpentier, and was reasonably well-off, but Pissarro, Sisley and Monet in particular found themselves in penury. Pissarro, still thinking that holding independent group shows was the way to success, founded an alternative fraternity with Alfred Meyer. This he called L'Union and Guillaumin and Cézanne both joined it.

The organisation of the third show was taken over by Caillebotte, who went to great pains in planning it and persuaded all the major figures to participate, including Pissarro who had threatened to show separately with L'Union. The exhibition, under the neutral label '3me Exposition de Peinture' took place in an apartment in the rue Le Peletier opposite Durand-Ruel's gallery, just off the boulevard Haussmann. It was well publicised and attracted about 500 people a day. Georges Rivière wrote a pamphlet, *L'Impressionniste*, to accompany the show and Victor Chocquet made it his business to be there the whole time, defending and explaining the works his friends had selected to show. Chocquet was an official in the customs service who had retired in 1867 after coming into an inheritance and, although not rich, was an avid collector of Impressionist paintings.

The quality of the exhibits, of which there were 241, was especially high, because, unlike the two previous exhibitions, the greater part was the work of purely Impressionist painters.

No attempt had been made to offset the cost by including painters not devoted to the cause and those like Alphonse Maureau, Ludovic Piette (1826-77) and Franc-Lamy-Pierre Désiré Eugène Franc, (1855-1919) were included because their style largely conformed to Impressionist aims. Caillebotte showed six paintings, Cézanne 16, Degas 25, Monet 30, Morisot 12, Pissarro 22, Renoir 21 and Sisley 17, all of which looked well since the proportions of the rooms were better suited to the display of small paintings than previous locations had been. Critics were impressed by several of the exhibits; they liked Caillebotte's *Paris: A Rainy Street;* Renoir's *The Swing* and *The Ball at the Moulin de la Galette;* and Monet's series of paintings

The French were immensely proud of their new railways, which had not only made Paris accessible to the provinces and the surrounding countryside accessible to the Parisians, but had in some way restored their pride. They symbolised regeneration, social mobility and gave labour a new dignity. Manet had travelled one day on the engine with a driver and fireman coming back from Versailles: 'What a magnificent spectacle these two men were, what *sang-froid*, what guts! It's a dog's life. These men are modern heroes.' Their poetic aspects fascinated painters and writers alike – in 1868 Gautier was writing that stations would soon be 'the new cathedrals of humanity, the centres where all ways converge' and Rivière caught some of this in his review of Monet's *Interior of the Gare St-Lazare* of 1877, which

> …shows the arrival of a train in full sunlight. It is a joyous, lively canvas.
> People hurriedly get down from the cars, smoke puffs off into the background
> and rises upward, and the sunlight, passing through the windows, gilds the
> gravel of the tracks as well as the trains. In some paintings, the irresistible, fast
> trains enveloped in light rings of smoke are engulfed in the platforms. In others,
> huge locomotives, immobile and widely scattered, await their moment of
> departure.

continued on page 108

Lilac: The Artist's Garden *by Armand Guillaumin. The artist was a friend of Pissarro and became a minor member of the Impressionist circle. He exhibited at all of the Impressionist exhibitions, except for those of 1876 and 1879. Towards the latter part of his career he was influenced by the work of Seurat and Signac.*

GARE ST.-LAZARE
CLAUDE MONET (1840-1926)

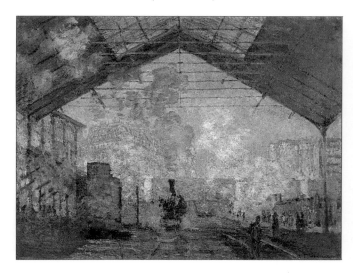

Monet painted this view of one of the capital's new railway stations in 1877. He chose to show the section of the station at which trains from the suburbs to the north of the capital arrived and the evolution of a new type of technique is evident in the picture. The painted surface is very highly worked and dissolves the subject in a network of small opaque patches of paint (the way in which the paint is worked is clearly shown in the detail). The roof of the station provides the composition with a surprisingly traditional perspectival framework rare in Monet's paintings. The painting was shown at the third Impressionist exhibition together with the painting below and is one of a series Monet made at the station. *The Gare St.-Lazare: The Normandy Train* was painted the same year and is further testimony of the painter's fascination with steam and the effects it could produce.

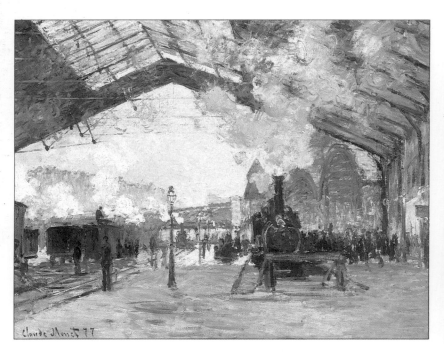

Criticism, however, did not spare Cézanne, who submitted a cross-section of recent landscapes. By 1877 his work had become less painterly, and his brush-strokes, applied in a uniform manner, imposed an almost classical structure on his subjects. Even so, his pictures were confidently written off as 'palette-scrapings'. However, though many of the critics did not care for some of the actual pictures that they saw – and some, like Cham and Leroy, continued to be ungenerous – they were at least beginning to understand what the new movement was about and to be more sympathetic to its aims.

Sympathy and modest acceptance did not lead to riches for the participants, however. At the subsequent sale, many of the works fetched lamentably low prices. Duret recorded that the 45 canvases sold by Caillebotte, Renoir, Pissarro and Sisley fetched only 7,610 francs and roughly the same number were withdrawn because the bids were so low.

The poor prices were partially due to the economic recession of 1877-8. In the spring of the following year, Faure withdrew some of the works he had put up for sale since they failed to make the high prices for which he had hoped. Faure was a leading baritone singer at the Opéra and had collected paintings by the Barbizon School. He had disposed of these in the early years of the decade in order to buy Impressionist works, partly as a speculation, and at one time or another owned 67 canvases by Manet. Hoschedé, one of Monet's important patrons, went bankrupt and was forced to part with over 100 works, of which 48 were by Impressionists, the same year. All his pictures went for below the price Durand-Ruel had originally paid for them. Manet's *Woman with Cherries*, had cost him, it seems, 4,000 francs (Durand-Ruel had paid Manet 2,000 francs for it in 1872). It now fetched only 450 francs (and was bought by Faure). Monet's works realised between 100 and 200 francs, while some of those by Morisot, Renoir and Sisley went for under 50 francs. Lot no. 2, Pissarro's *Effet de brouillard* fetched just seven francs. Desperate remedies were required, and many of the artists turned back to the Salon as the only way to increase their sales.

SECESSION, THE SALON AND THE FOURTH EXHIBITION

Renoir seceded from the group in 1878, as he was unhappy at the taint of 'Intransigence' that still clung to it. Sisley followed, explaining his decision to Duret:

> It is true that our exhibitions have served to make us known and in this have been very useful to me, but I believe we must not isolate ourselves for too long. We are still far from the moment when we are able to do without the prestige attached to the official exhibitions. I am, therefore determined to submit to the Salon.

Cézanne was also preparing to exhibit at the Salon, while Monet was becoming increasingly apprehensive about continuing to show at independent exhibitions. But notwithstanding the likelihood of fewer participants, plans for a fourth exhibition to be held in 1878 went ahead.

Mary Cassatt, an American painter who had moved to France in 1866, had exhibited at the Salon in both 1872 and 1874, when Degas had been particularly taken with her portrait of Zola. He invited her to join the Impressionists and show with them. Now she wrote to the American artist, J. Alden Weir, turning down his invitation to show at the first exhibition of the Society of American Artists:

> There are so few of us that we are required to contribute all we have…we are carrying on a desperate fight and need all our forces, as every year there are new deserters.

Pissarro, too, complained to Caillebotte: 'if the best artists slip away, what will become of our artistic union?', but he was still keen to remain part of a corporate artistic body and not participate in the Salon. Nevertheless about 1877 he also began to make significant

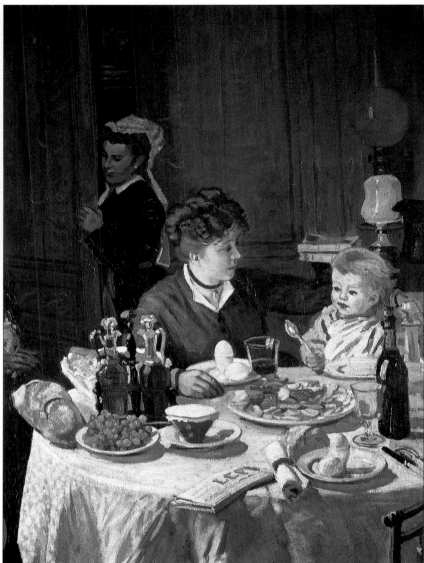

...y Eugène Manet was
...ove). Exhibited at the
...inting was made in
...onse Hirsch, which
...ailway line. Hirsch's
...s shown in an unconventional
...anding with her back to the spectator
...gainst the white steam from a passing
train. Detail of The Dinner by Claude
Monet (right). The picture was made at
Etretat during the winter of 1868-69.
Camille may have posed for the central
figure. The painting was rejected when
submitted for the Salon of 1870; it was
among nine works by Monet shown at the
first Impressionist exhibition.

concessions to public taste. Many of his paintings of the time lose the rugged, sketch-like qualities of his earlier work and have a far more detailed finish, which he achieved by retouching his *plein-air* studies in the studio. He hoped that this would make his work more acceptable to potential buyers.

DURET'S 'LES PEINTRES IMPRESSIONNISTES'

Although many of the group were demoralised by these defections and concessions, Duret did something to restore their morale by writing a pamphlet to accompany the exhibition, entitled *Les Peintres Impressionnistes*. It was an apologia on the lines of those of Duranty and Mallarmé.

Duret gave short biographies of Monet, Renoir, Pissarro, Sisley and Morisot and pointed out that many Impressionist paintings had won approval from critics and collectors alike. He was sure that Impressionism would eventually take its proper place in the canon of French art and that it should not be seen as a threat to the artistic status quo. He saw the official painters not as enemies but rather as 'fellow guests at the table' whom he invited to:

> keep your seats, we shall add an extra leaf beside you. We bring you a new dish,
> it will bring you the pleasure, of a new sensation, we invite you to enjoy it
> with us.

continued on page 112

THE IMPRESSIONISTS AND THE WORLD'S FAIRS

In 1855, 1867, 1878 and 1889, Paris played host to the world; on these four occasions, the aptly named World's Fair was held in the French capital. Paris was the centre of what was undoubtedly the greatest show on earth; on the Champ-de-Mars, around a vast central pavilion visitors thronged from every civilized corner of the globe. The four fairs also help chart the course of Impressionist activity – from the time when artists such as Pissarro first came to Paris as students to the moment when Impressionism finally began to win full recognition.

Of the Fairs held during the imperial epoch, the one of 1867 was undoubtedly better organized than its predecessor in 1855 – for one thing, it opened on time. Here, all the technological miracles of the industrial age were on display, from a monster 50-ton cannon exhibited by Krupp, to a patent new item of American furniture, described in the exhibition's catalogue as a 'rocking chair'. There was a special section devoted to the goods now stocking the new 'bon marché' stores, while, scattered outside in the surrounding park, complete 'model' workers' dwellings were sited. Napoleon III himself was an exhibitor here and, not surprisingly, he was awarded a prize. In the gallery of the Beaux-Arts, however, it was as if time had stood still. Works by Ingres, Corot, Théodore Rousseau, Meissonier and Cabanel crowded the walls, but Pissarro, Monet, Manet and Cézanne were all excluded. Manet responded by setting up his own pavilion in the grounds, where he exhibited 50 of his paintings. As Astruc commented: 'Since 1861, M. Manet has been exhibiting, or attempting to exhibit. This year he has decided to offer directly to the public a collection of his works'.

Thus, the pattern was set. At the 1878 World's Fair, the official choice of paintings was even more conservative. Not only were the Impressionists excluded; so, too, were great names from the past, such as Delacroix, Millet and Rousseau. Durand-Ruel responded by organizing an exhibition devoted to these masters; the result was that, despite Sisley's advocacy, there was no group exhibition at all that year. By 1889 – the year of the public subscription to offer Manet's *Olympia* to the nation and the year that saw Cézanne's *Maison du pendu* selected for exhibition – the movement had finally split.

The cover of a commemorative book (left), produced to celebrate the 1889 World's Fair is certainly traditional as far as the artistic elements in the foreground are concerned. In the background are the exhibition halls and the new Eiffel Tower, opened that year to commemorate the centenary of the French Revolution.

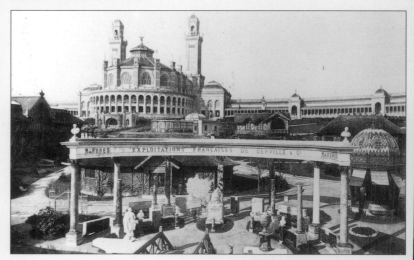

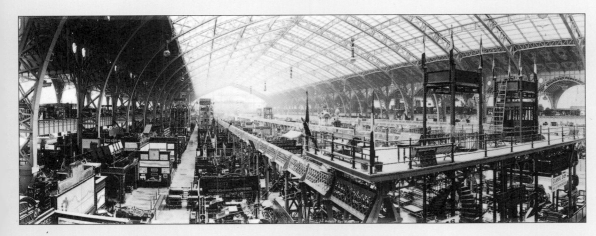

The Galerie des Machines (left) in the 1889 exhibition reflected the technological inventiveness of the 19th-century mind. Industry had been a prominent theme of the various exhibitions from 1851 onwards. The display here was clear proof of France's underlying economic strength, though industrial progress had brought with it growing social unrest.

This gravure print (right) was produced for the 1878 World's Fair. The occasion confirmed France's recovery from the Franco-Prussian War; on 30 June the first Fête Nationale since the Commune was celebrated.

The whole idea of the exhibitions was to celebrate the peak of civilized achievement. 'There, art stood side by side with industry', said Gautier, 'white statues stood next to black machines, paintings hung side by side with rich fabrics from the Orient'. The halls that housed the exhibits and the park surrounding them were similarly planned to impress (left).

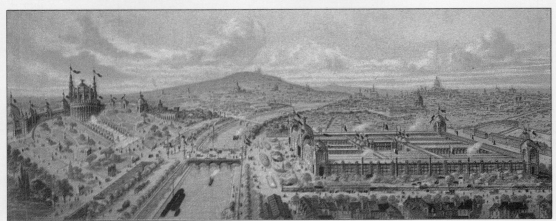

The main entrance of the exhibition (below) and one of the international galleries (right). The whole effect of the exhibitions was overwhelming; during them, Paris was packed with visitors from across the world – so much so that, on the exhibition grounds, French was hardly heard. Such exhibitions were backed heavily by both imperial and republican governments for reasons of prestige.

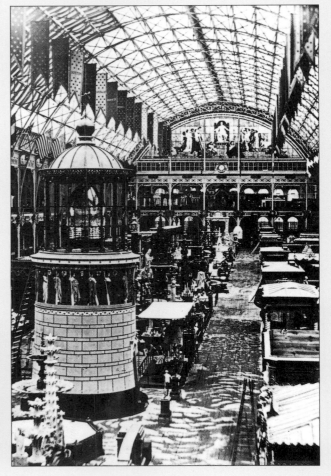

*American-born Mary Cassatt came from a
wealthy Pennsylvanian family. In 1877,
she met Degas and, through him, other
members of the Impressionist group, with
whom she began exhibiting in 1879. Her
approach to painting was particularly
influenced by her friendship with Degas. In
common with him, she felt that art should be
based on a solid study of the Old Masters and
on a complete mastery of the complexities of
line, colour and compositional organization.
Woman in Black (right) dates from around
1882 and is a product of Cassatt's mature
style. Her brushwork is broad and decisive,
while the way in which the wet colours were
dragged was also a personal characteristic.*

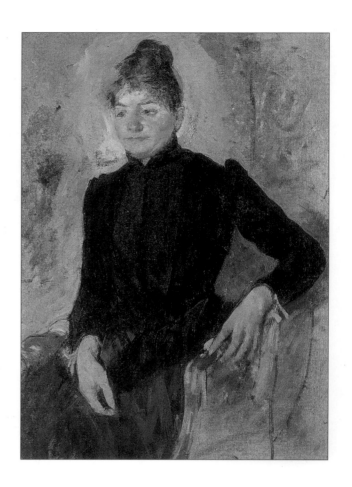

RECORD CROWDS AND FINANCIAL SUCCESS

It had been hoped that the fourth exhibition would open to coincide with the 1878 Exposition
Universelle, so that the works on show would gain maximum publicity and draw attention to
the contrast between them and the conservative works that would inevitably be on display
there. In fact, as Pissarro wrote to Eugene Murer, a *pâtissier* who owned a restaurant and
collected Impressionist paintings, 'not a single master was represented'.

The fourth exhibition, however, did not open until 1879, but, when it did, it attracted
record crowds, perhaps because the watered-down version of Impressionist technique and
subject-matter was more immediately accessible to the viewers. Henry Houssage, writing
three years later, put his finger unerringly on the point:

> Impressionism earns every form of sarcasm when it takes the names of Manet,
> Monet, Renoir, Caillebotte, Degas [but] every honour when it is called
> Bastien-Lepage, Duez, Gervex, Danton....

This time, though, the exhibition was also financially successful and at its close, each of the
participants received a dividend of 439.50 francs from the entrance charges. The quality and
cohesion of the work shown though was not as high as it had been in the third. Lesser painters
had been brought in to replace Renoir, Sisley, Morisot and Cézanne, whose loss was not
wholly compensated by the participation of Cassatt. Her paintings are often similar in
construction of those of Degas, in that she showed subjects at unusual angles and figures
arrested in the middle of some inconsequential activity. *The Cup of Tea*, for example, depicts a
woman sipping tea at the moment when her face is hidden by the cup. Paul Gauguin
(1848-1903), another significant newcomer, only joined the group at the last moment and was
not even included in the exhibition catalogue. It is not known what paintings he submitted,
for the only reference is to a sculpture.

DISPUTES AND DECLINE

While individual painters continued to work with Impressionist techniques, the movement, insofar as it had ever been cohesive and had had clearly defined aims, was now on its last legs, and group exhibitions were no longer seen as a viable promotional method. Even so, a fifth exhibition, which Degas had wished to be announced as one of 'Independent' painters, was held in 1880. Degas was over-ruled about the title, a decision he said upset and humiliated him. He remained a traditionalist in spirit, though his subject-matter, which ranged from race courses to café scenes and from ballet girls to washerwomen, in their style and objectivity still held to the tenets of Impressionism. However, Monet declined to submit work, explaining his absence to Duret: 'I believe that it is in my interest to adopt this position because I can have more confidence in business, in particular with Petit, once I have forced the door of the Salon'. Reaction was swift; *Le Gaulois*, for instance, was delighted:

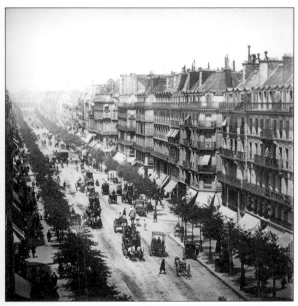

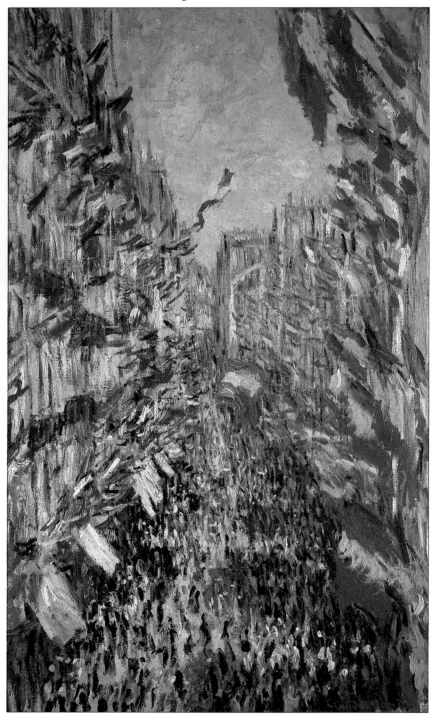

A fragment of a stereoscopic view seen from an apartment balcony on the boulevard de Strasbourg, looking north towards the Gare de L'Est (above). Rue Montorgeuil, Fête Nationale *(right) by Claude Monet was painted in 1878. The view, taken from a balcony, shows the extent to which Impressionist painting was based upon the new vistas Haussmann had given the capital and the rapidly developing techniques of photography. Monet has captured the effect of fluttering flags with broad dashes of pigment. The painting is one of two based on the same point of view and was shown at the fourth Impressionist exhibition.*

> The Impressionist school has the honour of informing you of the sad loss that
> it recently suffered in the person of Claude Monet...The burial service for
> Monet will be celebrated next 1st May – the morning of the opening in the
> church of the Palace of Industry (i.e. the official Salon), salon of Cabanel.
> Please do not attend. De Profundis....

Renoir, Sisley and Monet all submitted work to the Salon in 1881 and a dispute between Degas and Caillebotte over the inclusion of mediocre artists for the sixth exhibition in that year led to the latter's resignation. Only Degas, Pissarro, Morisot and Guillaumin remained of the original band.

MANET'S GENIUS RECOGNISED

Manet had continued to submit works to the Salon, convinced all along that this was the right course of action. Two pictures, a full-length portrait of Faure and *Nana*, were provisionally accepted for the Salon of 1877, but *Nana*, a half-dressed *cocotte* with her lover at her side, was found shocking. Henriette Hauser, a successful music hall artist and a *cocotte* herself, had posed for it. The picture had to be withdrawn and none of the 13 pictures he offered to the Salon of the following year were accepted. However, in 1879 he showed two works – *Boating* and *In the Conservatory*. For the first time, both were well received and Joris-Karl Huysmans wrote a particularly eloquent defence of the painter's work in *Le Voltaire*. Manet's reputation as an *enfant terrible* was on the wane: he was, after all, by now 47 and his work was no longer a novelty. The poet Paul Valéry, writing on Degas, said that 'a good study of modern art should point out the solutions found every five years to the problem of how to shock'. Acceptance by public and critics alike came with familiarity and new subjects for mockery. Even conservative critics began to recognise, albeit grudgingly, his skill as a painter and his contribution to the Realist school of French painting. Two more pictures were accepted in 1880; *Chez le père Lathuille* and a *Portrait of Antonin Proust*, which received praise from the unlikely quarter of Philippe de Chennevières, who had recently retired as Director of the Beaux-Arts, in an article in the *Gazette des Beaux-Arts*.

LAUNCH OF LA VIE MODERNE

The press, in the reviews it published on the Impressionists, was, as we have seen, a powerful influence on public opinion. Now it was to go a stage further. Georges Charpentier, already the publisher of Flaubert, the Goncourts, Daudet, Maupassant and Zola, brought out the first issue of *La Vie Moderne* in April 1879, as a new journal designed to bring 'spiritual distractions' and 'civilized joys' to the Parisian bourgeois reader. Duret and Armand Sylvestre were among its contributors and Edmond Renoir, the painter's brother, was to become one of its editors.

La Vie Moderne concentrated on a broad range of cultural topics related to art, literature and music and also devoted coverage to recent developments in science. In the summer of that year the magazine sponsored a series of exhibitions devoted to the work of a single artist. This indeed was something new. The journal explained that people were often curious to see inside an artist's studio, and the function of the exhibitions to be held would be to 'transfer momentarily the artist's studio to the boulevard [7 boulevard des Italiens] to a hall where it will be open to everyone...'.

De Nittis was the first artist to be shown, followed in June by Renoir. Manet's exhibition of 24 portraits opened in April 1880 at the same time as the fifth Impressionist exhibition, and was well received, not least by his sponsors, who not only praised his work, but stressed his elegant appearance and charming personality as well. Two months later Monet exhibited there, too. Monet, heavily in debt in the early part of 1880, at last began to sell to Durand-Ruel. John House has estimated that his income for 1881 was around 20,000 francs, and by 1885 it had almost doubled.

Renoir, too, was also financially secure. The Charpentier family, whose house was a

Chez le père Lathuille *by Edouard Manet, painted in 1879. The painting was exhibited at the Salon of 1880 with a more conventional portrait of Antonin Proust, a politician friend of the artist who, as a member of Gambetta's cabinet, was instrumental in winning the painter his Légion d'honneur. While critics admired the portrait and saw in it some attempt on Manet's part to atone for his paintings of the past,* Chez le père Lathuille *was roundly condemned by the press.*

meeting place for writers and left-wing politicians, had already given Renoir several important commissions and his *Portrait of Madame Charpentier and her children* was exhibited at the Salon of 1879. Renoir's social circle was slowly being extended and he was meeting more affluent potential clients, such as the Berard family with whom he stayed at Wargemont on the Normandy coast that summer. His bright decorative style of painting, especially in his portraits of women and children, proved very popular.

Pissarro fared less well, although even he said he was now enjoying the results of 'moderate but steady sales'. Durand-Ruel, with the financial backing of Jules Feder, had

Landscape at Pontoise *(left) by Camille Pissarro, painted in 1878. Close examination of the picture surface shows that the pigment is more densely worked than in Pissarro's earlier paintings. The shift in style towards a more detailed rendition of the landscape was prompted by the long-standing criticism that works by Pissarro were crude and unfinished. The change in style was a deliberate attempt to sell more pictures. Pissarro painted* Landscape at Chaponval *(right) in 1880.*

started to acquire works by Renoir, Sisley and Pissarro, buying paintings in large numbers and making the painters generous monthly allowances. But in 1882 Feder's Union Générale bank went bankrupt and brought in its train a stock market crash, which put an end to speculation and sent the French scurrying back to gold, government stocks – and savings. Durand-Ruel was once again forced to draw in his horns.

It had become apparent by now that the Impressionist painters' claim to be following in the tradition of their predecessors was patently true and that what was 'revolutionary' about them was not so much the content or technique of their work as their concept of the relationship of the artist to society at large. They no longer saw their role as servants of society, be it aristocrat or bourgeois, and they had staked their claim to their right of self-expression.

Of course, they were not alone in this. While none of the Impressionists or their precursors, such as Courbet, shared Richard Wagner's monumental egotism and conviction of his own genius, he expressed, in *The Artist and the Public*, written in Paris in 1841, the beliefs they held – beliefs that, in their early days, as with Wagner, so offended a public that was slow to see the change in the relationship between them.

As though the right to exercise my talent depended upon the public's completely meaningless disapproval! Why do artists, in whom the divine fire burns, quit their private sanctuaries and run breathless through the city's filthy streets eagerly looking for bored dull-witted people upon whom to force the offering of an ineffable joy? Something strange and incomprehensible seems to be at work; those who feel themselves subject to it cannot but regard its power as fatal. One's first thought is that the case is simply that of the genius' urge to communicate: what rings loud within him must be made to ring out to the whole world! Indeed it is held that the genius is duty bound to give pleasure to mankind – though who imposed the duty God alone knows! It cannot be a sense of duty, then, which drives the genius to accept the terrible self-denial which presenting himself to the public involves. Some secret demonic force must be at work. This privileged being, blessed with unique powers, goes begging. Cap in hand, he seeks the favours of bored, satiated pleasure-lovers, empty headed snobs, ignorant know-alls, malicious envious corrupt reviewers, and God knows what else that goes to form the public opinion of the day...But the genius who exposes himself to contempt because he has to pretend that he wants to please? No doubt the paramount factor, the one which alone sustains him in his darkest hours, is a god-like impulse to communicate his own inner bliss to the hearts of all men... Were his genius recognized, he would achieve

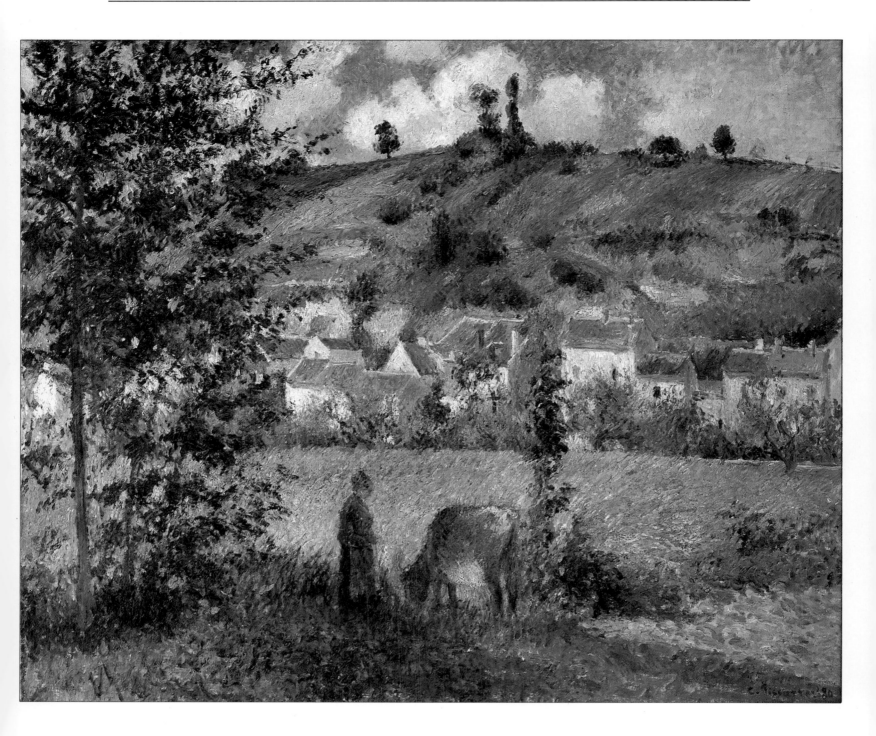

this, and so he works for recognition. Thereby he creates the impression of being ambitious, but this is not so: what he is striving for is not honour for its own sake, but for the freedom which is the fruit of honour.

It is perhaps because Impressionism as a movement or a cohesive theory was more the creation of contemporary journalists – and latter-day art historians – that, as the individual painters gained acceptance in the 1880s, so their individuality triumphed over the 'ism' with which they had been labelled. They were no longer angry young men and each had gone his own way. The days when the combination of a conservative Salon and a conservative press had attempted to put them down were over. They had succeeded in bypassing the official channels for showing their work and were now about to become suppliers of a highly marketable commodity that was to make money for them and the increasing number of canny dealers who saw their potential, not only in France but in Britain and the United States as well.

THE IMPRESSIONISTS AND FASHION

One of the key social themes to be depicted by the Impressionists was the changing face of fashion in mid-19th century France – a period that saw Paris emerge as the fashion capital of the world with the birth of haute couture. The process started in the 1860s, with the work of the English-born couturier Worth, who had opened his premises in the rue de la Paix in 1858. His clients included the richest and most fashionable figures of the Second Empire, including the Empress Eugénie herself and Princess Metternich; it was around his premises that the Parisian couture industry became established, together with all its various ancillary trades. Paris and fashion became synonymous; by 1900, the most successful fashion houses were employing up to 1,000 workers and exporting nearly two-thirds of all their model gowns.

Of the Impressionists, it was probably Renoir who captured the world of fashion to greatest effect, though not as acutely as Manet and Degas. The difference between the three stems from their

Béraud captures the glittering atmosphere in a typical Parisian salon to the full (bottom left). In such salons – the word means 'reception' – formal evening wear was essential for both sexes.

New crazes had an obvious influence on contemporary fashions. The bicycling fad of the 1890s is an obvious example, the split skirt being devised as stylish and practical wear (below).

approach to what they were depicting.

Manet and Degas, though both the supreme illustrators of Parisian life in their time, were dispassionate observers; Manet's last paintings, for instance, are a kind of visual parallel to the characterization Guy de Maupassant was attempting in his short stories. Renoir, on the other hand, invested his portrayals of the contemporary scene with a touch of social glamour all his own. Critics have sometimes referred to him as the 'Fragonard of modern art', and his society portraits are full of a graceful charm that rivals that of Fragonard himself. Indeed, in 1885, after a period of self-doubt, Renoir wrote to Durand-Ruel: 'I have taken up again, for good, the old painting, soft and gracious…It is nothing new, but it is a continuation of the painting of the 18th century'. At the same time as this new style was emerging, Renoir was starting to win social acceptance – not just through his talent, but also through his friendship with the publisher Charpentier.

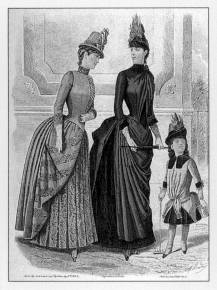

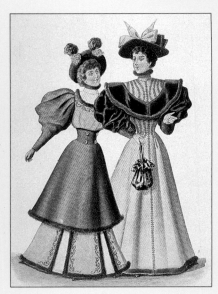

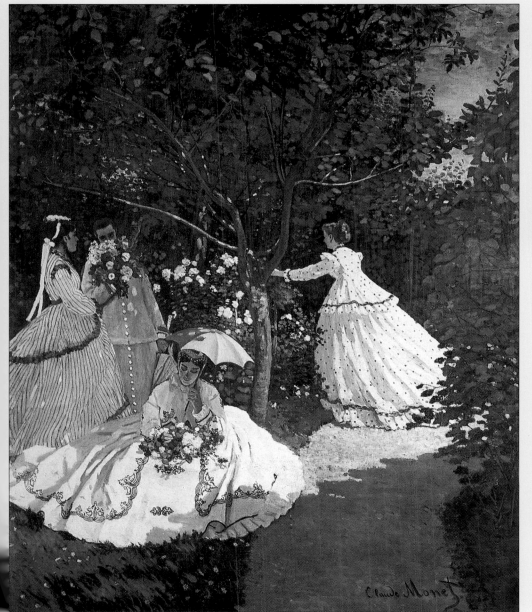

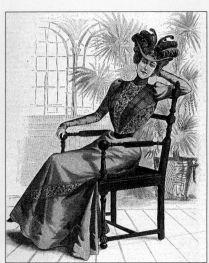

The changing face of fashion is mirrored in this selection of plates from some of the women's magazines of the period (above). The fashions shown date from 1875, 1885, 1894 and 1899 respectively. Monet's Women in the Garden (left) was painted in the summer of 1866 and was executed entirely in the open air at Ville d'Avray, near St Cloud. One of the fashionably dressed models was Camille Doncieux, whom Monet eventually married. The picture is painted on a huge scale; to enable him to work on the upper half, Monet had a trench dug in his garden, into which the bottom part of the canvas could be lowered. The painting was rejected by the 1867 Salon. Jules Breton, a jury member, commented: 'Too many young people think only of pursuing this abominable direction. It is high time to protect them and to save art'.

5 THE IMPRESSIONIST INHERITANCE

Impressionism made its last stand as a movement at the penultimate group exhibition in 1882 held under the auspices of Durand-Ruel. The seventh group show began with the usual round of bickering that had preceded the recent exhibitions, and for which Caillebotte, in a letter of 1881 to Pissarro, blamed Degas:

> Degas introduced disunity into our midst...He claims that he wanted to have Raffaëlli and the others because Monet and Renoir had reneged and that there had to be someone. But for three years he has been pursuing Raffaëlli to join us, long before the defection of Monet, Renoir, and even Sisley. He claims that we must stick together and be able to count on each other (for God's sake!); and whom does he bring us? Lepic, Legros, Maureau...
>
> All this depresses me deeply. If there had been only one subject of discussion among us, that of art, we would always have been in agreement.

Degas however was resolute and refused to participate without his protégés. Renoir, meanwhile, was greatly disturbed by the political affiliations of some of the exhibitors. In a draft letter to Durand-Ruel on the eve of the exhibition, he wrote:

> To exhibit with Pissarro, Gauguin and Guillaumin would be as if I were exhibiting with some Socialist group. Before long Pissarro will be inviting Lavrof [a Russian anarchist] or some other revolutionary. The public doesn't like anything smelling of politics, and at my age I certainly don't want to become a revolutionary. To go on along with the Israelite Pissarro would be revolution.

The Impressionists were painters of record; their aim, as painters of 'la vie moderne', was to record what they could see around them. They faithfully captured the spirit of Haussmann's new Paris and were obviously interested in further architectural developments. Gustave Eiffel (left), a leading engineer of the day, was to transform the Parisian cityscape with the erection of his tower (right). This commemorated the centenary of the 1789 revolution.

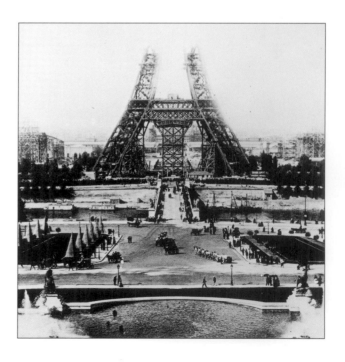

A painted sketch for Bathers *by Pierre-Auguste Renoir, painted in 1887. Renoir had confided in the dealer Ambroise Vollard that he had reached the end of what he could achieve through*

Impressionism and felt frustrated by his technique. Bathers *marks his return to more conventional subject-matter and also more conventional techniques of drawing and painting.*

Renoir had always been anxious to disassociate himself from any overtly radical artistic programme; it was he who had given the newly-formed Impressionist circle the innocuous name of the Société Anonyme at the time of the first exhibition. He also took great exception to Degas' stipulation that painters should not exhibit at both the group shows and the Salon. Renoir now submitted regularly to the Salon and was loath to relinquish the opportunity it gave him to publicize his work. A schism rapidly developed between Degas, Cassatt, Jean-François Raffaëlli (1850-1924), Jean-Louis Forain (1852-1931) and Federigo Zandomeneghi (1841-1917) on the one hand, and the landscapists, Monet, Renoir and Sisley, on the other. As a result a new caucus emerged, centred round Caillebotte and consisting of Pissarro, Monet, Renoir, Morisot, Guillaumin, Sisley and Gauguin. But anxieties persisted; some members thought that the addition of Gauguin was inappropriate, while money was again a pressing problem.

The financial crisis of 1882 had left Durand-Ruel over-extended, and he consequently faced the prospect of having to repay the loan that had enabled him to acquire a large stock of Impressionist paintings sooner than he had hoped. He could not afford to forego the opportunity of mounting what could prove a lucrative exhibition. Although the '7me Exposition des Artistes Indépendants' was advertised as the latest of a long line of shows, it was to some extent mounted to relieve Durand-Ruel's now considerable cash-flow problems.

THE SEVENTH EXHIBITION

The seventh exhibition opened on 1st March 1882 in the rue St Honoré in a large hall built to display a panorama of the French defeat at the battle of Reichshoffen in 1870. Degas, who had

threatened to resign rather than exhibit without Raffaëlli and his other friends, and Mary Cassatt, as some critics observed, were conspicuous by their absence. Nevertheless, as Joel Isaacson said, the show presented 'the most advanced, thoughtful and experimental art being produced at the time'. It appeared to endorse Duret's conception of the movement outlined in *Les Paintres Impressionnistes* as primarily a school of *plein-air* landscape painters dedicated to recording the fleeting effects of light and colour.

Monet showed a mixture of work, including landscapes, flower paintings and still lifes. Some paintings, like *The Seine at Lavacourt* were conventional, with a traditional compositional format and made up with small touches of restrained colour. Other works, such as the *Cliffs of Petites-Dalles*, involved the use of violent gestures of paint applied so as to capture the violent motion of the subject. Monet himself was well aware of the breadth of his technical repertoire at this stage in his career and also knew what effect his more demanding paintings had on the critics. In a letter to Duret, referring to his *Sunset on the Seine*, Monet says that it was not submitted to the Salon because 'someting more discreet and bourgeois' was required there.

In general, though, the critics were better disposed towards these less demanding paintings. They especially liked Caillebotte's *Game of Bezique* and Renoir's *The Luncheon of the Boating Party*, both of which were fairly conventional anecdotal tableaux. For example, Paul

Landscape at Louveciennes *by Camille Pissarro, 1878. The painting, subtitled* September, *is one of a cycle Pissarro painted on the seasons. By this time, Pissarro had moved away from the style he had developed before the Franco-Prussian war, which, as far as landscape was concerned, was influenced by Corot. After the mid-1870s, Pissarro's technique relied on a comma-like brushstroke, which he used to create form and tone, created out of hatched and cross-hatched areas of small strokes. These built up to form a textured impasto surface. The result, however, did not satisfy Pissarro, who believed that it lacked clarity and structure. This was to lead him to explore new themes and subjects in the 1880s.*

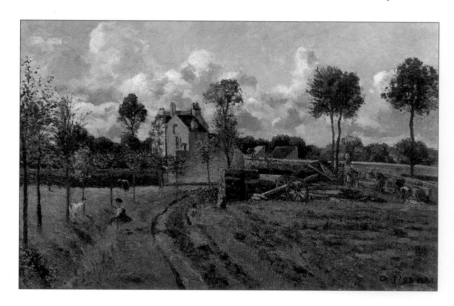

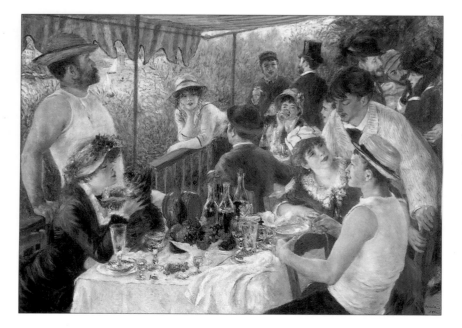

The Luncheon of the Boating party *by Pierre-Auguste Renoir, painted in the summer of 1880. The painting shows Chez le Père Fournaise, a restaurant on the Ile de Chatou, after lunch. The woman on the left is Aline Charigot, the future Madame Renoir. Caillebotte posed for the seated figure on the right. The woman to his left is the actress Ellen Andrée. The painting was shown at the seventh Impressionist exhibition of 1882 and was part of the collection of Durand-Ruel.*

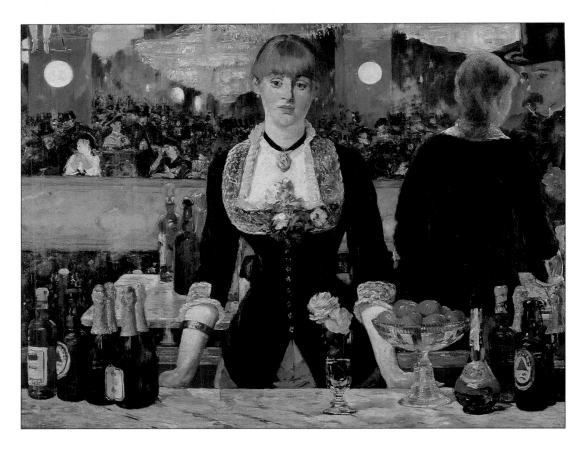

The Bar at the Folies-Bergère by Edouard Manet, painted in 1881. The painting shows a waitress at one of the two bars serving *customers in the gallery of the famous Parisian café-concert on the rue Richer.*

de Charry, in *Le Pays* said *The Luncheon of the Boating Party*

> …is a charming work, full of gaiety and spirit, its wild youth caught in the act, radiant and lively, frolicking at high noon in the sun, laughing at everything, seeing only today and mocking tomorrow. For them eternity is in their glass, in their boat, and in their songs. It is fresh and free without being too bawdy. This work and the *Partie de bésigue* by Caillebotte share the honours of the exhibition.

In fact Renoir's figure paintings were praised for their return to academic standards. He had just come back from Italy, where he had been looking at renaissance art – in particular the work of Raphael – and much of his time was now taken up with painting commissioned portraits. He was soon to abandon Impressionist techniques altogether.

Pissarro was also well received by the press. His earlier paintings of rugged peasants at work in often unattractive settings had won few devotees, but the paintings he now chose to show proved more immediately likeable, depicting, as they did, young peasant women at rest in pleasant landscapes or at home in their cottages. Moreover, they were well finished in the studio, depending less upon perceived experience than his previous works had done. They utilized the densely painted flecks of brightly coloured and contrasting pigments that he had begun to employ in the late 1870s.

NEW THEMES AND SUBJECTS

Manet now received his long-coveted official recognition. The critic Bertall gibed that he had painted the portrait of the politician Antonin Proust in order to advance his chances of being made a chevalier of the Légion d'honneur. In 1880, when Proust was widely expected to get a government post – which, under Gambetta, he did – Bertall had written sarcastically:

> It is Manet who has been charged with reproducing the characteristic contours
> of the hat and frock coat of the future minister of the fine arts, the same
> individual who, one hears, will assume the direction of the Ecole des
> Beaux-Arts, and chart the new course assigned to French art.

In fact, Manet had known Proust since childhood, so the gibe was unfair. Nevertheless, some six weeks after Proust's appointment in 1882, Manet finally achieved his ambition. It represented acceptance by the establishment.

Manet exhibited two pictures at the Salon of 1882. These were a portrait of the actress, Jeanne de Marsy, entitled *Spring* and *The Bar at the Folies-Bergère*. Although the press had become more tolerant in its attitude towards Manet's work – even the usually caustic Albert Wolff thought that *Spring* was 'ravishing in the impression it leaves. One cannot deny that M. Manet's art is truly his; he has not borrowed it from the museum, he has wrested it from nature' – the reaction to *The Bar at the Folies-Bergère* was mixed. A number of critics thought that the painting was riddled with technical imperfections in both drawing and colouring, while parts were considered unfinished. The correspondence between the figure and her reflection was also found to be inaccurate and the lighting of the picture poor. Some criticised the barmaid as rather pallid and mocked her head as made of cardboard. But once again, it was the subject-matter that was found inappropriate for exhibition at the Salon.

The café-concert or café-chantant had become a common theme in Impressionist paintings from the late 1870s onwards. Degas had painted Ellen Andrée and Marcellin Desboutin in 1876 at the Café de La Nouvelle-Athènes in his *Absinthe* and treated a host of similar topics on numerous occasions thereafter. Manet also made a series of pictures of barmaids between 1877 and 1882, notably *Corner in a Café-concert*, *Girl Serving Beer*, and *The Plum*, which was bought by Charles Deudon in 1881 for 3,500 francs.

The Bar at the Folies-Bergère appears innocent enough to modern eyes. But while the smart cafés, like Tortoni's, attracted the social elite, the proliferation of bars and 'cabarets' were a factual reminder of a worrying social situation. The huge influx of workers from the provinces seeking jobs in Paris and their need for both a social life and a palliative for their miserable poverty had led to a disturbing increase in addiction to both drink and prostitution. Whereas in 1850, the average consumption of alcohol per week was 1 ½ litres per head, by 1879 it had doubled, while, during the 1860s, it had been calculated that there were 30,000 'filles clandestines' and well over 200 brothels in Paris. Cafés were not only, as Gambetta said, 'the salons of democracy' – a frightening enough concept for the bourgeoisie – but also places where men could pick up prostitutes, often working as barmaids, and abandon their families for an evening, to get drunk on absinthe, wine and the beer that had become popular since its introduction by the Germans after the Franco-Prussian war.

The Folies-Bergère was somewhat more exclusive than some of its contemporaries, since its proprietor, Léon Sari, had renovated it, providing the latest in electric lighting, and stalls and boxes from which the more respectable patrons could watch the performance without milling around with the lower-class promenaders. Even so, the Folies-Bergère remained insalubrious. Guy de Maupassant, in *Bel Ami*, talks of:

> the circular promenade where…a group of women awaited arrivals at one or
> another of the three bars behind which, heavily made-up and wilting, three
> vendors of refreshments and love held court.

It was peopled not only with brilliant demi-mondaines, seeking a taste of low life, but with a wide variety of individuals of different social status rubbing shoulders with them in a common search for pleasure. Parisians made little distinction between it and the Alcazar d'Eté and the Ba-ta-clan, where tradesmen and their families from the *quartier* of the Temple and the furniture workers of the faubourg St Antoine were to be found.

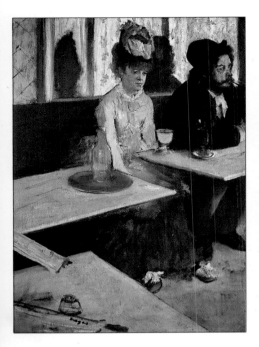

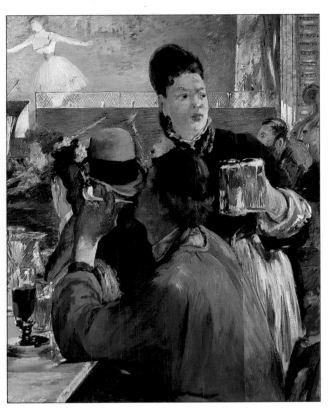

L'Absinthe *(left) by Edgar Degas painted in 1877. The composition of the picture is based upon the sharp recession of a zig-zag pattern concluding with the two figures to the right of the painting. The title of the picture comes from the name of the popular but addictive pale green liquor on the table before the woman in the centre of the picture.* The **The Girl Serving Beer** *(right) by Edouard Manet, painted in 1879. The picture was taken from a sketch made by the artist in the Brasserie Reichshoffen. The dress of the two seated figures in the picture is respectively working and middle class, indicating the degree of interaction among different social groups which took place in cafés-concerts.*

THE DEATH OF MANET

The Bar at the Folies-Bergère and *Spring* were the last paintings Manet sent to the Salon. He was now ill, and he spent the summer of 1882 at Rueil where he rented a house. There, he painted a number of small landscapes and still lifes. His health continued to fail and, shortly after the amputation of a gangrenous leg, he died on 30 April 1883, at the age of 51.

In January 1884, a retrospective exhibition of Manet's work, which Antonin Proust helped to organize, opened at the Ecole des Beaux-Arts, showing 116 paintings and some 60 prints and watercolours. This coincided with the publication of a monograph on the painter by Edmond Bazire, whose mistress, Suzon, had been the model in *The Bar at the Folies-Bergère*. The auction sale, organized by Durand-Ruel, which took place the following February, was accompanied by a catalogue in which Duret defended Manet's work. It stood comparison, he said, with the best of Delacroix, Corot and Courbet. He went on to challenge the state to buy examples for public collections, but here he had met with as little success as Manet himself had enjoyed when, in 1879, he had written to the Prefect of the Seine about a scheme of decorations for the Hôtel de Ville, which was then being rebuilt after its destruction by fire during the days of the Commune:

> To paint a series of compositions representing to use an expression now hackneyed but suited to my meaning, 'the belly of Paris,' with the several bodies politic moving in their elements, the public and commercial life of our day. I would have Paris Markets, Paris Railroads, Paris Port, Paris Under Ground, Paris Racetracks and Gardens. For the ceiling, a gallery around which would range, in suitable activity. all those living men who, in the civic sphere, have contributed or are contributing to the greatness and the riches of Paris.'

The sale was only moderately successful, with 167 works realising 116,637 francs. Most were acquired by colleagues and friends. The composer, Alexis-Emmanuel Chabrier paid 5,850 francs for *The Bar at the Folies-Bergère*, and *Argenteuil* and *Olympia* were bought in by Manet's family for 12,500 and 10,000 francs respectively. *Chez le père Lathuille* was sold for

continued on page 130

THE IMPRESSIONISTS AND ENTERTAINMENT

'To will always, this is the fact about Paris', wrote Victor Hugo in his introduction to the Paris Guide of 1867. 'You think she sleeps, no, she wills. The permanent will of Paris – it is of this that transitory governments are not enough aware. Paris is always in a state of premeditation…The clouds pass across her gaze. One fine day, there it is. Paris decrees an event. France, abruptly summoned, obeys….'

The citizens of the aptly nicknamed *ville lumière* would have profoundly agreed with Hugo's benediction. Not only Parisians, but people everywhere saw Paris as the centre of Europe, the hub of culture, fashion and invention. In a word, the city was unique. In Haussmann's newly-planned capital, the motto of the age seemed to be diversion; from Montmartre to the Tuileries, by day or by night, the Parisian love of entertainment was a dominant theme of daily life. There were restaurants, cafés, cabarets, bars, cafés-concert, theatres, music halls, dance halls, circuses; the fashionable flocked to the Opéra and the races; the whole city seemed devoted to the pursuit of pleasure at virtually any price. Small wonder, therefore, that, in 1870, the bombastic Prussian press called for the destruction of the 'modern Babylon'!

For the Impressionists, however, this love of pleasure and entertainment was a natural theme, particularly given their determination to depict life as it was lived. Manet and Degas, in particular, produced an imperishable artistic record of Parisian nightlife in all its varied facets, capturing its darker as well as its lighter side. As Philippe Burty, the critic of *La République Française*, commented in 1877: 'M. de Gas (sic)…paints with passion and zest, choosing singular aspects of Parisian life; the cafés, the boulevards, the cafés-concert of the Champs Elysées, the corridors and rehearsal rooms of the Opéra. He goes about this as a man of feeling, of wit and sardonic observation…the Salons are too hidebound to exhibit these delicate studies.'

Degas was fascinated by theatrical life – in particular, the ballet dancers of the Opéra, both on and off the stage, even though he was not as familiar with their life at first hand as might be supposed. In 1880, he somewhat shamefacedly wrote to the

Parisians loved to dance and the public dance halls of the period became extremely popular; here crowds are flocking to the Moulin Rouge, in the heart of Montmartre (below). The poster (left) advertising the Moulin was created by Toulouse-Lautrec. Such scenes inspired painters such as Degas and Renoir. In the 1870s, the latter often spent Sunday afternoon or evening in the nearby Moulin de la Galette, sketching the young girls who came to dance there.

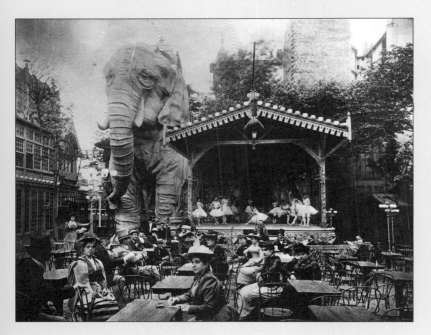

Following in the footsteps of the celebrated 'grandes horizontales' of the empire, La Goulue (below), the star of the Moulin Rouge, was notorious. The Prince of Wales was among her many lovers.

This photograph of the Moulin Rouge (above) features the outdoor stage and the cabaret's elephant symbol. The Moulin de la Galette (left), overshadowed by one of Montmartre's last surviving windmills, was the setting for Renoir's two paintings of a lively waltz scene. The Moulin was just around the corner from Renoir's studio; his friends helped him carry his canvas there each day.

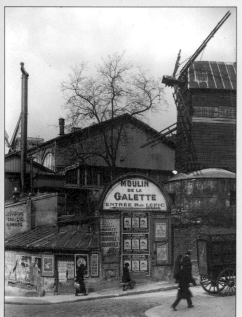

Jane Avril (right) was another major cabaret star of the period; here she is displaying her dancing prowess. The demi-mondaines had their own following among the rich and fashionable Parisian dandies of the day; they could make – and lose – fortunes with remarkable rapidity. Back in the days of the empire, Lord Hertford, known as the meanest man in Paris, had paid a million francs to spend one night with the Comtesse de Castiglione.

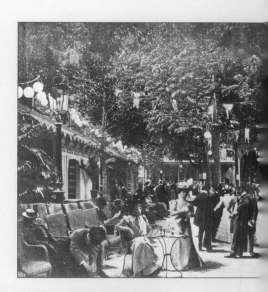

Crowds outside the Olympia Theatre (left). From the Opéra and the Comédie Française downwards to the ever-popular music hall, Parisians loved to be entertained. One of the great stars of the period was Sarah Bernhardt, whom Oscar Wilde nicknamed 'the divine Sarah'. Here, she is seen in a scene from Act II of La Dame aux camélias by Alexandre Dumas fils, which was a smash hit of the day (below). Verdi used the story of the play for his later opera, La Traviata.

From 1872 to 1880 Bernhardt (above and right) was the Comédie Française's super-star, with her portrayals of Racine's Phèdre and of Dona Sol, in Victor Hugo's Hernani. Later, after she had left the company, Shaw commented: '…it must be hard for her knowing that her real work is going on without her'.

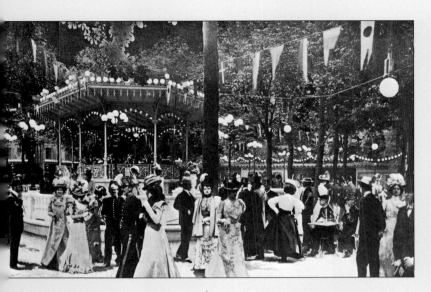

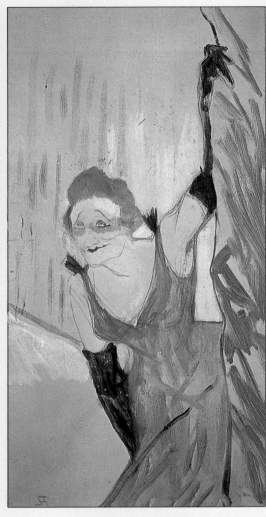

Parisian nightlife in the 1890s was at its gayest; this engraving of outdoor dancing at Le Jardin de Paris (above) comes from a series called Paris la Nuit. *Yet the pursuit of pleasure had its cost. Many of the great artistic figures of the day, including Maupassant, Dumas fils, Baudelaire, Jules Goncourt and Manet himself, were to die of syphilis.*

Yvette Guilbert (right) takes a curtain call and salutes her adoring public in this painting by Toulouse-Lautrec. Here, Lautrec has captured the wit and the character of one of the great French chanteuses of the day; in his portraiture and choice of subject matter, he was deeply influenced by Degas' example. Guilbert herself was a frequenter of Georges Charpentier's salon, as was Renoir.

banker Albert Hecht: 'Have you the power to get the Opéra to give me a pass to see the examination of the ballet dancers, which should be on Thursday, according to what I am told? I have done so many versions of the subject without ever having seen it that I am ashamed'. Few, if any, could tell this from his paintings, however. As the young William Rothenstein commented in 1894: 'He found in the life of the stage and in the intricate steps of the ballet, with its background of phantasy (sic), an inexhaustible subject matter which allowed for the colour of romantic art, and yet provided the clear form dear to the classical spirit. He delighted in the strange plumage of the *filles de l'opéra* as they moved into the circle of the limelight, or stood, their skirts standing out above their pink legs, chattering together in the wings'. Degas was similarly obsessed with horses and racing. Paul Valéry later recorded: 'In the racehorse, Degas discovered a rare subject, which could satisfy the conditions imposed both by his own temperament and his period on his range of choice'.

Then there were the glittering receptions, such as those held by Georges Charpentier, the publisher of Zola, Maupassant and Daudet, at his palatial home

in the rue de Grenelle, which all the leading figures in French literature and politics attended. Here, too, could be found Renoir, whom Charpentier and his masterful wife had befriended. Above all, there was the dinner. Gustave Geffroy, in his *Claude Monet*, gives a memorable account of one of the monthly dinners members of the Impressionist group held at the Café Riche between 1880 and 1894.

'The discussion sometimes got quite heated, particularly between Renoir and Caillebotte…They covered not only art, but every possible literary subject, politics, and philosophy, all of which appealed to Caillebotte's enthusiasm, for he was a great reader of books, reviews and newspapers. Renoir kept himself abreast by buying an encyclopaedia, out of which he culled arguments "to floor Caillebotte". Pissarro and Monet were also devotees of literature, both of them possessed of a sure and refined taste. I well remember a real duel for and against Victor Hugo, which unleashed a flood of passion, ardour and wisdom from which everyone emerged reconciled to go and sit on a café terrace and contemplate the ever fairy-like appearance of Paris by night'.

The House at Rueil, *by Edouard Manet,*
painted in 1882. The brightly coloured,
rapidly executed painting is one of a series of
open-air studies made by the artist of the
house and garden. The picture was
made in the summer before the artist's death
in 1883.

5,000 francs, but other lots made far less, with drawings and paintings selling in some cases
for tens, rather than hundreds, of francs. Works of the Barbizon School, which, by the mid-
1880s were considered masters, were selling for similar prices, but works by Cabanel,
Bouguereau and their peers were still fetching five times that sum.

IMPRESSIONISM ABROAD

Though the Impressionists were no longer subject to the ritual vilification that had greeted
their works in the early days, they were as yet far from being a sound financial investment.
Still suffering from the effects of the 1882 recession, Durand-Ruel had mounted a series of
one-man exhibitions in 1883 of the work of Boudin, Monet, Renoir, Pissarro and Sisley, but
these, too, were less than successful. The British public reacted, as the Parisian had a decade
before, in thinking that the paintings he exhibited at the Dowdeswell Galleries in London that
year were crude and unfinished, though the review (perhaps by Frederick Whetmore) in *The*
Standard of the exhibition a year before had said 'several of the pictures are excellent...and
until now the Impressionists have been little known in England'. Durand-Ruel fared no better
in Rotterdam, Berlin, or Boston when he exported a small exhibition to show there in 1883.
American collectors, it seems, thought the 'fancy prices' asked were only an attempt to extend
the already lucrative market for the work of the Barbizon masters.

Three years later, however, Durand-Ruel's plans met with more success. In 1886 he
mounted an exhibition in New York of 300 pictures with the help of the American Art
Association, which provided the space, covered the costs of publicity and insurance and was
able to get the customs to waive what would have been prohibitively high import duties on the
exhibits. The exhibition was well received, Durand-Ruel believed, because of his sound track
record as a dealer and his consistent and long-standing devotion to his friends' work. Later the
exhibition moved to the National Academy of Design and was supplemented with other
Impressionist paintings which had already found their way into American collections. Luther
Hamilton in *Cosmopolitan* thought it was

> one of the most important artistic events that ever took place in this
> country...We have had in years no other chance to see a collection in which the
> vitiating element of saleability was unconsidered. Parenthetically it may be
> recalled that the American market, owing to our general ignorance of all
> aesthetic matters, must impose a generally low standard....

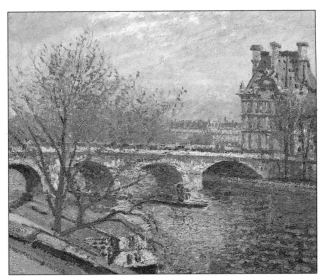

The Great Bridge at Rouen *by Camille Pissarro, painted in 1896;* The Pont Royal and the Pavillon de Flore *by Pissarro, 1903 (above right);* The Port at Rouen *(right) by Pissarro, painted in 1896. After a brief flirtation with the more systematized theories of the pointillistes, Pissarro once more returned to a conventional Impressionist style based upon direct observation.*

Durand-Ruel opened a gallery in New York in 1888 in order to avoid the expensive process whereby pictures imported without the payment of duty could be sold only if they were returned to France and re-imported back to the United States. While American dealers had been scouring Europe for works of art since the 1840s, they had been slow to take up the Impressionists. Now that the new school of French painting was acquiring more and more devotees, they wanted a share of the market and began to challenge Durand-Ruel's virtual monopoly of Impressionist work.

The eighth group exhibition coincided with Durand-Ruel's efforts in the United States, and the motives behind it were complex. Whereas in 1874 the battle lines between the Impressionists and the Salon had been fairly well defined, 12 years later they had become confused. Some painters, notably Pissarro and Degas, still continued to cherish the idea of independent group exhibitions. Others had since become dependent on the Salon or the dealers and were making a decent living from selling their work. Degas' adherence to his belief that it was impossible for an artist to exhibit at independent group shows and the Salon ended up by totally alienating both Monet and Renoir. Like Manet, both men no longer saw the virtue of independence for independence's sake, while, at the same time, Monet was opposed to the inclusion of Seurat and Signac.

Bathers at Asnières *by Georges Seurat, painted in 1883-84.* *A group of workers recline on the banks of the Seine opposite the* *Ile de la Grande Jatte. Seurat's interest in scientific colour theory,* *as opposed to observed colour, is evident in the manner in which* *colours have been created following scientific principles by the* *mixing of contrasting pigments.*

By the mid-1880s commissions from private customers and the greater interest from a number of dealers had changed the situation. The dealers were beginning to call the tune and impose stipulations of their own. Georges Petit, still Durand-Ruel's most formidable rival, who showed Impressionist paintings at his Expositions Internationales, made it a condition that the artists he represented did not show at independent exhibitions. Indeed, by 1886 there were few advantages in doing so. Degas, Pissarro, Morisot and Cassatt were among the exhibitors at the '8me Exposition de Peinture' – but the principal exponents of Impressionism, Monet, Sisley, Renoir and Caillebotte, stayed away.

Two newcomers, however, were to inject new life into the exhibition. Both Georges Seurat (1859-91) and Paul Signac (1863-1935) had undergone traditional academic training; the former at the Ecole des Beaux-Arts from 1878-79 under Henri Lehmann (1814-82) and the latter in the studio of an obscure Rome scholar, Emile Jean-Baptiste Philippe Bin (1825-97). Signac had been particularly struck by Monet's work when he saw it at the exhibition at La Vie Moderne in 1880, and he and Seurat were clearly influenced by Impressionist subject-matter and technique.

Seurat, as a young man, had come across the writings of several colour theorists, notably Eugène Chevreul, Charles Blanc, David Sutter and Ogden Rood, whose *Modern Chromatics* was translated into French in 1880. Chevreul's book, *The Law of Simultaneously Contrasting Colours*, a practical application of Newtonian theory, was written in 1839 as a result of his research into the dyeing industry and the ailing tapestry manufacturing trade. One of his most important discoveries was that colours placed side by side affect each other's colour and tonal values simultaneously.

Seurat started to put these theories into practice, and was quickly followed by Signac.

He adapted Monet's use of applying pure colours in broken patches and took it a stage further by painting in tiny dots of pure colour, a method which gave rise to his work being called *pointillisme*. Seurat restricted his palette to four basic colours – red, yellow, blue and green – fixing three more transitional hues between each pure colour. All were juxtaposed directly on the canvas on the assumption that the optical fusion on the retina would give more vivid harmonies. These effects can be seen in his *Bathers at Asnières*, first seen in public at the Salon des Indépendants, which had been formed to show the work of artists refused by the Salon. The bright orange tones of the spaniel on the left are subdued by the addition of flecks of blue and green, while the theory that bright forms generate a darker penumbra round them and

The Bridge at Asnières *by Paul Signac, painted in 1888. Many of Signac's paintings were executed not on location but in the studio, according to the theoretical principles of the interaction of colours. This manner of painting was very labour-intensive and ill-suited to capturing the fleeting effects of nature.*

dark forms a brighter penumbra can be seen in practice in the central figure. Seurat, Signac and, for a short time, Pissarro, who had met the two younger painters through Guillaumin, also experimented with imposing a scientific order, in terms of drawing, onto the common experiences of modern life.

These Neo-Impressionist techniques were evolved in the studio, under almost laboratory conditions, and had little to do with *plein-air* painting. The *Bathers* was meticulously planned; numerous drawings and 14 prepared painted sketches of each individual figure were made in the studio with their position in the final composition being determined by an intersecting grid of horizontals and verticals, in much the same way as the Old Masters had done. Where it was closest to the Impressionists was in its subject-matter and its treatment of it. A group of bathers, on the bank of the Seine, is made up of a variety of people, whose social class is a little uncertain, sharing their leisure. The half-naked figures in the water gaze across to the sailing boats and a punt in the middle distance, while one of the passengers appears to have lowered her parasol to shield her from the industrial buildings ruining the countryside.

If the picture was intended also to point to a tension between the classes, the same comment could also be applied to *A Sunday Afternoon on the Ile de la Grande-Jatte*, which caused a sensation at the eighth exhibition. Each figure appears to be a prototype – the soldier, the nursemaid, the bourgeois and the *cocotte* – though Seurat denied this intention. He saw it as akin to a Panathenaic frieze in which the citizens, dressed for a holiday and promenading as much to be seen as to see, were simply displaying the outward signs of their status in society.

Pissarro thought that this ordered and scientific approach to painting was a progressive extension of Impressionism. 'I am,' he said, 'personally convinced of the progress and

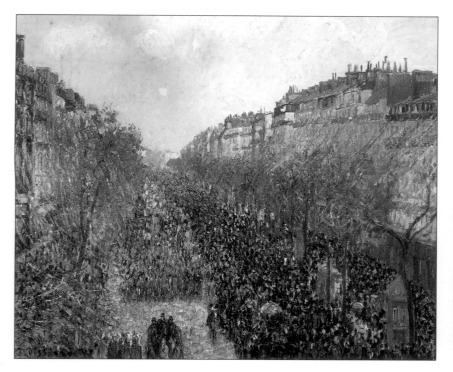

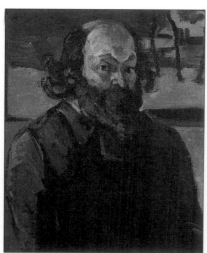

The Boulevard Montmartre, Mardi
Gras (above) by Camille Pissarro, painted
in 1897; Self-Portrait (above right) by
Paul Cézanne, painted in 1875-76. In the
self-portrait, it is possible to see how
Cézanne uses Impressionist techniques not
to record the sensation of light and colour
but rather to reconstruct form, a process
which becomes increasingly refined in the
1880s and 1890s. The Bay of Marseille
Seen from L'Estaque (right) was
painted by Cézanne in 1883-85. In this
instance, the application of paint and the
grasp of colour and the formal values of the
landscape are more ordered than in earlier
paintings by this artist.

character of his [Seurat's] art and certain that in time it will yield extraordinary results'.
Indeed, Seurat went on, in the company of Signac, Henri-Edmond Delacroix Cross
(1856-1910) and other 'pointillistes' to develop a mannered and artificial style, which is the very
antithesis of Impressionist painting. Pissarro, who had flirted with pointillisme, abandoned it,
saying in 1891 to Georges Lecomie, 'one must yield to one's painterly instinct...reason and
science run the risk of blunting our sensations'. He did, however, continue, in common with
many of his contemporaries, to lay increasing stress on the value of painting in the studio. In
1892, in an interview in the *Revue Bleue*, he said:

> ...the unity which the human spirit gives to vision can only be found in the
> studio. It is here that our impressions – previously scattered – are co-ordinated,
> and give each other their reciprocal value, in order to create the true poem of the
> countryside.

The Bathers *by Paul Cézanne, painted in 1898, was one of a series of monumental compositions based upon the idea of the figure in the landscape. In this painting the figures are not drawn directly from the model, but based either upon drawings by the artist made some years earlier, or taken from photographs of classical sculptures in the Louvre. The strokes of paint have been organized to give each individual object great solidity and are placed to emphasize the overall triangular construction of the composition.*

CÉZANNE AND IMPRESSIONISM

Cézanne's relationship to Impressionist painting had always been tangential. His earlier works were more closely related in both form and content to Romantic art, but, under the influence of Pissarro in the mid-1870s, he began to tackle subjects that were more directly related to mainstream Impressionism, though remaining distinct from the work of his immediate colleagues. True Impressionist painters record, or purport to record, visual stimuli without an obvious intercession on the part of the artist. The process, of course, is much more complicated in that artists necessarily select subjects, colours, vantage points and so on, but their aim is to make their work look as if their encounter with the real world happened by chance. Cézanne's paintings invert this formula and increasingly impose order on experience, much like Seurat. But he used different means, with the individual strokes of paint taking the shape of a geometric grid or following the contours of the subject. Shifts in colour similarly served to articulate the forms of objects, as can be seen in the landscapes he painted at L'Estaque between 1883and 1885.

What Cézanne claimed to be doing was making a conscious effort to 'make Impressionism more solid and enduring, like the art of the museums'. This did not imply a return to academic formulae, whereby pictorial space was explained through the means of one or more vanishing points and a geometric grid; instead, he fashioned a spatial language, where the depth of the picture was restricted like that of a bas relief. His later paintings show this

continued on page 138

THE IMPRESSIONISTS AND THE WRITERS

The Impressionists were not isolated figures in the intellectual world of their time; indeed, they had strong links with the new generation of writers that was emerging parallel with them, some of whom were to become the new movement's greatest propagandists and sympathizers. Of them, the figure that undoubtedly stands out as the most influential is the novelist and critic Emile Zola.

Zola was a childhood friend of Cézanne, who was to put his considerable literary talents at the disposal of the emerging Impressionist movement from the time of his appointment as a reviewer for the Parisian daily *L'Evénement* and his success in persuading his publisher to let him write on the 1865 Salon. Then and subsequently, he did his best to stir up controversy. Ernest Vizetelly, the English translator of Zola's *L'Oeuvre* (His Masterpiece), commented in 1902: 'He had come to the conclusion that the

derided painter (Manet) was being treated with injustice and that opinion served to throw him into the fray, even as, in more recent years, the belief that Captain Dreyfus was innocent impelled him in like manner to plead that unfortunate officer's cause'.

Paradoxically, Zola's characterization of the hero of *L'Oeuvre*, Claude Lantier, as an unhappy and unsuccessful painter, a mixture of genius and madness, provoked a final breach with the Impressionists. Cézanne, who suspected that Lantier's character was based on his own, was so angered that he never spoke to Zola again, while Monet sent the author an outspoken letter of criticism. 'You were kind enough to send me *L'Oeuvre*', he wrote. 'I have always had great pleasure in reading your books and this one interested me doubly because it raises question of art for which we have been fighting for such a long time. I have read it and I remain troubled and disturbed, I

Dumas père (above left) and Dumas fils were both enormously popular literary figures of the period. Dumas père's forte was the historical novel; his greatest triumphs included The Three Musketeers *and* The Count of Monte Cristo. *Dumas fils, his illegitimate son, was better known as a dramatist. His masterpiece* La Dame aux camélias, *created a sensation when it was first produced in 1852.*

Gustave Flaubert (above right) was the supreme master of the realistic novel, his best-known work being Madame Bovary. *Among the Impressionists, Caillebotte was a particular admirer. He wrote to Monet in 1884: 'I have just been reading Flaubert's letters. What an interesting book and what a prodigious artist…what a great craftsman he was and so uninterested in anything apart from his art'.*

*Stéphane Mallarmé (right),
painted by Manet. An impassioned
defender of the Impressionists,
Mallarmé believed that poetry
should evoke thoughts through
suggestion, rather than
description.*

must admit...I am afraid that the press and public,
our enemies, may use the name of Manet, or at least
our names, to prove us to be failures...I am afraid
that, in the moment of our succeeding, our enemies
may make use of your book to deal us a knock-out
blow'.

Despite this quarrel, Monet was a sincere admirer
of Zola's genius. But, although Zola stands supreme,
he does not stand alone. He followed in the footsteps
of writers such as Victor Hugo and Flaubert, while
his contemporaries included Duranty, the Goncourt
brothers, Huysmans and the poet Stéphane Mallar-
mé. Pissarro wrote in 1886: 'I went to dinner with the
Impressionists...Duret brought Moore, the English
novelist, the poet Mallarmé, Huysmans...it was a
real gathering. I had a long talk with Huysmans. He
is very conversant with the new art and is anxious to
break a lance for us'.

*Zola (below) was painted by
Manet in 1868; one of his articles
in* L'Evénement *describes the
sittings. The novelist's finest hour
came in 1898, when in 'J'accuse'
(right), he proclaimed himself a
champion of Dreyfus.*

*Victor Hugo (above left) was the
head of the Romantic school of
literature; many considered him
the greatest poet of his day. His
novels* Notre Dame de Paris
and Les Misérables *are both
epics. Forced into exile because of
his opposition to Napoleon III, he
returned to France in 1870 and
lived through the siege of Paris.
George Sand (above right) rebelled
against convention; her best-
known novels are* La Mare au
diable *and* Les Maîtres
Sandeau. *Among her many
lovers were Musset and Chopin.*

*The poet Paul Verlaine (left) was a
notorious figure in the bohemian
world of Paris, partly through his
drinking and partly through his
homosexual relationship with his
young protégé, Rimbaud. He
himself attributed his downfall to
the 'bad habits' he picked up serving
in the National Guard during the
siege of Paris in 1870-71,
culminating in 'the first quarrel of
our youthful household...it
happened after I had returned
home excessively vinous (to be
more precise, it was absinthe) from
the ramparts'.*

clearly. Whereas in general bright colours and thick pigments usually imply that the painted object is brought closer to the spectator, Cézanne applied intense colours with thick strokes of pigment in equal amounts in both the foreground and in the background in many of his paintings of Aix en Provence.

Les Grandes Baigneuses shows clouds and a blue sky which are painted with the same formal conviction as the lumpy nudes in the mid-ground of the painting. Cézanne has used such thin paint in the extreme foreground that the bare canvas shows through in some places. This device has the function of pushing thinly painted objects back into the distance. The process is a curious one and has the effect of almost turning the space within the picture inside out.

Formal concerns, in fact, dominate Cézanne's mature painting. In 1875 he began a series of paintings based upon the nude in a landscape, a theme which was to preoccupy him for the rest of his life.

The theme of the figure in a landscape dated from the 18th century and nudes always had some historical, mythical, moral or sexual connotation. Cézanne's have neither personality nor sexuality; he simply reduced them as a subject to their basic formal constituents, as in the two versions of *Les Grandes Baigneuses*. Both are pyramidical and have an almost classical severity in their construction with the figures aligned parallel to the picture plane and leaning inwards to form one or more triangles. In the version now in Philadelphia, the trees form an isosceles triangle, whereas the London version is more subtle, though even there the individual brush-strokes and the shape of the clouds support the geometry of the composition. Cézanne took his figures from memory – he was reluctant to paint from a model – or from the works of Titian, Veronese and Rubens that he saw in the Louvre, as well as from classical sculptures and the photographs of them available in Paris by the turn of the century.

Described by the painter Maurice Denis (1870-1941) as 'the Poussin of the Impressionists', Cézanne had said that his aim was to 'do Poussin again in contact with nature'. However, despite their underlying classical logic, his paintings were difficult to understand and were disliked by his contemporaries. This lack of recognition embittered him, and his works were bought only by a few enthusiastic collectors from the one place that they were available, the shop of the colour merchant Julien (*père*) Tanguy. He did not succeed in gaining admission to the Salon until 1882, when he finally succeeded, ostensibly as a pupil of Guillaumin.

Disappointment soured Cézanne and his resulting boorishness alienated his friends. When, for instance, Zola's novel *L'Oeuvre* was published, Cézanne saw in the hero – a failed artist who commits suicide – a cruel portrait of himself, and the two men were never to meet again. Towards the end of the 1880s, however, his reputation gradually improved; through Chocquet's good offices, he was asked to show at the Exposition Universelle, while, together with Sisley, Gauguin and Van Gogh, he exhibited in Brussels with the avant-garde Société des XX. The press also began to notice him favourably; Emile Bernard (1868-1941) wrote enthusiastically in *Men of Today*, as did Georges Lecomte in *L'Art Impressionniste*. In 1895 Ambroise Vollard bought 200 of his paintings for between 80,000 and 90,000 francs and organized his first one-man show, though many canvases had to be withdrawn because of public outrage. In 1898, 1901 and 1902 he showed at the Salon des Indépendants and was by now attracting the admiration of the younger generation, including Maurice Denis, Edouard Vuillard (1868-1940), Ker Xavier Roussel (1867-1944), Pierre Bonnard (1867-1947) and Odilon Redon (1840-1916). Denis painted *Hommage à Cézanne* in 1900 and was later to describe his work as 'the final outcome of the classical tradition and the product of the great crisis of liberty and light which has rejuvenated modern art'.

THE INFLUENCE OF IMPRESSIONISM

While Impressionism may have rejuvenated modern French art and would in time have repercussions on international art, it had relatively few followers then, at least in England. Despite the enthusiasm of some critics and painters, the main body of artistic opinion was implacably hostile. In 1888, W.P. Frith in England voiced the academicians' reaction:

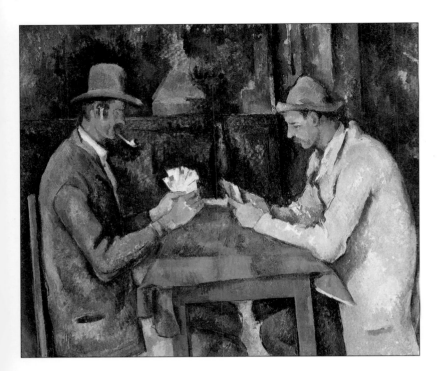

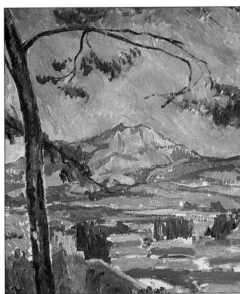

Card Players *(above) by Cézanne, painted between 1890-92.*
The solidity given to traditional themes of the figure in the
landscape has in this instance been applied to two human figures in
a domestic setting. The Mont Sainte-Victoire *(above right)*
by Cézanne, painted between 1904-05. The picture, which is
incomplete, shows the manner in which a formal appreciation of
this recurrent theme emerges from the application of a series of
interlocking patches of paint. The Mont Sainte-Victoire *(right)*
by Cézanne, painted around 1886.

> We have now done, long ago, with the Pre-Raphaelitic, and another, and far
> more dangerous, craze has come upon us. Born and bred in France, what is
> called *Impressionism* has tainted the art of this country...So far as my feeble
> powers enable me to understand the Impressionist, I take him to propose to
> himself to reproduce an *impression* – probably a momentary one – that Nature
> has made upon him. If the specimens of the impressions I have seen are what
> have been made on any human being, his mind must be strangely formed...It is
> to be hoped that the 'Impressionists' will not be allowed to play their pranks in
> the Royal Academy exhibition....

Even in 1900, *The Times* still had its suspicions:

> It is not quite easy to decide how far the admiration for these things, which is
> now generally expressed in France, and among advanced collectors elsewhere,
> is genuine, and how far it is the result of a desire to appear "in the movement",
> carefully forced by one or two clever dealers. We ourselves are inclined to think
> that the craze for the impressionists' landscapes will not last.

However, the New English Art Club, founded in 1886, whose leading members were Philip
Wilson Steer (1850-1942) and John Singer Sargent (1856-1925), embraced a modified form of

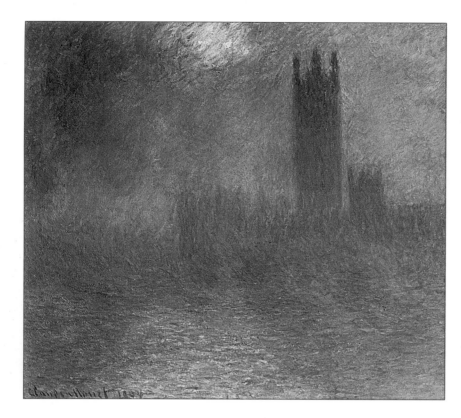

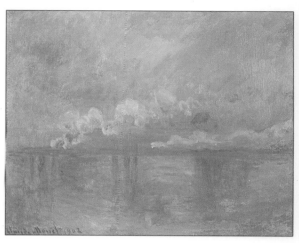

The Houses of Parliament, the Effect of Sun through the Fog *by Claude Monet, painted in 1904 (left)*. Charing Cross Bridge, London *by Monet, painted in 1902 (right). On this trip to London, Monet returned to the themes he had first explored in his earlier visit as a refugee in 1871.*

Impressionism for a time, while the Camden Town Group, of which Walter Richard Sickert (1860-1942) was a member, held an exhibition in 1889 under the name 'The London Impressionists'. Max Liebermann (1847-1935) painted in an Impressionist manner in Germany and in 1895, in the United States, 'The Ten', a group of painters who were distantly influenced by the Impressionists, held their first exhibition.

By the turn of the century, however, little remained of the principles that had animated Impressionist painting in the 1870s. Many of its principal exponents had found that a style contingent upon material experience had drastic limitations and had reverted to the order and logic of the classical tradition.

Moreover, by the 1890s a new generation of avant-garde painters, which included Vincent Van Gogh (1853-90) and Henri de Toulouse-Lautrec (1864-1901), had emerged. For them, Impressionism had no appeal, though they copied its form and subject-matter while investing their works with a new emotional force and symbolism. Maurice Denis in *L'Occident* in 1909 saw their predicament, which was also that of Gauguin:

> Art for them, as for their predecessors, was the rendering of a sensation, the exaltation of the individual sensibility. They began by aggravating all the excessive, disorganized elements belonging to Impressionism, and it was only gradually that they became aware of their innovatory role, and realised that their synthesism or symbolism was the precise antithesis of Impressionism.

Sisley continued to paint naturalistic studies in the district around his home at Moret-sur-Loing and by the 1890s Monet had become very popular and immensely successful. He could play off the dealers, such as Durand-Ruel, Petit and Boussod & Valadon, against one another to his financial advantage, and, again by the 1890s, his annual income was reputed to be over 100,000 francs. With financial security, he was free to experiment and in those years he embarked on a series of paintings, of which that of the *Haystacks* was the first. In these, he worked on several canvases simultaneously to maintain the

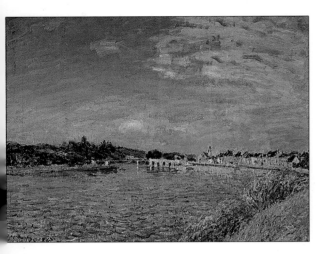

The Banks of the Seine *(left) by Alfred Sisley, painted in 1886. Examination of the surface of the painting shows rapidly applied, comma-like flecks of pigment. Later works by Sisley are characterized by the use of brighter colours and the fluid application of paint.* The Church at Moret *by Sisley, painted in 1894 (right). Sisley, unlike other members of the Impressionist circle, continued to apply the principles of Impressionism without major modifications and was not distracted by scientific theories, symbolism and the examples of a classical past that variously preoccupied his peers.*

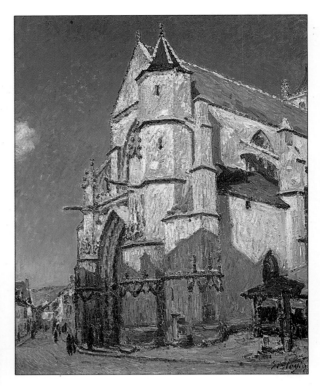

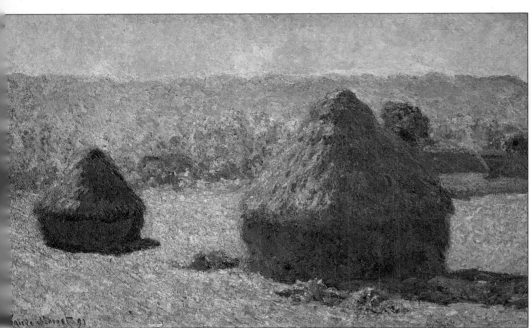

Haystacks *(left) by Claude Monet, painted in 1891, was one of a series of paintings on the same theme. Monet gives the pictures great luminosity, especially within the shadows, by juxtaposing unlikely colours. Examination of the haystack on the right shows the harmonies created by contrasting purple and orange shadows.*

naturalistic integrity of each, since he claimed he could not reasonably continue working on one when the light changed. All these paintings sold within three days for between 3,000 and 4,000 francs each. He followed with a series of *Poplars* painted on the banks of the Epte in the same year, and in the next two embarked on two series of studies of *Rouen Cathedral*. Georges Clemenceau, in *Pan*, a collection of essays published in 1896, understood what Monet was aiming to achieve:

> Rouen Cathedral is an unchanging and unchangeable object, yet it is one which provokes a constant movement of light in the most complex way. At every moment of every day, the changing light creates a new view of the cathedral, which seems as though it were constantly altering. In front of Monet's twenty views of the building, one begins to realize that art, in setting out to express nature with ever growing accuracy, teaches us to look, to perceive, to feel.

In 1890 Monet had acquired a country estate at Giverny, just north of Paris, and there, over the next few years, he created, with the help of a Japanese gardener, a garden which was designed to provide him with the perfect subject for his last experiments. He embarked on a series of paintings of water-lilies, including some truly monumental tableaux, for which in 1914 he had to build a special studio. They slotted together to form one continuous vista, at

continued on page 144

ROUEN CATHEDRAL SERIES
CLAUDE MONET (1840-1926)

Rouen Cathedral: Harmony in Grey by Claude Monet, painted in 1894 (below); *Rouen Cathedral: Harmony in Blue*, 1894 (below right); *Rouen Cathedral: Harmony in Blue and Gold* (right, detail facing page), 1894. These three paintings form part of a series showing the effects of light across the façade of the cathedral at Rouen at different times of day. The majority of the series show the cathedral's west front, depicted in thick, crusted impasto, in some cases dramatically overpainted in colours that vary considerably from the under painting. Research indicates, however, that most of these paintings were reworked in the studio to improve upon the image fashioned before the subject. Well-finished serial paintings, such as those above and opposite were enormously popular with collectors both in France and abroad and sold for very high prices, often financing more ambitious projects.

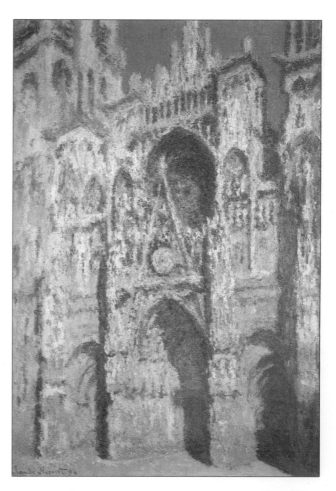

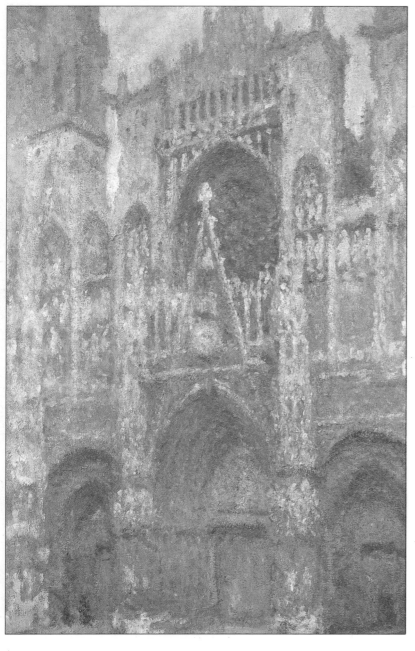

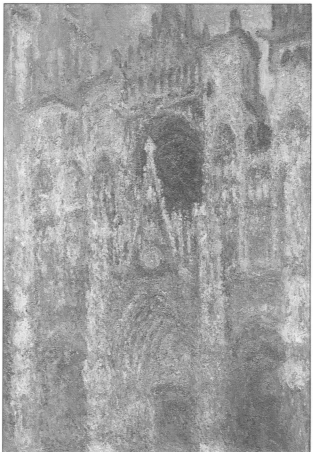

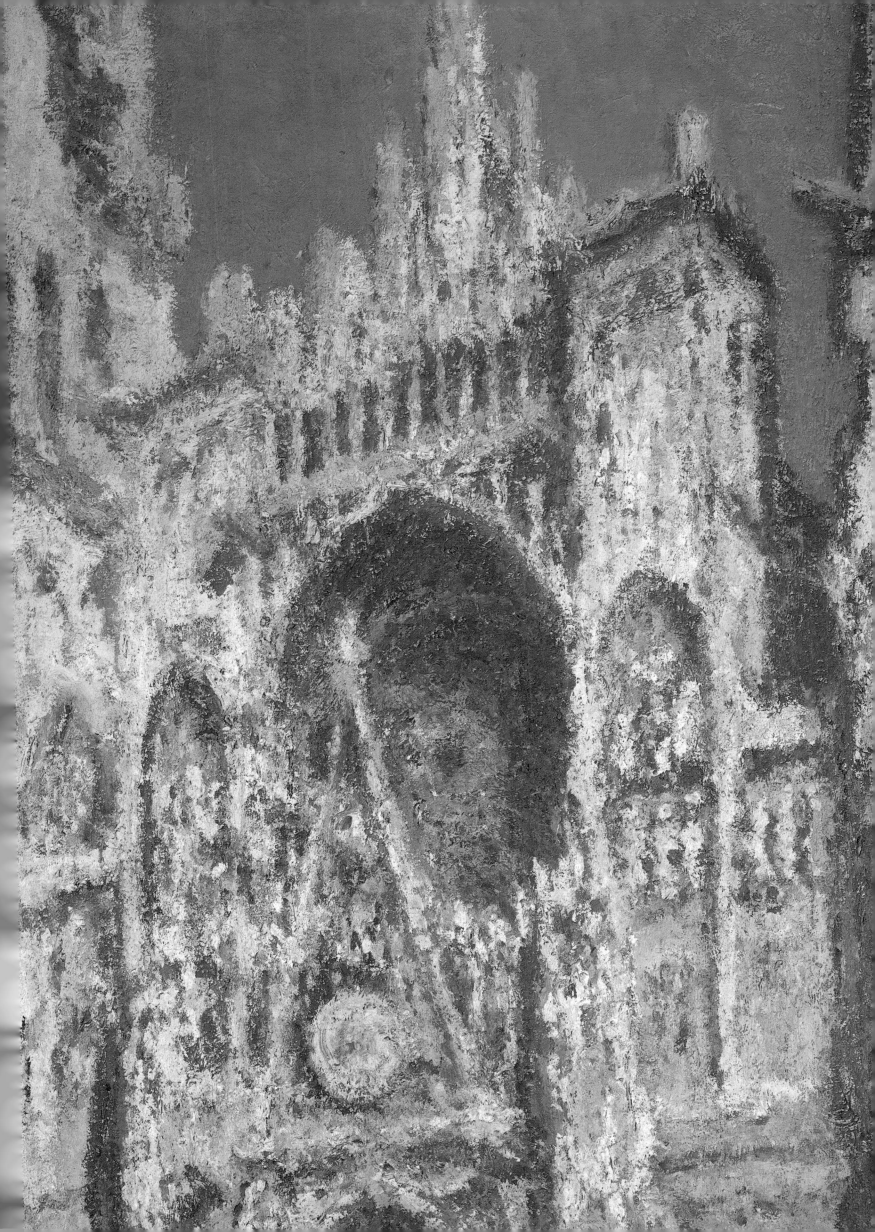

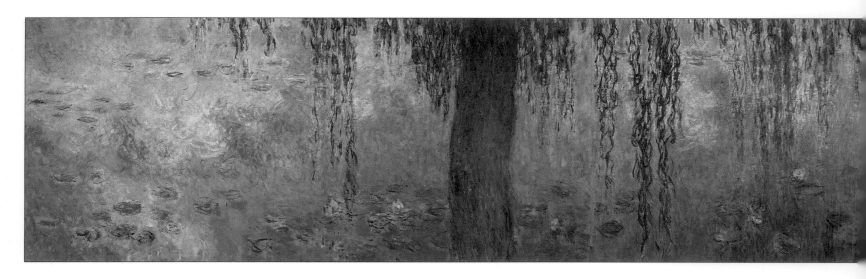

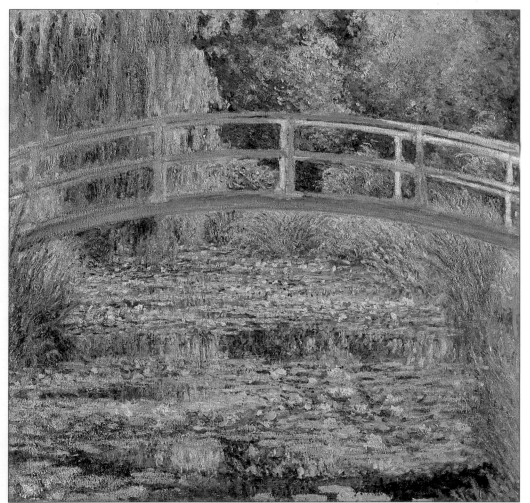

Morning with Willows: Water Lily Decorations *by Claude Monet, painted in 1922 (above). It is one of four huge panels, each made from component canvases. Four pictures on a similar scale are installed within an oval room at Giverny and completely surround the spectator. Although there is an unbroken link between the early works of Monet and those made in the last years of his life, the factual concerns of Impressionism have all but disappeared. The canvases are made in the studio rather than before the subject and take on an almost abstract value, where colour and scale become ends in themselves and do not need to be justified by reference to material objects in the outside world.*

Japanese Bridge, Giverny *by Claude Monet, painted in 1899 (left). The gardens at Giverny, designed in part by Monet himself, are the start of an almost unique generative process whereby an artist is recording the effects of nature which are of his own making. The process is extended and finally consummated in the larger cycle of paintings of water lilies shown above.*

which the spectator was forced to gaze down as if looking into a pond. With the help of Clemenceau, he arranged to donate these tableaux to the nation, and the exhibition of them in the Musée de l'Orangerie in Paris was opened in 1927, a year after his death.

By 1900, Impressionist paintings were not only safe investments for collectors. They had also become a respected part of the cultural heritage of France. An article on the history of the movement, entitled *L'Impressionnisme, son histoire, son esthétique, ses maîtres*, by Camille Mauclair gives some indication of the extent to which critical attitudes had changed since the first Impressionist exhibition in 1874. Writing for the *Mercure de France* in 1904, Mauclair, a

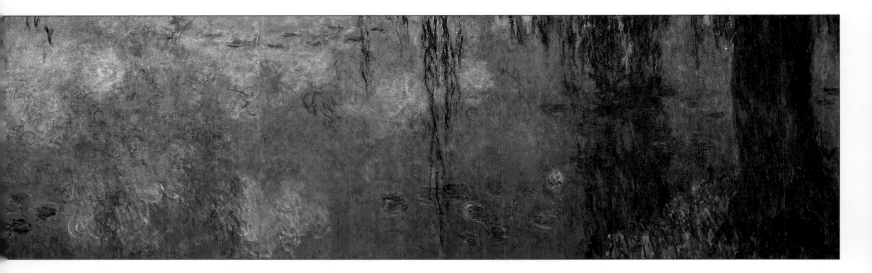

staunch nationalist and a notoriously conservative art critic wrote:

> It is absolutely evident that Manet, Monet, Renoir and Degas have created
> masterpieces that can rank with those in the Louvre and the same might be said
> of some of their less famous colleagues...

Impressionism was, he continued:

> the greatest movement in painting that France has known since Delacroix; it
> brings the nineteenth century to a glorious finish and presages well for the
> next. It has accomplished the great feat of having brought us once again into
> the tradition of our great national heritage.

Impressionism, indeed, does bring the century to a glorious finish. It also marks the end of the realist and naturalistic traditions in French painting of the period. Monet, Renoir, Sisley, Degas, Manet and the others had made some unique and profoundly important contributions to the history of art. They raised the status of landscape painting and did much to abolish the hierarchical organization of subjects into various genres. They developed gestural techniques of painting and new compositional devices to record movement and to simulate the effect of chance encounters with modern city life. However, they were contributing to a now well-established tradition, which had been initiated by Corot and the Barbizon School.

The generation of avant-garde painters that followed the Impressionists looked upon naturalism as outdated. Instead, they became preoccupied either with the abstract, formal values of colour and space, or with the arcane intricacies of their imaginations. Maurice Denis gives an indication of the changing concerns of this new generation of artists and, in particular, the way in which the Symbolists perceived the heritage of Impressionism in an article in *L'Occident*, written in 1908. His observations serve as a fitting epitaph for the Impressionists, as well as giving a clear indication of the aesthetic concerns of the Symbolists that had replaced them. Denis wrote:

> Art is no longer just a visual sensation that we set down, a photograph,
> however refined it may be, of nature. No, art is a creation of our imagination of
> which nature is the only occasion. Instead of "working outwards from the eye,
> we explored the mysterious centre of thought", as Gauguin used to say. In this
> way, the imagination becomes once more the queen of the faculties, in
> accordance with Baudelaire's wish. And thus we set free our sensibility; art,
> instead of being a copy, becomes the subjective deformation of nature.

6 THE GAZETTEER OF IMPRESSIONISM

Four areas of France have close links with the Impressionists, as the map here shows. In and around Fontainebleau and its forest, they followed in the footsteps of the Barbizon School, making their first experiments with plein air painting. Later, came a switch in activity to Normandy and the Channel coast, where the St-Siméon farm became known as the 'Barbizon of Normandy'. Paris remained the Impressionist headquarters until the 1880s; in later years, many went to live or stay for periods in the south. This gazetteer is divided into specific sub-sections, covering each area in which the Impressionists lived and worked. The sub-sections themselves are arranged chronologically; the entries within them follow a logical geographical order, to help the present-day visitor plan a tour.

THE FOREST OF FONTAINEBLEAU

In the history of Impressionism the forest of Fontainebleau in the Ile de France, and the small villages on its perimeter, Barbizon, Marlotte and Chailly-en-Bière, are primarily of interest for the part they played during the early stages of the movement and the period of *plein-air* painting that immediately preceded it. Only one location, the small town of Moret-sur-Loing and its suburbs, features in the later story: it was the home of Alfred Sisley for the last 20 years of his life, and provided the subject-matter for the many paintings he produced during that time.

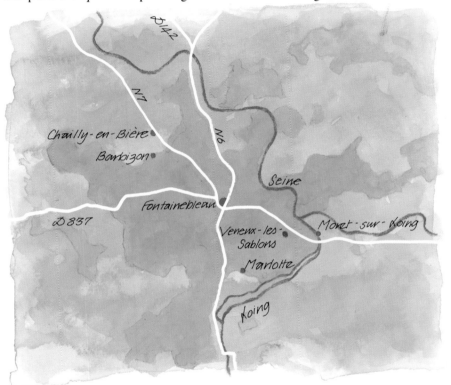

FONTAINEBLEAU

Artists were attracted to the forest of Fontainebleau from the early 19th century onwards: it was not only sufficiently far removed from urban life to afford them views of nature in her 'untamed' state but also within reasonable reach of Paris. By the mid-1860s, for example, Monet was able to reach the forest by taking the train to Melun and then boarding the regular coach service to the Chailly area. The Fontainebleau region also had the advantage of very diverse topography, giving painters a great range of subject matter. Geologically, the region forms part of the Paris basin and is composed of layers of sandstone overlaid by a later covering of limestone. The forest stands on limestone; where this has been worn away to reveal the sandstone beneath, forest gives way to shrub-covered plateaux and heath, fissured by ravines and punctuated by strange eroded rock formations. To the west of the villages of Barbizon and Chailly-en Bière stretches the flat agricultural plain of Chailly, where the sandstone itself has been further eroded to reveal the rocks beneath.

The forest itself consists of stands of beech and oak, often specimens of

Monet and Bazille made their first plein-air studies in the forest over Easter 1863.

considerable size, interspersed with open areas where the terrain is more rugged. Today the forest is even more accessible from Paris: the Autoroute du Soleil runs across its western flank, and its small rural communities have become country retreats for the well-off. Even so, these villages have retained some of their former rusticity, and the forest, though crisscrossed by a network of roads, is still sufficiently unspoiled to show what attracted the *plein-air* painters to it.

Much of the painting of the Barbizon School (the generation of *plein-air* painters who preceded the Impressionists) consisted of somewhat idealized forest landscapes that cannot be specifically identified: rock-strewn scenes in the heart of the forest; rocky

outcrops; marshy ponds with grazing cattle; and clearings with or without a single tree as a central focus but often lit by dramatic lighting. Certain parts of the forest that were particularly popular, however, are identifiable in the work of painters from the Barbizon School onwards, and some can still be seen today. One is the Bas Bréau, an area just east of Barbizon, which is noted for its massive oaks and beeches. It was a favourite location of the Barbizon painter Théodore Rousseau, while Monet painted one of the famous oaks here in a picture of 1865. Near Bas Bréau is another striking part of the forest, which was also much favoured by the Barbizon artists. This is the Gorges d'Apremont, where piled rocks of all shapes

and sizes are topped by a plateau cut by ravines and commanding views over the Bière plain.

One prominent figure in the Barbizon School, Millet, preferred the vast open expanse of the plain of Chailly to the forest interiors and immortalized it and its agricultural workers in a series of paintings, the most famous of which, *The Angelus* (1855-7), shows the distant church of Chailly-en-Bière on the horizon.

BARBIZON

The village that gave its name to the Barbizon School also became the home of two of the school's leading members; Rousseau, who retired there in 1847, and Millet, who settled there two years later. Both built themselves studios where they could paint; Millet's was at the bottom of his garden, and Rousseau adapted an old barn. Although Barbizon is a sizeable village today, in Rousseau's and Millet's time it was just a one-street hamlet, an outlying district of the larger village of Chailly-en-Bière. That is, presumably, why both artists lie buried in Chailly churchyard.

On earlier visits to the forest, before settling permanently at Barbizon, Rousseau lodged at the Auberge du Père Ganne which opened in 1822. (Le Père Ganne seems to have derived a substantial part of his income from feeding and boarding the many itinerant artists who came to paint in the forest.) The auberge, on Barbizon's Grande-Rue, still exists, but, now a museum, it bears little resemblance to the rude and rustic hostelry of the 19th century. Greatly changed, too, are Millet's and Rousseau's houses and ateliers, which are still to be found on the Grande-Rue, at numbers 27 and 55 respectively. The latter is now the Musée Municipal de l'Ecole de Barbizon. The four rooms on the ground floor contain photographic views of Barbizon in former times and an audio-visual display of the works of the Barbizon painters. In Rousseau's former atelier on the first floor are displayed one of

The forest had attracted painters ever since Rousseau moved to Barbizon in 1836.

Millet's house (left), the Auberge du Père Ganne (above) and the Musée Municipal de l'Ecole de Barbizon (above right) are all on Barbizon's rue Grande. The Auberge itself is also a museum; the Musée Municipal is housed in Rousseau's former home. One of the attractions of the Auberge – one of two in the village – was its cheapness; full board was only two francs 70 per day. However, the Goncourt brothers noted ruefully that the cuisine was largely confined to omelettes.

his drawings and a selection of oils and pastels by Dupré, Jacques, Diaz and other lesser known Barbizon artists. For a more comprehensive view of the work of these artists, however, a visit to the Louvre and Musée d'Orsay in Paris is strongly recommended.

CHAILLY-EN-BIÈRE

Whereas the earlier generation *plein-air* painters centred their activities on Barbizon, the Impressionists – Monet and Bazille in particular – made first for Chailly-en-Bière. The two young painters first visited the village in 1863, staying at the Auberge du Cheval Blanc. No paintings appear to have survived from this first trip to the Fontainebleau area, although we know from Bazille's letters to his parents that he and Monet were

greatly impressed with the rocks and oaks. We have more concrete evidence from their second visit two years later. Apart from his dramatically lit, Barbizon-School-like study of an oak tree in the Bas Bréau, Monet also produced some less stylized paintings: forest scenes, including two views of Le Pavé de Chailly, a woodland road (which no longer exists in a recognizable form) linking Chailly-en-Bière with Fontainebleau, and the courtyard of a farm in the village.

Monet's main purpose in coming to the forest, however, was to make some preparatory *plein-air* studies for an ambitious project, *Le Déjeuner sur l'herbe*, a painting he intended to exhibit at the Salon. We know from Bazille's correspondence with his family that Monet persuaded his friend to visit Chailly-en-Bière primarily for the purpose of posing as a

model for his painting, and *Les Promeneurs* (1865) shows Bazille and an unidentified woman in a preparatory study for the final work. Although the studies were executed in the forest around Chailly, Monet actually painted the first, small, preliminary version of the painting and the finished work itself in Paris at his studio in the rue de Fürstenberg. The huge painting was never exhibited, however. Monet subsequently cut it into fragments, two of which have survived and are now reunited at the Musée d'Orsay.

Bazille also painted views of the forest; but his major surviving work from this second visit to Chailly-en-Bière is *L'Ambulance improvisée* (1865), which shows Monet laid up in bed with an injured leg. It was painted at the Auberge du Lion d'Or, the inn where the two painters lodged on their second visit.

MARLOTTE

Renoir and Sisley also visited the forest of Fontainebleau in 1865. For Renoir it was not his first stay; he is recorded as painting in the area on an earlier occasion, when he had a chance encounter with the Barbizon painter Diaz, an example of the forest being a physical as well as a symbolic meeting place for the two generations of *plein-air* painters. Renoir and Sisley did not choose to stay at Chailly-en-Bière, but further south at the

village of Marlotte, a choice of location doubtless influenced by the fact that their friend Jules Le Coeur, an amateur painter, had purchased a house there the same year.

The following year Renoir, Sisley and Le Coeur painted once more in the forest, making a trip to Milly-la-Forêt and again residing in Marlotte. Although Renoir and Sisley seem to have stayed with Le Coeur for some of the time on these visits, they also lodged at L'Auberge de la Mère Antoine. Renoir's painting of the same name, produced in 1866, shows his friends (two of the figures are generally believed to be portraits of Le Coeur and Sisley) gathered around a table in the village inn, with Nana the serving girl and la Mère Antoine in the background. Sisley and Renoir also painted views of Marlotte itself and a number of Barbizon-School-like forest scenes. These include Renoir's *Jules Le Coeur in*

Fontainebleau Forest (1866), which shows his friend in a clearing with his dogs.

MORET-SUR-LOING

Moret-sur-Loing's overriding Impressionist association is with Sisley. Other Impressionists, particularly Pissarro, occasionally painted the small town, but for Sisley it was home for the last 20 years of his life and, together with the surrounding villages and countryside, provided virtually all his subject-matter over that period.

Moret has grown considerably over the last century, engulfing the hamlets where Sisley lived and worked, but it remains a picturesque town, tucked into the final meander of the River Loing before it joins the Seine. A busy route nationale skirts the town's southern flank but its

centre still remains something of a backwater.

The rue Grande, which is broad and lined with elegant houses, hotels and cottages on the Fontainebleau side of the town, narrows considerably at the church and river end. The narrow streets that wind around the church, the ancient half-timbered house and the multi-arched bridge would all still look very familiar to Sisley, who lived at this end of the town on two occasions. The house where he spent the last five years of his life still stands at the angle of the rue du Château and rue Montmartre, but is not open to the public.

Sisley first moved to the Moret area in 1880, living at Veneux-Nadon, then a small hamlet on the

The church of Notre-Dame above the river in Moret-sur-Loing, Sisley's home for 20 years.

outskirts of the town. He stayed there for two years before moving briefly into Moret itself. In 1884 he moved out of the town to Les Sablons, another small village on the outskirts of Moret (just 10 minutes from the town centre, the artist told his friend Monet, when he wrote to him extolling the delights of the area). Five years later he moved back to Moret to settle there for good, first renting a house on the rue de l'Église, then in 1895 another with a small enclosed garden on the rue du Château. He is now buried in the Moret town cemetery.

Sisley was first and foremost a lansdscape artist, and a painter of riverscapes in particular. Buildings are sometimes incorporated into his scenes but, with the notable exception of a series of views of the church of Notre-Dame, they are not usually the dominant feature. His paintings of Veneux-Nadon, for example,

focus mainly on the river, with its boats and barges moored on the banks, or on the orchards, plains and meadows surrounding the river. (There are, however, a couple of views painted within the village, showing it under snow, with a few figures in what must have been the main street.) Similarly, in his views of Les Sablons, the only buildings are usually a single farm or distant cottage viewed through a screen of trees.

Barges and poplars still line the banks of the Loing as they did in Sisley's time. Like the other Impressionists, Sisley frequently painted riverside scenes.

At Moret itself Sisley had favourite viewpoints at the river end of the town, which he returned to time and again in a series of paintings that depict changes in light or season. The dominating theme is the town seen beyond the Loing from various viewpoints on the St Mammès side of the river. The painter looks upstream towards the medieval bridge and the Moret mills, with the church, the porte de Bourgogne and the roofs of the town beyond. Sometimes we are afforded a clear view of this scene; in other paintings the bridge and town are seen through the alley of poplars that line the river bank. Sisley painted two series of this view, in 1887-8 and in 1892. Similar views can be enjoyed today on the route to St Mammès and at the viewpoint on the pré du Pin.

In 1892 Sisley painted a series of studies of the Moret mills, springing up from the islets in the centre of the Loing. Views within the town also occasionally occur in his work. In 1892, for example, he painted *La Rue*

de la tannerie, *Lilacs in My Garden* and *My House*. From their date, the last two paintings must depict his house on the rue de l'Église.

Sisley's main subject in the town itself, however, was the medieval church of Notre-Dame, which is depicted in more than a dozen paintings executed in the mid-1890s. All have an identical viewpoint, showing the west porch and south transept of the church, with a covered market building in the right foreground. The church is seen from sufficiently close up to fill almost the entire picture space, an uncharacteristic arrangement for an artist who favoured low horizons and expanses of sky.

Sisley also painted a great deal at St Mammès on the opposite bank of the Loing, at its confluence with the Seine. In 1884, for example, he painted from this viewpoint a large number of views of the Loing and its canal: there are typical Sisley riverscapes with a straggle of houses, a low horizon and a large expanse of sky. St Mammès, then as now, was a centre for inland water transport and many of these views show canal boats and barges moored against the banks. Others depict the weirs and barrages along the river. In addition to these pictures, Sisley painted many more local riverscapes and landscapes.

NORMANDY AND THE CHANNEL COAST

The busy ports, fashionable resorts and cliff-lined beaches of Normandy were a major source of inspiration for the Impressionists. But their choice of this particular stretch of the French coastline rather than any other was to a large extent dictated by its ready accessibility from Paris: the development of the railway network made resorts such as Deauville and Trouville, already popular with Parisians, even easier to reach.

Monet, the driving force of Impressionism, grew up in Normandy, which was already an area with a strong tradition of local painting and often returned to it throughout his career to paint his favourite locations. Apart from Monet, the painter who is perhaps most closely connected with the Normandy coast is Eugène Boudin, a forerunner of Impressionism and a native of the area, who spent much of his life painting its harbours, estuaries, resorts and the striking cliff formations at Etretat. For the visitor to Normandy, fine examples of his work can be seen in the Musée André Malraux in Le Havre and the Musée Eugène Boudin in Honfleur.

One particularly rewarding area to go Impressionist site-spotting is the Côte d'Albâtre, which despite its modern popularity, is essentially no different in appearance from when Monet, Pissarro and others painted it. Bounded by the chalk cliffs of Dieppe at one end and those of Le Havre at the other, this is an imposing stretch of the Normandy coast. Where the large chalk plateau of the Caux meets the Channel, the erosive forces of the sea have produced a typical limestone coastline: tall cliffs out of which the waves have carved entrances; steep-sided dry gorges (former river beds). known locally as *valleuses*, which the retreat of the coastline has left halfway up the cliff face; and, at ground level, small bays with sandy or pebble beaches. At these bays on the Côte d'Albâtre a series of coastal resorts, such as Etretat, Fécamp and Pourville, have grown up to cater for holiday-makers.

POURVILLE AND VARENGEVILLE

The coastline at the small town of Pourville and a little further west at Varengeville was the subject of three painting expeditions by Monet. The first two in February 1882 and from June to October of the same year, when he installed his family in the Villa Juliette in the centre of the town were periods of immense activity, to which about 80 paintings have been dated. They mark the beginning of his preoccupation with serial painting in Normandy, whose high points were to be his studies of the cliffs at Etretat the following year and his famous renditions of the façade of Rouen Cathedral the following decade. In producing such series, the painter first prospected for suitable subjects, then selected a limited number, which he then depicted from a variety of angles and in different lights. On the Normandy coast he worked in bad weather from sheltered positions in cliff hollows, huts on the beaches or, when there were

The bay at Pourville looking south-west. This was one of Monet's favourite studies.

Pourville fishermen. Monet produced around 80 paintings here in 1882.

bad storms, indoors, painting the view through a window.

When he returned to the area in 1896 Monet painted the same subjects that he had chosen on his 1882 expeditions, although on this second trip advancing years forced him to relinquish some of his previous, less accessible vantage points. During his second stay he also produced less work, returning to Giverny with 30 to 40 canvases.

At Pourville Monet concentrated on the bay of the little resort, depicting the views out to sea bounded by a headland at each end. Looking northeast, towards Dieppe, he painted the Côte aux Herons; in the opposite direction he depicted the bay, looking towards the cliffs of Varengeville and

the Point d'Ailly beyond. He also produced views of the beach itself, concentrating on the flat rocks exposed at low tide, the fishing boats and their nets looped up on tall poles.

At Varengeville his favourite subject was a small hut that was once a custom post, known as the Cabane des Pêcheurs or the Cabane du Petit Ailly. This was precariously situated on the flank of a steep-sided *valleuse* known as the Gorge du Petit Ailly, which remains isolated and rather inaccessible to this day. Monet painted the hut and the sea beyond on all his visits, showing it in different weathers and from different angles, including one looking down on it from on high. Sometimes it is silhouetted against the sun; in other canvases it is almost obscured by rain and spray. Monet also painted Varengeville's church, which also stands in an isolated position commanding an impressive view over the sea. In some views he looks across a narrow valley, the Gorge des Moutiers, and shows the church on the horizon; in others we see it at closer range, with pine trees in the foreground.

Of the other Impressionists, Pissarro and Renoir both painted in the

Pourville-Varengeville area. Pissarro made a brief visit to Varengeville in September-October 1899 but, unlike Monet, turned his attention inland to depict the kitchen gardens of an auberge near the Manoir d'Ango, a Renaissance château just outside Varengeville. Renoir painted at Pourville in 1879, probably on one of the many coastal visits that he made while spending the summer at nearby Berneval with his patron Paul Bérard. He produced a view of the bay from the top of the western cliffs and also a distant study of the gabled, stone and wooden houses in the little resort itself.

ETRETAT

From the beginning of the 19th century Etretat was for painters a place of pilgrimage, it might almost be said. Vernet, Delacroix and Courbet all went there to study and paint the fantastic limestone configurations produced by the erosion of the sea. It was Monet, however, who was most fascinated by the chalk cliffs, stacks and caves and most prolific in his rendition of them. Today the coastline here is as strong a tourist attrac-

The church at Varengeville, with its cemetery overlooking the Côte d'Albâtre (above) was also painted by Monet, both from a distance and at close quarters.

The headland at the north-east end of the bay (below) looks towards Dieppe. As well as Monet, Renoir and Pissarro also painted here, the former making one visit in 1879.

Two views towards the chalk cliffs of the Falaise d'Amont and the chapel of Notre-Dame-de-la-Garde, above Etretat. The author Guy de Maupassant watched Monet working there and noted how he moved from painting to painting during the same session to capture the changing light. This major painting trip was made in early 1884 as a result of which 18 canvases are known to have been produced. Previously the same location had been visited by Courbet.

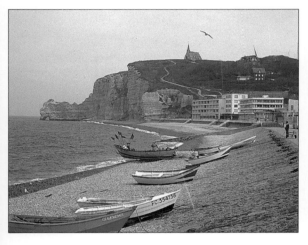

tion as it was a century ago and is relatively unchanged; all the main features of Monet's paintings can be seen either by walking along the beach or from the cliff tops.

Monet made several trips of varying length to Etretat. The earliest recorded painting, a sketchy view of the beach, dates from the winter of 1868, when he lived briefly in the town with his wife and young son. However, most of his work during this stay consists of interior studies of family mealtimes, such as *The Artist's Family at Dinner* (1868-9). His first major trip to the area was in January-February 1883. This was the occasion for a series of views of the cliffs, a project similar to that undertaken at Pourville and Varengeville the year before; the 18 known canvases that Monet produced on this visit establish the subject matter and viewpoints that were to occupy him on his subsequent visits. These were in August 1884, when bad weather prevented him from painting much; in

October-December 1885; and a brief sojourn in February 1886.

The cliffs at Etretat, with their eroded 'doorways', curve around the bay. The Falaise and Porte d'Amont stand at the eastern end, the Falaise and Porte d'Aval, which also has an eroded chalk stack known as the Aiguille, at the western end. Positioning himself at different viewpoints on the cliff tops or on the shore – positions often accessible only with difficulty – Monet painted views of each headland, with the broad sweep of the bay in the foreground. He depicted the cliffs in a variety of weather conditions, and since the weather can change very quickly on the Normandy coast, his task sometimes involved working on several canvases at the same time, moving from one to another as the light changed. (And it must never be forgotten that for some Impressionists, and for Monet in particular, light was the pre-eminent subject of any painting.)

Monet also painted in a neighbouring bay to the west, which has a particularly impressive chalk 'doorway' known as the Manneporte. There he produced a number of views showing the Manneporte, the Porte d'Aval and the Aiguille and also close-ups of the Manneporte alone. On his 1885 visit he painted two views of the Aiguille glimpsed at a distance through the aperture of the Porte d'Amont and two in the reverse direction showing the Porte d'Amont seen through the Porte d'Aval. Many of these pictures were executed from positions on the shore that would have been accessible only at low tide, so he must have worked very quickly on such occasions.

Among the other features at Etretat that drew Monet's attention were the small fishing boats beached on the shore. He painted these both from an annex of the Hôtel Blanquet or, as in *Boats in Winter Quarters at Etretat* (1885), from the terrace along the sea front which today bears his name.

His 'catchment area' extends to the cliffs of nearby Grainval to the south-west and as far as the headlands of the Petites Dalles to the north-east. Three years later, in 1884, Monet made a short return visit to the Petites Dalles, painting three more views of them, together with an inland study of the nearby forest.

Fécamp was also an early port of call for Berthe Morisot, who visited it in 1873 and painted a small group of studies of figures on the beach.

DIEPPE

Despite being a major passenger and commercial port, Dieppe still retains much of its 19th-century appearance in the narrow streets and the squares of its old town. The port was frequently visited by Renoir, whose friend the painter Jacques-Emile Blanche lived there (in 1879 Renoir

Calm weather off the Falaise d'Aval, looking away from Etretat towards Manneporte. This was the exact scene painted by Courbet during his 1869 visit.

Monet's fascination with Etretat was matched by that of Courbet, who painted in the area some years earlier. Courbet's first prolonged visit was in 1869, when he stayed for more than a month, producing at least 10 seascapes, two of which were exhibited at the Salon the following year; one was *Cliffs at Etretat after the Storm* (1869-70), which was a view of the Porte d'Aval. It is likely that these paintings were direct inspiration for Monet's. Whereas Monet was primarily interested in the cliffs and other coastal features, Courbet was more drawn to the sea itself, of which he produced many studies. Like Monet, he worked in all types of weather and painted from the window of the house where he lodged when the rain prevented *plein-air* work.

FÉCAMP

Another coastal town in Normandy that provided inspiration for Monet was the fishing port of Fécamp. The earliest recorded works of the artist produced there date from 1868 and

are typical Monet seascapes, showing boats moored in the harbour. In 1881 Monet made a more prolonged visit to the port, painting about 20 pictures. On this occasion he produced two more harbour scenes and a view of the jetty in rough weather, but most of his work on this visit consists of studies of the sea and coastline with distant headlands in the background.

The jetty in the harbour of Fécamp on the Normandy coast. In 1868, Monet painted several seascapes and other studies here; he revisited the village in 1881, when one of his subjects was the jetty in stormy weather. The other Impressionist to paint here was Berthe Morisot, who visited Fécamp in 1873.

painted some decorative panels with Wagnerian subjects for Blanche's father); and Monet produced a handful of general views of the port and the neighbouring coastline, as overtures to his major work in Pourville in 1882. Dieppe's most significant connection with Impressionism, however, is that Pissarro spent two prolonged summer periods there late in his career, depicting the town.

Pissarro's first visit was in 1901. Embarking on a painting trip to Normandy, he searched for suitable sites and selected Dieppe. He settled his family in a rented summer house at nearby Berneval and installed himself in the Hôtel du Commerce on the **Place Nationale**. From this vantage point he could look out to the church of St Jacques, with the rue St-Jacques extending beyond and the square in front. His paintings show the square and the street thronged with shoppers and visitors to the weekly market or annual summer fair.

On his second visit, in 1902, Pissarro painted another series of animated scenes of daily life, this time around the Avant-Port. Although the layout

Solitary figures on the pebble beach at Fécamp (above). Monet painted seascapes here, concentrating on studies of the coastline, with the headlands firmly in the distance. The harbour at Fécamp (below) was painted both by him and Berthe Morisot.

2229. Dieppe. — Les Arcades et la Poissonnerie

A 19th-century postcard (left) shows Dieppe as it was when it was visited by Pissarro, who made two major painting expeditions there in 1901 and 1902.

Charming maisons dieppoises can still be found in the town; these examples are set in a secluded cobbled backstreet (right).

The rue St-Jacques, thronged with afternoon shoppers, and the church beyond it (below). Pissarro painted the scene here in 1901 from a vantage point in the Hôtel du Commerce.

of Dieppe's harbours has changed somewhat since Pissarro's day (for example, the former Bassin Bérigny to the south is now a park), the area around the Avant-Port has remained relatively unaltered and still retains some of the atmosphere captured in Pissarro's paintings. There are 17 known works from this series. Each was painted from the same vantage point – a room on the Poissonnerie overlooking the port – and takes in the same scene, which was bounded to the east by a promontory topped by the church of Notre-Dame de Bon Secours and to the west by the beach and jetty. However, despite the single vantage point, each canvas represents a slight shift in the angle of vision.

BERNEVAL

The small coastal resort of Berneval just north-east of Dieppe is primarily of importance in the history of Impressionism for its proximity to the Château de Wargemont, the country house of Paul Bérard, a diplomat and financier who was a major patron of Renoir in the 1880s. The artist met Bérard in Paris through the publisher Georges Charpentier and in 1879 was commissioned by him to paint a portrait of his eldest daughter Marthe. Over the next six years, when he spent at least part of each summer on the estate, Renoir produced a series of portraits of the diplomat's four children and their cousins. Many of these were painted at Wargemont, where the artist seems

Dieppe's harbour (above) around the Avant-Port remains relatively unchanged. The place Nationale (left) is where Pissarro rented a room in the Hôtel du Commerce. By this time, a worrying eye infection was forcing Pissarro to paint from behind closed windows. However, he was now recognized by his fellow artists as one of the greatest painters of the day; Paul Cézanne, for example, spoke of the 'humble and colossal' Pissarro.

to have been welcomed as one of the family. One such is *The Children's Afternoon at Wargemont* (1884), one of Renoir's major group compositions, which shows the three Bérard daughters relaxing in the salon.

Renoir also painted the children in outdoor settings: for example, in 1879 he produced two portraits of Marthe in a striped fishing costume on the beach at Berneval in 1881 and a picture of her cousin Alfred dressed in hunting costume in the grounds of Wargemont.

Portraits were not Renoir's only preoccupation on these visits. He also painted a series of decorative panels, still lifes and flower pieces, specifically to decorate the château; *The Festival of Pan* (1879), a large allegorical landscape with young girls in classical draperies, which was hung in the drawing room; *The Rose Garden and the Château of Wargemont* (1879); and a number of more general studies of the surrounding countryside and coast.

Although the Bérards do not seem to have commissioned any more work

from Renoir after 1884, the artist apparently continued to visit them. He also made trips to the Normandy coast throughout the 1890s. In 1898, for example, he was back at Berneval – no longer as a lone visitor but with his wife and children in tow. The family rented a summer chalet and he used this as the setting for *Déjeuner à Berneval* (1898), which shows his elder son Pierre reading in the foreground and, in the background, his younger son Jean, together with a relative of his wife, who lived with them.

BOULOGNE

Manet spent the summer of 1869 with Degas at the cross-Channel port of Boulogne, where he painted half a dozen views from his hotel window. These include two versions of *The Folkestone Boat* and studies of the jetty, the harbour and the quayside by moonlight.

HONFLEUR

In marked contrast to the great sea-port of Le Havre on the northern side of the Seine estuary, the port of Honfleur, which faces it on the southern side, has changed remarkably little since the 19th century, when it played host to so many artists. As was the case with other Norman ports visited by the Impressionists, the docks provided most of the subject-matter at Honfleur: not only the shipping but also the Lieutenance

(the 16th-century quayside residence of the governor of the town, that stands in front of the wooden church of Ste Catherine), the swivel bridge and the Phare de l'Hospice (the light-house).

Both Boudin and Monet painted the dockside area throughout their long careers. As late as 1917, for example, Monet took a short trip to this, one of his favourite haunts, to paint *The Port of Honfleur*, an attractive view of the town that shows the jetty, the quayside and Ste Catherine's weather-boarded steeple.

Another important location for painters at Honfleur was the Côte de Grâce, a prominent hill behind the town. The impressive views from this vantage point were well-known to artists before the Impressionists; Huet, Isabey, Corot, Daubigny and Jongkind all painted there. It had the additional advantage of a nearby rustic inn on the road to Trouville: Mère Toutain's Ferme St-Siméon, which

Picturesque houses around the old dock in Honfleur (above). Honfleur was painted by many artists; the nearby St-Siméon farm was known as Normandy's Barbizon. Manet painted Boulogne harbour (left) in 1869.

provided board and lodging and became the regular place for artists to stay. The Ferme still exists today, on the route Adolphe Marais, on the edge of the town. No longer a rustic inn, it has become a smart hotel, a transformation which started as long ago as the turn of the century. Writing to his son from Le Havre in 1903, Pissarro records how he slept at the Hôtel St-Siméon: '...formerly it was a farmhouse although nothing remains of those glorious days...'

Boudin, a native of the area, was familiar with the Ferme and used it as a painting base for three months in 1854. It must have been about this period that he started to produce the collection of pastel studies of sea and sky which so impressed the poet Baudelaire when he visited the artist at Honfleur.

It was Boudin who was responsible for introducing Courbet and the young Monet to the Ferme in the late 1850s. Monet in turn introduced it to his friend from Paris, Bazille, and in 1864 the two young painters spent the

summer in Honfleur, lodging in the town, eating at the Ferme and painting in the area around the Côte de Grâce and on the beach at Ste Adresse, on the other side of the estuary. Bazille painted various landscapes that were damaged en route back to Paris but his view *Courtyard of the Ferme St-Siméon* survived. Monet's output includes views from both sides of the Honfleur-Trouville road, with the Ferme in the distance; this was a favourite subject with him and he was to return to it again later, as in *Road near Honfleur in the Snow.*

Bazille left Honfleur in 1864 when the summer ended, but Monet prolonged his visit into November, spending some time with his parents at Ste Adresse. This gave him the opportunity to produce other paintings of the area – for example, the chapel of Notre-Dame on top of the Côte de Grâce and the rue de la Bavolle in the centre of Honfleur, both of which still exist.

The Phare de l'Hospice (above), the lighthouse at Honfleur, was among the subjects the Impressionists painted in the harbour area. The port as a whole (left) has changed little since the 19th century.

LE HAVRE AND STE ADRESSE

Heavily bombed during the war and since rebuilt, the busy seaport of Le Havre today bears little resemblance to the place where Boudin and Monet grew up and painted. But the neighbouring residential town of Ste Adresse, with its steep terraces lined with large houses reaching down to the beach, has kept much more of its 19th-century appearance. Both places are closely interwoven in the early history of Impressionism and contain a number of locations depicted in the work of Monet, Boudin, Bazille and Pissarro. And it was Monet's view of Le Havre harbour entitled *Impression, Sunrise* (1872) that, scathingly taken up by a critic at the first Impressionist exhibition in 1874, gave the movement its name.

Neither of Le Havre's most famous artistic sons was actually born there. Boudin's family came to the port from nearby Honfleur in 1835 when

he was 11; and Monet's family moved there from Paris in 1840, the year of his birth.

In 1846 Boudin, having drawn in his spare time since his youth, set himself up in a small studio on the Grand Quai down by the harbour. Five years later, the town awarded him a three-year scholarship. His earliest works were not the sketchy seascapes for which he is known today, but much heavier Barbizon-style landscapes, still lifes and views of the harbour, such as the two views of the port, town hall and the Tour François I, dated 1852, that can be seen in the Musée André Malraux.

Boudin remained based at Le Havre until 1861. He then moved semi-permanently to Paris, but he returned to Normandy every year to paint its sky and sea, shipping, harbours and estuaries and exhibited his work in Le Havre throughout his career.

It was here, in late summer 1858, that the talented young caricaturist,

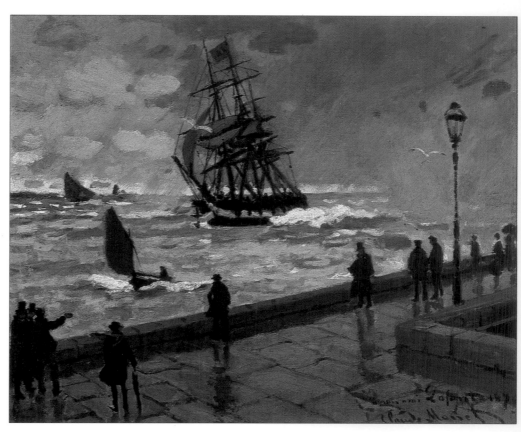

Monet, first met Boudin the marine painter. Boudin encouraged the young man to try his hand at painting and shortly after their first meeting took his protégé to try his hand at *plein-air* painting in the nearby village of Rouelles (now a suburb of Le Havre) and at the Ferme St-Siméon.

Monet's first known works are the caricatures of Le Havre notables, such as *Caricature of His Teacher, Ochard* (1856-8), that he drew during

Monet painted Jetty at le Havre *in 1870. This was the artist's home town; he had started his career there, drawing caricatures. One of the subjects that attracted him was the harbour (left); this 19th-century photograph conveys the atmosphere of the scene at the time.*

his adolescence. These drawings earned him something of a local reputation and were exhibited in Gravier's artist's materials and framing shop on the rue de Paris in Le Havre.

Monet's decision to make a career as a painter was not without family opposition and, although they provided some financial support during his early years, it eventually ceased. A sympathetic aunt, Madame Lecadre, then came to his rescue, but his situation was often precarious, and during the first 10 years of his career, despite spending some time in various Paris studios, he was often forced to live in the homes of his parents and his aunt, both at Ste Adresse; he was there, for example, for long periods in 1864, 1867 and 1868. During those stays he painted many scenes in the locality, in particular the beach at Ste Adresse and Le Havre harbour, favourite subjects which he returned to several times

later in his career.

Monet produced many views of the St Adresse beach depicting it in various weather conditions. In some the artist looked north towards the town, showing shelving beach and breakwaters running down towards the sea and the Cap de la Hève headland cutting across the scene beyond from left to right. In other paintings the view is southwards towards Le Havre and shows its more prominent buildings silhouetted against the horizon. This latter viewpoint was also the one adopted in a painting by Bazille, executed in 1864 when he came to visit Monet for the summer.

In summer 1867 Monet painted views not only of the Ste Adresse beach but also of the town's church, together with one of his most famous early works, *Terrace at the Seaside near Le Havre*; this looks out across a sunlit, flower-decorated terrace, which contains the figures of his father, aunt, cousin and another man, towards a sea dotted with distant sailing boats.

At Le Havre much of Monet's work consisted of harbour scenes. In his early canvases he favoured storm-tossed shipping and the jetties. One of these paintings, intended for the

Salon of 1868 but rejected, shows the long-since-demolished Jetée du Sémaphore and its lighthouse lashed by huge waves. His most famous views of the port were painted in 1873, on a trip which also took in a visit to Etretat; as well as close-up studies of moored ships and the façade of the old museum on the Grand Quai, he produced three loosely executed views of the old avant-port, including the celebrated *Impression: Sunrise*, which was exhibited at the first Impressionist show; visits to the port later in the 1870s produced more views of shipping in the avant-port and scenes showing the buildings on the quayside and the bassin du Commerce from a viewpoint looking towards the place de la Mature (now the place Général de Gaulle) and the Théâtre.

The harbour at Le Havre was also the destination of Pissarro on his last painting trip, in 1903. He had depicted the area several times previously, in the 1860s and 1870s. This time

he installed himself in the Hôtel Continental on the quayside overlooking one of the jetties and painted a series of 18 views of the port, surveying the entire harbour from an easterly direction along the Grand Quai and out towards the jetty to the west.

TROUVILLE

The resorts of Trouville and its smarter neighbour Deauville, on opposite sides of the Touques estuary, lie at the point where the cliffs of the Normandy corniche meet the wide sandy beaches of the Côte Fleurie, to which the towns owe their long-standing popularity. From the time of the

Trouville, with its golden sands, was already a popular tourist resort in the imperial era and continued to attract fashionable summer visitors throughout the rest of the century. The postcard (right) captures the contemporary scene, while the photograph shows that the resort still retains much of its stylish atmosphere. Painters who worked at Trouville included Courbet and Boudin; the latter built a villa there in 1884, where he died in 1898. Of the Impressionists, Monet was active in the town during the summer of 1870.

Second Empire both became fashionable watering-places for Parisian society, which was drawn to the smart hotels, casinos and seafront promenades. The artists followed, lured by the prospect of patronage.

Courbet was one such. In autumn 1865 he stayed in Trouville for three months and the following year he spent a month at neighbouring Deauville as the guest of the Comte de Choiseuil. His surviving works from this period are general views of the beach and studies of the sky and sea, but he must also have been otherwise occupied, since his letters talk of painting the prettiest women in town and of the numbers who visited his studio.

It is Boudin, however, who most

The port of Deauville (top) and one of its quiet tree-lined streets (above). The harbours and plages of Deauville and Trouville were favourite subjects of Courbet, Boudin and Monet on their visits to the Channel coast.

fully recorded Second Empire society at the seaside. First visiting Trouville in the mid-1860s, he set up his easel on the promenade and painted the crinolined ladies and fashionably dressed men on the beach, either standing by bathing huts or seated on small salon chairs. These pictures made his reputation and, unlike his earlier marine and sky studies, proved lucrative.

Once his finances were secure, Boudin divided his time between Paris for most of the year and Deauville and Trouville in summer, building in 1884 a villa at the former, on the rue Olliffe, where he died in 1898. Boudin did not confine himself to depicting fashionable society on the beach or at the Deauville races but also painted the local inhabitants, hunting for mussels at low tide, shopping in the covered market at Trouville or washing laundry in the Touques estuary.

Five years after Boudin painted his first pictures of Trouville society, Monet was also painting on the beach there. In summer 1870, just before the outbreak of the Franco-Prussian War, the newly married artist was staying with his wife and baby son at the Hôtel de Tivoli. Monet, however, chose not to paint fashionable strangers but informal studies of his young wife relaxing under a parasol, views along the seafront, such as *Hôtel des Roches Noires at Trouville*, which he painted from its terrace, and the harbour with its sailing boats.

ROUEN

The city of Rouen, straddling the Seine some 30 miles inland from the mouth of its estuary, is one of France's oldest and most important ports, with a history that dates back to Roman times. In the 1880s and 1890s, when Pissarro and Monet painted extensively in the city, it was not only a major port but also well on the way to becoming the industrial centre that it is today; it was also served by two railway lines, with two stations serving the residential area on the right bank and no less than three catering for the industrial zone on the left bank. In the Second World War, however, Rouen suffered extensive damage and it no longer retains as

much of its 19th-century appearance as, for example, does Dieppe, another large port that provided subject-matter for the Impressionists. Even so, several of the locations that feature in Impressionist works have survived, most importantly the cathedral, whose façade Monet depicted in his famous series of studies in 1892 and 1893.

Monet was the first Impressionist to paint Rouen in any detail. His earliest works, produced in 1872 and 1873, are views of shipping on the Seine and of the quayside of industrial landscapes of such suburbs as Le Robec and Déville, both now absorbed into the conurbation. When he returned much later, in 1892, on a major painting expedition, he began with panoramic views of the city painted from the Côte Ste-Catherine, a chalk hill which, though no longer set apart from the urban sprawl, still

commands an impressive view of Rouen and the Seine. He then turned his attention to the centre of the city, painting a favourite but no longer existing artists' view: looking from the old market square, up the rue de l'Epicerie to the southern side of the cathedral. (Six years later Pissarro must have placed himself in virtually the same spot to paint his views of the rue de l'Epicerie, except that he chose to paint it on market day when the square in the foreground was full of stalls and people.)

Despite the already-mentioned views of Rouen painted by Monet in 1892, the artist's main purpose in visiting the city that year, and the following, was to paint a series of views of one aspect of Rouen Cath-

angle and from a more oblique angle that took in the medieval houses abutting the St Romanus Tower (these have since been demolished). The two visits produced a total of about 30 paintings of the cathedral, a selection of which were exhibited at the Durand-Ruel gallery in Paris in 1895.

Pissarro made several visits to Rouen: in 1883, when he stayed in the hotel belonging to his friend and patron Murer, in spring and autumn 1896 and in late summer 1898. Like Monet, Pissarro began his first visit with some distant panoramic views of the city. He then progressed to the interior of Rouen, where, apart from his view, *Rue de l'Epicerie, Rouen*, he painted the place de la République

and the cathedral. On subsequent visits he became increasingly attracted to the views from the quayside and stayed at hotels on it, from which he could paint the scene from his window. His favourite subjects were the Pont Boïeldieu, one of the two crossing points over the river in Pissarro's time, which he painted looking both upstream and downstream; the harbour itself, with barges loading and unloading at the quayside; and the warehouses, stations and factories on the left bank. These left-bank views are probably the scenes that bear least resemblance to modern Rouen. Heavy bombardment in the war wiped out the area and it was afterwards replaced with administrative centres and parks.

The Gros-Horloge (left) and half-timbered houses in the centre of old Rouen (above) are just as they were a century ago. This 19th-century photograph of the west front of Rouen's Notre-Dame cathedral (right) shows how the church must have appeared to Monet.

edral, recording the changing light effects that passed across its surface during the course of a day. The façade he selected was the impressive western one, with its large central door flanked by the smaller St John and St Stephen doorways and the St Romanus and Butter towers.

To paint the cathedral Monet rented three separate first-floor rooms from local shopkeepers: at 23 and 31 place de la Cathédrale and, just to their right, at 81 rue Grand Pont. These afforded him varying viewpoints of the west façade: directly face-on, from a slightly oblique

PARIS: THE CITY

Visitors to Paris in search of Impressionist locations will experience a mixture of reward and disappointment. Given how much of the Impressionists' time and energies were expended in the capital especially during the 1860s and 1870s, actual physical signs of their presence are thin on the ground. The studios where they painted portraits of one another no longer exist (although most of the streets in which these were located remain); none of their favourite cafés and other haunts have survived; and the areas where they lived – the Batignolles district and Montmartre – have been transformed out of all recognition. On the other hand, fortunately, much of what the Impressionists painted in Paris – the bridges over the Seine, the parks and gardens, the newly constructed grands boulevards – have proved to be more durable, and it is possible to visit many locations that still resemble the views in their paintings.

The recently built Louvre pyramid sits in surroundings well known to the Impressionists.

THE SEINE: QUAIS AND BRIDGES

The Seine flowing through Paris, and the views from its banks, fascinated the Impressionists just as much as did the river winding its way through open countryside. Among the earliest depictions of it are Berthe Morisot's study of the Pont d'Iéna of 1866 and two views painted in 1867 by Monet and Renoir. Monet's picture shows the Pont Neuf and the Ile de la Cité looking upstream from the Louvre, with the dome of the Panthéon on the horizon. Renoir's view is from the Quai Malaquais, on the opposite side of the river, again looking upstream, but in this case towards the Pont des Arts and the right bank.

A few years later, in 1872, Renoir produced his own painting of the Pont Neuf, working, according to his brother Edmond, who accompanied him, from a small café on the Quai du Louvre; the artist looks across to the Ile de la Cité with Henri IV's equestrian statue on the right.

The ornamental gardens of the Tuileries, next to the Seine (above). Until 1871, this was the site of Napoleon III's palace. Manet was one of the many painters to work here. The Pont Neuf (below) was painted by Berthe Morisot, Monet, Renoir and Pissarro.

The Pont Neuf was a particular favourite with the Impressionists. The following year Monet painted it in the rain from a similar angle, and much later, in 1901, Pissarro produced a series of studies of the bridge. He worked from the Ile de la Cité, renting an apartment at 28 place Dauphine, from where he could depict the Louvre on the right bank, beyond the Pont des Arts, and the equestrian statue to the left. Being situated in the middle of the Seine, he was well placed to paint views on all sides; in some of his canvases of 1901 and the following year he looks across to the left bank.

Pissarro produced a further series of paintings of the Seine in 1903, the final year of his life. This time he sited himself further downstream, on the Quai Voltaire, where his vantage point took in the Ponts des Arts and du Carrousel, the Quai Malaquais, the Institut and the Hôtel de la Monnaies on the left bank and the Pont Royal and Pavillon de Flore of the Louvre on the right.

Throughout the 1870s and 1880s Guillaumin painted a number of views of the quais in the south-east of Paris, and his contribution to the sixth Impressionist exhibition of 1881, for example, included views of the Quais des Célestins, de la Rapée, Henri-IV and d'Austerlitz.

Away from the Seine, Sisley produced in the early 1870s several paintings of the quaysides of the Canal St-Martin, which still runs north-east from the river.

PARKS AND GARDENS

The city's parks and gardens provided one of the ideal settings in which to depict Parisians relaxing – a favourite Impressionist subject. The earliest of these views is probably Manet's *Concert in the Tuileries Gardens* (1862), which shows a crowd of fashionably dressed people relaxing under the trees. The Tuileries, the part-wooded, part-ornamental gardens running alongside the river from the Louvre to the Champs-Elysées, occupied Monet's attention in 1867: he produced four canvases of the gardens at the Louvre end. Much later, in 1899 and 1900, these were the subject of another of Pissarro's Parisian series. Staying in a rented room on the rue de Rivoli, he painted a number of views of the gardens, some looking towards the Louvre and the place du Carrousel. others facing away from the Louvre towards the ornamental pond.

Another, larger recreational area that attracted the Impressionists was the Bois de Boulogne. Renoir painted

a winter scene there, *Skating in the Bois de Boulogne* (1868), and in 1873, used the Bois as the setting for his monumental equestrian painting *A Morning Ride in the Bois de Boulogne*. Riders can still be seen exercising in the Bois today, though few are as elegant as the woman and boy in Renoir's painting. For her part, Berthe Morisot produced some studies of the ducks, geese and swans on the lakes in 1885 and 1888.

For Manet, and particularly for Degas, the Bois de Boulogne held further attractions – its racecourses. Horse-racing was an early interest of Degas, and the race meetings he attended and observed in the Bois in the 1860s and 1870s are among the first modern subjects to appear in his work.

The Parc Monceau, a smaller, residential park in the north-west of the city, was the subject of a series of three sunlit, flower-filled paintings by Monet in 1876. The park was convenient for Monet, since it was not far from the Gare St-Lazare, the

Seductive scenes, such as this waterfall and pond (above), with their varieties of green and subtle reflections in the water, and bustling race meetings in the Bois de Boulogne (below) attracted the attention of Manet and Degas. Renoir, too, painted in the Bois.

Paris terminus of the railway line from Argenteuil, where he was then living.

BOULEVARDS AND STREETS

Anyone visiting Paris will be struck by its boulevards, the long broad streets that afford sweeping vistas across Paris. They had their impact on the Impressionists too, for, when they first worked in Paris, the boulevards were a relatively new feature, the result of Baron Haussmann's grand re-design of the city. As an aspect of the modern life of the time, therefore, they feature prominently in the Impressionists' work.

Busy street scenes outside the Café de la Paix (above) and 35 boulevard des Capucines (left) – where the first Impressionist exhibition was held – were painted as subjects in themselves and as backgrounds for photographs. Degas, in particular, was a keen amateur photographer.

The earliest major paintings of a boulevard are Monet's two versions of the *Boulevard des Capucines* (both 1873), which show the thoroughfare thronged with people. Like most of the Impressionists' boulevard views, this was executed from a high viewpoint looking down on to the street, in this case towards the Opéra. The vantage point was a window in the studio of the photographer Nadar, at

35 boulevard des Capucines, where the first Impressionist exhibition (which included one of Monet's views of the boulevard) was held the following year. Five years later, Monet produced two more, very freely executed street scenes: the *National Holiday, rue St Denis, Paris* and *The Rue Montorgueil Decked out with Flags*. Both depict the same holiday, on June 30, 1878. Both studies look down on and along the street and concentrate on the effect produced by hundreds of fluttering tricolors projecting from the windows of shops and apartments.

On the same day Manet was painting two similar, though more naturalistically treated, flag-bedecked views: *Rue Mosnier, Paris, Decorated with Flags*. In these the artist looks down into the street (now the rue de Berne) from the window of his studio at 4 rue St-Petersbourg (today the rue de Leningrad). The same year Manet painted another view of the street (which was in a newly-constructed quarter of Batignolles), showing men at work in it: *Street Pavers in the Rue Mosnier*.

Gustave Caillebotte, an artist who specialized in unusual perspectives, often painted the boulevards of Paris but did not always choose to identify

them. Some of his pictures, such as *Paris Boulevard seen from Above* (1880), which looks down on to an avenue with trees, benches and pedestrians, could be located almost anywhere in the city. Other paintings are more specific. *Balcony* (1880) shows two figures looking out from a balcony over some trees into the boulevard Haussmann, and *Rue Halévy Seen from the Sixth Floor* (1878) shows a long vista stretching away between the blocks of shops and apartments of a street that links the boulevard Haussmann with the place de l'Opéra.

Degas and Renoir also painted street views, but more as a background for portraits than in their own right. For example, despite its title, Degas's *Place de la Concorde, Paris* (1875) is actually a portrait of Viscount Lepic and his two children and the place is no more than a backdrop to them. Again, the main subject of Renoir's *Place de Clichy* (1878) is the head and shoulders of a young woman in the lower right of the picture. Renoir's *Les Grands Boulevards* (1875) is a more straightforward, ground-level study, but it is impossible to identify the location from the painting.

In the 1890s Pissarro painted three series of paintings of Paris streets and squares. The first group of four was painted in 1893 from the Hôtel Garnier, near the Gare St-Lazare. Unlike Monet's earlier series, the paintings are not station scenes but look down on the crowded streets in front of the station: and the rue St-

Monet was not the only Impressionist to depict the Gare St-Lazare (though he explores the subject more thoroughly than any other painter). Four years earlier, in 1873, Manet had painted it in *The Railroad*. The artist lived just north of the Gare St-Lazare, on the rue St-Petersbourg,

Lazare and the place du Havre.

Four years later Pissarro returned to the same area to paint another 20 or so views. This time he stayed at the Grand Hôtel de Russie on the rue Drouot, from where he painted scenes looking east along the boulevard Montmartre and south-west along the boulevard des Italiens and more views of the streets around the Gare St-Lazare. Pissarro made a third visit the following year, 1898, staying nearer the river, at the Hotel du Louvre on the rue de Rivoli. From there he painted impressive views looking along the length of the avenue de l'Opéra, in different weather conditions, and, nearer to hand, the rue St Honoré and the place du Théâtre Français from various slightly different viewpoints.

The boulevards and streets of Paris have, of course, another importance for the visitor in search of Impressionist connections. It was on them that the movement held its exhibitions, from the first in 1874 to the last in 1886: two on the boulevard des Capucines, one on the avenue de l'Opéra, two on the rue St Honoré, one on the boulevard des Italiens and two on the rue Le Pelletier.

RAILWAY STATIONS

In the 19th century the railway was very much a symbol of modern life, and the Impressionists owed much of their mobility to it. For example, it enabled Pissarro to commute between Pontoise, a town outside Paris, and his Montmartre apartment and allowed Monet to live at the Paris suburb of Argenteuil, from which a train ran every hour to the Gare St-Lazare in the capital. Monet's regular acquaintance with this station prompted him to paint a series of 12 views of it in 1877; however, he did not choose to commute from Argenteuil for this project but rented a small apartment in the nearby rue Moncey.

The series was painted in and around the station itself, with Monet making quick preparatory sketches on the platforms between trains. His paintings show the steam-filled interior – from both the mainline and suburban sides of the station – with trains arriving. He also painted exterior views of the back of the station, showing the rue d'Amsterdam that runs down the east side and the Pont de L'Europe, which crosses overhead.

The Gare St-Lazare in north-east Paris was familiar territory for Pissarro and Caillebotte, who used it to travel to places such as Pointoise and Argenteuil. Monet immortalised the station and its steam trains in a series of paintings he created there; later, his son recalled that Monet only gained permission to paint in the station because railway officials thought he was an approved Salon artist.

and from there he could probably have seen the view of the station that in his painting forms the backdrop to the two elements that dominate the work; the angle of the rue de Rome and the Pont de l'Europe, which project from billowing steam.

The Pont de l'Europe also features in a painting of that name by Caillebotte in 1876. Its criss-cross girders cut across the picture plane as in one of Monet's paintings, but by contrast the viewer would be hard pressed to know that a busy railway terminus lies below. Caillebotte's painting views the scene from above, looking along the bridge and the rue de Londres to the place de la Trinité beyond.

THE BEAUX-ARTS AREA

Traditional artistic tuition in Paris at the time of the Impressionists was carried on at the Ecole des Beaux-Arts, situated then, as now, on the left bank and fronting the river along the Quai Malaquais. As well as enrolling in the Ecole, the student would be attached to the studio of an established painter. Monet, Bazille, Sisley and Renoir all chose to work at the studio of Gleyre, one of the more liberal-minded artists of the time, who had a studio in the same quarter as the Ecole – though it is not known exactly where the studio was located. It was there that many of the main protagonists of Impressionism met for the first time.

During their first years in Paris several of the Impressionists shared studios in the Beaux-Arts quarter. The earliest of these was that shared by Monet and Bazille at 6 rue de Fürstenberg, which looked out over Delacroix's atelier, situated in the same street. (The Atelier Delacroix has survived to this day and is open to the public. It gives the visitor an idea of what a studio looked like in the 1860s, but since Delacroix was then an established and successful artist who had had his atelier purpose-built, it is obviously a much grander affair than anything the young Impressionists would have rented). Bazille painted a view of the studio he shared with Monet, showing a stove, a chair and canvases by the two painters hanging on the wall.

It was probably in 1867 that Bazille moved to a studio at 20 rue Visconti, which he shared with both Renoir and Monet; in that year he produced a picture of the studio, again unpeopled. It could also be in this studio – or in his next one in the rue de la Condamine in the Batignolles district – that he painted his *Portrait of Auguste Renoir* (1867), showing the painter seated on a chair with his knees drawn up. The same year Renoir reciprocated with *Portrait of Frédéric Bazille at His Easel*, in which his studio companion is working on a still life. Three years later Bazille produced another studio scene, *The Artist's Studio, rue de la Condamine*, which shows him and his friends.

By 1870 Bazille, and probably Renoir, had left the Batignolles district and were back in the Beaux-Arts quarter, living at 8 rue des Beaux-Arts. But their stay did not last long. The Franco-Prussian War started that year and both painters were mobilized. After the war most artists found studios in the Batignolles district.

Two views of the Atelier Delacroix in the Beaux-Arts quarter, where many artists of the time had their studios. Delacroix himself was an apostle of the Romantic school of art and as controversial in his time as the Impressionists proved to be in theirs. The disputes between his followers and those of Ingres became notorious.

MONTMARTRE AND THE BATIGNOLLES DISTRICT

Apart from the Beaux-Arts quarter, the main area of residence for the Impressionists in Paris was the north-east of the city. Their life there was centred around two quarters: Mont-martre, which had been officially designated part of the city only as recently as 1860 and was still geog-raphically and socially a distinctly separate area; and the Batignolles quarter, which lay at the bottom of a hill in the district abutting Mont-martre and which had been subject to considerable redevelopment from the 1860s. In this area, roughly bounded by the northern extension of the avenue de Clichy, the Gare St-Lazare and the boulevard de Rochechouart, the Impressionists and their immediate circle had their studios, painted city life, especially the night life, and met at the Café Guerbois and the Nouvelle-Athènes for drinking and animated discussion.

However, hunting for hard evi-dence of the Impressionists' existence in north-east Paris is unrewarding work. Some of the streets where they had their studios still exist: the rue Moncey, where Monet and Sisley both worked at one point; the rue St Georges, where Renoir had a studio in the 1870s; and the rue d'Amster-dam and rue de Leningrad, where Manet painted at various times; but no trace of their sojourns remains today. The same is true of their cafés and other haunts, with the notable exception of the Folies-Bergère; the fashionable café where Manet set his last major painting, *The Bar at the Folies-Bergère* (1882), still stands on the rue Richer.

It is still worth visiting the area, however, for, although the cafés and café-concert (the Parisian equiva-lent lent of music-halls) have gone, the district is still a centre of Parisian night life and even today retains something of the atmosphere that permeates much of the work of Man-et, Degas and Renoir. Just off the place de Clichy, at 11 avenue de Clichy (known in the Impressionists' time as the grande rue des Batignol-les) was the Café Guerbois, the favourite drinking and debating spot in the 1860s and early 1870s for the Batignolles group, as the young pain-ters centred around Manet were known. Here Manet set one of his most popular salon paintings, *Le Bon Bock – The Engraver Bellot at the Café Guerbois*, using an artistic acquaint-ance, the engraver Bellot as a model. Today a clothing store stands where the café used to be.

After 1877 Manet transferred his allegiance from the Café Guerbois to the Nouvelle-Athènes, which stood on the place Pigalle. This was the setting for several works by Manet and Degas, notably Degas' *L'Absinthe* (1876), for which the actress Ellen Andrée and the painter Marcellin Desboutin acted as models; and Man-et's *The Plum* (1877). There are, however, numerous other works for which the Nouvelle-Athènes was probably the source if not the setting; they include two scenes, both entitled *At the Café*, painted by Renoir and Degas in about 1877.

Running east from the place Pigal-le is the boulevard de Rochechouart, where, at number 63, was a circus, the Cirque Fernando, demolished only in 1972. This was the setting for such works as Degas' *Miss La La at the Cirque Fernando* (1879), showing the high-wire artiste suspended from the roof and Renoir's *Jugglers at the Cirque Fernando* (1879).

Artists still meet, paint and sell their work in Montmartre (above). Renoir himself had his studio there. The Folies-Bergère (below) still stands on the rue Richer, though the building has changed substantially from 1882, when Manet set his last major painting there.

An element of Parisian night life much depicted by the Impressionists was the café-concert, whose singers and stage acts featured particularly prominently in Degas's work of the 1870s. Two of the main café-concert were the Ambassadeurs and the Alcazar, both situated on the Champs-Elysées, near what was then known as the Rond Point. In a series of pastels, Degas vividly portrayed the night life at both. His *The Song of the Dog* (1875) and *Singer with Glove* of (1878) both depict Thérèse, the most famous singer of the time, performing at the Alcazar. *The Café-Concert, Les Ambassadeurs* (1875) also portrays a singer and orchestra performing. Many other pastels, however, have much less specific titles, such as *Cabaret* or *At the Café-Concert*.

The other venue for evening entertainment depicted by the Impressionists – principally Degas but also Renoir and Mary Cassatt – was the Opéra, the imposing Second Empire building (newly finished in the Impressionists' time) at the head of the avenue de l'Opéra. It was here that Degas set his 1870s views of the ballet and ballet classes, such as his famous *The Dancing Class* (1874).

Montmartre, on a hill that has views of the whole of Paris, still has a separate identity to match its place apart, but this was even more marked in the Impressionists' day. Two early views of Montmartre – Sisley's *View of Montmartre* painted from the Cité des Fleurs, **Batignolles** (1869) and Pissarro's *The Telegraph Tower at Montmartre* (1863) – give an idea of just how rural the area was then. Today development and tourism have changed it so much that, overall, it does not even vaguely resemble the Montmartre of the most famous Impressionist view of the area, Renoir's *Moulin de la Galette* (1876), despite the token retention of the mill from which the open-air dance hall took its name. (At one time Montmartre boasted about 30 mills, and several of these still stood at the turn of the century.)

It is, however, still possible to find in Monmartre the odd unspoilt place that retains something of the almost rustic character possessed by the Moulin de la Galette in the last century. One such place is the Musée

The memorial plaque outside the Villa des Arts at 15 rue Hégésippe Moreau records the fact that Renoir, Cézanne, and Signac all worked there. This is probably the only studio still extant in Paris to be associated with the Impressionists.

de Montmartre, a museum containing fascinating historical material on the district. Set in its own grounds, it overlooks a vineyard and, beyond, Paris to the north. Renoir (who stayed on in Paris in the Batignolles and Montmartre districts after his friends Monet, Pissarro and Sisley had moved out of the capital by the early 1880s) rented a studio on the rue Cortot, expressly for the purpose of painting his *Moulin de la Galette* on site. While here he also painted several other works in the garden of the rue Cortot, notably *La balançoire* and *The*

Garden of the Rue Cortot in Montmartre (both 1876).

Another corner that is still unchanged is the twisting, cobbled rue Hégésippe Moreau, on the western side of the hill, near Montmartre's cemetery. Here, at number 15, behind an impressive pair of iron gates, still stands the Villa des Arts, probably the only extant studio in Paris associated with Impressionist painting. This was Renoir's address in 1892, and a plaque on the gates records that, among others, Cézanne and Signac also worked here.

PARIS: SUBURBS AND OUTSKIRTS

In the 1860s and early 1870s, before the Impress-ionists acquired some material security and moved out of Paris, the suburbs to the west of the city were the centres of much artistic activity. Two areas were of particular importance. Before the Franco-Prussian war, Pissarro, Sisley, Monet and Renoir were all living due west of Paris in the Louveciennes-Bougival area and painting various locations around this part of the Seine valley. After the war, when the artists returned to Paris, many of them moved to the

north-west of the capital, in particular to the Argen-teuil area. Argenteuil, together with Petit-Gennevilliers on the opposite bank of the Seine, was already beginning to be industrialized when Monet went to live there, but even so it was still in essence a rural-looking suburb. Today it is a developed area unrecognizable from the Argenteuil of Monet's pictures, and those seeking locations which still resemble the scenes in the Impressionists' paintings are better advised to visit their earlier haunts.

LOUVECIENNES

The proximity of royal hunting forests and the Palaces of Versailles and Marly made the small town of Louveciennes and its neighbouring villages ideal locations for the nobility to build residences, and the area has a long history as a fashionable retreat from the bustle of Paris. By the time the Impressionists moved there, be-tween 1869 and 1871, the area had become the preserve of the wealthy bourgeoisie, and over the intervening

years little has changed in this re-spect. Built on a hilly site, the town has many twisting roads, is largely surrounded by parkland and, although somewhat larger than in the days of Pissarro and Sisley, is still recognizably the Louveciennes of their paintings.

Sisley moved to Louveciennes in 1871, staying in the town for five years. However, he was familiar with the area beforehand, since he painted several forest views at nearby La

Celle-St Cloud in the late 1860s. He lived at 2 rue de la Princesse, in the Voisins quarter, and painted this twisting road several times, both near his home and a little further on, where it bordered the estate of Madame du Barry – scenes that are little changed today.

Pissarro spent three years in Louveciennes, from 1869 to 1871 – although he was forced to flee from his home during the Franco-Prussian war, taking refuge in London. He

As well as the roads on which they lived, Pissarro and Sisley depicted most of the others leading out of Louveciennes, as, for example, Pissarro's *The Road to Rocquencourt* (1871). Both also painted many views within the little town itself: small houses with cottage gardens and twisting paths are shown in all seasons, under a heavy blanket of snow or with the fruit trees in flower. Sisley, who in 1875 moved to the neighbouring village of Marly-le-Roi, continued to paint Louveciennes after he had left.

CHATOU, CROISSY AND ST MICHEL

The loop of the Seine between Chatou to the north and Bougival to the

Louveciennes was Pissarro's home for three years until the Prussians forced him to flee during the Franco-Prussian war; his house (above) at 22 rue de Versailles near the aqueduct (below) still stands. Sisley, too, lived in the town for five years, moving there in 1871. Among the pictures he painted there is The Road at Louveciennes *(right), executed in 1872-73. Two years later, Sisley moved to Marly-le-Roi, though he continued to paint in Louveciennes as well. The town still retains much of the atmosphere that attracted both painters there.*

lived on the outskirts of the town at 22 rue de Versailles, near the tall, brick-built aqueduct that was constructed to carry water from the Seine to the Palace of Versailles and that still dominates the scene today. The rue de Versailles remains but is now no longer the quiet country lane depicted in Pissarro's paintings but a major route for traffic. Pissarro painted several Corot-like views looking north along the rue de Versailles, in both summer and winter, including one painting, *The Road to Versailles at Louveciennes – Rain-effect* (1870), that shows his house and front garden. Monet also painted two views of the Versailles-St Germain road which show it under snow.

south has been made famous by the scenes painted there by Monet and Renoir in the summer of 1869. At this point the river contains a string of islands, and on one of these, Croissy, was a fashionable boating and bathing place called La Grenouillère, which had a floating restaurant linked to the island and main banks by footbridges. Monet and Renoir were both living nearby on the south bank at the time, the former in a rented house at St Michel, near Bougival, the latter with his parents in the Voisins quarter of Louveciennes. Their painting trips to La Grenouillère that summer would probably have been across a newly constructed footbridge at Bougival.

The seven paintings of La Grenouillère that survive depict Parisians at leisure. Rowing boats are moored to the island bank and figures either sit or stand on the bank or on the little islet between the bank and the floating restaurant. Today nothing remains of La Grenouillère, but the paintings are acknowledged by the renaming of the central island as the Ile des Impressionnistes. The north bank of the Seine from Chatou to Croissy-sur-Seine has a peaceful, leisurely air that cannot be dissimilar to its atmosphere when Monet and Renoir worked in the area; there are walkways along the banks and many summer houses.

Both Monet and Renoir used this part of the Seine for other landscapes. Monet painted about a dozen views of the Seine at Bougival in different seasons and in the 1870s Renoir produced a number of boating scenes and riverscapes at Chatou. The best-known of these is *Luncheon of the Boating Party* (1880), a celebration of simple pleasures, for which a mixture of friends and professional models posed. It was painted on the terrace of the Restaurant Fournaise on the Ile de Chatou, a favourite haunt of those taking boating trips on the river.

Between 1872 and 1876, when Sisley was living at Louveciennes and Marly-le-Roi, he frequently painted the Seine at Bougival. The 20 or so extant views dating from this period show the river in all seasons, with laden barges and women washing clothes on the river banks.

For short periods between 1881 and 1884, Berthe Morisot rented a house in Bougival at 22 rue de la Princesse which led to Louveciennes. There she painted a number of views of her husband Eugène Manet (the Impressionist's brother) and their daughter Julie in the garden of the house, and river scenes.

MARLY-LE-ROI AND PORT-MARLY

In the story of Impressionism, Marly-le-Roi, situated south of the Seine, on a height above it, and Port-Marly, on the river bank below, are most intimately associated with Sisley. Marly-le-Roi is the site of a château

Sisley's The Road at Marly-le-Roi *was painted in 1875, the year the painter moved there from Louveciennes.*

which Louis XIV built to serve as a retreat from the affairs of state and intrigues at Versailles. His series of pavilions, in their elaborate setting of formal gardens and ornamental lakes, did not survive the French Revolution, and today, as in Sisley's time, only parts of the grand scheme remain. These include the grounds themselves, now the Parc de Marly; the grille Royale, the point of entry for the king when he approached Marly from Versailles; and the rudiments of the impressive water system, which brought water from the Seine to irrigate the lakes, cascades and fountains of both Marly and Versailles; the aqueduct still exists as do various ornamental lakes in the park and the watering-place where the water from displays collected.

These features of the former

château were among Sisley's favourite subjects. He painted the aqueduct, the watering-place, the roads and village houses around it, the *machine de Marly* (a pumping house by the river, which fed the water system) and the adjacent barrage. The pumping house that Sisley painted was not the original, but a recent rebuilding of 1858, one of a series of reconstructions, the last of which was pulled down in 1967. Sisley painted all these places many times, in both winter and summer and in 1876 showed the pumping house under flood.

Flooding at Port-Marly was a common subject in Sisley's work of this time. In 1873 he painted the village with the riverside route to St Germain submerged under water, and three years later he produced a celebrated series of five similar views – some looking upstream, some down – depicting the same area flooded.

Other paintings of Port-Marly by

Sisley include more distant views of the village, some depicting it under snow; *July 14 at Marly-le-Roi* (1875), showing flag-bedecked streets; and *The Forge at Marly-le-Roi* (1875); and several views, also painted in 1875, of sand being unloaded at the quayside.

While he was living at Louveciennes in 1869-71, Pissarro produced a number of landscapes of the area, including a distant view of Marly-le-Roi; a scene showing a steeply descending road from the viewpoint of the Coeur Volant (part of the Marly-Versailles route), looking down to the watering-place and Port-Marly; and a study of barges on the Seine.

SÈVRES

Sèvres is a suburb south of the Seine, between the Parc de St Cloud to the north and the Forêt de Meudon to the south. Sisley lived there, at 7 avenue de Bellevue, from 1877 to 1880, when he moved to Moret-sur-Loing on the other side of Paris. Like Monet, Sisley was fascinated by the effects of light reflected from water and at Sèvres the river dominated his choice of subject matter: he produced studies of the bustling quayside and of the Pont de Sèvres, a multi-span bridge across the Seine. In addition, he painted views of the village, the famous Sèvres porcelain factory and the railway station.

While living at Sèvres, Sisley also ventured further afield to paint other places on the Seine. These included Billancourt (now firmly a suburb of Paris but then consisting of a few small houses), which he painted from both banks of the river; and Meudon, an area to the east of Sèvres. Upstream, he painted a number of quayside views on the Seine at Le Point du Jour, near the Porte de St Cloud.

VILLE-D'AVRAY

Ville-d'Avray, a suburb of Paris west of Sèvres, sandwiched between the Parc de St Cloud to the north and the Forêt de Fausses Reposes to the south, was the home of Corot, who produced many landscapes of the area, paintings which had a marked influence on the early work of Pissarro and Sisley produced at Louveciennes. Corot also gave informal tuition to Berthe Morisot and her sister Edma at Ville-d'Avray in 1861.

Ville-d'Avray's most notable association with Impressionism, however, is that it provided the location for Monet's celebrated *Women in the Garden* (1866-7), his second major *plein-air* painting after the immense *Déjeuner sur l'herbe*. Monet painted much of the work at Chemin des Closeaux, a house near the station at Ville-d'Avray, where he spent the spring and early summer of 1866. The four figures shown life-size in this work are elegantly costumed women (his future wife Camille posed for at least three of them) in the setting of a flower-filled garden. Over 3m high, the huge canvas had to be lowered into a specially dug trench in the garden to enable Monet to reach the upper portions. It was completed indoors at Honfleur later that summer.

One of Marly-le-Roi's great attractions is the Parc de Marly, created by Louis XIV as part of a hunting lodge.

ARGENTEUIL

Impressionist painting at Argenteuil dates from the post 1871 period. Monet lived there and was visited by his associates. In Monet's time the small town showed the beginnings of some industrial development and, with an hourly train service connecting it to the Gare St-Lazare in Paris, it was plainly already a suburb of the city rather than an isolated rural retreat. It still retained the atmosphere of a country village, however. The heights of Sannois dominated the view to the north-east; there were pleasant wooded banks for strolls by the river, which, since Argenteuil was a sailing centre, was full of small craft of all types. All this was a far cry from the densely built-up industrial area that is Argenteuil today.

Monet lived successively in two rented houses at Argenteuil, both near the railway station. The first of these, the Maison Aubry, at the angle of the boulevard St-Denis and the rue Pierre Guienne, belonged to a relative of Manet, through whom Monet acquired the tenancy in 1871. The second, larger establishment, to which he moved in 1874, was just around the corner at 5, boulevard St-Denis. The station and the roads still exist (although the boulevard St-Denis is now the boulevard Karl Marx), as does Monet's second home, but the appearance of the whole area is so altered that it is hard to visualize the suburban residences and flower-filled gardens that feature in Monet's Argenteuil work.

Manet, who was living nearby at Petit-Gennevilliers, and Renoir were frequent visitors to both houses, and in their gardens all three artists produced paintings and portraits of one another and Monet's family. The three of them became close friends and Manet was convinced for the first time by Monet of the value of *plein-air* work.

Sisley was also a frequent visitor to Argenteuil at this time and painted a number of views there around 1872 and 1873.

A fourth Impressionist who painted at Argenteuil was Caillebotte, who worked there not because of any connections with Monet, whom he did not meet until 1874, but

because he lived there, by the river. An engineer and part-time painter at this time, he, too, played host to Renoir and a little later helped Monet to construct a covered boat for use as a floating studio. Two canvases of 1874 by Manet, notably *Monet Working on His Boat*, and a number of paintings by Monet show the 'atelier' in use on the Seine.

Scenes from and on the river were naturally a dominant aspect of the Argenteuil canvases. Monet, Manet, Renoir, Sisley and Caillebotte painted a wide variety of views: boating trips, regattas, the surrounding landscape and the two bridges that cross the Seine at Argenteuil. Monet, however, was by far the most assiduous, producing about 80 riverscapes. He painted the river from almost every possible viewpoint: upstream and downstream, from both the Argenteuil and Petit-Gennevilliers banks, close up and at a distance. Many of the views downstream show a substantial turreted house framed by two tall factory chimneys on the horizon and in the middle ground the Ile Morante, a large island in the Seine, now gone. From it Monet often painted his more distant upstream views of Argenteuil, centring on the newly built Romanesque-style church with its tall spire. Other river views by Monet show the Bassin d'Argenteuil filled with small craft, sailing boats on the river and the wide, tree-lined promenade along the Argenteuil side which has now disappeared under an expressway.

The Argenteuil bridges were another dominant motif. There were two, a railway and a road tollbridge, and Monet painted both many times from both banks of the river. One beautiful canvas, *The Argenteuil Bridge* (1876), shows the Seine on a golden summer's day, with the railway bridge crossing it to the right, sun-baked trees and shimmery buildings on the opposite bank reflected – the still waters, and moored sailing boats idling in the foreground. Like many crossings over the Seine, both bridges were damaged in the Franco-Prussian War, and when Monet arrived at Argenteuil reconstruction of the road bridge was unfinished. He was therefore able in 1872 to paint two views of it surrounded by scaffolding: one, *The*

Bridge at Argenteuil under Repair, looking across from Petit-Gennevilliers, the other, *The Wooden Bridge*, looking downstream, with the view in that direction framed within a central span of the bridge.

Monet was the only Impressionist apart from Sisley to paint with any frequency within the town of Argenteuil itself. In 1872 both artists painted almost identical views of the boulevard Héloïse, one of the main streets in the town and still in existence today, although considerably altered in appearance. Monet also painted the *Grande Rue at Argenteuil* (1875) (the street is now the rue P. Vaillant-Couturier); *Boulevard de Pontoise, Argenteuil, Snow* (now the boulevard Alsace-Lorraine); *Argenteuil, the Hospice* (1872) (the hospice is on the rue Pierre Guienne), views of the railway station (1872 and 1875); and *View of Argenteuil, Snow* (1875), showing the boulevard St-Denis with his own house in the left background.

While living at Argenteuil, Monet also travelled further afield; he painted upstream at the nearby village of Epinay-sur-Seine and, on the other side of the river in the much more industrialized surroundings of Asnières-sur-Seine, where in 1878 he produced half a dozen views of the Ile de la Grande Jatte. Some of Monet's paintings are river views with the factories of Asnières in the background; others are studies of the Seine viewed through a screen of branches from the island.

The more industrial part of the Seine around Asnières is today more closely associated with the post-Impressionist movement than with Impressionism itself, largely because of Georges Seurat's two best-known paintings, *Une Baignade* (1883-4) and *A Sunday Afternoon on the Island of La Grande Jatte* (1884). Several Impressionists did paint views in this area, but, with the exception of Monet's uncompromisingly industrial *Unloading Coal* (1875), set on the quayside at Clichy, industrial subjects do not feature in the paintings. Berthe Morisot's 1875 pictures of the Plaine de Gennevilliers and her and Sisley's renditions of the Seine at nearby Villeneuve-la-Garenne are essentially rural landscapes.

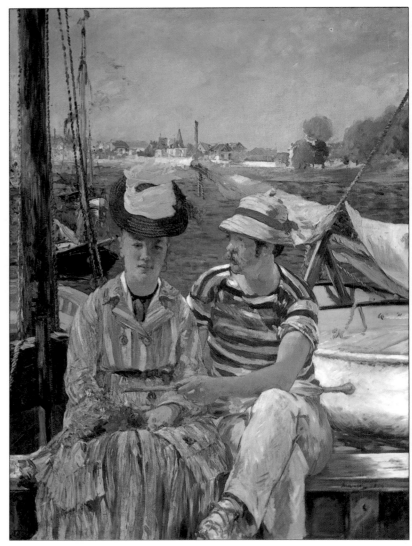

Parisians flocked to Argenteuil to boat and bathe and the Impressionists were quick to follow. From 1871, Monet was active there, as were Renoir, Sisley and Manet; the town was Caillebotte's home. Monet painted The Seine at Argenteuil *(above) in 1873;* Argenteuil *(below) dates from 1874. Manet painted his* Argenteuil *(right) the same year; Monet's* The Dock at Argenteuil *(below right) is from the same period. It was here that Manet was finally converted to the idea of working out of doors and Monet borrowed from Daubigny the idea of building a floating boat-studio, large enough for the painter to sleep in.*

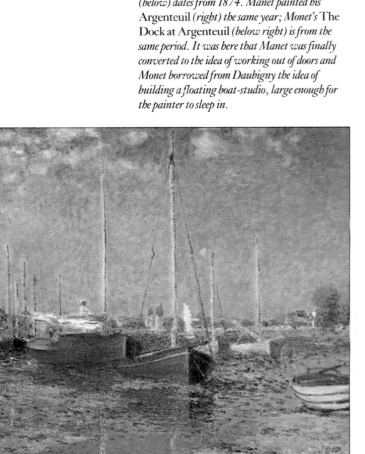

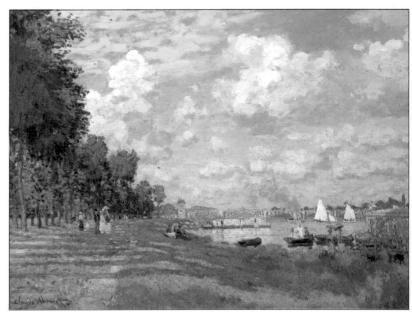

THE AREAS AROUND PARIS

Further out from the capital and its suburbs, there are two areas that have particularly important associations with the Impressionists. One is the River Oise and the nearby towns of Pontoise and Auvers-sur-Oise, which were major locations in the 1870s and early 1880s for Pissarro, Cézanne and Gauguin. The other region is further west along the Seine and its tributary the Epte. Monet and Pissarro both moved further away from the centre of Paris to this area, the former first staying at Vétheuil, then establishing himself in his own house at Giverny, the latter living at Eragny-sur-Epte.

The Seine at Vétheuil (above left), where Monet lived before moving to Giverny. Auvers-sur-Oise was associated with Pissarro, Cézanne and Van Gogh, who spent his last days at the Café Ravoux, now the Maison Van Gogh (right).

AUVERS-SUR-OISE

Auvers-sur-Oise, a small town up river from Pontoise, has now almost been joined to its larger neighbour by modern development. Even so, it is still self-contained and sufficiently unspoiled to give some idea of the atmosphere of the small rural community where the Impressionists worked, and many of the scenes that they painted can still be seen today.

One of the first artists to put Auvers and the surrounding countryside on the map, in the 1850s, was the naturalistic painter Charles Daubigny. It was he who first had the idea, later adopted by Monet, of constructing a studio boat from which to paint on the river. From his home in Auvers, in the Vallées quarter (still in existence today), he travelled in his boat along the Oise to paint the river and the views from its banks. Many other artists followed Daubigny's early example, notably Berthe Morisot and her sister Edma, who stayed at Chou, between Pontoise and Auvers, and painted along the Oise in 1863 in the company of the *plein-air* artist Oudinot.

Pissarro took up residence in the Hermitage district of nearby Pontoise, both before and after taking refuge in London during the Franco-Prussian War. The house he inhabited there in 1872 drew many others to the region, particularly Guillaumin and Cézanne. The same year the latter moved to Auvers, living in a

The church of Notre-Dame (above) in Pontoise. Pissarro lived in the Hermitage district here before and after the Franco-Prussian war. His visitors included Cézanne and Guillaumin. One of Pissarro's favourite painting locations was the nearby hamlet of Valhermeil and the banks of the Oise itself. The study of The banks of the Oise, near Pontoise, cloudy weather *(below) was painted in 1878.*

house that has since been demolished on the rue Rémy. Often working together, Pissarro and Cézanne painted many views in and around Auvers and Pontoise, notably in the hamlet of Valhermeil at the western end of Auvers.

Pissarro's family doctor, Paul Gachet, also moved to Auvers at this time. His house, still standing at number 78 on the street now named after him, contained a studio where Pissarro, Cézanne, Guillaumin and Gachet himself (working under the name of Paul Van Ryssel) all practised print-making. The substantial white building was depicted several times by Cézanne in 1874 and later, in 1890, by Van Gogh. This part of the town contains many other locations rich in Impressionist associations. The crossroads of the rue Rémy and the rue Dr Gachet were painted by both Cézanne and Van Gogh. The western extension of the rue Dr Gachet, the rue François Coppée, was the site where a number of Paul Cézanne's works were painted, including *La Maison du pendu, Auvers* (1873-4). Here, too, can still be found the Castel du Four, the house owned by the pâtissier Murer, where he hosted weekly dinners and art lotteries attended by Pissarro and his circle.

Van Gogh came to live at Auvers-sur-Oise in 1890, spent his last two

months there under the care of Dr Gachet and now lies buried beside his brother Theo in Auvers cemetery. During this short period he worked prodigiously, painting many views of the town and its environs. Among the places in his work still visible today are the Romanesque church and the 17th-century château. The Café Ravoux, where Van Gogh spent his last days, also still stands on the rue du Général-de-Gaulle. Now the Maison Van Gogh, it will, like the château, be opened to the public in 1990, the centenary of the artist's death, as part of a major artistic programme.

The rue Victor Hugo in Auvers-sur-Oise (below). Pissarro moved to Eragny in 1884; he painted Effet de neige à Eragny *(right) a decade later.*

ERAGNY-SUR-EPTE AND GISORS

Eragny, a small village on the River Epte just north of Gisors, can hardly have grown much in size since Pissarro first moved there in 1884. His improved financial situation enabled him in 1892 to buy a house there, where he settled and from where he made frequent painting trips and excursions right up to 1903, the year of his death. In the large garden he built a substantial studio, in which he painted many of his late works.

As with the paintings he had done earlier at Pontoise, during his second stay there, much of Pissarro's work at Eragny consists of generalized, even idealized, studies of rural life: apple-picking, looking after sheep, harvesting. (Many of these pictures are executed in the Divisionist style he adopted between 1885 and 1890.) But he also painted more specifically located scenes that can be identified. Many are distant views of the village at various seasons; the later examples seem to have been painted from the large studio window, while others look in the direction of Bazincourt.

Pissarro also painted the view from his back garden on several occasions. One such work, *View from My Window* (1886-8), shows on the left a large building that was to become his studio. Other paintings with specific locations include the village watering-

place; a Divisionist view of a train on the line to Dieppe in 1886; and several renderings of the road leading south from the village to the old market

The old centre of Gisors, near the church (below), where markets and fairs were held, was one of Pissarro's favourite subjects. Other themes included views of the surrounding countryside (bottom); a favourite location was Ludovic Piette's farm.

town of Gisors.

Gisors, the nearest large community, played a considerable part in Pissarro's work during the Eragny period. The town has grown and changed considerably since Pissarro's time, but the old centre has been carefully restored and looks much the same as when the artist painted and drew his many scenes of markets and fairs there in the 1880s.

Other locations painted by Sisley include the Prairies, an open meadow area on the edge of the town; the New Quarter, a similarly spacious area; and the Sacré Coeur convent.

VÉTHEUIL

This village on the east bank of the Seine between Mantes and Vernon has changed very little since Monet moved there from Argenteuil in 1878. He lived in Vétheuil with his wife, Camille, and the Hoschedé family for three years, during which time Camille died; his residence is now commemorated by one of the village streets, which is named after him.

Monet and his entourage first lodged in a small house on the Mantes road, but moved quickly to a much larger one, at the other end of the village. In 1881 the artist painted a series of views of his garden there. Other subjects included studies of the 12th-century church, but the bulk of his output consists of panoramic views, executed either from Lavacourt, on the opposite bank of the Seine, or from the Ile St Martin, one of the many islands in the Seine at this point in its course. As was his practice, Monet painted these views in the widest possible range of weather conditions – in sunlight, through fog, with the Seine frozen over, the ice breaking up and during the flooding of 1881. Other locations included the road to La Roche-Guyon.

Monet paid a return visit to Vétheuil in 1901, when he rented a house overlooking the river at Lavacourt. From its balcony, he executed a series of 15 paintings, showing the effect of changing light and weather conditions on his standard view of the village.

Monet's house and gardens at Le Pressoir, Giverny. Monet lived at Giverny for nearly 45 years, continually changing and enlarging his home, his studios and the celebrated gardens he created. Here, in a letter written shortly before his death, he summed up his artistic credo: 'I have always had a horror of theories…I have only the merit of having always painted directly from nature, trying to convey my impressions in the presence of the most fugitive effects'.

GIVERNY

The village of Giverny lies by the Epte, near its confluence with the Seine, on the main route from Vernon to Gisors. Monet first moved there in 1883, settling into the house that he was to buy seven years later and where he lived for the rest of his life. This extensive property, in an area of Giverny known as Le Pressoir, was bounded by four roads. To the sides were two lanes, the ruelle Leroy and the ruelle L'Amsicourt; the front faced onto the main road to Vernon; and the back looked out on to the other main street in the village, the rue du Haut. Beyond the main road at the front, on the other side of the railway line (no longer in existence), ran the River Ru, a small tributary of the Epte that was later to provide the water for Monet's celebrated gardens.

The creation of the water gardens at Giverny and their depiction in a series of massive decorative panels – his *grandes décorations* – were Monet's last great project, occupying him until his death in 1926. He first began work on the gardens in 1893, buying additional land between the railway line and the Ru to give him access to the river. Two years later he had finished the water lily pond and the Japanese bridge spanning it, which together feature in so many of his Giverny paintings; but in 1903 pond and gardens were further extended, to their present size. Monet also enlarged his studio space at the same time, adding two more studios to the one he already had; one he reserved for working on his *grandes décorations*.

During his first two decades at Giverny Monet divided his time between working trips away from home and painting the village and the surrounding countryside. One of his earliest paintings in the area is of the town of Vernon, a subject he was to take up again in 1894, when he produced a series of six views of the town from the opposite bank of the Seine, all almost identical in viewpoint, with the church dominating the scene.

The Seine was one of Monet's favourite subjects and at Giverny he painted it on several occasions from Port Villez, on the opposite bank of

The water gardens and one of the studios at Giverny. Monet created his landscape around his house and transferred it on to canvas in many paintings, most notably in his series of studies of water lilies. These, like many of his later canvases, are on a massive scale; they now hang canvases, are on a massive scale. The gardens, too, have been lovingly restored; the celebrated Japanese bridge is still in place, as are the irises, the rose trellises and the wisteria.

the river sometimes showing it frozen over. Bennecourt, the same side of the river as Port Villez but further upstream, was another favourite location.

Giverny also provided the setting for two of Monet's major late series: studies of haystacks and poplars. Occasional pictures of haystacks make their appearance in his work from 1886, but the main series dates from the autumn and winter of 1890-1. It depicts a group of haystacks in a field known as Le Clos Morin, situated at Monet's end of the village. These studies, each made from the same viewpoint but showing a different lighting effect according to the time of day, prefigure the series of views of the façade of Rouen Cathed-

ral Monet painted the following year.

Monet's next major series, more than 20 studies of poplars on the Epte, were painted in the summer and autumn of 1891. They were followed in 1893 by studies of ice-floes on the Seine, in 1894 by views of Vernon and in 1896-7 by 16 studies of early morning on the Seine near Giverny.

In later life Monet continued to make trips abroad to paint – London in 1899, 1900 and 1901, Venice in 1908. At home he concentrated increasingly on painting motifs close to hand in his gardens: the Japanese bridge, the rose trellises, the irises and wisteria and, above all, the water lilies. In 1918 Monet decided to present to the nation the series of large

decorative panels featuring the water lilies in his garden. Originally, they were intended for a specially designed decorative scheme in the Hôtel Biron in Paris, but eventually they were installed in the Orangerie, where they can be seen today.

After some extensive restoration, Monet's house and gardens were opened to the public in 1980. Today the visitor can walk around the gardens that the artist designed and visit the house (which contains his extensive collection of Japanese prints) and its studios. Giverny is a rewarding place for those interested in Monet's work, allowing the visitor to see many of the sources of inspiration for the artist during the final years of his long and productive career.

PROVENCE AND THE MEDITERRANEAN COAST

Provence and the Mediterranean coast make three different contributions to Impressionism. They feature as the backdrop for painters who were native to the area (Bazille, Cézanne); as a location for a specific tour (Monet, Courbet); or as a warm weather retreat in old age (Renoir, Boudin, Guillaumin). Whichever category the artists themselves fit, one factor common to all of the Impressionists who painted in the area was their preoccupation with the unique qualities of the Mediterranean light, with its strength and clarity. Allied to this was the attraction of an undulating coastline of bays and promontories that provided spectacular viewpoints from which a painter could work. Many of the towns along the Côte d'Azur would be barely recognizable to these artists today, but outside the built-up areas, driving along the Esterel Corniche or the inland backroads of Provence, it is still possible to observe the same artistically appealing characteristics in the landscape.

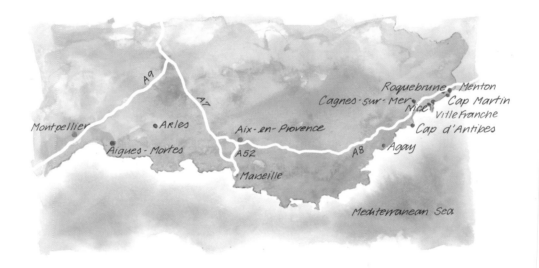

Nice (left) in the 19th-century was an early favourite among the resorts on the Côte d'Azur. The flower market in Aix-en-Provence (above), a traditional sight familiar to Cézanne.

AGAY

Agay, a small town on the Esterel Corniche, was the favourite wintering place for Guillaumin. Although even less populous in the artist's lifetime than it is today, it had the advantage of a direct railway link to Paris. Guillaumin first discovered it in 1887 and, attracted by the strong chromatic contrast between the red porphyry rocks on the Esterel and the blue of the Mediterranean, returned there to paint each winter until his death. Favourite viewpoints and motifs appear to have been studies of the little town and its bay, seen either looking east from Cap Dramont with the rocky outcrop known as Le Rastel d'Agay in the background, or west from the Pointe de Baumette. Other subjects included coastal studies of

the red rocky outcrops, the sea and the wind-swept coastal pines.

AIX-EN-PROVENCE

Aix-en-Provence, birthplace of Paul Cézanne and his home for much of his working life, is the old capital of this distinctive region. The city was founded in Roman times, but the bulk of what is locally termed 'Old Aix' – as opposed to the modern city that has grown up around it – was built in the 17th and 18th centuries.

Brilliant light and sea bathe the Mediterranean coast at Agay (left, below left), the favourite winter home of Guillaumin. 28 rue de l'Opéra (below) in Aix-en-Provence was where Cézanne was born in 1839.

This central core has altered little since Cézanne's day. The Cours Mirabeau, Aix's broad central thoroughfare, is still lined with shady plane trees, with rows of pavement cafés on either side and a fountain at either end. Cézanne would also recognize other locations that marked important events in his life: the rue de l'Opéra leading off the Cours Mirabeau, the street where he was born, in 1839, at No 28 and the rue Boulegon where he lived, at No 23, for the last six years of his life. Many of the major buildings in the city, such as the 17th-century town hall where the painter was married to Hortense Fiquet in 1886, are equally unchanged, as is the little fountain in

picture that Cézanne 'borrowed' the earlier painter's signature to append to one of his own first essays in painting – the panels of *The Four Seasons* with which he decorated the salon walls of his family's country house, the Jas de Bouffan. This house, which still exists today, signposted from the city's inner ring road, was part of a large estate just north of the city purchased by Cézanne's father, one of Aix's more prosperous businessmen, in 1859. The Musée Granet also contains a small group of Cézanne's early paintings. Many of these are copies of other works in the museum and are displayed side by side with the originals for easy comparison. There is also a large collection of paintings left to the museum in 1849 by the Provençal painter F.M. Granet, from whom the building takes its name.

There is no doubt that the provençal landscape was of great importance for Cézanne from an early age, even though its influence is not immediately apparent in either the choice of subject or the sombre tones of his early paintings. As a schoolboy, he explored the countryside around Aix in the company of his school friend Emile Zola, his junior by a year;

The tree-lined Cours Mirabeau in Aix (left) and 23 rue Boulegon (below), where the now revered Cézanne spent the last six years of his life.

the square in front of the town hall which Cézanne painted four years later. However, this painting is a rarity in Cézanne's artistic output, since in the main, he concentrated almost all his efforts on depicting the provençal countryside around Aix, rather than the city itself.

The place to assess the first influences on Cézanne is the Musée Granet, a 17th-century one-time priory set slightly back from the rue Cardinale on the place St Jean de Malte. This contains the city's collection of paintings; it also was the home of the art school at which the young Cézanne studied. Among the major works in the collection with which he was familiar was Ingres' *Jupiter and Thetis*. It was from this

A view of the Mont Ste-Victoire, one of the Provençal landscape's most dominant features (above). It was one of Cézanne's favourite subjects. The Château Noir (below) at Le Tholonet was another.

in his painting. From this point, Cézanne divided his time more or less evenly between Aix and Paris and views of the local landscape become a dominant theme in his work.

A drive along almost any of the roads radiating from Aix reveals the physical features that so attracted Cézanne. These are the visible rocky structures in strongly contrasting colours, non-deciduous vegetation whose appearance remains fairly constant throughout the year and, above all, the strong clear quality of the Mediterranean light.

It is also possible to visit several specific locations where Cézanne produced much of his prolific Provençal output of oil paintings, watercolours and pencil drawings. His most celebrated subject is the Mont Ste-Victoire, a long mountain range to the north-east of Aix. Although the range dominates Aix from many angles, the best way to view the mountain as depicted by Cézanne is to take the D17 road to Le Tholonet, passing other places that were frequently painted by Cézanne along the way. These include the Château Noir, a

indeed, after the latter left Aix for Paris in 1858, the theme of the countryside features in the long correspondence between the two men. It is not, however, until after Cézanne's own direct contact in Paris with Impressionism and the subsequent lightening of his palette that the Provençal landscape becomes visibly influential

Cézanne's studio in the avenue Paul Cézanne (above) is still preserved.

farmhouse situated just outside Le Tholonet, which, together with the surrounding woodland, was a particular favourite of Cézanne's and the nearby quarries at Bibémus, where he rented a small hut to use as a studio.

For much of his time in Aix, however, Cézanne lived and painted at the Jas de Bouffan. Some of his earliest works were painted specifically for this house, including a portrait of his father reading and the aforementioned panels of the *Four Seasons*. The house and its surrounding grounds are also the subject of numerous paintings and watercolours.

Cézanne sold the Jas de Bouffan in 1899 and two years later built himself a studio on the road leading to Les Lauves, a low ridge of hills which commanded views out to the Montagne Ste-Victoire. It was from here that most of his last landscapes were painted. Today the studio is in the city's northern suburbs on the appropriately named avenue Paul Cézanne. It is open to the public and is signposted from the inner ring

road. The interior is set out as it was in the painter's last days, with the models for the still lifes that were another favourite subject as well as a number of Cézanne's personal possessions.

More of the landscape that inspired Cézanne can be seen by taking the D65 or D64, two small roads to the south-west of Aix. These lead along the valley of the River Arc, which was another part of the Provençal landscape much painted by the artist. Also featured in his paintings is the small village of Gardanne located south-east of Aix.

Further south, on the Mediterra-

nean coast, is L'Estaque. This is now a suburb of Marseilles, but in Cézanne's time was a quiet Provençal village where he could paint the mountainous coastal landscape and the blocky structures of the houses themselves. In 1870 he retired here with Hortense Fiquet to avoid being drafted into the army during the Franco-Prussian War and was visited briefly by Zola. Cézanne returned to paint here on several other occasions and in 1882 was joined by Renoir, who also painted several views of the locality.

CAGNES-SUR-MER

The supreme example of the Mediterranean as an old age retreat is provided by Renoir's home at Cagnes-sur-Mer. He first visited the south in 1882 on his return from Algeria and Italy, working with Cézanne at L'Estaque, and he returned there again with Monet the following year. It was presumably what he saw on these and subsequent visits, coupled with the attractions of a warm winter climate for someone so dogged by ill-health in later life, that persuaded him eventually to settle permanently in the south.

From the turn of the century,

Renoir spent an increasing number of winters at Cagnes and in 1907 he purchased Les Collettes, a hillside estate with an old farmhouse and an olive grove on the outskirts of Cagnes-Ville looking towards the ancient hill town of Haut-de-Cagnes. He had a substantial house and gardens constructed for himself and his family, equipped with a studio in which he could work. Here, along with the female nudes that are an increasingly dominant subject in his later work, Renoir also executed landscapes, painting the old farmhouse at Les

The fortified town of Haut-de-Cagnes (left) sits on a hill overlooking the sea. Renoir had a good view of it from the house (right) he built at Les Collettes, the estate he bought in 1908. He spent much time improving the house and its gardens (above and below), living there until his death in 1919. Though Renoir became increasingly crippled by rheumatism, which forced him to paint with his brushes attached to his wrist, he continued to 'put colours on canvas in order to amuse myself' until the end of his life. His home is now a museum.

Renoir's studio, various personal possessions, a few late canvases and a selection of sculpture.

CAP MARTIN

It was from Cap Martin, a favourite tourist viewpoint at the time, that Monet painted his first Mediterranean views on his return from a trip to Italy in 1884. As with his later trip, in 1888 when he stayed at Cap d'Antibes, Monet selected this headland because it afforded impressive views along the coast in two directions. Eastwards he was able to paint the town of Menton looking towards Italy and to the west the Monaco Corniche with Monte Carlo and the Tête du Chien promontory in the background.

Inland from Cap Martin and Menton is the ancient town of Roquebrune. Various artists, including Guillaumin and Monet, worked here but it is most notable as a favourite painting location for Corot.

Collettes, the gardens, olive trees and views of the countryside around the estate, all of them broadly executed in predominantly earthy colours.

While the lower town has continued to grow, the fortified medieval town of Haut-de-Cagnes is relatively little changed since Renoir's time; Les Collettes, too, has managed to retain the feel of the secluded oasis where the painter retreated to spend the last 12 years of his life. Now on the rue des Collettes, the house and gardens are preserved as the Musée Renoir Les Collettes with a reconstruction of

Sunset over Cannes, seen from Cagnes. This was the sort of scene that attracted the Impressionists to the south of France.

CAP D'ANTIBES

Monet based himself at Cap d'Antibes for his second visit to the Mediterranean in 1888, when he spent four months painting the area. He stayed at a somewhat grand artists' pension in Cap d'Antibes known as the Château de la Pinède and set about exploring the peninsula to find suitable viewpoints. His Antibes paintings, like those painted from Cap Martin four years earlier, make use of the headland as a point from which to obtain impressive views of the coast in both easterly and westerly directions. To the east Monet painted a series of views of Antibes seen sometimes from the Jardins des Salis on the southern outskirts of the town, at others from the Pointe Racon on the Plateau de la Garoupe. These show Antibes at some distance across the bay, with the towers of the

Fine, clear light over the Cap d'Antibes (above right) with typical Mediterranean vegetation (below). Monet painted from the Cap in 1888.

Grimaldi castle and the cathedral just discernible. Other easterly-looking paintings are wider-sweeping views across the Baie des Anges.

The views to the west look towards what was then the small town of Juan-les-Pins. They were generally painted from a vantage point not far from the Château de la Pinède looking across the Golfe Juan with the Vallauris mountains in the distance. In Monet's time this area was much less built-up and the fact that Juan-les-Pins is depicted through a screen of pines is evidence of how much tree cover existed on the peninsula a century ago.

Antibes was also a popular location for Boudin. Deteriorating health led the artist south in later life; from 1893 he made increasingly frequent winter visits to the Mediterranean, painting also around Villefranche and Beaulieu. Boudin painted distant views of Antibes and Juan-les-Pins from similar vantage points to Monet, but he also produced studies at closer quarters of Antibes' harbour and port.

Boudin also visited Antibes, where one of his subjects was the harbour (right). By the end of the century, the area was becoming extremely fashionable among the well-to-do.

THE GAZETTEER OF IMPRESSIONISM

Antibes in the soft early evening light (left). Monet spent four months painting the area around the resort, basing himself at the Château de la Pinède, an artists' pension in the town.

Market day in the covered market in Antibes (below). Monet must have observed such bustling scenes, but decided to concentrate on landscapes during his visit.

MONTPELLIER

Montpellier is an inland town in the Languedoc, much further west than any of the other places in the south of France associated with the Impressionists. For anyone interested in the history of the movement, however, it is well worth a visit.

Situated in the heart of the town, on the axis of the boulevard Sarrail and the rue Montpellieret, Montpellier's museum, the Musée Fabre, is an institution whose genesis and continued existence are intimately connected with local artistic talent and benefactors. At their core is the Hôtel de Marsilian, an 18th-century town house that was the home of the painter François-Xavier Fabre, who donated it and his collection of paintings to the town in 1825 and became the museum's first curator. One of his successors, Alfred Bruyas, was keen on collecting contemporary works and it is due to him that the museum possesses not only work by 19th-century local artists, including Bourdon and Cabanel, but also large collections of important paintings by now celebrated artists such as Delacroix, Géricault, Couture, the Barbizon painters and Courbet. Bruyas' particular friendship with Courbet resulted in the latter's making a trip to Montpellier in 1854; this is recorded in a painting commissioned by Bruyas, one of the museum's masterpieces, *The Meeting*, which shows the encounter between artist and patron on a country road outside the town.

Montpellier was the home of Bazille, whose family had a town house at 11 Grande Rue (which still stands today) and a country estate, Méric, at the nearby village of Castelnau-le-Lez on the road to Nîmes. Although Bruyas knew Bazille, it seems that even the curator's advanced tastes did not extend to collecting the works of the young Impressionist or of his Parisian friends, and the fact that the Musée Fabre possesses the best collection of Bazille's work is largely due to bequests made by members of the artist's family after his untimely death in the Franco-Prussian war a few days short of his 28th birthday.

Among the pictures by Bazille in the museum is a portrait of a young girl in a striped dress in a landscape setting. Entitled *View of the Village*, this is one of a group of paintings executed during the period 1864-8 when the artist returned each summer from Paris to stay at Méric. They show members of the family or household posed on the terrace which overlooks Castelnau-le-Lez (now all but absorbed into Montpellier). The family house and terrace still stand but are not open to the public.

In 1867 Bazille made a number of drawings and paintings of the medieval fortified town of Aigues-Mortes, south-east of Montpellier, on the coast. Some show the town's towers and its gateway, the Porte de la Reine at fairly close range; others are more distant views of the town from across the marshy salt-flats, scenes that have changed very little to this day.

7 THE A-Z OF IMPRESSIONISTS

Frédéric BAZILLE (1841-70)

Bazille decided to follow an artistic career when he left school, but, on the advice of his parents, he enrolled at the medical faculty in Montpellier. He arrived in Paris in 1862 to continue his medical studies and attended Gleyre's atelier, where he met Monet, Renoir and Sisley. Having failed his medical exams, he devoted himself to painting. His family, relatively prosperous, was able to support him during the 1860s, and he in turn often gave financial support to his poorer colleagues.

Bazille's larger composition of 1867 *The Family Reunion*, accepted at the 1868 Salon, is very similar to Monet's canvas of 1866, *Le Déjeuner sur l'herbe*: both show a large *plein-air* figure group in a setting of dappled sunlight. Bazille's *View of a Village* (1868) shows his interest in the effects of light on a landscape; the background is treated in a style reminiscent of Courbet.

Bazille shared a studio with Renoir in the late 1860s, and the two artists

Frédéric Bazille at work in his studio, painted by Auguste Renoir in 1867, three years before Bazille's death.

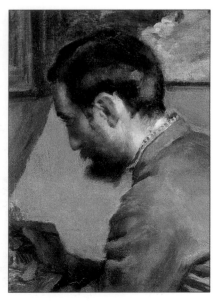

painted portraits of each other during this time. Monet, too, occasionally used the studio. Bazille's style of portraiture was close to that of Manet, as can be seen in such works as *Edmond Maître* (1869). *The Artist's Studio, Rue de la Condamine* (1870) acknowledges a debt to Courbet, both in its subject-matter and in its inclusion of a copy of Courbet's *Bathers* in the background. A few months after completing it, Bazille was killed in the Franco-Prussian war, at the battle of Beaune-la-Rolande.

Louis Eugène BOUDIN (1824-98)

Born in Honfleur, Boudin was closely associated with the sea during his early life; at the age of 10 he sailed on his father's boat as a deck boy. His family then settled in Le Havre and he began to work as a salesman in a stationer's shop, where he remained for many years. With another employee, he set up his own shop, in whose window he often displayed paintings by Troyon, Couture and Isabey. In 1846, realizing where his true vocation lay, he sold his share of the business and devoted himself to painting, working extensively on the coast.

In about 1858 Boudin met Monet in a picture framer's shop in Le Havre, where Monet used to exhibit his caricatures. Boudin encouraged him to do more serious work and they painted in the open air together. Monet was always to acknowledge his debt to Boudin, saying, 'If I have become a painter, I owe it to Eugène Boudin.' In 1859 Boudin met Courbet, with whom he developed a long-lasting friendship. The same year he exhibited at the Salon for the first time and moved to Paris, working with Troyon. In the early 1860s he met Corot, Daubigny and Jongkind and, on the advice of Isabey, began to paint beach scenes. He returned to

A photograph taken in the 1870s of Eugène Boudin painting 'en plein air' in his favourite marine surroundings, sent to the art dealer, Paul Durand-Ruel.

the coast each summer, painting at Deauville, Trouville and Le Havre.

In 1868 Boudin took part in an exhibition that included works by Daubigny, Courbet, Manet and Monet. During the Franco-Prussian war, he fled to Brussels. On his return, together with Monet, he visited Courbet in prison. During the 1870s he painted regularly on the coast, and in 1874, probably at the invitation of Monet, exhibited at the first Impressionist show. In 1883, the picture dealer Paul Durand-Ruel organized an exhibition of his work, which was well received, and three years later the State purchased one of his paintings from the Salon. From 1892, poor health obliged him to spend his winters in the warmer climates of the Côte d'Azur and Venice, which proved a new source of inspiration.

Gustave Caillebotte

Gustave CAILLEBOTTE (1848-94)

Son of a wealthy businessman, Caillebotte was a minor member of the Impressionist circle who nevertheless provided an important supportive role to the group. During his early years he showed little interest in art and trained to be a lawyer, but after military service he abandoned law and took up painting, entering the studio of the Salon painter Léon Bonnat.

Caillebotte used his assured regular income to help in the organization of Impressionist shows. His first major work, *Raboteurs de Parquets*, was rejected by the Salon of 1875, and by 1876 he was exhibiting with the Impressionists. Like his colleagues, Caillebotte chose to paint scenes of contemporary life, but his style was more representational and polished: works such as *Le Pont d'Europe* hover between the techniques of Tissot and Degas. One of his favourite viewpoints was looking down on a scene from an upper window. With their extreme light and dark tones, his works owe something to Degas's New Orleans paintings and in their turn influenced the young Signac's compositions.

Caillebotte's involvement in Impressionist exhibitions was untiring and, by his patronage, he enabled many of the movement's poorer members to make a living; the paintings he collected in the 1870s figure among the finest in the Musée d'Orsay today. During the 1880s he began using the brighter palette favoured by his Impressionist colleagues, and an increasing love of sailing resulted in many riverscapes. He bequeathed his entire collection of Impressionist and other paintings to the state (there were 65 paintings in total). The gift proved controversial and some of the paintings were rejected.

Mary CASSATT (1844-1926)

Daughter of a Pittsburgh banker, Mary Cassatt travelled extensively in Europe with her family during the 1850s, spending long periods in Paris, Heidelberg and Darmstadt. In the early 1860s she attended classes at the Pennsylvania Academy of Fine Arts in Philadelphia and in 1865-6 travelled to Paris, where she worked in the Louvre, studying with Gérôme and Chaplin. She exhibited her first work at the Salon in 1868, at a time when she was painting around the outskirts of Paris. In 1870 she went to Italy, but on the outbreak of the Franco-Prussian War that year she returned to the United States.

In 1872 Cassatt returned to Italy, where she stayed in Parma, copying works by Correggio and studying the techniques of printmaking. During the next few years she travelled widely, visiting Seville, Antwerp, Paris and Rome. Her work at the Paris Salon was noticed and admired by Degas, with whom, after she settled in Paris in 1875, she struck up a lasting friendship. She contributed to the Impressionist exhibition of 1879 and

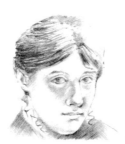

Mary Cassatt

to all subsequent shows except that of 1882, when she supported Degas in the friction caused by his wish to introduce new members to the group. Other close friends included Berthe Morisot and Mallarmé.

Cassatt's early works, mainly of figures, were greatly influenced by 16th- and 17th-century art, but her association with the Impressionists soon resulted in her using a much lighter palette and broken brushstrokes. She painted mainly figure compositions and portraits, in which the mother-and-child theme began to predominate during the late 1880s. It was probably her close association with Degas that encouraged her to

take up printmaking again; she produced many prints, both in monochrome and colour, which clearly show the influence of Japanese art. In 1894 she purchased and restored the Château de Beaufresne, north-west of Paris, and this was her country home for the rest of her life.

Paul CÉZANNE (1839-1906)

Son of a businessman, Cézanne was educated in Aix-en-Provence, where he met Zola. In 1857, while still at school, he began to attend the Free Municipal School for Drawing at Aix, but, probably conforming to parental wishes, he went on to study law at Aix University. However, in 1861, encouraged by Zola's earlier departure for Paris and his regular letters, Cézanne abandoned law and went to the capital visiting the Salon and meeting Pissarro at the Académie Suisse. After a brief return to Aix, when he worked at his father's bank, he was soon back in Paris, exhibiting at the Salon des Refusés in 1863 and studying at the Académie Suisse, where he met Guillaumin, and in the Louvre, where he copied works by the old masters.

A photograph of Paul Cézanne as an old man taken in 1904 in Aix-en-Provence, where he painted many of his best-known pictures.

In 1864 his first submissions to the Salon were rejected; of all the Impressionists, Cézanne was to submit works most doggedly to the Salon throughout his life. During the next few years, his time was divided between Aix and Paris, with his friends Zola, Guillaumin and Guillemet encouraging him in his painting and his father providing him with an allowance – although this was withdrawn on several occasions. During his early years, his preferred subjects were portraits and morbid scenes of the imagination, such as *The Rape* (1867), painted mainly in sombre tones, with an extensive use of the palette knife; but from around 1866 he also began to work out of doors.

In 1872 Cézanne's work was again rejected by the Salon and he joined with Manet, Pissarro, Renoir, Jongkind and others in requesting another Salon des Refusés. He and his companion Hortense Fiquet went to live in Pontoise, where he worked with Pissarro and Guillaumin, using a much lighter palette. In 1874 he exhibited at the first Impressionist show, but although he was to remain close to members of the group, notably Pissarro, Guillaumin and Renoir, he exhibited with them only once more, in 1877, persisting in his efforts to become accepted by the Salon. During this time, he came to know Victor Choquet, who bought several of his works.

In the early 1880s Cézanne painted with Pissarro and Renoir and met Gauguin at Pontoise. In 1882, as a result of Guillemet's intervention, one of Cézanne's works – a portrait – was at last accepted by the Salon. His work, which could be seen at the shop of Père Tanguy, the colour merchant, was beginning to attract younger artists, and both Gauguin and Signac bought paintings. During this period Cézanne spent most of his time in Provence, occasionally returning north to visit Zola, Monet and Pissarro. His friendship with Zola, however, broke up in 1886, on publication of Zola's novel, *L'Oeuvre*, which portrayed Cézanne as the failed young painter Claude Lantier. The same year Cézanne's father died, leaving his family a substantial legacy, which removed all financial worries from the painter.

By this time Cézanne's reputation in artistic circles was beginning to grow, and he received invitations to exhibit with Les XX in Brussels. In 1895 he was given his first one-man show, consisiting of some 150 works. At the same time, two of his works in Caillebotte's collection entered the Luxembourg Museum in accordance with the donor's bequest. In 1899 he was profoundly saddened by having to sell the family home, the Jas de Bouffan. His work came to be admired by an increasing number of young painters, in particular Maurice Denis, who exhibited *Homage to Cézanne* at the Salon in 1901.

Cézanne spent most of his last years in Aix, producing many paintings of Mont Ste Victoire, which was a favourite subject throughout his long career. Of all the Impressionists, it was Cézanne who had the most enduring effect on the subsequent development of painting, and both Picasso and Braque openly declared their debt to his art.

Jean-Baptiste-Camille COROT (1796-1875)

Together with Courbet, Corot had perhaps the strongest influence of pre-Impressionist painters on the movement, because of his enduring commitment to *plein-air* painting. In addition, his long-established position in the art world enabled him to give support to the emerging group.

The son of a cloth merchant, Corot began to cherish the idea of an artistic career around 1815, but his father set him to work as an apprentice in the drapery trade. In the evenings, however, he attended drawing classes at the Atelier Suisse in Paris, and his parents eventually gave in to his wishes, providing him with a generous allowance with which he was able to devote himself to painting.

At first Corot worked under Michallon, then Bertin, sketching from nature in and around Paris and the Fontainebleau forest. Then in 1825 he went to Italy, where he travelled mainly in the Roman Campagna, Rome itself and Naples. Sketches he made during this time, such as that for his *Bridge at Narni* (1826), were probably executed in the

A photograph of Jean-Baptiste Corot in his later years painting 'en plein air'.

open air – but his Salon exhibits were painted in the studio. These won him official success: he was awarded a second-class medal at the Salon of 1833 and many of his works were subsequently bought by the state. He also exhibited at the World Fair of 1855, where six of his works were on show.

In 1860 Corot met Daubigny, the following year the Morisot sisters – he was particularly fond of Berthe Morisot – and in 1862 Courbet. In 1864 he became a member of the Salon admission committee, which that year was notable for the number of works it accepted by Impressionists-to-be, a development that may have been partly due to Corot's influence. Painting in the Fontainebleau forest in the mid-1860s, he met many of the Impressionists, and his work was profoundly to influence the landscape painting of Monet, Sisley and Pissarro. At one time the Impressionists considered inviting Corot to exhibit at their first show, but this came to nothing, probably because, by the time of the exhibition, Corot had distanced himself from them.

Gustave COURBET (1819-77)

One of the most controversial artistic figures of the 19th century, Courbet was the son of a landowner in the Franche-Comté. He attended the Academy at Besançon, where he received the traditional training of life-drawing and copying from the old masters and showed an early interest in landscape painting. In 1839 he moved to Paris, frequenting various studios and making contact with artists and art critics, including Baudelaire, Champfleury, Astruc and Castagnary.

Courbet's first submissions to the Salon were accepted in 1844. His talent was quickly recognized by critics and he was awarded a medal at the 1849 Salon, where the State bought *After Dinner at Ornans*. His first controversial work was the huge composition *A Funeral at Ornans*, uncompromising in its depiction of local dignitaries; and thereafter his work at the Salon, such as *The Bathers* (exhibited 1852) often achieved notoriety. His relationship with the government, too, was uneasy and was made worse by his increasing

A photograph of Gustave Courbet – his work greatly influenced many of the young Impressionists.

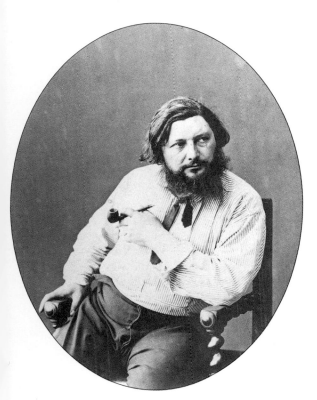

involvement with the anarchist politics of his friend Pierre-Joseph Proudhon.

As a mark of independence from the establishment, Courbet staged a one-man exhibition at the 1855 World Fair, which rivalled the Salon Show; it included a huge canvas, *Studio of an Artist*, exhibited in his Pavillon du Réalisme. His choice of contemporary subject-matter, as in *Young Ladies by the Seine (summer)* (exhibited at the 1857 Salon) continued to cause controversy, and the anti-clerical *Return from the Conference* and *Venus and Psyche* were both rejected by the Salon, probably on the grounds of impropriety. However, he also continued to have work regularly accepted.

At the World Fair of 1867, Courbet once more held his own show, and this time his example was followed by Manet, who exhibited nearby. During the Commune of 1871 Courbet was implicated in the destruction of the Vendôme column, and after the army regained control he was imprisoned for six months. After his release, he found that his property was being confiscated to rebuild the column and fled to Switzerland, where he remained until his death.

Courbet's work had a great influence on the young Impressionists. His use of the palette knife was taken up by Cézanne, Pissarro and Monet in their early work, and the speed with which he was observed to work on a landscape in oils in the open-air was eagerly emulated by many of the Impressionists.

Charles DAUBIGNY (1817-78)

One of the earliest exponents of *plein-air* painting, Daubigny was taught first by his landscape-painter father, Edmé-François and then at the Ecole des Beaux-Arts in the class of Paul Delaroche. From 1848 he exhibited at the Salon and frequently received awards. Closely associated with the Barbizon School, he often painted in the Fontainebleau forest with Corot, Diaz and Théodore Rousseau. To enable him to paint in the open air in all conditions, he worked from a studio boat, and his dedication to *plein-air* work gained him the admiration of the young Impressionists.

Daubigny's place on the Salon jury from 1866 to 1869 was instrumental in the Salon's acceptance of many Impressionist works. In 1870 Daubigny, like Monet and Pissarro, escaped from the Franco-Prussian war to London. It was through Daubigny that Monet was introduced to the picture dealer Paul Durand-Ruel, who was also in London at the time. During the preparations for the first Impressionist exhibition of 1874, there was a plan to invite Daubigny, Corot and Courbet to exhibit as well, but the project did not go ahead.

Hilaire Germain Edgar DEGAS (1834-1917)

Born into a wealthy banking family, Degas started copying works in the Louvre soon after leaving school. Although he originally intended to study law, he decided to follow an artistic career and entered the Ecole des Beaux-Arts in 1855. His great inspirations at that time were the painters of the Renaissance and Ingres, whom he visited during his first year of study. During the late 1850s he lived mainly in Italy, staying in Rome, Naples and Florence, copying the Renaissance masters and working with Gustave Moreau.

Degas's early works are chiefly historical paintings, portraits of family and friends and copies from the old masters. In 1865 he successfully submitted his *Battle Scene from the Middle Ages* at the Salon, and from then on exhibited there regularly. In the late 1860s he began to paint contemporary subjects, such as racehorses and ballet dancers. His friendship with Manet and other members of the Batignolles group may have encouraged this development, since until then he seemed to be heading for a traditional academic career.

During the Franco-Prussian war, Degas served in the Garde Nationale. After the war, when he began to develop eye problems, he went to stay with his brother in New Orleans, where he painted *The Cotton Exchange, New Orleans* (1873). In 1874 he participated in the first Impressionist exhibition and from then on was to be one of the driving forces

Edgar Degas – from painting he turned to pastels and sculpture.

behind the movement's shows. During the mid-1870s he experimented with printmaking, especially monotypes, which he was to use throughout his remaining career, either in their pure state or with pastel additions. It was in monotypes that he depicted scenes observed in Parisian brothels and his first *femme à sa toilette* compositions, which were to play such a prominent part in his later work. Major portraits of the 1870s included those of his friends Edmond Duranty and Diego Martelli.

Degas met Mary Cassatt during the mid-1870s and invited her to exhibit with the Impressionist group, and a lasting (though sometimes difficult) friendship developed between them. It was also during the 1870s that Degas first explored the medium of sculpture, producing his innovative figure of a ballet dancer clad in a real tutu. His compositions of this time became more unorthodox and daring and there is much discussion as to what part his failing eyesight,

the influence of photography and *japonisme* played in this development.

Degas remained faithful to the Impressionst movement and was absent from only one show, that of 1882, reportedly as a result of a disagreement with Gauguin, who objected to the artists Degas wished to introduce into the group, such as Raffaëlli. At the 1886 exhibition, he showed, among other works, a group of pastel nudes that caused a great deal of critical comment because of their supposed impropriety.

In the 1890s Degas's vociferous support of the anti-Dreyfus lobby alienated him from many of his colleagues. By this time he had begun to make enthusiastic use of photography as a basis for his paintings, taking pictures of friends or models in the poses he wished to represent in his oils and pastels. His eyesight became progressively worse and he was eventually forced to give up painting; he then concentrated on grandiose pastel compositions and sculpture, the latter eventually taking over completely in his last years.

Henri FANTIN-LATOUR
(1836-1904)

Son of the painter Jean-Théodore Fantin-Latour, Henri showed a precocious talent while still at school and copied his first painting in the Louvre at the age of 16. Soon he made the acquaintance of the realist painter Bonvin and the engraver Bracquemond, and his copy of Titian's *Pilgrims on the Road to Emmaus* was favourably commented upon by Couture and Lehmann. However, although he entered the Ecole des Beaux-Arts at the age of 18 with a high grade, he failed his end-of-term exams and left. Artists he met while at the Ecole included Degas and Legros.

After leaving the Ecole Fantin-Latour continued to work on copies in the Louvre and met a number of notable painters, among them Manet, Courbet, Whistler, Berthe and Edma Morisot, Carolus-Duran and Lord Leighton. In 1861 his first work was accepted by the Salon, and he attended Courbet's informal studio, which had just opened. The painter

he most admired at the time was Delacroix, and after the master's death he composed *Homage to Delacroix* (1864); the first major portrait group he executed, it depicts among others Duranty, Whistler, Champfleury, Manet, Baudelaire, Legros, Braquemond and Fantin himself.

During the late 1850s and early 1860s Fantin-Latour made several trips to London, where his work was more popular and where he was consistently helped by a number of patrons. In 1865 he met Monet and Bazille and was responsible for introducing Berthe Morisot to Manet. In 1870, he painted the famous *A Studio in the Batignolles Quarter* with Manet as the central figure, surrounded by Astruc, Renoir, Zola, Edmond Maître, Bazille, Monet and Scholderer. Despite his close ties with the Impressionist group, he did not exhibit with them in 1874 and disapproved of Manet's admiration for their aims.

Gradually, Fantin-Latour's representational portraits and still lifes gave way to mythological and symbolic works, and he turned increasingly to lithography. A growing enthusiasm for music, and Wagner's work in particular, resulted in many lithographs on operatic themes. In the 1880s he participated in various public campaigns, such as that for the monument to Delacroix, and helped to organize Manet's posthumous exhibition at the Ecole des Beaux-Arts.

Armand GUILLAUMIN
(1841-1927)

Guillaumin, a tailor's son, was largely self-taught as an artist, going to the Louvre as often as he could while working for his uncle's lingerie business from the age of 16. In 1861, he attended the Académie Suisse, where he met Cézanne and Pissarro, who was to afford a lasting source of encouragement and introduced him to Manet, Degas, Bazille, Renoir and Sisley. Throughout his early career Guillaumin was dogged by financial difficulties, and during the 1860s he and Pissarro took a job painting blinds in order to earn a living. Eventually he found a night job that left his days free for painting.

Guillaumin's early enthusiasm was Courbet, and his first canvases reveal this influence; when Courbet was imprisoned after the Commune of 1871 Guillaumin visited him. During the early 1870s, Guillaumin and Cézanne went to Pontoise to see Pissarro. There they visited Dr Gachet (Van Gogh's future doctor), on whose printing press they made their first prints. Another near-neighbour, Eugène Murer, who had been at school with Guillaumin in Moulins, began to buy his work at this time.

At the first Impressionist exhibition in 1874 Guillaumin was represented by three works. During the period following the show he and Cézanne worked closely, painting by the Seine together, and several works show their collaboration. In 1877 Gauguin bought some of Guillaumin's works and they painted together. Guillaumin's relations with the more conservative members of the group, Renoir and Degas, were always rather uneasy and he had greater sympathy with the younger generation of artists.

At the first Salon des Artistes Indépendants of 1884, Guillaumin was the only Impressionist to exhibit. In 1885 he introduced Signac and Seurat to Pissarro, with the result that Pissarro invited them to exhibit in the last Impressionist show of 1886. He became good friends with Vincent Van Gogh through his brother Theo and also kept in touch with Gauguin.

In the 1890s Guillaumin – surprisingly, in the context of his early socialist leanings – was an anti-Dreyfusard, and this caused a temporary rift with Pissarro. After winning a large sum of money in a lottery in 1891 he was able to devote himself to painting without financial worries and began to travel more widely, making excursions to the Mediterranean, Normandy, Brittany and the Massif Central. In 1893 he discovered the valley of the River Creuse in central France and painted there regularly for the rest of his life.

Edouard MANET (1832-83)

Son of a top civil servant in the Ministry of Justice, Manet developed an early interest in art and during his schooldays often visited the Louvre with his friend Antonin Proust. After several unsuccessful attempts to enter the Naval Academy, he managed to persuade his family to let him pursue an artistic career. Together with Antonin Proust, he attended the studio of Thomas Couture, where he remained for six years. With Proust, he visited Eugène Delacroix and asked for permission to copy the *Barque de Dante*. In the late 1850s he met both Fantin-Latour and Degas in the Louvre.

The first works Manet exhibited at the Salon attracted the attention of many young painters, including Fantin-Latour, Legros, Bracquemond and Carolus-Duran, and Baudelaire, Duranty, Champfleury and other critics commented on his work. In 1862 he became one of the founder-members of the Société des Aquafortistes and he was to make frequent use of printing throughout his career.

At the Salon des Refusés of 1863, Manet's *Déjeuner sur l'herbe* attracted more attention than any other work, and controversy continued when *Olympia*, his nude study of a prostitute, was exhibited in 1865: although it owed much to the traditions of Titian and Giorgione, its blatant subject-matter caused a scandal. Zola espoused Manet's art wholeheartedly in his articles on the Salon and an enduring friendship sprang up between the two men. At the World Fair of 1867 Manet held a one-man show, much on the model of Courbet's in 1855.

By the end of the 1860s Manet had met Monet, Cézanne, Bazille and Berthe Morisot. Although much in sympathy with the aims of the young Impressionists and often meeting them at the Nouvelles-Athènes café during the early 1870s, he declined the offer to participate in the first Impressionist exhibition of 1874, preferring to show his works at the official Salon. In the 1860s his paintings favoured frontal lighting of the subject and flat, unmodelled areas of paint. As a result of his connections with the Impressionists in the 1870s, however, his brushwork became more broken and his palette more luminous, as in such works as *The*

Edouard Manet as painted by Henri Fantin-Latour in 1867. Manet never officially identified himself with the Impressionists, but his work is closely related to theirs.

Road Menders in the Rue de Berne (1877-8). A staunch republican all his life, Manet executed several watercolours and lithographs depicting the scenes he saw in Paris after the defeat of the Commune in 1871. In 1880 his health began to deteriorate but he continued to exhibit regularly at the Salon and in 1882 was awarded the Légion d'honneur. His *Bar at the Folies Bergère* (1882), exhibited at the Salon, was his last major work.

Although Manet's training was largely traditional and owed a great debt to Italian and Spanish masters, his original handling of paint and his modern subject-matter set him apart from other Salon exhibitors. A sophisticated socialite rather than a bohemian, he never officially identified himself with the Impressionist group. Even so, his adoption of the Impressionist palette and techniques during the 1870s closely allies his work with theirs.

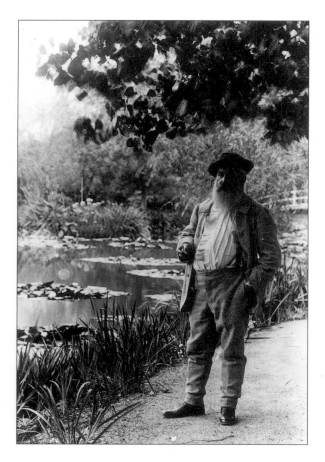

Claude Monet photographed at Giverny around 1920. His garden became an obsession which inspired his famous waterlily series.

Claude MONET (1840-1926)

Monet's first artistic leanings were encouraged by his aunt, who was an amateur painter, and later by Boudin, whom he met in about 1858 and with whom he painted out-of-doors. He later studied painting under Gleyre, although his attendance at the studio was erratic, since he preferred to paint in the open air of the Fontainebleau forest and the coast. His early work owes much to the example of the Barbizon School, Corot and Daubigny. His main associates at that time were Bazille and Renoir.

Monet's large compositions *Déjeuner sur l'herbe* (1866) and *Women in a Garden* (1867) showed him following in the tradition of Courbet and, to a certain extent, of Manet. In 1864 he painted with Bazille at Honfleur and Sainte-Adresse, meeting there Jongkind and Boudin, who was to be an enduring source of encouragement to the young artist; and he also worked with Courbet at Trouville. In 1865 he first exhibited at the Salon.

Monet's early career was financially unstable, and in the late 1860s he received help from Bazille, sharing his studio on occasion. He also worked closely with Renoir during the late 1860s and early 1870s. During the Franco-Prussian War, he fled to London, where he was introduced by Daubigny to the picture dealer Paul Durand-Ruel and also met Pissarro. On his return to Paris, he visited Courbet in prison in the company of Boudin. Inspired by Daubigny's example, he often painted on the Seine in a studio boat. At this time he met Caillebotte.

At the first Impressionist exhibition of 1874 Monet exhibited 12 paintings, including *Impression: Sunrise* (1872), which was to give the group its subsequent name. Both Manet and Renoir painted with him at Argenteuil during the mid-1870s, and he also worked extensively on the coast. This was a time of acute financial difficulties and he needed help from Caillebotte to find a studio from which to work on his Gare St-Lazare paintings, the first of many series.

He settled in Vétheuil, where, a year after the birth of his second son, in 1879, his wife Camille died. His loss and his isolation at Vétheuil further cut him off from the rest of the Impressionist group, from whose artistic aims he was already becoming distanced – although he remained on friendly terms with several. His increasing links with the dealers Durand-Ruel and Georges Petit showed him that his future lay in one-man rather than group exhibitions, and, except for the 1882 Impressionst show, he no longer exhibited with his former colleagues or at the Salon.

In 1883 Monet settled at Giverny with Alice Hoschedé, who had been sharing his life since the illness of his wife. He travelled extensively during the mid- and late 1880s, visiting central and southern France and Holland. With his increasing success, his artistic circle became wider, and his friends included John Singer Sargent, Whistler and Paul Helleu. Series paintings, in which he depicted the same subject (haystacks, poplars, Rouen Cathedral) increasingly pre-occupied him.

During the 1890s he became a public figure; he organized a public subscription for the purchase of Manet's *Olympia* for the Louvre and acquired many friends in the artistic and literary world. Many young painters visited him at Giverny; Bonnard and Vuillard found special favour with him. In his large paintings of water lilies in his gardens at Giverny, which occupied the last years of his life, he pushed the study of light and colour to its furthest extremes, almost to the realm of abstraction.

Berthe MORISOT (1841-95)

Berthe Morisot and her sister, Edma, the daughters of a government administrator, were given drawing lessons at an early age as part of their general education. Both decided to continue seriously; they were taught by Guichard, who was enthusiastic about their talent, encouraging them to sketch out-of-doors. Berthe first copied in the Louvre in 1858, her main inspirations being the Venetians.

Through Guichard, the two sisters

Berthe Morisot painted by Edouard Manet in 1872. Manet exerted a strong influence both on her personal life and her work.

were introduced to Corot, who, although he did not have official pupils, was always happy to impart advice, and he became a regular visitor to the Morisot home. He later advised them to work with a landscape painter, Oudinot, and both sisters exhibited at the 1864 Salon works that they had executed at Auvers-sur-Oise under his direction.

While copying in the Louvre, Berthe Morisot had met many artists, including Fantin-Latour, who in 1867 introduced her to Manet. The latter was to have a lasting influence on her work and life. She posed for him as one of the figures in *The Balcony*, which was exhibited at the 1869 Salon, and was to be his model on many subsequent occasions. In that same year Edma married and decided to give up painting – but she often sat for Berthe later.

Berthe Morisot's place in the Impressionist group, while central, was to a certain extent circumscribed by her sex. She could not, for instance, participate in the gatherings at the Café Guerbois, nor did she appear in Fantin-Latour's group portrait *A Studio in the Batignolles Quarter*, even though she was much closer at the time to Manet, the central figure in the group, than many of the other painters portrayed.

Morisot continued to submit works to the Salon, many of them at least partly executed out-of-doors. This commitment to *plein-air* painting encouraged her to throw in her lot with the other members of the future Impressionist group and she was a founder member in 1874 of the first show, at which she exhibited nine works. In the same year, she married Manet's brother Eugène, but unlike her sister, she continued painting. She no longer exhibited at the Salon, only at Impressionist shows, missing only one, that of 1879, after the birth of her daughter.

During the late 1870s, Morisot made the acquaintance of Mary Cassatt, with whom she collaborated in the late 1880s in printmaking. In addition to her paintings, she also produced dry-points and many drawings and water-colours, often closely related to her oil paintings. She established a close friendship with Renoir in the 1880s and he painted a portrait of her and her daughter. Her circle of friends widened and many eminent literary figures frequented her soirées.

Camille PISSARRO (1830–1903)

Born of a Jewish father and Creole mother, Pissarro settled in Paris in 1855, no doubt seeing Courbet's Pavillon du Réalisme during the World Fair. In the late 1850s he started to paint in the open air and intermittently attended the Académie Suisse, where he met Monet, Guillaumin and Cézanne. The paintings of his early career owe much to the work of Corot and Courbet and use the latter's heavy palette-knife technique.

During the 1860s Pissarro's work was regularly accepted at the Paris Salon; even so, this did not help him financially, and he was to have problems supporting himself throughout his career. During the upheaval of the Franco-Prussian war – Pissarro estimated the war lost him 'about 40 pictures out of 1500' when the Prussians occupied his home – he went with his family to London, where he saw works by Turner, Constable and Crome. Returning to France, he worked with Cézanne and Guillaumin at Pontoise.

As well as paintings, Pissarro regularly produced etchings and engravings. In the 1870s his brush strokes became more broken. During the following decade his landscapes gave way to peasant scenes, and this change has been linked to his enthusiasm for the anarchist writings of Kropotkin and Recluse, who advocated a return to the soil and small communes. Pissarro gave active encouragement to Gauguin in his early career and later met Seurat and Signac. It was largely through Pissarro's efforts that the two young artists were included in the 1886 Impressionist show, where he exhibited alongside them in the new divisionist style that characterized their work. The controversy that their inclusion aroused played a part in distancing Pissarro from the other original members of the group, notably Renoir and Degas.

Through his connection with Seurat and Signac, Pissarro fre-

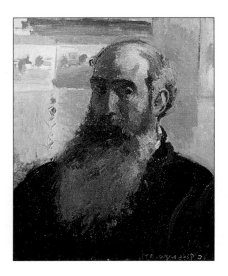

Self portrait of Camille Pissarro painted in 1873 in middle age. The only member of the Impressionists to exhibit in all eight shows, he helped to hold the group together.

quented Post-Impressionist circles and met Van Gogh, Félix Fénéon and Maximilien Luce, his anarchist sympathies finding kindred spirits in this circle. At the beginning of the 1890s, he began to suffer from eye trouble, which prevented him from painting in the open air. From then on he often painted from inside buildings, looking out onto the scene and adopting the high viewpoints favoured by Caillebotte. He also moved away from divisionism back to his earlier style of painting. The views he painted towards the end of his life of Paris and Rouen were notable.

Pissarro was probably the most broad-minded and flexible of the Impressionists, and by his constant participation in Impressionist exhibitions (he was the only one to exhibit at all eight shows) he helped to keep the group together. As well as landscapes and figure scenes, he produced many drawings, water-colours and prints. His extensive correspondence, especially to his son Lucien, provides great insight into the aims and world of the Impressionists.

Pierre-Auguste RENOIR (1841–1919)

A tailor's son, Renoir was apprenticed to a porcelain painter in Paris, while at the same time attending drawing classes at art school. When the porcelain works went out of busi-

ness he painted fans and blinds for a living. In 1860 he began to work in the Louvre and two years later attended Gleyre's studio. He then enrolled at the Ecole des Beaux-Arts and from 1864 exhibited at the Salon. With his colleagues from Gleyre's studio, he painted in the Fontaine-bleau forest, where he met members of the Barbizon School.

During the late 1860s Renoir shared a studio with Bazille, at which Monet joined them for a short while, and the three frequented the Café Guerbois, where they met Manet. Renoir's works of the time are large-scale and owe much to the influence of Courbet, as can be seen in *Diana the Huntress* (1867). Renoir's parents moved to Louveciennes, where he lived with them for a while, often visiting Monet, who was staying near Bougival. The two painted many works side by side in a very similar style, such as their pictures of La Grenouillère.

Renoir was mobilized during the Franco-Prussian war and lived in

A photograph of Pierre-Auguste Renoir as an old man painting in the open air. The loose, fluid technique of his later paintings was partly due to failing eyesight.

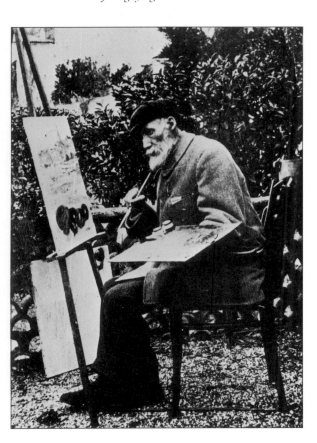

Paris during the Commune. In the early 1870s he stayed with Monet at Argenteuil, where Manet joined them, and showed several works at the first Impressionist exhibition of 1874. The following year he met Victor Choquet, the first of many patrons who were to further his career, and painted several portraits of his family. The increasing number of commissions he began to receive during the late 1870s, through dealers and influential patrons such as the Charpentier family, may have been in part the cause of his gradually becoming distanced from the Impressionist group, and he was to participate in only four of their eight shows.

In 1878 Renoir began to exhibit at the Salon once more, and the following year his portrait of Mme Charpentier and her children was hung there very prominently and attracted much attention. During the early 1880s he travelled extensively (in Italy he painted Richard Wagner's portrait) and worked at L'Estaque with Cézanne.

Renoir's free Impressionist brush-work of the 1870s gradually gave way to a more polished handling during the 1880s, and his *Grands baigneuses* (1886), the result of many studies, seemed to look back to more traditional studio practice. His main friends at this time were Monet, Caillebotte, Morisot, Cézanne and Pissarro, although his relations with the latter were soured in the later years of the century, when Renoir adopted a strong anti-Dreyfus stance.

In 1898 Renoir stayed in Cagnes, in the South of France. His brush-work became much more fluid during this time and portraits and pastoral scenes made up the main body of his work. In later years he was much fêted, and in 1907 his portrait of Mme Charpentier and her children was bought by the Metropolitan Museum of New York. The same year he settled permanently in Cagnes, where he lived until his death. Some of Renoir's outdoor figure compositions of the mid-1870s and early 1880s – sunlit scenes of everyday young people at leisure, such as *Le Moulin de la Galette* (1876) and *Luncheon of the Boating Party* (1881) – have popularly come to embody the spirit of the Impressionist movement.

Georges SEURAT (1859-91)

Son of a legal officer, Seurat enrolled at the Ecole des Beaux-Arts in 1878 and was taught by Henri Lehmann, a pupil of Ingres. His early drawings are classical in spirit and show the influence of Ingres. Seurat's studies were interrupted by military service at Brest, where he filled sketchbooks with thumbnail sketches. When he returned to Paris he decided to paint independently.

In Paris Seurat began to draw with conté crayon, developing an unmistakable style marked by its emphasis on chiaroscuro and the subtle gradations of the crayon on textured paper. His main sources of inspiration at this time were Delacroix and Puvis de Chavannes; the marriage of these two seemingly incompatible influences can be seen in Seurat's first major work *Une Baignade, Asnières*, rejected by the Salon but exhibited at the first exhibition in 1884 of the Société des Artistes Indépendants, which he had helped found.

In his painting of La Grande Jatte (1884) Seurat developed further the innovations of colour and brushwork of *Une Baignade*, shedding earth colours from his palette and developing the divisionist style that characterized the Neo-Impressionist school: known as pointillism, this placed in juxtaposition on the canvas small spots of pure colour which, when viewed at the correct distance, were blended by the eye. Both Seurat and Signac (whom he had met during the founding of the Indépendants) were invited by Pissarro to exhibit at the 1886 Impressionist exhibition.

With the support of Signac, and the critical weight of Félix Fénéon behind him, Seurat became the leader of the neo-Impressionist group. Despite his innovatory style, his method of working was deeply rooted in academic practice: he executed a large number of studies in preparation for his canvases (in both conté crayon and oils) and he painted the finished works in the studio. After the Impressionist show, Seurat painted a series of coastal scenes at Honfleur and further figure compositions, such as *Les Poseuses* and *La Parade*. Seurat was involved, as were most of the neo-Impressionists, in anarchist circles,

Georges Seurat

and certain critics saw in his later figure paintings a satire on the vacuity of contemporary society.

In the late 1880s he painted coastal and port scenes at Port-en-Bessin and Gravelines, harmonious compositions that laid great emphasis on horizontal, vertical and diagonal lines and were probably inspired by the writings of Charles Henry on aesthetics and classical rules of proportion. Seurat's death at the age of only 31 interrupted work on his last major canvas *The Circus*.

Paul SIGNAC (1863-1935)

Largely self-taught as an artist, Signac was first influenced by the work of Monet and Degas and visited several Impressionist exhibitions. It was at an inaugural meeting of the founding of the Société des Artistes Indépendants in 1884 that he met Georges Seurat, who, like himself, was evolving a style based on pure complementary colours and optical mixing. They later met Guillaumin, who introduced them to Pissarro, which led to his inviting them to participate in the last Impressionist exhibition of 1886.

The divisionist technique of Signac's canvases and their uncompromisingly naturalistic subject matter (suburban streets, gasometers, seamstresses at work) soon attracted attention and the recognition of enlightened critics. After the 1886 exhibition, Signac painted in Brittany, to which his other passion, sailing, often took him. He developed a close friendship with Maximilien Luce and Pissarro's son Lucien, and the trio often painted together along the banks of the Seine. While he was in Paris in 1886-7, Van Gogh also became a good friend.

In 1887 Signac went to the South of France, where he was struck by the quality of the light and produced his most luminous canvases. More gregarious than Seurat, Signac acted as a spokesman for him and they worked closely until Seurat's death in 1891. As well as landscapes, Signac also produced portraits and figure compositions. His portrait of Félix Fénéon of 1891, showing the critic against a multicoloured background, displays in one painting several current artistic trends: Symbolism, *japonisme* and scientific colour theory.

Signac spent most of the 1890s in either Paris or St Tropez. In common with many other neo-Impressionists, Signac had strong anarchist sympathies and in 1894-5 he executed a large-scale canvas entitled *The Age of Harmony*, a vision of a future utopia in an anarchist society. In 1899 he made a major contribution to art theory with the publication of *From Eugène Delacroix to Neo-Impressionism*, which outlined the neo-Impressionists' colour theory. The book was enthusiastically received by a whole new generation of artists, including Matisse and Severini, and served to give neo-Impressionism a new lease of life.

Signac's output in oils declined during the first decade of the 20th century, and water-colour, a medium he had first taken up on the advice of Pissarro, played an increasingly important role in his work. From 1908 he was president of the Société des Artistes Indépendants.

Alfred SISLEY (1839-99)

Born in Paris of British parents, Sisley was sent to London in 1857 to prepare for a commercial career; his father was a prosperous businessman dealing in textiles. During his four years in London, Sisley visited the museums, where he admired the paintings of Constable and Turner, and he may also have seen some works by the Barbizon painters, who were beginning to be shown in London. Returning to Paris in 1862, he persuaded his parents to allow him to pursue an artistic career and attended Gleyre's studio, where he met Renoir, Bazille and Monet.

Apart from a few early still lifes,

Alfred Sisley

Sisley's work was mainly to comprise landscapes; his earliest influences were Corot and Courbet and, with his friends from Gleyre's studio, he painted in the open air in the Fontainebleau forest. Unlike his companions, he was relatively prosperous at that time and did not need to earn a living from painting. In 1866 he exhibited his first work at the Salon.

During the late 1860s Sisley worked with Monet, but his brushwork and colour failed to show the daring and freedom of his colleague's until the early 1870s. The Franco-Prussian war ruined his father's business and health, and after his death Sisley was virtually without means, with the result that he turned from an amateur into a professional painter and increased his output. Even so, financial troubles dogged his career from then on – although he did receive a limited amount of support from various patrons, including the picture dealer Paul Durand-Ruel.

Sisley moved from central Paris to the outskirts living at Louveciennes, Marly-le-Roi and Sèvres. There he painted many works by the Seine. He exhibited at the first Impressionist show in 1874 and the same year went to London, where he painted a considerable number of landscapes. In the manner of Monet, Sisley favoured the depiction of subjects under differing atmospheric conditions and he painted many snow scenes.

During the 1870s and 1880s Sisley continued to produce a steady output of paintings, but his participation in the Impressionist shows was sporadic. He had a one-man show at the offices of *La Vie Moderne* in 1881 and another at Durand-Ruel's in 1883. In 1890 he began to exhibit at the Société Nationale, continuing to do so regularly until his death from cancer.

INDEX

206

PICTURE CREDITS

Quarto would like to thank the following for providing photographs, and for permission to reproduce copyright material. While every effort has been made to trace and acknowledge all copyright holders, we would like to apologize should any omissions have been made.

For reasons of space, the following abbreviations have been used:
tl=top left tr=top right bl=bottom left br=bottom right cl=centre left cr=centre right t=top b=bottom c=centre